INSIDE THE PHOTOGRAPH

PETER C. BUNNELL

INSIDE THE PHOTOGRAPH

Writings on
Twentieth-Century
Photography

Foreword by
Malcolm Daniel

aperture

Editors: Diana C. Stoll and Nancy Grubb; Designer: Wendy Byrne;
Production: Matthew Pimm

The staff for this book at Aperture Foundation includes:
Ellen S. Harris, *Executive Director*; Michael Culoso, *Director of Finance and Admin-
istration*; Lesley A. Martin, *Executive Editor, Books*; Susan Ciccotti, *Assistant Editor*;
Bryonie Wise, *Production Manager*; Andrea Smith, *Director of Communications*;
Kristian Orozco, *Director of Sales and Foreign Rights*; Diana Edkins, *Director
of Exhibitions and Limited-Edition Photographs*; Martha Fleming-Ives, Robert
Stephenson, and Monnee Tong, *Work Scholars*

Inside the Photograph: Writings on Twentieth-Century Photography was made
possible with generous support from the E. T. Harmax Foundation and The
Publications Committee, Department of Art and Archaeology, Princeton University.

First edition
Printed and bound in Singapore
10 9 8 7 6 5 4 3 2 1

Library of Congress Cataloging-in-Publication Data

Bunnell, Peter C.
 Inside the photograph : writings on twentieth-century photography /
 Peter C. Bunnell ; foreword by Malcolm Daniel.
 p. cm.
 Includes index.
 ISBN-13: 978-1-59711-021-1 (hardcover with jacket : alk. paper)
 ISBN-10: 1-59711-021-3 (hardcover with jacket : alk. paper) 1. Photography.
 2. Photography—History—20th century. 3. Photographic criticism. I. Title.

 TR185.B86 2006
 770.9'04—dc22

 2006007629

Aperture Foundation books are available in North America through:
D.A.P./Distributed Art Publishers, New York, N.Y. 10013
Phone: (212) 627-1999, Fax: (212) 627-9484

Aperture Foundation books are distributed outside North America by:
Thames & Hudson, 181A High Holborn, London WC1V 7QX, United Kingdom
Phone: + 44 20 7845 5000, Fax: + 44 20 7845 5055, Email: sales@thameshudson.co.uk

aperturefoundation
547 West 27th Street, New York, N.Y. 10001
www.aperture.org

For John Szarkowski

CONTENTS

FOREWORD

By MALCOLM DANIEL 8

PHOTOGRAPHERS

Alfred Stieglitz and *Camera Work* 11

Observations on the Herbert Small Collection
of Stieglitz's Early New York Photographs 17

Three by Stieglitz 23

Clarence H. White: The Reverence for Beauty 32

Gertrude Käsebier 53

Edward Weston on Photography 60

Ruth Bernhard 78

Barbara Morgan 84

Aaron Siskind: The Bond and the Free 90

Minor White's Photographic Sequence
"Rural Cathedrals": A Reading 101

Harry Callahan 115

Walter Chappell: Time Lived 126

Walker Evans: An Introduction to His Work
and His Recollections 133

Wright Morris 147

Robert Frank's *Fourth of July—Jay, New York* 161

Lisette Model 164

Diane Arbus 169

Elliott Erwitt 176

Eikoh Hosoe 180

Tokio Ito 184

Michiko Kon 187

Jerry N. Uelsmann 190

Jerry N. Uelsmann: Silver Meditations 197

Jerry N. Uelsmann: Museum Studies 206

John Pfahl: Altered Landscapes 210

Ray K. Metzker 218

Paul Caponigro 223

Emmet Gowin 227

Edward Ranney: The Character of the Place 239

Thomas Joshua Cooper: The Temperaments 248

Michael Kenna: A Twenty-Year Retrospective 254

GALLERIES

Helen Gee: Remembering the Limelight 263

The Witkin Gallery 268

Light Gallery 275

Acknowledgments 278

Index 279

Text and Photography Credits 288

FOREWORD

Those readers who are among the many students who passed through Peter Bunnell's three decades of legendary Princeton lectures and seminars—especially those who, like myself, enrolled at the university intending to study some other aspect of art history and left a few years later as committed converts to the history of photography—will hear Peter's animated voice and earnest expression of ideas in the essays that follow. So, too, will those friends and colleagues who have spent evenings enthralled by Peter's accounts of an emerging photo world and by his historical or interpretive analyses of photographers' work. The rest of you will have the pleasure of first discovering in these pages the testimony of an eyewitness to photography's coming-of-age in America; perceptive readings of what the author's lifelong photographer-friends express visually; the lessons of a distinguished professor and art historian; and the engaging tales of a master raconteur.

Dress comfortably. The essays in this book—addressing a century of photography—are not about high fashion. They are plainspoken, insightful discourses about the soul of the medium, not its surface. At the same time, they are not about the meaning of *photography*, but rather about the meaning of *photographs*, as seen by one uniquely qualified to take you by the hand and guide you to the realization that he himself had as a college student some fifty years ago: regardless of the form they take, the most rewarding photographs are those made by artists of deep conviction who are interested in communicating ideas.

Importantly, Peter has stood on the ground-glass side of the camera, having received a BFA in photography in 1959 from Rochester Institute of Technology, where his fellow students included Carl Chiarenza, Bruce Davidson, Ken Josephson, and Jerry Uelsmann. Although Peter rarely, if ever, writes about technical aspects of the medium (the craft per se is not his central focus), he recognizes those visual clues that reveal an artist's conscious choices and thereby point to the heart of the matter—what the photograph means.

Within a week of arriving at RIT with visions of a career in fashion photography, Peter had met Beaumont Newhall, a pioneer in charting the history of photography, and Minor White, who would become Peter's mentor and the prime example of what came to interest him most—as Peter puts it: the "artist-photographer as a seeker who explores

meaningful truths and risks much in that search." By the time he left Rochester, Peter's course as a historian and curator was set. At Ohio University he pursued a master's degree in photography and art history with a thesis on the Pictorialist photographer Clarence H. White, and at Yale he did further graduate work, with much primary research on Alfred Stieglitz.

Somewhere along the way, Peter learned how to observe and record the salient details of the world around him—I don't know if this was the habit of a good student, the discipline of a scholar, or the innate attentiveness of a photographer. At Princeton, I vividly remember attending a lecture by a noted photographer, a friend of Peter's who had previously spoken to photography students a half-dozen times at Peter's invitation. Although I listened intently, with pad and pencil in hand to record the wise words of one of the medium's masters, at the end of the hour I had written only the date and the photographer's name. I'd be hard pressed now to tell you much of what was said. But Peter, I am certain, can quote the photographer precisely: by the end of the lecture he had a sheaf of notes—destined, no doubt, for those file cabinets of his, which may be one of the medium's best archives of the last fifty years and which have served to give flesh and bones to the ideas and observations in this book.

Peter's long career and great passion for photography brought close friendships with many of the subjects about whom he writes in this volume—not only his RIT classmates and Minor White, but also Aaron Siskind, Harry Callahan, Lisette Model, Diane Arbus, and in more recent years, Emmet Gowin and Thomas Joshua Cooper. Those relationships give him privileged insight into the link between photographic creativity and the psychology and experience of both photographer and viewer. "When we understand the artist's personal condition," Peter writes, "we are better able to reflect on his or her statement."

Early in his career, Peter spent several years as a curator in the Photography Department at New York's Museum of Modern Art under the directorship of John Szarkowski, from whom he learned much about "reading" photographs, and to whom he has dedicated this book. Peter's tenure at the museum, from 1966 to 1972, was a critical period, during which the photographs of Arbus, Lee Friedlander, and Garry Winogrand were presented in Szarkowski's *New Documents* show. Peter curated his own innovative exhibitions that looked at the medium in a broader context of artistic practice and tradition, *Photography as Printmaking* (1968) and *Photography into Sculpture* (1970), as well as a

series of monographic shows on the work of Paul Caponigro (1968), Clarence H. White (1971), Emmet Gowin and Robert Adams (1971), and Barbara Morgan (1972).

In 1972, Peter assumed the newly created David Hunter McAlpin Professorship of the History of Photography and Modern Art at Princeton—the first endowed university chair devoted to photographic history, and one from which he would train a generation of scholars. The hallmark of his pedagogy over thirty years was a belief in the primacy of the individual photograph, and his seminars—taught with photographs from the museum collection he built—were inspirational. It was a type of academic experience that is now difficult to come by. Thus, the collected writings presented here are both anachronistic and particularly timely. For those who would willingly become entangled in the minutiae of technique, process, and craft, at one extreme, or in the ontology of the medium, at the other, these essays serve as a reminder that, as Peter says, "at the end of the day there is still a person making a picture which has an individual meaning."

If you've read this far, you are likely to be a receptive audience for the wisdom contained herein and for the joy and challenge of discovering what is inside the photograph.

<div align="right">

MALCOLM DANIEL, Curator in Charge
Department of Photographs
The Metropolitan Museum of Art

</div>

ALFRED STIEGLITZ AND
CAMERA WORK

Two books dealing with the work of Alfred Stieglitz reassure us that not only is publishing in photography sound but Stieglitz's great contribution to photography will not be easily forgotten. The first book, *Alfred Stieglitz: An American Seer*, a personal memoir and partial biography of Stieglitz by Dorothy Norman, is the culmination of her nearly twenty-year association with Stieglitz and her subsequent efforts to bring the full measure of his work into print. The second, *Camera Work: A Critical Anthology*, by Jonathan Green, provides for the first time a major anthology of Stieglitz's publication *Camera Work*. The importance of these two books cannot be overemphasized, nor should they be considered just one more example of the increasing popularity and interest in photography. Both are superior examples of book production, and each illuminates the work of the founder of what may be considered modern photography.

Stieglitz structured modern photography, and his principles are as relevant and viable today as during his lifetime. This is because, as a kind of architect, he not only originated ideas but acted. No one ever made photographs like Stieglitz. The essence of his spirit, which expresses not so much an individual personality as a particular relationship with the world, lies within his imagery. His photographs embody not a concept of form or representation, but the resolution of a dialogue between creator and conscience. Thus his photographs must be read, and in this way are documents. They are psychological documents, not physical, and are more like medieval manuscript illuminations than conventional descriptive photographs. They appear simple, but they are genuinely complex.

Stieglitz's belief in the photographic medium was total, and often he wrote that he owed "allegiance only to the interests of photography." But his view of the medium was far from restrictive. It went beyond the visual present to embrace historical completeness. He understood that the individual frame of a photograph marked only a provisional limit; its content pointed beyond that frame, referring to a multitude of phenomena that could not possibly be encompassed in their entirety. This idea

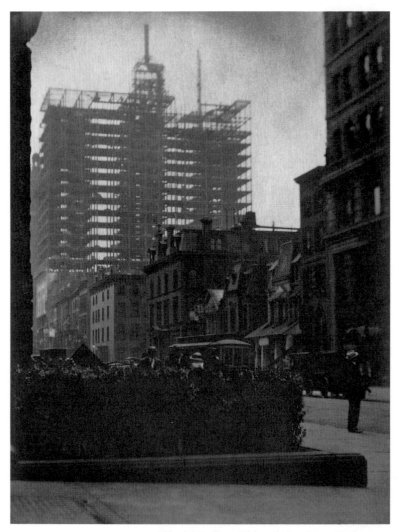

Alfred Stieglitz, *Old and New New York*, 1910
From *Camera Work*, no. 36. Private collection

he termed "equivalence," and this extension of photographic aesthetics reveals the unmistakable originality of his thought. The first manifestation of the conceptual methodology that resulted in the theory of equivalence is *Camera Work*, the publication Stieglitz edited from 1902 to 1917. *Camera Work* must be thought of as a whole, with a meaning that pervades its every element. There is no argument that is not constructive. There is no image that is not revealing. Put another way, Stieglitz believed that the exercise of vision and intellect, incorporated in all creative disciplines, served to illuminate the ultimate meaning of pictorial content. Thus, within its pages one finds, often juxtaposed: Edward Steichen and George Bernard Shaw, Henri Matisse and Charles Caffin, Julia Margaret Cameron and Benjamin DeCasseres, Clarence H. White and Frank Eugene, Picasso and Gertrude Stein, Stieglitz and Henri Bergson.

Camera Work is generally considered first in terms of its unequaled craftsmanship, but more than style, it makes evident a generosity and spirit that have never been equaled. It is the most intelligible literature on photography yet published. Likewise, Stieglitz's photographs bear on more than the character of straightforward photography. Ultimately they serve as a body of work to define the very framework of the medium. Before Stieglitz, photography had been a thing apart from the arts of expression. Because of Stieglitz, this can never again be true.

Jonathan Green, a member of the creative photography faculty at MIT, succinctly records in his introduction the developments surrounding *Camera Work*. The description is without error, and his presentation of the publishing facts behind the magazine is illuminating. Without resorting to blind praise, Green clarifies the vision behind the publication and the virtues and failings of the movement it documented. His breakdown of the magazine's content by period is insightful, reflecting one who has carefully read the contents. He fully understands that Stieglitz and Steichen recognized that the surest way to describe their photographic aesthetic was to show what it was not. For this reason, to the considerable perplexity of subscribers, Stieglitz sought to launch a full-scale investigation of modern art, at least insofar as he knew it. By concluding the publishing of the magazine with the work of Paul Strand, photography was set on a new course for succeeding generations in this century. Strand did not so much discover a new photography as he reaffirmed belief in photography as practiced in the nineteenth century. In short, it was a photography that dealt with subject selection more than

treatment as an approach to the consideration of meaning. Similarly, Strand understood that for photography to be contemporary it should reflect the most contemporary—or modern—forms of seeing and analysis. Photography after *Camera Work* no longer reflected the art of the past, but showed that it was an art of the present.

What is also significant in terms of *Camera Work* is the realization that the publication of a magazine of quality, reproducing the finest work available, was the surest way to achieve dominance in the field. Stieglitz knew that to launch a revolutionary movement it did no good to argue with a few and haunt the recesses of the radical avant-garde. Thus his first exhibition of the Photo-Secession was held at the highly prestigious National Arts Club, and in the pages of his magazine the foremost photographic manufacturers were advertisers. Their authority was lent to the cause for which the magazine stood, as was its quality of production. Nothing but the finest was acceptable, thus clothing pictures and writing alike in extremes of respectability. The magazine had a wide circulation; although its edition of one thousand would, by today's standards, be considered minute, its influence as an arbiter of taste was enormous. Without *Camera Work*, the Photo-Secession would have been simply one more organization of local interest.

The format of Green's book is superb both in its feeling for the overall sense of quality with regard to *Camera Work* and in its tasteful echo of the typography and layout. There is some slight confusion as one moves from article to article, but this is minor. A unique contribution of Green's research is the presentation of a complete index to the *Camera Work* texts and plates, as well as brief biographies of the major contributors. The reproductions have been clearly made with the care that reflects all Aperture books, but they will suffer slightly in the process of being made from the gravure originals. In the rephotographing of these gravures, the texture of the paper and ink in the originals inevitably interferes with the copying process, giving reproductions a somewhat more "grainy" appearance than the originals. The color plates are superb. The only other publication of *Camera Work* is the full set published by Kraus Reprint (1969), and here the reproductions are so poor as to be useless. A meaningful comparison might be made with the full reprint, in that while everyone might have a favorite article Green has not included, the sheer volume and repetitiveness of the original make his book invaluable for the general reader of the period. The history of photography must ultimately be found in the periodical literature, and the bulk of scholarly research in the field rests in this area.

With the publication of Green's book, one major area of study in the field is in book form, and scholars and students seriously interested in this period no longer need seek costly original issues or use the reprint. Here in one volume are the major developments and ideas in photography between 1903 and 1917.

Dorothy Norman's book on Stieglitz is entirely different from Green's work, in that it reflects the fruits of insight and impression gained from long and deep personal experience, as opposed to objective research. Many persons will find this book wanting, preferring instead the perspective of a historian or scholar who treats each fact without emotion or reminiscence. However, this is to overlook, or indeed to demand, something not within the aim or background of the author. The note at the beginning of the book clearly states the goal and the primary source of these pages—the personal recollections not only of Mrs. Norman but of Stieglitz himself. By the time Mrs. Norman met Stieglitz in 1927, he was truly famous and secure in his contribution to American art. His recollections of how this was achieved were not so much biased by a vision of himself as reflective of his knowledge of events. Such knowledge was sometimes very limited. Stieglitz was also contradictory, and if one goes through the thousands of letters he wrote, now contained in the Stieglitz Archives at Yale University, one can clearly sense and understand the psyche of this artist. Mrs. Norman, through her presentation, seeks simply to present the psychology and action of this man, but she does not seek to explain the why or give the perspective of the details surrounding his actions.

The sheer amount of information, in terms of both commentary by Stieglitz and the data covering Stieglitz as an artist and arts impresario presented by Mrs. Norman, makes this the most significant work on Stieglitz to date. In part, it is in the tradition of the affectionate collective portrait *America and Alfred Stieglitz* (1934), of which Mrs. Norman was also an editor. The chronology and exhibition lists are invaluable, the details presented in her notes are likewise unique, and the bibliography is a significant contribution. Most of all, the reproductions will be most rewarding to the individual discovering Stieglitz through his photographs for the first time. No other publication presents so many reproductions of his life's work. The quality of these reproductions is not the finest that could be desired, but they are well above adequate. One of Stieglitz's contributions to photography was his articulation of the immense subtlety in the original photographic print. No other photographer before him managed to draw out of the photographic print the

same sense of tactility and spirit. The ineffable quality one feels from a Stieglitz original cannot be gained from a reproduction, and while Mrs. Norman does not make an apology for the quality of reproduction, she does clearly urge that the reader seek the originals and look well and deeply into them.

It is not the purpose of this review to rewrite or re-edit either of the books under consideration. I would question certain aspects of Stieglitz's interpretation of events and of Mrs. Norman's presentation of them, but, as I have stated, I do not feel it was her goal or her concern to set herself up as an objective scholar intent upon documented truth. This is especially the case in matters in which the impression of uniqueness in Stieglitz's actions and work are concerned. For years, everyone who has spoken for him has imparted something of an image of purity, resembling not so much a being untouched as something on the order of having been brought forth from the brow of Zeus. Every artist suffers this fate, and the best triumph over it, and in what amounts to a dual autobiography one should not seek impartiality. Stieglitz, apart from his photographs, left two primary autobiographical sources for the study of his life and action—his written correspondence and the reminiscences he told to Mrs. Norman and others. Another volume of material similarly based on the latter material is Herbert Seligmann's *Alfred Stieglitz Talking* (1966), published by the Yale University Library, and the student of biographical and critical methodology would be wise to compare these two volumes, as well as Mrs. Norman's earlier uses of the same material. With this book the stage has been set for the next study, which will require a cooler or more dispassionate approach. Jonathan Green's approach is reflective of this methodology, but he, like all of us, must be indebted to Dorothy Norman for her gift of sharing over these many years.

Originally published as *"Alfred Stieglitz: An American Seer* and *Camera Work: A Critical Anthology,"* *Print Collector's Newsletter* 5 (September–October 1974): 95–96.

OBSERVATIONS ON
THE HERBERT SMALL COLLECTION
OF STIEGLITZ'S EARLY
NEW YORK PHOTOGRAPHS

When Alfred Stieglitz returned to New York from Europe in 1890, he was returning home, and there he found himself in an environment that lacked the romantic picturesqueness and urban historicism of his European experience. New York was a metropolis, and while aspects of its dynamic commercialism repelled him, he plunged into photographing there with a fervor and intensity that was characteristic of his approach to the medium and to his quest for understanding. Indeed, some years later, he stated that he rarely understood anything unless he had photographed it. Thus the place of his New York photographs, taken in the decade after 1893, is critical in the interpretation of all of Stieglitz's later achievement. His first successful and widely acclaimed urban pictures, *Winter, Fifth Avenue* and *The Terminal*, may be seen as departures from the European work that preceded them; they also serve as an introduction to pictures he would make in Europe on an 1894 return trip there— visiting such places as Paris and Venice—and likewise presage photographs made still later in New York.

From his earliest period in photography, Stieglitz was interested in a picture-making challenge that went beyond content or pictorial values alone. It was technique that greatly interested him, and he was attracted by the opportunity to do something with his medium that was difficult or considered unlikely. Inclement-weather photography was one such area, as was night photography. With his snow pictures, he was interested not only in the pictorialism of the city under such conditions, but also in the challenge to manipulate his medium and master a difficult technical problem. Just being out of doors under such conditions, when other amateurs were generally spending the hours printing, mounting, and making frames, was a quality that marked the zeal of Stieglitz's efforts. There were numerous manuals that guided the photographer in his activity during these "melancholy" times of the year,

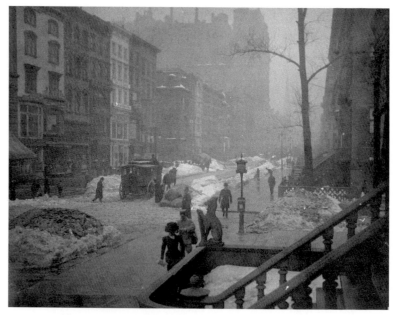

Alfred Stieglitz, *Fifth Avenue from 30th Street, New York*, ca. 1899
Collection of the Center for Creative Photography, Tucson, Arizona

when photography was considered inopportune or fit only for "poets." In addition to the technical issues, the immediacy of this sort of photography, along with the sense of dramatic or physical time as seen through the weather conditions, were qualities of realism that Stieglitz enjoyed. While the snow hid certain aspects of the real or "homely" city, it also enhanced certain pictorial conceptions that might be seen to link the American photographer with his colleagues in picturesque Europe. This quality can also be identified in the work of his native contemporaries in painting, but about whom Stieglitz knew little at the time.

Pictures of this period were presented by Stieglitz not only as prints, but also, and more likely, as lantern slides, one of the most popular photographic formats of the day. Stieglitz was an avid amateur in this respect, and he wrote frequently on the subject of making lantern slides and on how to program exhibitions of such work. The catalogs of these exhibitions frequently illuminate how photographic subjects were identified and interpreted. At an exhibition of slides by members of the Camera Club of New York at the Knickerbocker Athletic Club Theater on April 21, 1897, Stieglitz exhibited work in practically every category, including "Cloud and Marine Studies," "Venice," "Architecture," "Wind and Storm," "Snow and Ice," "Street Scenes," "Picturesque Oddities," "Mountains and Lakes," "Cataracts and Glaciers," "Portraits and Figures," and finally, "Night." The works he showed in this particular exhibition were mostly from his earlier years in Europe and from his trip there in 1894. A study of his slides from this and other exhibitions gives clues as to the identification and dating of the works in the Herbert Small Collection.

The dating and attribution of the pictures in this collection are problematic, and without further research positive conclusions are impossible. My observations represent only a partial study and they are not based on having seen the originals. It is my view, however, that these images are by Stieglitz and that they date from after the series of well-known street views of around 1893—*Winter, Fifth Avenue*; *Five Points*; and *The Terminal*. From the location of the primary site of the photographs—Madison Square Park (near where Broadway and Fifth Avenue intersect at Twenty-third Street in New York City)—it would seem that a strong starting point in the matter of attribution and dating might be the coincidence of the location of the Camera Club of New York headquarters at 3 West Twenty-ninth Street. Six of the images, depicting New York street life, demonstrate a most characteristic aspect of Stieglitz's

approach to photographing at this time, especially with urban subjects such as these. It is what might be called a progressive or process approach, in which he did not photograph individual, tightly packed views but rather stimulating fragments as he moved through a region seeking suitable subjects. He generally started out from a base facility, in this case it could have been from the Camera Club, and moved on to one of the most popular photographic sites of the day, Madison Square Park, where he circuited the area exposing negatives as particular subjects struck him—scenes that combined an architectural setting with human activity. This discipline is particularly evident in a study of Stieglitz's 1894 Venetian photographs, in which one can literally trace his movement on foot through the city from a starting point—his hotel—and his return there via a different route. His approach to photographing was as a sort of outing or hunt, in which similar motifs were photographed repeatedly. With one of his most famous photographs, *Winter, Fifth Avenue*, there are at least three negatives of the motif taken at different times. Later, the most successful of the three images comes to be seen as an exceptional work in which the technical craft has not been allowed to overload the pictorial theme; however, it must be recognized that initially this photograph was part of a larger body of near-anecdotal work.

This sort of analysis, and the opportunity to study such a body of work as this (albeit a collection that represents no image of outstanding quality or uniqueness) is reflective of the ultimate value of these pictures. It enables us to observe the photographer's work as it develops in a single photographing session, and in addition, as part of the fabric of his oeuvre from which certain images are isolated as major works. In Stieglitz's case, this is particularly important because he was one of the first photographers of the modern era to mature through the medium, and these images show part of that evolution.

These pictures reflect a style characteristic of Stieglitz's work at this time, and this helps to attribute the authorship to him. Particularly distinguishing are the oblique angle of view with a strongly weighted one-sided balance, various triangular forms throughout the composition, and a basic architectural structure established in the image by the buildings themselves, with the human subjects interacting on a kind of stage setting.

The majority of the images may be dated with certainty to the period before the erection at Twenty-third Street of the Flatiron Build-

ing, which opened in 1902 and which Stieglitz photographed in the snow in 1903. The photograph of the great arch erected for the celebrations in honor of Admiral Dewey on September 30, 1899, would appear to be the terminal date for the group. Again, the majority of the photographs are located around Madison Square Park, and we might therefore properly assume that they relate to the period when the Camera Club was located nearby (as it was from its founding in 1896). Stieglitz did his processing and photographic work there, while he maintained his residence much farther north in Manhattan, at Madison Avenue and Eighty-third Street. Considering that this collection of images represents a rather unified group, all coming from one owner, it would seem reasonable to date them to 1899. The fact that the pictures are related to a significant snowfall may be determined from the titling on the back of two images (not in Stieglitz's hand), and this might suggest they were made following the blizzard in New York on February 11–13, 1899— one that rivaled the more famous one of 1888. This would perhaps place an Easter picture later that spring; this picture is clearly not part of another series on the same subject taken in 1892 or 1893. Also, the sophistication of the composition of most of the pictures seems to relate more strongly to the work after 1900 rather than to the earlier work from the 1890s. A final note: none of these images appears to have been used to illustrate any of Stieglitz's numerous articles written during the 1890s.

With photographs such as those from the Small Collection, and others dating from this time, Stieglitz came to be identified with Pictorialist interpretations of the city. His pictures were not of great drama or architectural splendor, like those of his commercial contemporary Percy Byron, or later by his protégé Alvin Langdon Coburn, but of a more intimate city on a human scale. It is this theme that most clearly identifies Stieglitz's photographs, including even those grander ones of later years taken from high up in buildings. This is a quality that, it seems to me, he imparted to the young Paul Strand, for while Strand's first city views in the mid-1910s have a visual texture rather more abstract than Stieglitz's, they do impart this intimate and lyrical quality that may be seen in Stieglitz's images. The city, as both a place and a concept, frightened and invigorated Stieglitz throughout his life, and his photographs of it may be seen to lie between these emotional poles. While he was cautious in his assessment of urban life, I do believe that he found it challenging and, on the whole, that he remained fundamentally

optimistic about it. In an article that was completely illustrated with reproductions of Stieglitz's photographs, James Corbin, the author of "The Twentieth Century City" (*Scribner's Magazine*, March 1903), probably put it best for each of them when he wrote: "The life here is the life of a present that looks out to the future, infinite in the variety of its possibilities."

Originally published as "Some Observations on a Collection of Stieglitz' Early New York Photographs" in the Center for Creative Photography's bulletin, no. 6 (April 1978), *Alfred Stieglitz: Photographs from the Herbert Small Collection*, pp. 1–14.

THREE BY STIEGLITZ

In December of 1934, at a time when his active photographic career was ending, Alfred Stieglitz presented a retrospective exhibition of his work at An American Place. Simultaneously, a group of friends published *America and Alfred Stieglitz* in his honor. One of the contributors, Harold Clurman, of the Group Theater, wrote in it: "The love of which Stieglitz's prints are an expression is an infinitely tender, patient concentration of all that life brings before his tireless gaze: an impulse to touch and to understand through touch everything that gives life to an object without ever evincing the desire to make it forcibly other than it is."[1]

This capacity for love, Clurman went on to say, made Stieglitz a *seer*. And in being a seer, Stieglitz had developed an extraordinary capacity to endow a photograph with a power of authenticity that pushed mere depiction to the side of revelation. Clurman was incorrect, however, when he concluded his observation by saying that Stieglitz's ultimate desire was to show us nothing other than what is. The vividness of actuality in a Stieglitz photograph, when it is so heightened as to initiate the desire to touch, forces us also into the domain of what could be termed "poetic reality." Based on experience, on notions of personal sensibility and of lived-in three-dimensionality, Stieglitz speaks to us in his photographs of ideas. This fulfillment of content that he brought forth in his photographs is what positions the viewer to think beyond what is seen or can be touched. Poetic reality becomes what is felt and understood in the emotional, even sacred sense. Thus, concerning an endeavor that over many years had become more psychological than physical, Stieglitz could be understood to rephrase Clurman's observation when he said: "The quality of touch in its deepest living sense is inherent in my photographs. When that sense of touch is lost, the heartbeat of the photograph is extinct."[2]

The essence of feeling, the "heartbeat" as he termed it, was what Stieglitz sought to emphasize to his audience. That he needed an audience was without question, for his photographs as well as for his many and endless stories. His talking, described as "thinking aloud,"[3] is a phenomenon that should be considered when we look at his photographs. Stieglitz was a man who wished to tell the world what he thought of it. Every image came from deep within him, and his goal was to manifest

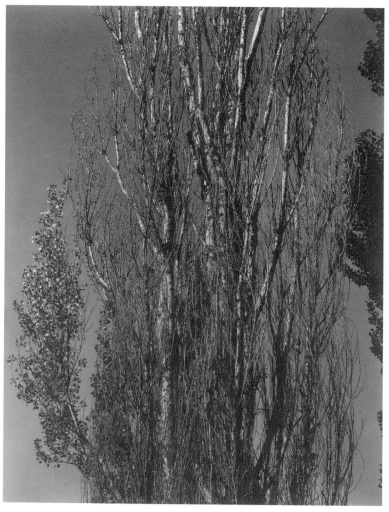

Alfred Stieglitz, *Poplars—Lake George*, 1932
Private collection

this depth on the outside, and to have others awakened by it as if by his presence itself. Georgia O'Keeffe, who knew him best in these later years, said that what he could not put into words he put in a picture.[4] Lewis Mumford, reviewing the exhibition of 1934, also wrote about the notion of touch, putting it more in perspective than his friend Clurman had: "[Stieglitz's] photographs are not alone his work but his life. . . . The prints are all of the first order, and he who touches them touches the man. Stieglitz has done, in his photographs, what only the camera could do; and he has said, in this mechanical medium, what only an affirmative and vital spirit could say."[5] What Stieglitz talked about, and what he showed us, were the three subjects that formed the major chord of his late work: womankind, nature, and the cityscape. As this collection shows, upon this triple theme he left us an inspired group of images.

ONE

It is with the photographs of Georgia O'Keeffe that we have the greatest sense of Stieglitz as a public artist, very nearly impresario-like in goal, the outgoing man presenting the totally consuming focus of his passion: this woman as artist, lover, partner, goddess. The figure pictures, mostly nudes, are remarkable for their intimacy—a physical embodiment for all to see. As a document of a relationship, this sort of thing was rare for its time. O'Keeffe was presented as a woman of nearly polar opposites: a sensual, voluptuous object on the one hand, and a delicate androgyne on the other, coy and withdrawing, then assertive, even dismissive.

There were more than one hundred fifty pictures made in the first four years of their relationship, which began in 1918. However, the public display of such intimacy could not continue under the credulous eye of their audience, especially the critics. O'Keeffe's notoriety—that is, how her art was interpreted in the sense of its sexually liberated character and what it revealed about her nature—both repelled and attracted her. After 1923 her subjects changed, as did the degree of abstraction in her renderings. Stieglitz, too, turned to other subjects, as if guided by her. A new dialogue developed, and the dark and anxious pictorial passion cooled. O'Keeffe became less his quarry and more and more the observed, separated from him and from us: seated in the back of a car, laying her hands on a skull and on other reminders of pictures and places: sullen and alone. We sense O'Keeffe's uncertainty with the camera and maybe even with the photographer. She was no longer under Stieglitz's spell.

The most remarkable characteristic of his first photographs of O'Keeffe is their contrived exaggeration. Stieglitz truly had a nineteenth-century theatrical sensibility. But in another way, the interaction of artist and model that was at work in the creation of these images might also be seen as a kind of elaborate pas de deux. Perhaps the notion of touch can be presented again here—not in the sense of lifelike tactility, but of holding, supporting, directing. While in an actual dance, the two lovers act out their maleness and femaleness, Stieglitz seems to wrap O'Keeffe in his arms and body metaphorically through the act of photographing. The glorious prints, most exquisite in palladium, capture the fleeting moment of a balance held or an expression arrested, of a body alive and erotic, with every sinew exposed.

Looking at these photographs, as if through the camera, we gaze spellbound at the emotion that existed between the two. We witness the inexplicable result of Stieglitz's sincerity: its most urgent necessity to transform O'Keeffe from a person into a creature. Stieglitz, through O'Keeffe, holds his audience by imagination. The photographs he made of her taking headlong risks often portray her as having a nervy, flamboyant performance style. For some today these are difficult pictures, so rarefied is the stylization, so real the urgency of pathos, and so magnificent the show of her sex.

TWO

The cloud photographs, the "Equivalents" as Stieglitz called them, relate in a most fundamental way to the notion of change. In their making and in their study, they are about the act of becoming different. In sequencing several images together, Stieglitz created a kind of lyric narrative: a song, of sorts, about feelings stimulated through shape and tone and texture. Using a straightforward language of symbolic abstract relationships and the traditional iconographic repertoire, he aroused an awareness of our own experience and an acknowledgment of the emotions and feelings between people, and between man and spirit. These pictures call up the past and herald the future. Symbolist in every respect, they hark back to the whole of Stieglitz's aesthetic preoccupation in art, but with the added dimension of an abstraction of recognizable and familiar forms into which we can vest meaning rather than obtain it through the simple act of subject identification. To put it another way, the photograph *is* the subject, not just about it. Coming as they do at the turning point in his photographic relationship with O'Keeffe, the "Equivalents" are indebted to her as much as they are frequently about her.

A sequence of "Equivalents" is interesting in that each image is rarely monumental or as compelling in its own right as an intricate view of the landscape or a portrait. Considering individual photographs, like so many events in life or first impressions, as fragments waiting to be joined through disciplined scrutiny, is the core of Stieglitz's theory of equivalence. He recognized that if a series of images was placed together, fragments of thought, facets of emotion and insight could express a whole thought, a whole idea, and, finally, a portrait of a person or of a relationship. The misapprehension many people share about these sets of images is that they have some unfathomable message, so deeply coded as to be indecipherable. This is not so, and Stieglitz himself suggested on several occasions that, really, their interpretation was pleasurable and uncomplicated.

One of the most arresting aspects of these pictures is how the orientation of ground/horizon/sky was dealt with when the finished prints were mounted. In many cases, this vertically layered orientation, normal in realist landscape presentation, was altered, sometimes by turning the print 90 or 180 degrees. This was not a game, but part of a modernist strategy in which a traditional representation was consciously rejected. The technique had been seen earlier in some of Paul Strand's work, and O'Keeffe also utilized it. One of Stieglitz's most famous pictures of O'Keeffe's hands, made in 1920, carries the instruction that the photograph may be hung or oriented in any of the four cardinal points. In the cloud photographs, this altered orientation was sometimes used to create and enliven the dynamic of the forms and their space. It also works in such a way that subtly, perhaps unconsciously, we are made to feel edgy by sensing that something is *wrong* (meaning different from our ordinary experience of looking up at the sky), but we cannot quite realize this sensation or what causes it. Stieglitz's goal in these sequences was to help regain the viewer's equilibrium. Another aspect of these works is the rich, liquid tone of the prints themselves, together with their jewel-like size. The prints are some of the most luxurious that Stieglitz ever made. They are also some of the finest he made on silver paper, and their tone echoes the diaphanous atmosphere of the actual place where they were taken.

The cloud photographs were made at Lake George, at a place called "The Hill." To observe the country and sky in the Adirondack foothills—above and beyond the expanse of Lake George in its glacial basin, toward the mountain on the eastern shore—is to experience a sense of ancient time and natural harmony. This is an aged, eroded land

covered in green, with few sharp contrasts. It is a mature place suggesting not timelessness but evolution. The trees around Stieglitz's property, such as the poplars, several of which he had planted with his father, were advanced in age, dead and dying by the 1930s. In better condition, but still well worn, was the staid frame house where he spent his summers. The essential feelings here were those of familiarity and accommodation. As city residents, Stieglitz and his colleagues found Lake George the idealized environment of nature, and every one of the sky pictures, from "Music: A Sequence of Ten Cloud Photographs" of 1922 and "Songs of the Sky" through the last images of the 1930s, reflects the dichotomy of the city and the country.

What Stieglitz saw, he pictured. He was always photographing. In the Lake George house, he had a chair at the window and another on the porch, a subject that in 1934 was so magnificently photographed that it became the summation of his experience and of his photography.[6] He would wait and watch, and as he grew older he sometimes needed assistance to ready his camera, to position it in the landscape when something he saw challenged him to photograph it. In commenting on the subjects of Stieglitz's photographs, especially the Lake George pictures, but also on his contemplative method, O'Keeffe said: "Something had to be around enough to photograph." And she continued in her unique way: "He did not go out of his way to see what he saw." As a footnote to the sense of melancholy that we feel in Stieglitz's last pictures, O'Keeffe concluded: "He kept on with this sense of experiencing even after he was not able to make an actual picture."[7]

THREE

The New York photographs of the 1930s reveal this sense of experiencing to the furthest degree. The buildings in the cityscape and the photographs of them are both immaculate. There is nothing instantaneous about the pictures; rather, they project the sensation of a monumental stasis, a logic with an aura of perfection. Stieglitz's arrangements encourage the belief that nothing could be changed without having to start over again to rebuild the entire image. The cityscape shown in these pictures becomes a metaphor for the architecture of photography itself— about planning, composition, rendering in silver as in steel and stone. We know that, as with Lake George, he would sit and study a scene out one of the windows high above New York: from the seventeenth-floor gallery at Fifty-third Street and Madison Avenue, or from the apartment in the Shelton Hotel, south on Lexington Avenue. Over time he would

remember the passage of light across and down the building surfaces, during which seasons the angle of the sun would be higher or lower, creating arrangements of light that would select, illuminate, and define the abstract stone planes of the faceted buildings or the spaces between them. Most of these pictures were made in a relatively short space of time after he had observed the scene for many months. Their structure was not discovered; he knew what he was looking for. The usual awe and excitement of discovery was replaced by the piercing precision of a nearly vatic stare.

Stieglitz had always been a photographer of the city, always a resident of the city. However, as much as he was aware of the mass of people who lived there and on whom he fed, he usually depopulated the place in his pictures. He seemed to resist the human density of the city, and the physical change of it. Early in his work the cityscape was covered in a concealing and cleansing blanket of white snow; later, the buildings were shrouded in darkness, with light glowing from within through individual windows. As the years went by, he rose higher and higher in the buildings, away from the street, and his pictures of the 1930s are the ultimate representations of this viewpoint and this separateness. It was as if he had set up an idealized condition in the city to rival what he felt at Lake George. He frequently alluded to the notion of living on a ship high above the street, or of the city itself being an island, and therefore a place of idealization, a place to define and examine certain issues.

The complication was that such a viewpoint almost always put him in conflict with the very power symbolized by the huge skyscrapers around him. There can be no doubt that Stieglitz was commenting on the ironic state of American society when he pointedly turned his camera toward the massive towers of Rockefeller Center, the construction of which had begun in 1931, two years into the Depression. That the skyscrapers loom higher and more luxuriant than the twin spires of Saint Patrick's Cathedral leaves little uncertainty as to his concern for the spiritual condition of American culture. The skyscraper had become the new icon, but, though Stieglitz knew it signified that the city was being robbed of its history and of what he perceived as its traditional values, he knew too that it was the symbol of the future.

Stieglitz used the distinctive New York skyline to speak about American identity, American values. He had always been interested in an art that would express itself in an American context. All of his friends and colleagues, in whatever medium they worked, were concerned with

this issue. Thus, we can see also that in an almost self-contradictory way, Stieglitz was commenting in these pictures on how photography was a medium specific to the new environment. Thanks to Stieglitz, photography was already perceived by some to have an American identification as a significant contemporary art form with a modernist mechanical and technical side, its optical rendering akin to the sharp precisionism of the new architecture. That photography, like much of this architecture, was not fully accepted placed the medium in the arena of controversy that engaged the world of the metropolis. Could technology be humanized was the question; could the city be considered a living organism that, like everything else, could have its affirmative voice? Could modernism rival nature?

Of all of Stieglitz's mature photographs, the city views seem the most abstruse. The vastness of their space is greater even than that of the sky in the miniaturized "Equivalents." The images of O'Keeffe are of details, intimate and touchable. The cityscapes offer a third perspective, an abstract configuration symbolizing the greatest mystery of all: the uncertainty of the future, where the secular and spiritual masters are in conflict. These pictures have no specific subject in the sense of description and, therefore, they too are in a sense equivalents. Most significantly, in this last work Stieglitz was making photographs in the faithful presumption of a literate, responsible audience that would want to read them. They are, in other words, not *about* actual city life, but a challenge to it. These last photographs were his way of measuring himself against what was all around him bidding for dominance in the future. With these views he invited the outside in. Looking out the window of An American Place one day, Stieglitz is reported to have said: "If what is happening in here cannot stand up against what is out there, then what is in here has no right to exist. But if what is out there can stand up against what is in here, then what is in here does not need to exist."[8]

NOTES

1. Harold Clurman, "Alfred Stieglitz and the Group Idea," in Waldo Frank et al., eds., *America and Alfred Stieglitz* (New York: Doubleday, Doran, 1934), p. 268.

2. Dorothy Norman, ed., "From the Writing and Conversations of Alfred Stieglitz," *Twice a Year* 1 (Fall–Winter 1938): 110.

3. Georgia O'Keeffe, interview by Peter C. Bunnell, March 27, 1981.

4. Ibid.

5. Lewis Mumford, "The Art Galleries," *New Yorker*, December 22, 1934, p. 30.

6. O'Keeffe, interview by Bunnell, March 27, 1981.

7. Both quotations are from an O'Keeffe interview by Bunnell, June 28, 1979.

8. Dorothy Norman, "Alfred Stieglitz," *Aperture* 8, no. 1 (1960): 59.

From *Alfred Stieglitz: Photographs from the Collection of Georgia O'Keeffe*, exhibition catalog, Pace/MacGill Gallery, New York; Gerald Peters Gallery, Santa Fe, 1993.

CLARENCE H. WHITE:
THE REVERENCE FOR BEAUTY

Between 1898 and 1917, there flourished in this country a movement in support of expressive photography that was rooted in principles of art that had been traditional for centuries. Pictorialism, as it was called, had as its basic concept the notion that certain photographs were the product of the creative imagination and the insightful, craftsmanlike effort of the self-conscious photographic artist.[1] In addition, and more importantly, the artist-photographer was seen in a new light with regard to his responsibility for the work produced; that is, the content and rendering of the photograph were seen to be reflective of the picture maker's originality and not of the mere re-presentation of undifferentiated facets of exterior reality. What this meant, in practical terms, was that in Pictorial photographs subject was indivisible from content, and that selection was the critical gesture in picture making. These attitudes about photographs and photography were far different from those held by most people at the time: ones based on the belief that photography entailed simple observation, reaction, and routine mechanical procedures.

Photography was most often viewed as a sequential medium in which the photographer was the pivotal figure in a series of events that began with revelation and proceeded through action. The idea was that the recognition of what was photogenic caused a sequence of responses, the very minimum of which were the manipulations of the craft of photography that lead to the creation of a visual document. Although by this definition the photographer was not prevented from exploring beneath the surface of things to expose the significance of outer appearances, he was clearly not a participatory instrument in the scene.

In contrast to this approach, a new style was formulated in the late nineteenth century in which the photographer became involved with the actual contrivance of the subject. By necessity, to work in this new way required a less reactive and more premeditative sensibility. Photographs produced following this approach functioned as a kind of literature, in which the formulation of elements was not only to be sensed, but read. Photographers working in this arena were interested in revealing how

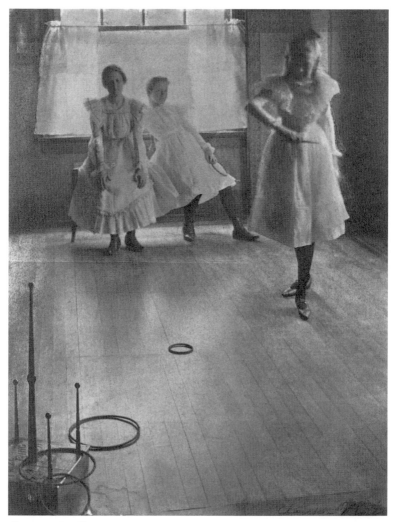

Clarence H. White, *Ring Toss*, 1899
Princeton University Art Museum; Clarence H. White Collection

things are, rather than showing things as they are, and their pictures often displayed that precise combination of emotion and reason that caused them to imprint themselves on our consciousness. In his photography, Clarence H. White was concerned with this latter style.

White was born in West Carlisle, Ohio, in 1871. Between 1887 and 1906 he lived in Newark, Ohio. The son of a salesman in a wholesale grocery company, he followed his father in seeking similar employment and he became a bookkeeper in the same concern. By 1893, at the age of twenty-three, he took up photography as a substitute for painting, a profession, or even an avocation, that had met with his parents' disapproval. Although wholly self-taught, by 1899 he had achieved an international reputation for his innovative photographs. In the succeeding decade he exhibited in such cities as Boston, Dresden, London, New York, Paris, Turin, Vienna, and in the important American salons in Chicago and Philadelphia—also serving on their juries of selection. He was a founding member of the Photo-Secession, a group of vanguard photographers organized in New York by Alfred Stieglitz in 1902.

White's work was published in the Photo-Secession's magnificently printed journal *Camera Work*, and was exhibited in its gallery, "291"; it formed the largest individual contribution to the last Photo-Secession group exhibition at Buffalo's Albright Art Gallery in 1910.

White moved from Ohio to New York in 1906, and the following year he became Lecturer in Photography at Teachers College, Columbia University. In 1914 he founded the Clarence H. White School of Photography in New York, and during the summers he also conducted schools in New York, Maine, and Connecticut. He was a sensitive and dedicated teacher and among his students were Margaret Bourke-White, Anton Bruehl, Laura Gilpin, Bernard Horne, Dorothea Lange, Ira Martin, Paul Outerbridge, Ralph Steiner, Karl Struss, Doris Ulmann, and Margaret Watkins. In 1916 he became the first president of the Pictorial Photographers of America. This group, founded at a time when the character of Pictorial photography was under attack, sought to perpetuate the values of expressive photography as they had been defined at the beginning of the century, and also to apply them to the newly developing fields of commercial and illustrative photography. In 1925, while leading a student tour in Mexico, White died suddenly.

The qualities that make White's photographs so memorable have to do with both form and content. In his finest pictures the disposition of every element, the arrangement of each line and shape, is dominated by a confidence that elevates the common aspects of camera

vision to an expressive intensity few photographers have managed to attain. It is clear that White was aware of the stylistic principles and devices of Asian art, and indirectly with pictures by certain American and European contemporaries through his familiarity with reproductions of works by the painters William Merritt Chase, Pierre Puvis de Chavannes, John Singer Sargent, George Frederic Watts, and James McNeill Whistler, among others. But perhaps a stronger influence were the literary illustrators of the era, whose work he saw in such popular American magazines as *Brush and Pencil*, *Everybody's*, *Godey's*, the *Monthly Illustrator*, *Munsey's*, or *Scribner's*. Unlike so many of his Pictorialist colleagues, who sought to incorporate what they believed to be "impressionist" principles into their photographs, White was able to transform the sensory perception of light into an exposition of the most fundamental aspect of photography—the literal materialization of form through light itself. His prints, mostly in the platinum medium, display a richness, subtlety, and luminosity of tone rarely achieved at any time in the history of photography.

White's vision was based in his Newark, Ohio, society, but unlike many of the lesser photographers of his day, and those who followed him in what continued as the Pictorialist photographic movement, his poetic imagination transformed these local facts into greater truths. Within a style that was evolving as he worked, he created a body of work that was unique in photography. He showed that photography relied on contemplation and planning, and that through the continued use of picture subjects that did not vary greatly, he could come to a deeper understanding of their intrinsic meaning. His legacy reinforces our contemporary realization that photographic vision can encompass ideas and attitudes that intensify and mature through the determination successively to plan and to penetrate. The work of Clarence H. White confirms that photography affects us like experience; it shows us what we see.

In his first years photographing, between 1897 and 1906, White concentrated on genre subjects, selecting as his models members of his family, such as his son Lewis shown with his wagon, his mother, or members of his wife's family, notably the tall, lithesome, and introspective Letitia. She appears most frequently in a dark gown or drape, in such a picture as *The Bubble*. Later, White would photograph a variety of women, some of them well known, such as the actresses Nazimova and Maude Adams. It is clear that even though White was an enthusiastic portraitist of men, his greatest interest lay in the stylized depiction

of women. This subject choice reflected the Pictorialists' belief that it was the most artistic and spiritual in art's long tradition, and White's particular fascination was derived from a confluence of many sources: Symbolist imagery and rhetoric, the earlier Pre-Raphaelite school, and even the contemporary Gibson girl. Women were seen as the primary subject of the storyteller's art, of parables, and as the epitome of nature—woman viewed in nature's primordial garden—and it was this literary origin, together with the notion of seriousness in art that concentrated upon notions of truth and beauty, that infused White's attitudes. In his article "Seriousness in Art," the author George Gibbs advised his readers, such as the young Clarence White:

> Let us look upon seriousness, taking into consideration the definitions of Truth and Beauty. . . . So long as the artist is very evidently in earnest may we not be appealed to on a plane a little lower than the attempted sublime? Nature, human or otherwise, is a many-sided mirror which, if we only appreciate her, can tell us many things we do not know. In the woods and field she has a reflection for every heart, a mood for every humor. He who can translate the language of these moods is a great artist, even though he may choose to introduce some ideas of his own. The well-beaten purple path winding away over the tender green hillside toward the gabled farmhouse! The rosy milkmaid resplendent in her healthy beauty, surrounded by a halo of pink and violet buds that seem to rejoice in the youth of the maid and of the year! Tangled fleecy clouds which skim lightly through a sky that is Purity! . . . If these were translations of Nature's moods could they not teach us something that was not known before?[2]

Such an image as *The Watcher*, 1906, one of the more overtly Symbolist of his pictures, demonstrates White's translation of one or more of the reproductions of contemporary European art that he saw in journals such as those mentioned above. It is a haunting image that has the effect of casting a humble but spiritual vision in a strange, portentous light. It is important to note that the costumes and draperies his figures wear, as in this picture, were not contemporary dress but were created to evoke the mood and look of an appropriate period of the past, sometimes even suggestive of the early Greeks.[3] At the same time, the pictures were undoubtedly interpreted by his contemporary local audience as having very specific temporal manifestations; in this picture, for instance, the model's identity would be known as she posed above

the Licking River outside of town, and the glass sphere she is holding would be recognized as a product of the A. H. Heisey Company in Newark.

One of the important aspects of White's photographs noted by his critics (especially those who were adverse to his work) was the sense of locality. One wrote:

> In order to properly understand the real nature and character of Mr. White's work it will be necessary to discover if possible the precise reasons for its condemnation on the one hand and its approval on the other, and an analysis of the situation based upon careful personal observation has led to the conviction that those who condemned it did so from some of the following reasons: Some did not like [it]—could see nothing in it because they did not like the model. This was a prejudice akin to that of the individual who could never see any beauty in the Venus of Melos because he did not happen to fancy its face. Others found the use of the same model throughout tiresome. This from a typical New Yorker who has become accustomed to life on new experiences—new excitements—new tastes—who to a great extent has become blasé and detests repetition and demands the new—as the most natural object in the world. Lombroso would find in it an evidence of degeneration on the part of those who raised it. As nearly every great artist in the age of great art made repeated use of the same model, Mr. White is not entirely without precedent. Apropos of this, one of the gentlemen of the club very wittily remarked that Mr. White's was a one-man and at the same time a one-woman exhibition. The marvel of the thing is that with one model he has been able to do so much.[4]

This review by Joseph T. Keiley is perceptive in that he has not only differentiated White from other workers, but he has articulated one of the key ideas of Pictorialist aesthetics. Keiley has described the power of the photographer's imagination, rather than his ability to travel or to select from a wide array of models. When White left Ohio late in 1906, he was not in search of new subjects; rather, he was seeking a way to devote himself to photography and to place himself more fully within the larger world of serious, artistic photography. That movement was based in New York, and Alfred Stieglitz was its leader. In retrospect, we can see that White's move actually diminished his abilities as a photographer. Not only was his time to be consumed by other work, he was

also in an environment that lacked entirely his rich sources of imagery and inspiration. It is clear that while White retained his belief in the primacy of making art, progressively, after 1907, he seemed to lose the absolute need to translate the experiences and joyous emotions that gave meaning to his life into pictorial form, as he had so clearly done in his native Ohio.

In his teaching, White quietly fostered the most fundamental goal of artistic endeavor: the search for spirit. This belief in spirit would seem to be in opposition to photography, what with its primary focus on the real world, or real time, or realistic depiction. But as with some other photographic artists of his time, White came to understand the penetrating dimension of photography—that in the act of seeing one is sometimes able to infiltrate behind surface appearances and in their very reality render underlying truths. His adherence to teaching, clearly at the sacrifice of his own work, reflected his belief in the enhancement of human life by imparting this understanding to other photographers. Just as photography had given him life, he now turned his life into teaching photography to others. While his school educated numerous professional photographers, his goal was to instill in every student, and in whatever discipline, the idea that artistic creation gave substance to one's search for human values. In a catalog for the school that was published shortly after his death, there appears a statement that summarizes his philosophy of teaching:

> Every resource of thought, feeling and skill is needed to win the rewards of personal satisfaction and business success. For not a few, however, the studies and associations of the school have yielded values for which there is no material measure. Men and women have found themselves, worked out a better adjustment to life, and discovered new sources of interest and happiness.[5]

In the last decade of his life, the force of strong, new formal concerns in image-making became manifest. "Abstraction" is the term most generally applied to these concerns, but in photography this is a relative term at best. Formal simplification, flatness, and a greater dependence on line would better describe the direction. Certain of the extreme techniques of this new style, such as changed viewpoints, close-up, and sharp cropping, were never adopted by White in his photography, although slight evidence of these tendencies may be seen in the 1917 boat construction pictures made at the Bath Shipyard in Maine, or in a detail of rocks on the Maine coast made in the early 1920s.

These, together with pictures taken near the end of his life at the Croton Reservoir outside New York City, reveal White's awareness of the changing mainstream in contemporary photography as seen in the work of his colleagues Stieglitz, Paul Strand, and Karl Struss, among others. One feels that had White lived longer his work would have changed somewhat, although it is doubtful that he would have revised his fundamental beliefs to the point of accepting the very reductive presentation of the objective world that came to be the hallmark of what was called "straight photography." But this analysis skirts points that White understood very well, and that he had demonstrated throughout his work. The first is that design in the construction of photographs is as integral to photography as it is to all the other arts, of whatever period. It had always been his desire to give substance and credence to the formal considerations of the photographic picture along with the subject matter, while maintaining the harmony of one with the other. White saw no need to stress a real or imagined uniqueness in photography or to endorse the separation of photography from the other arts, as proponents of the "straight" style seemed to demand. Indeed, in his teaching curriculum, he had enthusiastically acknowledged the contribution that painting, especially modern painting, could offer to the photographer in understanding once again the contiguous linkage between photography and the traditional arts. This was the basic tenet of Pictorial photography itself. The second point is that he did not personally adopt the subjects of the new style—still life of utilitarian objects, for instance. In his own work he would not give up what he felt was the subject matter of ideas in favor of the subject matter of formal principles. In so doing, he was remaining steadfast in his respect for the aesthetics of Pictorial photography that he had done so much to define and demonstrate.[6]

In 1918 White stated his position with regard to these issues in reply to an interviewer's question: "Has any development along the lines of what we might call cubistic art got into pictorial photography?":

> Yes, it has gotten into photography to a slight extent, but I am loath to call it cubism or any similar ism. The development of modern art, I think, is in the direction of construction; and construction, picture construction applies to photography as definitely as it applies to painting and other art. Indeed, a great feeling of the need of this has expressed itself in connection with photography.

The rules of composition as usually understood have been too narrow. We might say there are no rules, but there are certain fundamentals. These fundamentals have been made to apply in a great variety of ways. Take this print for example [not identified]. . . . Here is a little of what we might call cubism in modern photography. We first look at it and we get pleasure from the play of light and dark on the object. It produces a sense of satisfaction to the eye, and yet when we examine it more closely we feel that the artist has violated the rules of what might be called composition. We must construct our rules of composition from examples, rather than make the construction that is demanded by our art out of formal rules.[7]

Recognizing that one of the hallmarks of the new photography was a greater emphasis on pure image-making, White continued in the same interview: "I think the greatest weakness of the young worker is the lack of something to express. He is too much interested in the photograph for the sake of the photograph alone—that is, in the medium or in the taking of the photograph itself. The photograph should express something."[8]

Edward Weston, whose mature work of the late 1920s would be seen as the epitome of straight photography, came to New York in 1922 to see Stieglitz and others. He met Clarence White and wrote back to a friend in California a most complete analysis of the older man:

> . . . luncheon and afternoon with Clarence White—at his school—Quiet—unassuming almost retiring—extremely sensitive to pattern—sure of himself as a teacher and critic—and very critical—yet always apologetic over his own prints and admitting difficulties in obtaining his ideal—despite a very fine attitude. His work was disappointing—lacking any vitality— though he told me he would not work the same if the chance came now—for ten [years] he has practically given himself up to teaching—I am afraid in his overemphasis of design he has lost spontaneity—Not that I undervalue pattern—form—for without it no picture has lasting value—But I feel too much calculation in his work. He found too much empty space in my work—and as he talked I could easily admit of his argument (from *his* viewpoint)—nevertheless knowing if I were to do them over I would do them the same!

He is a great admirer of the Japanese print, and the way in which they fill space, but I feel only a resulting messiness and over-elaboration—if photographers were to emulate the complexity of some Japanese prints.[9]

Weston's opinion of White is critical, and as he himself suggests with reference to White's argument, his own also reflects a particular viewpoint. It is, however, an important analysis, for it is written by a member of the next generation, who sees in White's work the manifestation of conservative visual solutions and, particularly, past subject values. White's contemporary critics, those from the 1890s through the early 1910s, had been mostly positive in their remarks, understanding and sympathizing with White's goals, and seeing them as relevant to the contemporary concerns they shared. Later writers, and especially those in recent years, have been largely critical of White. The true measure of his later pictorial achievement, and of his open-minded and eclectic teaching philosophy, has been little investigated. It seems that what happened, as the fundamentals of White's photographic approach became applied to commercial and illustrative uses, is that his own work came to be perceived as more and more removed from the ongoing mainstream of art photography.[10] This is the sort of attitude expressed about him by Weston, for instance, but White was not alone in this respect. A not too dissimilar critical attitude confronted Edward Steichen in the 1920s, and later as well.

Perhaps what most impressed people about White was his sensitivity as a human being and especially as a teacher. The photographer Anton Bruehl, a late student of White's, has said: "He was a simple, humble man, nothing phony, as only a great man can be. Kind, sympathetic, never nasty or sarcastic in any way. He showed each of us a way to think for ourselves. He let each of us follow our own desires. Very little pressure was exerted on us as students. Rather, his approach was to guide us to do it well, follow our inclinations and imaginations, and to be sincere! It was mainly by association that you received what you learned from Clarence White."[11] It was this sensitivity and respect for the feelings of others that reinforced White's adherence to his traditional beliefs as the post–World War I era of self-indulgence took hold. Materialism and assertiveness became the mode of action, and the widespread pressure to use photography gainfully placed him in the difficult situation of having to make a living by teaching students how to succeed in

the new environment, while at the same time upholding the principles of idealized expression.

White was a socialist who apparently formed his ideas under the early influence of Eugene Debs and Clarence Darrow, and through such books as Edward Carpenter's *Towards Democracy*, a work he greatly admired. But White, like many of the artists whose idealistic politics he shared, held the view that art might best serve the humanist cause not by the depiction of social conditions or by expressing indignation, but by essaying positive values that suggest the aspiration of spirit and the results of intellect and hard work. The entire body of White's work reflects a view of life that is essentially affirmative and that seeks, in its affirmation of beauty, the spiritual goal of progress and betterment in American society. That this approach became progressively more difficult in the years after his move to New York, and especially after the war, may also be at the root of his unsettled conflict with life in the seething metropolis.

White's portraits, which he undertook to do more and more after coming to New York, owe a great deal to the qualities of his genre images. The focused clarity of the early statements, usually composed of only the single figure, and the immensely sensitive handling of tonal structure, enabled him to treat the portrait medium, with its emphasis on the individual figure, expertly. A 1909 portrait of an unidentified man holding a book is a good example. The rhythmic pattern of the tilted head, matched with that of the open book, sets up a configuration of double diagonals in a kind of light zone that conforms and runs parallel to the darker diagonal of the picture edge itself, which, as an imaginary line, runs through the man's middle body. The picture would be lifeless, however, if it were not for the crisp white highlights of the shirt and the subtle tonal variation in the lighter zone above and behind his head, which, as reflective of the sitter's actual environment, give depth and three-dimensional harmony to the photograph. A more complex use of this sophisticated tonal juxtapositioning in an image may be seen, too, in the advertising photograph for domestic linens of about 1919.

One characteristic of White's work that was commented upon by all of his admirers was his mastery of the photographic printmaking media. His skill in platinum and palladium printing was always singled out, as was his adventurousness in multiple processes such as gumbichromate. His free, sometimes spirited surface manipulations done

early in his career placed him squarely within the Pictorialist aesthetic notion that the photograph as a work of art was a crafted object like any other, in any medium, revealing of the artist's hand. These physical qualities of his prints are our surest links to the traditions in the graphic arts that lie behind the Pictorialist movement. The British, who originated this genre of photography in the mid-nineteenth century, and who truly began the movement of Pictorial photography in the early 1890s, recognized the validity of this tradition (one that was truly their own) and enthusiastically adopted the character of the printmaking media as a fundamental attribute of the new photography. Until after World War I, one could say the American photographers such as Alvin Langdon Coburn, Frank Eugene, Gertrude Käsebier, White, and many others also fostered this idea in their work. *The Round Table* of 1904 is a prime example. One of the most accomplished of all White's photographs, its indebtedness to Japanese sources is obvious. Without timidity and directly onto the print surface, White added decorative elements to the background of the picture and articulated and enhanced lines and tones that he felt were required for the print to truly function as a picture. This clear and open recognition of the pictorial reality of the print—and not the scene—is a characteristic of the best of fine art photography from this period. Later on, as tastes changed and the purism of straight photography took hold, critics tended to deride this attitude.

In addition to the quality of White's handling of the photographic material itself, but related to it, was his exquisite achievement with the effects of light. His range encompassed the "broad and frank in contrast," as one writer put it, to the sensitively subtle in delicate discriminations of tonality. Charles H. Caffin, one of his most steadfast supporters in the critical press, wrote: "I doubt, indeed, if there is any photographer in this country who excels him in the matter of tone."[12] This was written as part of his introduction to White's first portfolio appearance in *Camera Work* in 1903. Caffin continued: "More than anyone I know does he succeed in making his prints most beautiful studies of the variety and expressional value of luminosity."[13]

Since the turn of the century, this quality, this "value of luminosity," had been the hallmark of the entire American school of Pictorial photography. It drew awe from the Europeans and it established for the Americans, and White in particular, the international status of Pictorial artists of unique accomplishment. It was this aspect of photography that proved to be White's most important influence on others. In his works,

from the dark and evocative images of Letitia seated or standing, where the light highlights her fresh features, to the sparking overall tones of the *Pipes of Pan*, to a 1912 nude with baby (made as a portrait commission), one can recognize and appreciate this mastery. In certain of White's early pictures, especially those that appear to depict actual characters from literature, there is a quality of light to suggest that night is the time through which the distinctive personality of the subject is being felt. This light is, in some images, as Shakespeare's Romeo described it, "an artificial night" of his love's own making. Throughout his work, White maintains a brilliant shutter-movement of black and white, of misty overcast and sparkling sun, of midnight and morning. White's emotional affection for the ideas he was portraying is symbolized in his handling of light: something that shines with its own strength and from its own source. The light itself becomes subject; as it is hidden in darkness, it can then shine within the viewer's imagination.

In one instance, and a very rare one in photography, Clarence White photographed jointly with his mentor, Alfred Stieglitz. A 1907 figure study reflects a brilliant control and articulation of the medium. It is fascinating to consider the contribution of each artist. Stieglitz would later infer that the presence of the glass sphere was all White's idea, suggesting that such "props" were alien to his approach. Considering Stieglitz's later portraits of Georgia O'Keeffe, this is perhaps not altogether true, unless, of course, he saw the globe symbolically as representative of an era no longer interesting to him. As we know, the globe was owned by White and frequently used by him. The skillful use of light to illuminate the model and to reflect on the glass surface to create a kind of reverse spatial environment would be more characteristic of White than of Stieglitz at this time. The use of the overall dark, deep tone suggests equally Stieglitz and White, though it was a characteristic of Stieglitz's work to have the figure seem to emerge from the environment of the picture itself, as the sitter does in this case. Aspects of this photograph, and of others taken at the various sittings, suggest that Stieglitz's later portrait style of the 1910s owes a debt to White's, and the same could be said for another close associate of White, Alvin Langdon Coburn.

White made very few landscape photographs, and in a curious contrast to the incredibly strong manner in which he contained a figure in a composition, his work in landscape reveals just the opposite with regard to composition. In an 1897 Ohio snowscape, and in a 1907 view

of Newport, Rhode Island, we recognize a very different visual resolution. In each case, the edge defines only the picture space and not the real limits of the subject. This was surely a conscious decision on White's part, as if to suggest the continuousness of the land or architectural forms. It, perhaps even more than certain aspects of posing the figure in other pictures, reflects his admiration of Chinese pictorial modes as they might appear in a hand scroll. Comparing these early pictures to that of a Maine coastal view of about 1921, we feel a different equilibrium, and sense how his viewpoint might have been changing during this period of his life.

White's treatment of the nude is also interesting. Most always discreet in revealing the female body, he avoided explicit sexual rendering, and the few pictures of standing, undraped nudes are something of an exception in his work. These 1909 or 1910 compositions, perhaps taken in Morningside Park near Columbia University, are nonetheless reflective of his respect and affection for the subjects. The light and dark tones temper a harsh, erotic view of the figure, which, characteristically even for this period, is still posed in an idyllic forest glade. One photograph from the "Pipes of Pan" series of 1905 is meaningful. This is a picture of one of White's young sons. In other pictures in this series the sex of the boys is fully exposed with no immodesty on the part of either the model or the photographer. The revealment of a boy's body was perfectly acceptable, since the adolescent male was seen to echo the Classical past, and the photographer could thus work with impunity. The inspiration for this series of pictures was clearly White's close friend and photographic colleague, F. Holland Day. It was Day's invitation that brought White to Maine in 1905 for the first time. Day, an accomplished photographer and deeply interested in literature and poetry, was a genuine eccentric who was a significant influence on White for much of his life.

In 1900, Sadakichi Hartmann, one of the most astute critics of his day, wrote a series of observations that posited White within the structure of Pictorial photography as it was then defined: "What he does is consistent, often beautiful, and entirely independent of other photographic work, for even if he takes his matter at second-hand from those he venerates, he understands how to imbue it with a spirit of his own."[14] Such a perceptive analysis of White's work at this early point—indeed, only about six years after he first took up photography—may now be seen to characterize the distinctive qualities of his life's work, too:

Consistent
Beautiful
Derived from extant artistic prototypes
Imbued with an independent and personal spirit

The elaboration of these observations provides a framework we might use to depict not only White, but the broad complex of the Pictorialist photographic movement during its primary period: consistency of style with personal identification, a search for beauty as defined in its canonical precepts, the production of a beautiful object, finely made, and presented in the context of artistic craftsmanship reflective of past printmaking techniques. Underlying these tenets may be recognized an attitude that, while not stated, was nonetheless understood. It had to do with the element of personal responsibility in the creation of works of art. More than any other aspect, this attitude should be seen as the most significant concept to come from the tradition of the arts in other media. It reflects the ultimate understanding that the photographer has something to say. The assumption that the photographic artist could indeed speak to, and for, a society may be seen to be the most fundamental element in the new order of art photography. That Hartmann recognized this implicitly in White is not unusual for this critic, but it is important that he gave to White, at the very beginning of the photographer's career, the imprimatur of acceptance and the confirmation that art of this sort could be produced anywhere—including in Ohio. Indeed, that localism, that quality so openly commented upon by many others, was both the source of White's expression and the well from which he drew his individuality.

The issue of what we might term "locality" is an important and instructive one. The pursuit of art photography had been from the beginning mostly an urban endeavor. In the first years, it was centered in the major European cities such as London, Paris, Dresden, and Vienna. In this country, with Stieglitz's assumption of an international leadership role in 1902, New York took over from F. Holland Day's Boston, where there had been significant activity early on. But there was ambitious work being done in Chicago, Pittsburgh, Philadelphia, and St. Louis, too. The fact that White emerged from the small-town environment of Newark, Ohio, perplexed some of his critics, and some of those who would attempt to copy him, but it also informed them of the basis for certain qualities felt in his work. These had to do in part with what was believed to be the expression of an idyllic way of life in con-

temporary, modernizing America. White's art was frequently compared to what was called "rural" literature: novels and short stories by writers such as Mary E. Wilkins-Freeman of New England, whose realistic picture of country life was frequently mentioned in the criticism of White's pictures. Sherwood Anderson, White's compatriot from Ohio, was yet to write his greatest stories, but later he also would be seen as having a vision similar to White's. Another comparison, more visual in nature and particularly related to his depiction of women and children (as, for instance, in *Ring Toss* of 1899), was that made with the work of John Singer Sargent or William Merritt Chase. White's work may also be seen to reflect the mood of the pastoral school of American painting, notably late Impressionist in style, as in works by artists such as Otto Henry Bacher, Frank W. Benson, Thomas Dewing, Theodore Robinson, or J. Alden Weir, among others.

White's handling of the genre subject, that of everyday life depicted realistically, derived, as we have said, in large measure from his understanding of those rituals of ordinary life that gave space and completeness to that life. In their celebration of elemental things, his pictures told a story. Each image, when taken with others, was part of a larger narrative. His critics recognized this quality and frequently remarked that each picture was as if from a story, but never telling it completely. Hartmann wrote: "In his pictures one can read as in an open book."[15] White's was a photography of such spare but wondrous clarity, and the facts of his life, such as his family, became metaphors in his work.

It is understandable, then, to recognize the influence on White's work of the popular illustration used in such magazines as *Everybody's*, the *Metropolitan Magazine*, *Munsey's*, or *Scribner's* as sources for his compositions of incidental life. One artist in particular, Albert E. Sterner, whose popularity was very high in the 1890s, might be singled out as representative of many others.[16] What is especially fascinating, however, is what occurs when White is commissioned, as he was in 1901, to take up literary illustration himself. Through the assistance of Stieglitz, White received the commission to illustrate a new edition of the novel *Eben Holden* by Irving Bacheller. From this commission he received another, in 1903, to illustrate a narrative for *McClure's Magazine*: "Beneath the Wrinkle" by Clara Morris. The photographs used in these publications have interest in comparison to his others. One can sense in them a relative incompleteness in their depiction; a stronger sense of the dramatic moment as the scene has been excerpted from the continuity of the

verbal narration, a sort of narrative dissolution. In the context of the publications, the pictures are successful and, like motion picture stills today, they struggle in any attempt at summation. When comparing them to his other pictures, which had struck some critics with their sense of narration, one recognizes how these writers intuitively understood that White was not illustrating, but summarizing experience. In illustration one seeks only to reinforce information already held. Joseph Keiley, in praising White's work, set aside the aspects of illustration when he wrote: "[The] subject with subtle poetry leaves much to and stimulates the imagination of the observer."[17] It is this attribute that differentiates our response between the straightforward illustration pieces by White and his painter sources, and White's more original works.

When White decided in 1904 that he had to devote himself fully to photography, he also realized that eventually he would have to join the mainstream in metropolitan New York. In 1903 he began to travel there more frequently to see Stieglitz and others. We can suspect that, as an aspiring artist, he was becoming victimized by Midwest claustrophobia, but whether he knew that in moving he would be abandoning the key to his success is not clear. Nonetheless, he felt the pressure building in his work. In his letters to Stieglitz from this period he indicates that he was in a "rut" as far as his photography was concerned. Once away from Ohio, in addition to taking on the pressure to earn a living through photography in an unfamiliar environment, White was forced to abandon the unique inspirational source of picturesque possibilities that were his Ohio imagery. Some have argued that his work did not change appreciably once he moved to New York; that even though he did not address urban subject matter found there, his pictures were, nevertheless, very much like his earlier ones. This is clearly not the case. It is not only a quality of lyric and local poetry that they have lost, it is a quality of knowledge that they have lost.

Half of the photographer's work is in the discovery of his subject. White had grown up in a world that was more or less explained. He photographed against a background of knowledge. While in Ohio, he was still close to the rituals and social ways of village America and his photographs celebrated them, the life of an Ohio village, and the events that gave grace and completeness to that life. They also celebrated elemental things, the time spent in the fields or woods, the simple pleasure of unhurried living, the playing of games in interior spaces. They gave beauty to the Ohio village life, every little variation, all of the many emotions. White, growing up within an extended family, knowing noth-

ing else, had no real sense of other societies, and his pictures thus had a kind of fortification against the outside. They were his private epic. One could say that when White moved to New York, his youth was over, his supports went, and it is clear that he was not fully secure. While in Ohio, White had eased himself into knowledge. To photograph was to learn. Once he was forced to abandon the intensity of photography as he had practiced it in Ohio, he was to find himself with incomplete knowledge. All of the varied emotions that had made up the rural order of his birthplace were no more. As experience provides the material for all of us, so White needed new experiences in the city to make his photography work.

We can rightly speak of White as having a primary career that spans the period of about 1897 to 1907 or perhaps 1909. In this space of ten years, he made a remarkable number of images, most with an intensity of feeling that may be said to inspire true admiration. After that, the less frequent pictures lose the indelible mark of conviction and affection.

What this shows is that locale is important, as well as the degree of commitment needed to sustain important artistic endeavor. Photographers of the first rank understand this innately; those who do not still recognize the critical density of thought and emotion required to photograph, and seek to attain it. Knowledge is what feeds both thought and emotion. White understood this, and though he did not speak much about it, there is evidence in his observations on teaching to suggest that he understood what had happened to him and how he must alert others to the same pitfall. Some writers rebuked him for being a teacher of female dilettantes, especially in his summer classes. In some measure he probably was, but the core curriculum in the New York school, founded in 1914, reflected a belief in professionalism at the highest level.[18]

Clarence H. White was surely a good man. One writer, no doubt meaning well, called him a "simple man." There are numerous portraits of him, including a self-portrait of 1925 made as part of a collection for members of the Stowaways, a social organization of artists, graphic designers, and others. Most formal, posed portraits, such as this one, show him in the guise of the artist-photographer as is customary with such images. In 1912, Coburn made a portrait of White for the collection *Men of Mark*. This work was published and White's colleagues presumably had their opinions about this portrayal of him. White and Coburn were close friends, and we assume that White assented to the way Coburn depicted him: heroic in stature, with only the head and

upper torso shown from slightly below, clothed in a light shirt with a dark scarf tied around the neck. White's shoulders are tilted in a rakish manner and his gaze is to the right, away from the viewer and no doubt toward the source of some unseen inspiration. It is altogether the romantic conception of the artist-photographer. A truer rendering of White would have him much more humble, even pedestrian in appearance. It would be a candid image showing that he was practically never without a suit and tie, except when in Maine with his family, where he affected wearing a sailor's outfit, somewhat in the spirit perhaps of his friend Day, who was often attired in a North African burnoose. White, in contrast to his description in some posed representations, was a very gentle man, soft-spoken and probably loving to a fault. He never sought material reward, something that caused hardship for his large family of a wife and three sons. But his strengths lay within him and were seen in his perseverance and in his steadfast adherence to the honest beliefs that he vested in the medium of photography and the pursuit of art. After he moved to New York he had adventures of a sort, but it was the affecting and fulfilling strength of his imagination from his early years that carried him along throughout the rest of his life. His career was a slow progression out of a homespun tale that had been his childhood and youth and early fame. He died young, seemingly in mid-sentence we might say, in his early fifties while photographing with his students in Mexico City in 1925.

Modesty, simplicity, conviction, and decency; in retrospect these are the feelings we derive from the portraits of White—both the formal images and those candid pictures of him teaching in Canaan, Maine, or in New York. Max Weber, a painter and instructor in White's schools, once said about White that he was a kind of poetic pioneer in photography, and Weber likened his work to pictures by Vermeer.[19] Weber went on to speak of White's aestheticism and his sensitivity. These traits are those of a contemplative man, suited more to repose than to boldness of action. White and Stieglitz infrequently saw eye to eye as the years passed, but as Alvin Langdon Coburn has suggested, they were similar in their love for photography and in the promulgation of it as an art form.[20] In the Pictorialist photographic movement there were those such as Hartmann and Caffin who could write perceptively about its sources and techniques, and even its applications, and there were those like White who could demonstrate in his reverent way exactly what its accomplishments were.

Reverence and beauty are both terms and ideas that appear early and throughout the commentary about Clarence H. White and his work. Criticism about his work most always reflected also a respect for White himself—the photographer's photographer, one who lives in and through photography. Julia McCune, his first pupil in Newark and one of his most important models, who appeared in *The Orchard* and other pictures, remembered him as "the greatest man I have ever known, a radiant soul, who urged me never to do anything carelessly, but with considered beauty."[21] And Charles Caffin, in introducing White's 1908 portfolio in *Camera Work*, referred to his "instinctive reverence."[22] Thus it would seem that in trying to find the center of Clarence H. White, we may cast aside the various facts of his life and the nuances of his time, and we need only identify his unfailing reverence for beauty, to know we have found the man.

NOTES

1. See Peter C. Bunnell, *A Photographic Vision: Pictorial Photography 1889–1923* (Salt Lake City: Peregrine Smith, 1980).

2. George Gibbs, "Seriousness in Art," *Monthly Illustrator* 6 (September 1896): 67–74. Another, on religious imagery, is also typical: Will H. Low, "Madonna and Child in Art," *McClure's* 6 (December 1895): 33–47.

3. See James H. Chapman, "In Greek Costume at Pelham Bay," *Monthly Illustrator* 5 (September 1895): 274–85.

4. Joseph T. Keiley, "Exhibition of the Pictures of Clarence H. White," *Camera Notes* 3 (January 1900): 123–24.

5. *Clarence H. White School of Photography* (New York: Clarence H. White School of Photography, n.d. [after 1928]), n.p.

6. See Bonnie Yochelson, "Clarence H. White Reconsidered: An Alternative to the Modernist Aesthetic of Straight Photography," *Studies in Visual Communication* 9 (Fall 1983): 24–44. This article reflects some of the most important new research on White to be done in several years. Yochelson's interpretation requires serious consideration in the effort to rethink the development of photography after World War I.

7. Clarence H. White, "The Progress of Pictorial Photography," *Pictorial Photography in America, 1918* (New York: Pictorial Photographers of America, 1918), pp. 5–16.

8. Ibid.

9. Edward Weston, "Weston to Hagemeyer: New York Notes," in Peter C. Bunnell, *Edward Weston on Photography* (Salt Lake City: Gibbs M. Smith, 1983), p. 42.

10. Yochelson, "Clarence H. White Reconsidered."

11. Anton Bruehl, interview by Peter C. Bunnell, July 7, 1960.

12. Charles H. Caffin, "Clarence H. White," *Camera Work* 3 (July 1903): 15–17.

13. Ibid.

14. Sadakichi Hartmann, "Clarence F. [*sic*] White," *Photographic Times* 32 (January 1900): 18–23.

15. Ibid.

16. Throughout his life, White kept collections of magazine issues such as those mentioned here and earlier, and clippings of articles from similar sources pertaining particularly to art [see notes 2 and 3]. Another such article, "American Art and Foreign Influence" by W. Lewis Fraser, *Quarterly Illustrator* 2 (January–March 1894): 3–10, is devoted to the work of Albert E. Sterner.

17. Keiley, "Exhibition of the Pictures of Clarence H. White."

18. White's summer schools, which began in Maine in 1910 and later took place in Connecticut, were undoubtedly modeled on the earlier summer courses offered in Ipswich, Massachusetts, by White's Columbia University colleague Arthur Wesley Dow. Dow also came in for similar criticism. See Frederick G. Moffatt, *Arthur Wesley Dow (1857–1922)* (Washington, D.C.: National Collection of Fine Arts, 1977), pp. 92–103.

19. Max Weber, interview by Peter C. Bunnell, September 8, 1960.

20. Alvin Langdon Coburn, letter to Peter C. Bunnell, September 1, 1960.

21. Julia McCune Flory, letter to Peter C. Bunnell, February 24, 1960, and interview, October 29–30, 1960.

22. Charles H. Caffin, "Clarence H. White," *Camera Work* 23 (July 1908): 6–7.

From *Clarence H. White: The Reverence for Beauty*, exhibition catalog, Ohio University Gallery of Fine Art, Athens, Ohio, 1987.

GERTRUDE KÄSEBIER

I have longed unceasingly to make pictures of people . . . to
make likenesses that are biographies, to bring out in each
photograph the essential personality that is variously called
temperament, soul, humanity.

Gertrude Käsebier was a remarkable and talented woman, one of the
leading members of the Pictorialist photographic movement in the
United States. Widely respected and admired in her lifetime, she was an
artist who saw her challenge to the conventional aesthetics of photo-
graphic portraiture become imitated in her own lifetime. Not forgotten
in the various modern studies of the history of photography, she has in
recent years become the focus of considerable interest as part of the
movement to look again at the woman artist.[1]

"Pictorial photography" was a term used to identify an approach
to photography that was originated in England in the 1890s and contin-
ued in this country for twenty years or more by Käsebier and such fig-
ures as Alfred Stieglitz, Edward Steichen, and Clarence H. White. It was
characterized by a general overall softness of tone and detail, and the
organization of forms in Pictorial photographs was accomplished
through the massing of light and shade rather than in building up detail,
which is inherently the more photographic compositional device. Con-
siderable emphasis was also placed on the physical articulation of the
surface of the print itself, and such printing techniques as gum-bichro-
mate, platinum, and multiple gum platinum were extremely popular. In
addition to these strongly Whistlerian qualities, Pictorial photographs
were characterized by their fundamental narrative content. The essential
belief held by the photographers working in this period was that photo-
graphs were capable of embodying emotion and thought. The guiding
tenet was that the medium should be used for the expression of ideas
and not simply to document the world of visual sensation. These pho-
tographers were less interested in facts than in sentiment. Strongly
influenced by the realization brought to painting by Impressionists
that subjects suitable for the world of art could not be dictated by aca-
demic structure, the photographer of this period sought to find in the

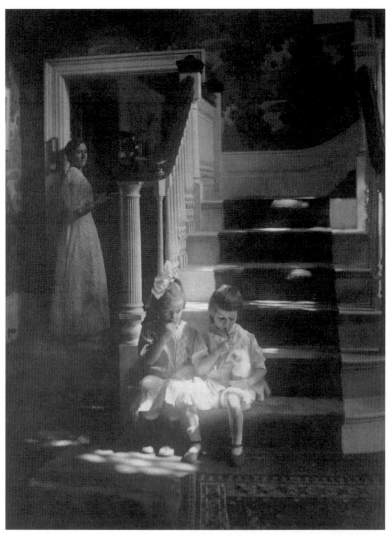

Gertrude Käsebier, *Lolly-Pops*, 1910
Princeton University Art Museum; Gift of Mrs. Robert S. Ratner

commonness of everyday experience the expression of greater values and truths.

Gertrude Stanton was born of Quaker parents in Des Moines, Iowa, in 1851. As a small child she crossed the plains in a covered wagon to Leadville, Colorado, where her father was to be engaged in silver mining. Gertrude was raised there, but as a teenager, after her father's death, she went to live with her maternal grandmother in the East. Later she moved to her mother's boardinghouse in New York. Here she met Edward Käsebier, an importer of shellac, from Wiesbaden, Germany, and they were married in 1873. They had three children: a son, Frederick, and two daughters, Gertrude Elizabeth and Hermine Mathilde. Early in her marriage she applied to the Cooper Union, then the most noted art school in New York, only to be turned down. After devoting fourteen years to raising her family, she entered Pratt Institute in 1888 to study painting, particularly portraiture. Just before she entered Pratt she had been given a camera, but because of her professors' disdain of photography she did not seriously explore the medium. In the next five years, she devoted most of her time and energy to painting.

In 1893, Käsebier went to Europe for further study. Leaving her son with her husband and taking her daughters with her, she took the camera along, apparently more as an afterthought than through any real interest in it. One rainy day in France, when it was not possible to paint out-of-doors, she made several indoor portraits with her camera. Pleased with the results, she realized that she had found the better medium with which to express herself and she abandoned her original interest in painting. For the next several years she sought to master photography. She would leave her husband and son in New York, and with her daughters she would tour France for several months at a time. When in Germany on visits to her relatives, she sought formal instruction in the technical aspects of the medium.

About 1897, Käsebier became determined to utilize the camera for professional portraiture, but being without experience she apprenticed in a Brooklyn photographic studio for some months. After overcoming her husband's reluctance, she established her first studio at a fashionable location on Fifth Avenue near Thirty-second Street, and soon became one of the foremost portrait photographers in New York.

In 1907, she explained her passion to be a portraitist: "I am now a mother and a grandmother, and I do not recall that I have ever ignored the claims of the nomadic button and the ceaseless call for sympathy, and the greatest demand on time and patience. My children and

their children have been my closest thought but from the first day of dawning individuality, I have longed unceasingly to make pictures of people . . . to make likenesses that are biographies, to bring out in each photograph the essential personality that is variously called temperament, soul, humanity."[2] She had entered the field of portrait photography at a time when commercial portraiture was dominated by theatrical settings with high Victorian furniture, painted backgrounds, and dull, flat lighting. She set out to change these customs by using more sculptural lighting—including natural light—and settings of a more neutral yet subtle elegance.

Of medium size and rather inclined to fullness of figure, she favored eccentric colorful costumes, including capes, Chinese blouses, and large plumed hats. Invariably, she had hands stained with chemicals, as she insisted on doing all her own photographic processing. She was completely feminine and noted for her warm, sympathetic spirit, good humor, and quickness and skill at repartee. Her enthusiasm as one of the few professional women artists of her day was easily contagious to the young women who came to know her and seek her advice concerning careers in photography.

These were the years when the iconoclast Alfred Stieglitz was struggling for the recognition of photography in terms related to the traditional arts. The camera was recognized as a tool for the creative artist, and Käsebier herself said of the medium: "To accomplish artistic work, of any individual worth, nature must be seen through the medium of the artist's intellectual emotions."[3] Beginning with exhibitions at the Camera Club of New York and later with publication in the first issue of Stieglitz's sumptuous *Camera Work* magazine, Käsebier became a significant force in the Pictorial photographic movement. She was a founder and fellow of the Photo-Secession, established by Stieglitz in 1902, and she was also a member of the English Linked Ring group. She won numerous medals and citations in international exhibitions.

In her professional capacity she photographed many of the notable creative personalities of the day, including members of The Eight, John Murray Anderson, Mark Twain, Gelette Burgess, Jacob Riis, Jan Kubelik, Charles Dana Gibson, Solon Borglum, Booker T. Washington, Stanford White, and her photographic associates, F. H. Evans, Stieglitz, and Clarence H. White. She was commissioned to illustrate works of popular fiction, and her photographs were widely reproduced in such magazines as *McClure's*, *Munsey's*, *Scribners*, and *World's Work*, and

photographic publications such as *Camera Notes*, the *Craftsman*, *Photo-Era*, *Photographic Art*, and *Photographic Times*.

Käsebier had a fascination with and devotion to the American Indian, and she made portraits of the members of Buffalo Bill's Wild West troupe. The series, begun in her New York studio and continued in the north central plains, is notable for her insight into the personalities of these Americans and for the absence of apocryphal clichés. The collection of these photographs is now in the Anthropology Archives of the Smithsonian Institution.

In 1907, she executed a series on the French sculptor Auguste Rodin that is of considerable historical importance as an interpretive study of the artist and a documentation of his art and studio. Further, she produced over several years a cycle dedicated to aspects of motherhood, which included photographs of mother and child, young children growing up, and enduring incidents of family life. Most notable of this group were the widely reproduced *Blessed Art Thou Among Women* and *The Manger*. This series, her most romantic, most intuitively derived images, may be considered a contribution to the history of art comparable to that of Mary Cassatt's treatment of similar themes.

The key exhibition of Käsebier's work was at the Little Galleries of the Photo-Secession in New York in February 1906. Charles Caffin, writing for *Camera Work*, praised her work by saying: "I know of no photographer at home or abroad, who displays so much charm of invention. There is always in her work the delight of surprise; no ordinariness, not even a tolerable repetition of motive; but, throughout a perpetual freshness of conception, as extraordinary as it is fascinating."[4]

Stieglitz's interest in the kind of photography Käsebier and others practiced ceased in large measure about 1915, and thereafter she allied herself with a group of more reactionary photographers not dedicated to the modern aspirations in photographic imagery and creation. These new concepts had to do with the clarity of sharpness, as compared to earlier soft-focus effects, and to subject motifs derived from the new literature and paintings, such as those exhibited at the Armory Show in 1913. With Clarence H. White and Alvin Langdon Coburn, Käsebier was instrumental in organizing a rival group to Stieglitz's called the Pictorial Photographers of America. This group, which continued its existence for many years, was in large measure responsible for the continuance of an insipid form of Pictorialism, which, although once considered advanced, was by 1930—in a much-changed world—out of

favor as a generally ill-conceived expression. Käsebier maintained her studio until 1929 and she died five years later.

The photographs in the Virginia Museum collection represent an excellent cross-section of Käsebier's expression and style. In addition to professional portraits of men and women, there are genre pictures that show the most subtle and imaginative qualities of her work. One of these qualities was her ability to combine in a single image a complex pictorial composition with an expression of the individuality of the subject or sitter. This may be seen in the photograph of Käsebier's friend and professional colleague Frances Benjamin Johnston, and also in the portraits of Mrs. Vitale with her child. The various sittings of women, including the stunning one of the figure reading beside the window through which comes the natural illumination for the picture, are eloquent examples of a portrait style devoid of any theatrics. With men, she frequently used the neutral background to stress the face (as in her portrait of Charles Dana Gibson), or to emphasize the overall compositional presence of the individual (as in the image of the man holding a cane and gloves). A complex juxtaposition of these two approaches to the background may be seen in the picture of the figure standing on the roof. The upper part of his body, especially his head, is isolated and contrasted to the entire lower mass. The delicate gesture of the catching of the eye, while the figure is turned, may be seen here and in the portraits of her daughter Hermine and of Harriet Daily.

The majority of these photographs are representative of her use of unmanipulated techniques, being prints in a rich, warm-toned platinum. Luminous, yet without the overbearing encumbrance of detail, this quality of controlled light and shade is beautifully seen in the view of the Venetian palazzo of the Baron de Meyer.

Perhaps the most notable photograph of the Virginia Museum's group is that titled *The Heritage of Motherhood*. The print displays all of the manipulative techniques of printmaking, along with that of titling, which Käsebier used in producing an image of great power. She frequently titled her works with highly charged sentiments rather than merely identifications of place, and this is a notable example. Anne Tucker, in her book *The Woman's Eye*, has commented that "*The Heritage of Motherhood* is a title capable of evoking various responses. Without the photograph, these responses would probably center on the more traditional relationships of a mother's nourishing and protective role toward her children. But the photograph does not portray this

image. In it, a large woman sits, cape or shawl loosely about her shoulders, in a barren, rocky landscape, the whole picture very dark. When the title is applied, suddenly her solitude becomes evident. How can motherhood be implied without the presence of a child? Why is the woman alone in such an environment? It then becomes a personal, atypical approach to motherhood, one born from experience."[5] One contemporary reviewer described this picture as being from the wastes of desolation and suggested that the playwright Henrik Ibsen might have found inspiration in it. Through such a photograph, we can see that Käsebier was not unfamiliar with, or afraid of, the realities of the emotions from which she derived her expressive values.

Käsebier's position in the history of photography remains firm. It is not simply a matter that within the medium there has been a paucity of women and that she was one of the first to gain international recognition both as an artist and a professional. Her portraiture, throughout her career, was of the first rank, well in advance of many of her colleagues, and together with the photographs by White, Steichen, and others, her Pictorial work will remain among the masterpieces from the years 1898 to after World War I.

NOTES

1. Anne Tucker, *The Woman's Eye* (New York: Alfred A. Knopf, 1973); Jane Cleland O'Mara, "Gertrude Käsebier: The First Professional Woman Photographer, 1851–1934," *Feminist Art Journal* (Winter 1973–74): 18–20, 23; *Women of Photography: An Historical Survey* (San Francisco Museum of Art, 1975).

2. Käsebier, in Giles Edgerton, "Photography as an Emotional Art," *Craftsman* (April 1907): 88.

3. Käsebier, in Joseph Keiley, "Gertrude Käsebier," *Photography* (March 19, 1904): 215.

4. Charles H. Caffin, "Mrs. Käsebier's Work: An Appreciation," *Camera Work*, no. 1 (1903): 18.

5. Tucker, *Woman's Eye*, pp. 15–16.

From *Arts in Virginia* 16 (Fall 1975): 2–4.

EDWARD WESTON
ON PHOTOGRAPHY

The notion that photographers have not significantly contributed to the literature of their medium is not true. Granted, photographers have not generally been disposed to group activity or to what may be termed the manifesto form, but a review of any anthology of writing on photography will reveal intelligent and deeply felt statements by photographers. The one photographer who has given to the contemporary literature the most complete record of the self is Edward Weston, who, in his *Daybooks*, chronicled his life in photography as few others have. Through this compelling journal, we can chart his evolution as an artist, his thinking about the medium, and find the all-important documentation of and reaction to his personal and psychological life, which manifests itself in his creative work. But Weston's *Daybooks* in their present form are not the whole story; indeed, they were revised and edited by him during his lifetime and they represent only a partial self-portrait. Weston intended that his diary be published in one form or another and he even prepared it for publication himself.[1] While much of his editing reflected second thoughts on revealing the identity of certain persons, more serious was his constant reappraisal of his career as an artist and his one-sided musings on his success or failure. In the end, at the conclusion of his life, he had prepared with the *Daybooks* a document that was to be a prism of himself both as a man and as a recognized photographic artist.

This is an understandable act for any person who keeps a journal as the basis of an authorized biography. Literary figures and some painters are familiar with the form, and in a few cases we have a similar effort by other photographic artists, notably Minor White's "Memorable Fancies." But for the art historian as well as the biographer, the trace of the artist in a less self-conscious, immediate, and untouchable form such as correspondence or published pieces sometimes proves of greater value as an insight into the progressive and evolving chronicle of the artist's perceptions and values. This, of course, is in addition to what is revealed by the works of art themselves, which are always the primary source. It is a measure of Weston's stature as a photographic

Edward Weston, *Dunes, Oceano*, 1936
Princeton University Art Museum; Gift of David H. McAlpin, Class of 1920

artist that we are as interested in him as we are. *Edward Weston on Photography* is an anthology that presents for the first time the majority of his writings on photographs, which were meant for general consumption and which were unalterably fixed at particular points in time. In these articles, lectures, letters to the editor, and exhibition statements we find revealed the most fundamental of his thoughts with regard to photography, devoid of intimate biographical connections or personal meditations on aims and achievements. Here, Weston speaks with a self-directed authority, a quality he felt about himself and his work from his earliest years. These articles render in print what his photographs do in platinum or silver, and with a similar precision they identify where he placed his beliefs with regard to his chosen medium. Further, they show clearly, and in some cases uniquely, the progressive mark of influence on his thinking, and they reveal the models—both role models and stylistic models—for his life in photography.

Because Weston became a ruthless editor of his work as the years progressed, discarding the major part of his photographic work from about 1906 to 1921 as well as pages from the *Daybooks* prior to 1923, the analysis of his early interests, first in portrait photography and then in Pictorialism, is now made possible with greater substance through these texts. With the exception of a few prints in various collections, very little is known of his work prior to his significant change in approach and style in the early 1920s. Frequently the only records of this early work are the reproductions in published sources. The texts contained in this anthology span a period from 1911 with his first published article, "Artistic Interiors," written for *American Photography*, to the 1950s, at which time he comments on color photography, and, nearing the end of his life, publishes a reaffirmation of his enduring belief in the uniqueness of photography with a re-edited version of an earlier article, "What Is Photographic Beauty?"

Weston began professional photography in California in 1906, working as an itinerant photographer specializing in children's portraits. He had been introduced to the medium in 1902 by his father, who gave him an amateur's camera. He was essentially self-taught, although he did attend the Illinois College of Photography for six months in 1908. In the context of the observations above about the reappraising of his career, it is interesting to compare his two views of this experience. In 1939, Weston wrote: "I learned a lot about what not to do when making portraits," but earlier, in 1912, he wrote about his experience at such a school that he "had a short course in one and have never been sorry."

His real training came during a two-year apprenticeship in the studio of a working photographer, but throughout his life he insisted in his writing that one's education must be self-directed, and he cautioned those who did not carefully and selectively seek advice and direction elsewhere—especially in areas outside of photography. One of his basic attitudes with regard to education was that "photography has become so simple an affair that a child can Kodak and even learn to finish well." When he had a rare retrospective showing in 1933, he exhibited pictures taken in 1903 from his youth in Chicago as if to demonstrate this point. At this time he referred to this work as immature but related both in technique and conception to his current imagery. He carefully omitted from this same exhibition pictures from 1906 to 1912, which by this time he had expunged from his body of work. He did show work dating from 1913 to 1920, but he described it as reflective of the period in which he was "trying to be artistic."

It is evident from the articles written throughout his life that Weston was an avid reader of photographic periodicals and that in spite of what he sometimes said, he used such publications as sources of information and a standard against which to measure his own accomplishments. While we have only a few direct statements documenting his reading, the sources of his own writings between 1911 and 1920 reveal the following titles: *Photo Era, American Photography, British Journal of Photography, Photo-Miniature,* and *Camera Craft.* We also know that he was familiar with *Camera Work.* The bibliography of his published photographs reveals many other publications, including the popular annuals, with which we can be certain he had familiarity during these years: *American Annual of Photography, Photography, Photograms of the Year,* the *Camera, Photography and Focus, Bulletin of Photography, Photo-Graphic Art,* and *Pictorial Photography in America,* among others.

What this information provides is a depiction of how technical information and style were transmitted from one generation to another as well as the standards of photographic work to be achieved. It must be remembered that few people saw exhibitions of original prints, or at least exhibitions other than those of the professional associations. This latter point is very significant in understanding the young Weston, for during these early years he was very conscious of his reputation, and he worked hard to assure for himself a place in the arena of professional photography and later in that of artistic photography. And while from the start he was critical of popular taste, he wrote in 1913:

I am a great believer in the value of competitions and exhibitions, both as an education and as a business getter. By giving support you aid the magazines, salons, and exhibits, and in return receive splendid advertising upon winning a prize; and where, oh where would we who believe in pictorial photography be, if 'twere not for such magazines as *American Photography?* Not all of us are blessed with the opportunity of seeing salons, and we must derive our inspirations from the splendid halftone illustrations of work by the masters of our art published monthly in leading photographic periodicals. Those who do not read and subscribe to these magazines and patronize their advertisers unwittingly deal a blow at the advancement of pictorial photography; those who do, reap the benefit of knowledge imparted by those who know, and also avoid the necessity of digging out perplexing elementary problems in both art and technique.

In reading this statement, one gains not only confirmation as to Weston's sources at this formative time of his career, but also something of the tone of his very businesslike attitude about professionalism and his standards as a working photographer. Further, it helps explain something of his later motivation to contribute to the literature himself, in part even through his journal, for the benefit of others. The mode of Weston's writings throughout his life was to establish himself as a kind of model, suggesting that his methods and successes would aid those coming after him. He was never afraid of competition, and he understood that only through the challenge of comparative appraisal would real growth be possible.

One of the most significant facts to be uncovered in Weston's published writings throughout his career is his deep-seated interest in portraiture. Readers today will probably find this surprising because so much has been made of his later aversion to professional portraiture, and because Weston is so largely perceived as a landscapist, in light of his later work. The fact is, however, that from the beginning of his professional work and through his entire career he continued to address himself to questions of the photographic portrait and the figure. In articles between 1912 and 1917, and again all through the 1920s, there are repeated references to portraiture, and these culminate in two lengthy discussions of the subject in 1939 and 1942. To know and understand his views on this genre is to understand Weston's basic

involvement with the photographic medium. It is as if his concern for what he termed the "quintessence of the object" were most revealed in the rendering of the human face or the figure through photography. It echoes his most profound and deeply felt interest in the "poetry of being," which is in constant transition, revealing the person himself and seemingly captured only through photography. It is of the essence in understanding Weston that he believed that photography was unique when used to record this fleeting quality.

Another early concept held by Weston and retained throughout his life was the belief that photographs are made and not taken, and he believed that "art is outward expression of inner attainment." His concern for being an artist in the medium was not simply the reference to practices and manners derived from other media, but the knowledge that "as great a picture can be made as one's own mental capacity—no greater. Art cannot be taught; it must be self-inspiration, though the imagination may be fired and the ambition and work directed by the advice and example of others." He believed that "the picture must be the product of one's intellect. . . . Any individuality in my work is entirely due to the selection, arrangement, and lighting of the subject—the picture is conceived in the mind."

Weston's belief in the importance of the basic chemical and technical approach to photography is revealed exceptionally early in his career. His formulation of what was to become his famous dictum, "previsualization," rests on his early admonition of 1916 to "get your lighting and exposure correct at the start and both developing and printing can be practically automatic." This rooted interest in the control and perfection of technique as a component of visualization was forcefully expressed by Weston from the very start. What was to separate the quality of one photograph from another was the expressive realization of photographic craft. In his early articles on studio operation, he consistently demanded that the photographer demonstrate high-quality technique and appropriately charge his customers for it. In 1916 Weston already refers to "straight photographs," and this naturally leads to the consideration of his aesthetics of pure photography.

Weston held that there were qualities of photography that were unique to the medium, and throughout his life he urged—even insisted—that photographers appreciate them as the keystones of photographic appreciation. It is interesting to note how early in his thinking these attitudes appear. Certainly by the mid-1910s he was fully aware of the controversy raging throughout the photographic world concerning

the manipulated, poetically pictorial photograph versus the straightforward and more realist approach. It is doubtful that he saw examples of this latter work other than in reproduction, but even via these secondary sources such imagery was clearly having its effect. By the time of his 1916 lecture he had firmly adopted the attitude that photography "aping another medium" would only spell its failure, and he used the term "photopainting" to label the work executed in this manner. Much has been written by way of trying to understand Weston's turning from the Pictorialist mode to the straightforward, literalist approach represented by the work of Stieglitz, Strand, and others. We know now that he was aware of the developing currents in modern art, and much like his counterparts in New York, he recognized that abstraction was not simply a matter of representation but that it also spelled the deathblow to impressionistic and literary depiction. If he did not find confirmation of this notion in any other publication (and the popular photographic magazines were conservative in this regard), *Camera Work* gave him ample documentation of developments since Stieglitz's first publication of Matisse and Rodin in 1910 and 1911 and of Picasso in 1911. By the time of *Camera Work*'s Strand issues in 1916 and 1917, Weston had abundant evidence of the new aesthetic and how it would affect photography. His firsthand exposure to modern art came at the Panama Pacific International Exposition in San Francisco in 1915, and some influence of that exhibition is already evident in his comments in the 1916 lecture "Photography as a Means of Artistic Expression," delivered before the College Women's Club in Los Angeles.[2]

A careful reading of his June 1922 text "Random Notes on Photography," again prepared as a lecture and given before the Southern California Camera Club, identifies what may well have been the most influential article of any in the development of Weston's maturing thought. This was a piece titled "Stieglitz," written by the well-known critic Paul Rosenfeld. It was published in the April 1921 issue of the *Dial*, and it is significant that Weston had access to this article before leaving California for his important visit east during October and November of the next year. From this single article, Weston appears to have found the phraseology with which to articulate his entire aesthetic understanding of the medium and the confirmation of his developing aesthetic. In the article Rosenfield writes: "The photographs of Stieglitz affirm life not only because they declare the wonder and significance of myriad objects never before felt to be lovely. They affirm it because they declare each of them the majesty of the moment, the augustness of the

here, the now." He continues: "Never, indeed, has there been such another affirmation of the majesty of the moment. No doubt, such witness to the wonder of the here, the now, was what the impressionist painters were striving to bear. But their instrument was not sufficiently swift, sufficiently pliable; the momentary effects of light they wished to record escaped them while they were busy analysing it. For such immediate response, a machine of the nature of the camera was required."[3]

In the first of the above passages, Rosenfeld was speaking about Stieglitz's portraiture, and in the second he suggests Stieglitz's landscape work, although it must be noted that the great series of landscape and cloud studies was still a year to two years away. Weston was to quote the phrase "majesty of the moment" in successive articles written during 1922 and obliquely refer to it for years afterward. He uses it first in "Random Notes," where he quotes extensively from the Rosenfeld piece. It appears again in the August 1922 letter to *American Photography*, where he pointedly affirms his belief in straight photography and makes reference to the work of Frederick H. Evans, and finally, in his letter to John Wallace Gillies for publication in his 1923 book *Principles of Pictorial Photography*.

From this latter text, written in late 1922 or early 1923, one gains confirmation that by the time Weston visited the East he had read most of the significant literature of the new American photography in such publications as the *Dial*, the *Broom*, the *New Republic*, the *Nation*, and also John Tennant's perceptive reviews in the long-standing journal of the Pictorial movement, *Photo-Miniature*. Through all of these sources Weston was making contact, really for the first time, with the eastern photographic workers. This was especially the case with Stieglitz, who had never before been singled out or even noted in a Weston article. In none of his writings prior to 1922 had Weston even referred to members of the Stieglitz circle, with the exception of Clarence H. White, Karl Struss, and Anne Brigman, but all of them were, by the 1910s, outside of the Stieglitz group and participants in the organization known as the Pictorial Photographers of America.

A series of pertinent quotations from the text of "Random Notes" indicates how strongly Weston was attuned to the new aesthetics in the medium and how influential Stieglitz had become via the articles by Rosenfeld and others. It is in this lecture that Weston precisely states the essential point of previsualization: "I see my finished platinum print on the ground glass in all its desired qualities, before my exposure—and the only excuse I make for after manipulation . . . is the possibility of

losing a difficult position or expression by the delay in correcting some minor fault." And he establishes as a rationale for his technique the "continued search for the very quintessence of life—the poetry of being." Significantly, Weston is still concentrating on portraiture and figure composition, the major component of his work, so he states further that his aim is to grasp "the very essence of man," and he concludes: "There have been those whose work showed fine perception of rhythm and balance and values—but considered as portraits, as likenesses—were sterile. So to combine pictorial qualities and likenesses is the real achievement. Few, only a handful, even less than that, are doing this."

Weston's trip east in October of 1922 has been described as one primarily to visit his sister and brother-in-law in Ohio, with a hoped-for journey on to New York. From the evidence in his June lecture, and with an understanding of his personal drive for achievement in photography, it would be more accurate to suggest now that the visit to New York was of the utmost importance, indeed that it was the essential motivation for the trip. Weston understood that it was necessary for him to make personal contact with these photographers and writers at the center of the new photography. He recognized that their direction was that of the future, and everything we know about his past behavior in such matters indicates he realized that he had to be a participant in this movement at its source. In 1922, there was no other way for him to meaningfully enter this sphere of action. This meant he had to see the work of these leaders in the original; for instance, all of the major articles on Stieglitz cited above contained not a single reproduction. He also realized that they had to see *his* work, which he knew was changing significantly. Challenge and affirmation were needed now as at no time earlier in his life. He had not abandoned his Pictorialist leanings, as his work shows, and the fact that he spoke warmly of seeing Clarence H. White and Gertrude Käsebier indicates that he was tolerant of their aesthetic and that he was still poised at the point of change. Stieglitz, Sheeler, Strand, and, notably, Georgia O'Keeffe, who was then living with Stieglitz, provided Weston with the challenge he needed, criticizing his pictures and drawing comparisons to works by themselves. O'Keeffe's paintings made a strong impression on Weston with their reductiveness and a sharp linearity that rendered forms with the precision of a lens. These were the qualities he also saw in Stieglitz's work, and he records Stieglitz as summarizing his aesthetic as "a maximum [amount] of detail with a maximum of simplification." Importantly,

Weston also saw John Tennant, who praised his work but who also drew the inevitable comparison to Stieglitz's. The visit with Stieglitz did not go entirely smoothly, as the *Daybooks* and other documents show, but it was the confrontation and confirming participation that were essential. Stieglitz was probably the first such photographer that Weston had really come up against in such a personal, one-on-one forum and too much praise might have shaken Weston's sense of self-directedness and self-assuredness. Stieglitz's exhibition the year before, in 1921—his first since 1913 and the focus of the numerous articles mentioned above, including that by Rosenfeld—was a masterful triumph, presenting 145 photographs dating from 1886 to 1921. And even though Weston did not see the exhibition itself, we can suppose that he found it meaningful, in the context of his own work, that of the total number of prints Stieglitz exhibited, 113 were portraits or figure compositions. If nothing else, it must have represented for the young Weston the profound authority of an oeuvre of total artistry in photography. Weston left New York with a vision of his own future.

The most important feature of Weston's published writing after this time—that is, during the decade into the early 1930s—is the refinement and articulation of his aesthetic of "straight photography." The very brief and reductive statements begin to appear, and these describe the boundaries of his pictorial theories and approach. He has also expanded his framework of sources, reflecting his experiences in Mexico and his broadening critical awareness.[4] The following is a sampling of statements from this period: "Photography is of today. It is a marvellous extension of our own vision; it sees more than the eye sees" (1926); "I herewith express my feeling for Life with Photographic Beauty" (1927); "Photography can take its place as a creative expression only through sincerity of purpose" (1927); quoting Van Gogh's letters: "A feeling for things in themselves is much more important than a sense of the pictorial," and William Blake: "Man is led to believe a lie, when he sees with, not through the eye" (1930); "The lens reveals more than the eye sees. Then why not use this potentiality to advantage" (1928); and "Since it has the validity of a new expression, without tradition or conventions, the freshness of an experimental epoch, the strength of pioneering, photography has a significant status in the life of today" (1928).

This final quote suggests that Weston, like so many others of the period, had adopted the fashionable but naïve concept that photography was a traditionless medium, that straight photography was somehow

unique to their time. This attitude mostly reflected the desire to pull away from the Pictorialist tendency to relate to other, older media of visual expression and to certain photographic works from the nineteenth century, but it was also an attempt to make of photography an American art. The new photography was seen as a pioneering effort because of its technological authenticity, which in turn was viewed in opposition to everything European and everything before World War I. Weston honestly believed that photography was fresh and without rules, presumably those kinds of rules laid down by authorities in other media, and on the subject of the manipulative practices used to suppress the photographic quality of a work he was anything but impassive. This single issue becomes an obsession with him to the end of his life, and his outrage over it appears in almost all of his writing, even when it was no longer a credible topic for concern. In 1929, for the catalog of the *Film und Foto* exhibition in Stuttgart, Germany, he wrote: "Those who feel nothing, or not completely at the *time of exposure*, relying upon subsequent manipulation to reach an unpremeditated end, are predestined to failure." By the mid-1940s this idea became: "A photograph has no value unless it looks exactly like a photograph and nothing else." Earlier, in 1930, in one of his most important articles of that decade, "Photography—Not Pictorial," Weston writes: "No photographer can equal emotionally nor aesthetically, the work of a fine painter, *both having the same end in view*—that is, the painter's viewpoint. Nor can the painter hope to equal the photographer *in his particular field*." In 1930 he defined what the photographer could do best: "To photograph a rock, have it look like a rock, but be more than a rock. Significant representation—not interpretation." Or, again, from the 1932 piece "A Contemporary Means of Artistic Expression," photography is the "fusion of an inner and outer reality derived from the wholeness of life—sublimating things seen into things known."

A major component of Weston's conceptualization was his belief in the control of technique and how pure photographic technique was the sole basis of significant photography. In 1934 he wrote: "In the discipline of camera-technique, the artist can become identified with the whole of life and so realize a more complete expression." In every piece for the general audience he describes and analyzes his working procedures, thus suggesting that the strict premeditation and morality of his method will provide the basis for meaningful imagery through straight photography. Allied to this belief was his constant need to declare himself an artist in the medium, and in 1934 he wrote that "a photogra-

pher who could not affirm his intention, who could not correlate his technique and his idea . . . was not an artist." Clearly the point here, as in all the writing of this period, was the search for a precision of intent and the presentation of a unique reality. As was pointed out above, beginning as early as his articles on how to manage a portrait studio, we find that he advised one to make good work and charge accordingly for it; that the quality of craftsmanship would be recognized and appreciated as integral to the artistry of the total work.

Weston's career as a photographer evolved through a series of distinct periods: his professional and Pictorialist period from 1906 to about 1918; a transitional period representing his work prior to going to Mexico, or roughly 1918 to 1923; the Mexican period from 1923 to 1927, which preceded a post-Mexican period dating to about 1934. The remainder of the 1930s, through the years after his 1937 receipt of a Guggenheim Foundation Fellowship, constitute another period, and, finally, the years 1939 to 1948 represent yet another distinct phase in his professional career. It is worth noting that his published writing appears strongest and is more copious in the most significant of these periods, that from about 1927 to 1934. As we have seen, however, Weston had developed his essential ideas early, and throughout the whole of his career he changed little and tended only to refashion his ideas with new terms and with greater assuredness. Certain of his writings were republished by other publications than those that commissioned them or to which he had first submitted them, and he was in the habit of repeating essential phrases in a variety of articles. What characterizes the writing, nonetheless, is a strong self-confidence and a confirmed belief in the acceptance of the responsibility for one's work. He assumes that he can offer a larger community insight into the medium through his own example, and while he denies being able to offer concrete advice, presumably reflecting his aversion to the establishment of rules, he repeatedly describes his working method with the clear implication that while simple, it is the true path to success in photography as he defined it. With the exception of Ansel Adams, no other photographer has given his public such insight into just how he creates his work. If we agree that the crucial tenet of expressive photography in its broadest sense is the acceptance of one's work as a public art, then Weston was truly an artist in the medium.[5]

Following his award of the Guggenheim Fellowship in 1937, the first ever made to a photographer, Weston clearly assumes a new position in the hierarchy of photographers. From that date forward he is

always identified in the media as a Guggenheim fellow. (It was an accolade no other photographer was to share until 1940, when Walker Evans received the fellowship.) The status that this award granted Weston cannot be overstated. In 1939, after completion of his Guggenheim project, he undertook the preparation of a panoramic series of five major articles for *Camera Craft* magazine, an old West Coast publication that through the 1930s was represented by an editorial policy that was still at considerable variance with Weston's aesthetic. The five unified articles, two of which were of such length they required publication in successive issues, were written with Charis Wilson, a young woman Weston had met in 1934 and whom he would marry in 1938. She was the daughter of the then-popular writer Harry Leon Wilson, author of *Ruggles of Red Gap, Merton of the Movies*, and with Booth Tarkington, the play *The Man from Home*. Though only nineteen when she first met Weston, she soon became more than his model for a series of alluring nudes begun in 1935. Important for our concerns here, she became the chronicler of Weston's ideas between 1936 and 1946, the year of their divorce.[6] Considerable speculation has been voiced as to the role Charis Wilson played in the preparation of Weston's writings during that period. Although she wrote almost all of his published works during this time and authored the report of their Guggenheim project, *California and the West*, a careful reading of the five *Camera Craft* articles reveals that the essential ideas, indeed even specific phrases, belong to Weston's earlier bibliography. The concern with the Pictorialist legacy is repeatedly represented, as is the notion of good craft and the purity of photographic seeing and previsualized control. Weston's concern for the "living quality," as he put it, continues, and he still passes himself off as something of a rebel to be serving as a model for others. For example, one can read what has happened to the concept of the photographic moment as taken from Rosenfeld's Stieglitz article of 1921. The Westons now write: "For photography is a way to capture the moment—not just any moment, but the important one, this one moment out of all time when your subject is revealed to the fullest—that moment of perfection which comes once and is not repeated."[7]

The five articles, in order of publication, are a summation of Weston's thinking on the medium: "What Is a Purist?"; "Photographing California"; "Light vs. Lighting"; "What Is Photographic Beauty?"; and "Thirty-five Years of Portraiture." Some of the more significant phrases to appear in these articles are: "My work is never intellectual. I never make a negative unless emotionally moved by my subject. And certainly

I have no interest in technique for its own sake. Technique is only a means to an end"; "I have tried to sublimate my subject matter, to reveal its significance and to reveal Life through it"; "It cannot be too strongly emphasized that *reflected light is the photograph's subject matter*"; "Photographic beauty as a term is only applicable to a finished print. But the photographer who would achieve it must remember that it is his seeing that creates his picture; exposure records it, developing and printing execute it—but its origin, in his way of seeing, determines its final value. His seeing must discover, before his technique can record"; "Our own vision is automatically selective; we see what we want to see. It is a long job for the photographer to train his eye to lens-sight, and then learn to use that undiscriminating lens-sight selectively to suit his purpose."

In a letter to this author, Wilson describes how she and Weston worked together:

> From the onset of the *Camera Craft* articles I began to accumulate notes and quotes on all likely subjects in a loose-leaf binder. The subject dividers made adding and retrieving easy, and I could see at a glance if enough material had accumulated for an article. The original notes consisted of things Edward had written and things other people had written. These were supplemented by material derived from "interviewing" Edward on specific subjects.
>
> The interviews were extended discussions on particular aspects of photography. The trick was to pry him loose from a well-worn phrase that he felt "covered everything" and, by asking all kinds of peripheral questions, encourage him to cover more ground and give more specifics. Edward was a confirmed reductionist, apt to prune and snip and condense ideas until nothing remained but a bit of branchless stalk, so it was my job to reverse the process by expanding the condensations and retrieving a sufficient number of snippings and prunings to give some shape and interest to the product.
>
> We had no fixed routine. We might discuss a possible article at the outline stage, or I might turn out a draft first. Then either of us might see changes needed or possible additions or improvements. Sometimes material needed deletion because it was sufficiently complicated to need an article of its own. We both went over final drafts carefully before sending them off.

I never tried to change Edward's views or add to them—only to express them as clearly and convincingly as possible. One thing that made it easy was that Edward was the least ambiguous man where the basics of photography were concerned. His views were as sharp and clear as his photographs, and I had heard what he had to say on most of these subjects so often that to write in his words was never a problem.[8]

In 1941 the *Encyclopaedia Britannica* published Weston's lengthy essay titled "Photographic Art." This edition of the *Britannica* was of considerable importance because it represented a major revision of past editions, and the need to update the understanding of photography was essential. It is significant that the editor, Walter Yust, decided to ask a practicing artist to write it. And once this decision was made, Weston was the obvious choice. Yust had first suggested in the late 1930s that Weston merely revise the old article authored by Frank Roy Fraprie, a Pictorialist, amateur popularizer, author of such works as *Photographic Amusements*, but the bias reflected in Fraprie's article was totally unacceptable to Weston and he refused, stating that he could only start all over again. By November 1939, the text and reproduction photographs were sent off to Chicago, and in April of the following year the proofs came back to the Westons for correction.[9] In the article, Weston draws on his own significant piece "Photography," written in 1934 for the Esto Publishing Company. He briefly describes a limited history of the medium that has as its basis the split between pure and derivative photography. He summarizes the whole of the nineteenth century as a massive search for painterly effect, and he cites only one historical figure of the period as being worthy of continued consideration, David Octavius Hill. In his review of the modern period he describes the continued dialectic between the purist and Pictorial approaches and he attributes to the Photo-Secession responsibility for the change in the medium's mainstream direction. He perceptively points out that while several of its members continued to follow the painterly tradition, they used only photographic means to achieve their effects. The source for the historical information was surely Beaumont Newhall's *History of Photography*, but the general historical treatment was shallow. The lack of such historical insight is, however, not surprising when one recalls Weston's earlier suggestion that the medium was traditionless and that the work by members of his generation was "pioneering." In summation, Weston declares that "photography must always deal with things—it cannot

record abstract ideas—but far from being restricted to copying nature, as many suppose, the photographer has ample facilities for presenting his subject matter in any manner he chooses," and he illustrates the piece with photographs by Stieglitz, Sheeler, Strand, Steichen, Adams, Weston's son Brett, and his own work—notably two portraits.

One quality of this article, and of another written in 1942 on portrait photography, is a sense that the audience is thought to be more literate about photography than before and that his concepts require a more ingenious articulation. This would suggest the influence of Charis Wilson, an accomplished writer, who certainly saw the complexity of the issues before them and understood that by this time in Weston's career the public could match allusion with allusion. Indeed, the 1943 article "Seeing Photographically" is a precise and well-reasoned statement of Weston's mature ideas, even though it derived from the *Britannica* piece of three or four years earlier.

By this time, Weston had become the most publicized American photographer of the new aesthetic. Stieglitz, and to some extent Strand, were less influential. They were representative of an older generation while Weston represented a kind of middle generation, and Ansel Adams and Walker Evans were of the new generation. By the time of his death in 1946 Stieglitz felt very much alone and neglected. On the other hand, Weston's place was assured when, in the same year as Stieglitz's death, he had his first major New York exhibition at the Museum of Modern Art.

Perhaps the most forward-looking of Weston's writings in his last years, because of their implications for his unfinished work, were his comments on color photography. Clearly he was fascinated with it, and he executed some stunning color images. Characteristic of his lifelong approach, he observed of the newly perfected technique: "Any predictions that color will supplant black and white are ridiculous; drawings, dry points, etchings, lithographs are not negated by painting. The aesthetic possibilities of color will be determined by the creative ability of the individual."[10]

The final points that are revealed in Weston's writings in the 1950s were his deepened interest in the revelation of a unique beauty through photography and the concept of personal growth. Progressively, Weston came to realize how his work had evolved and how it represented a much more detailed account of his life than any written diary he had kept. His photography ended in 1948 with his illness, and it must be noted also that the last chronological entry in the *Daybooks* is from 1934, with only a single entry ten years later. So it is that when he writes

the introduction for his *Fiftieth Anniversary Portfolio* in 1952, he begins with the brief statement: "When I was very young—say in my early forties—I defined art as 'outer expression of inner growth'. . . . I can't define art any better today, but my work has changed. Art is not something apart to be learned from books of rules; it is a living thing which depends on full participation. As we grow in life, so we grow in art, each of us in his unique way."

This sense of maturing growth and deepening insight was further evidenced in the publication of his last major essay, which was essentially the republication of the 1939 piece "What Is Photographic Beauty?" It was revised slightly in 1951 and it may contain the most enduring statement of Weston's philosophy. About the photographer and his audience, he writes: "If his seeing enables him to reveal his subject in such terms that the observer will experience a heightened awareness of it and so inevitably share in some measure the photographer's original experience—and if his technique is adequate to present his seeing—then he will be able to achieve photographic beauty." This realization that the significant and fundamental tenet of pure photography is not a technique or an instinct for the visible, but revelation through heightened awareness, is Weston's own masterful summary of his thinking. Here at the conclusion of his career, like Stieglitz with his theory of Equivalence before him, Weston calmly sets this truth before his colleagues as his legacy to challenge the next generation.

NOTES

1. Three lengthy excerpts from the *Daybooks* were published during Weston's lifetime. The first, in 1928, was published in *Creative Art*; a second was published in 1947 in the *Stieglitz Memorial Portfolio*, edited by Dorothy Norman; and a third was published in 1950 as the text for *My Camera on Point Lobos*.

2. Nathan Lyons, "Weston on Photography," *Afterimage* 3 (May/June 1975): 8–12; Peter C. Bunnell, "Weston in 1915," *Afterimage* 3 (December 1975): 16.

3. Paul Rosenfeld, "Stieglitz," *Dial* 70 (April 1921): 397–409. Reprinted in full in Beaumont Newhall, ed., *Photography: Essays and Images* (New York: Museum of Modern Art, 1980), pp. 209–18.

4. From the *Daybooks* and other manuscript material, we know that Weston was a conscientious reader who kept folders of quoted statements by various writers and artists on arts, politics, and what he termed "life."

5. See Peter C. Bunnell, "Introduction," in *Photographic Vision* (Salt Lake City: Peregrine Smith, 1980), pp. 1–7.

6. Charis Wilson, letter to Peter C. Bunnell, April 8, 1981.

7. The five articles by Weston are: "What Is a Purist?," *Camera Craft* 46 (January 1939): 3–9; "Photographing California," *Camera Craft* 46 (February 1939): 56–64, and continued in *Camera Craft* 46 (March 1939): 99–105; "Light vs. Lighting," *Camera Craft* 46 (May 1939): 197–205; "What Is Photographic Beauty?," *Camera Craft* 46 (June 1939): 247–55; and "Thirty-five Years of Portraiture," *Camera Craft* 46 (September 1939): 399–408, and continued in *Camera Craft* 46 (October 1939): 449–60.

8. Wilson, letter to Bunnell, April 25, 1981.

9. Wilson, letter to Bunnell, February 12, 1982.

10. Edward Weston, in Jacob Deschin, "The Future of Color," *Photography* 1 (Winter 1947): 35–37, 140–44.

From *Edward Weston on Photography/A Critical Anthology*
(Salt Lake City: Gibbs M. Smith, 1983).

RUTH BERNHARD

Light is my inspiration. My photographic images search for
dimensions that words cannot touch—the result of intense
responses to personal experiences. I do not wish to "record,"
but rather to touch upon the illusive meanings which I perceive
and try to comprehend in this limitless universe.

Born in Berlin in 1905, Ruth Bernhard left her studies at the Berlin
Academy of Art in 1927 to join her father, Lucian, a graphic artist and
designer, in New York. Two years later, she began her career as an
advertising and illustration photographer, working for architects, design-
ers, and artists, some of whom were friends or associates of her father.
An important early commission was photographing the objects for the
catalog of the 1934 Philip Johnson exhibition *Machine Art* at New
York's Museum of Modern Art.

During a trip to California in 1935, a chance meeting with the
photographer Edward Weston, who was unknown to her, first inspired
Bernhard to pursue photography as an expressive medium. She was
unprepared for the experience, and later described it as overwhelming:
"It was lightning in darkness. It was not visual alone. It was an experi-
ence that encompassed and engulfed my whole being. Like the music of
Bach, Weston's work was a loving, yet impersonal statement of the
acceptance of life and his relationship to and with the whole of the uni-
verse. I could hardly believe what was happening—here before me was
indisputable evidence of what I had thought impossible—an intensely
vital artist whose medium was photography."

The meeting was a turning point in Bernhard's life. In 1936 she
moved to Los Angeles, ostensibly to study with Weston, who in the
meantime had moved to Carmel. Bernhard stayed in Hollywood, where
she maintained a commercial photography business and began to under-
take personal photography as well. New opportunities for professional
work brought her back to New York in 1939, where she began her
series of photographs of seashells, the first pictures that reveal her
unique and romantic vision.

As part of the war effort, Bernhard became a farmhand in the
Women's Land Army after receiving training at the State Institute of

Ruth Bernhard, *Classic Torso*, 1952
Princeton University Art Museum; Gift of the artist

Agriculture in Farmingdale, New York. She was assigned to a large farm in Mendham, New Jersey, growing crops and caring for animals.

Bernhard returned to California in 1947, and moved to her longtime home in San Francisco in 1953. It was a heady period for photography in that city; the Westons (Edward, her mentor, and his son, Brett), Ansel Adams, Minor White, Dorothea Lange, Don Worth, Larry Colwell, Imogen Cunningham, Wynn Bullock, and several others were all working in the Bay Area and northern California. With her carefully considered still-life "portraits" of shells, leaves, and everyday found objects and especially her lyrical images of nudes, Bernhard established herself as a key figure in West Coast photography. She was one of the few photographers of the post–World War II era whose work and activity shaped the vision of the artist-photographer—an attitude about the poetics of depiction that matured in the nurturing avant-garde atmosphere of San Francisco after the war. Utilizing subtleties of light and shadow, she transformed the simplest subjects into resonant, sensual, almost fairytale-like representations.

By the late 1950s, Bernhard had begun teaching private classes in her studio and giving workshops such as Classic Figure Photography, Problems of Posing and Lighting the Figure, and The Art of Feeling. She joined the faculty of the University of California Extension, San Francisco, and by 1967 she was holding seminars and lectures titled "Seeing and Awareness," "The Creative Process and Photography," and "Seeing the Invisible," the latter sponsored by the Esalen Institute. In 1962, she curated the exhibition *From Subject to Symbol* at the San Francisco Museum of Art. She became one of the most highly acclaimed and respected teachers of photography, lecturing and conducting master classes throughout the United States, Europe, and Japan. Her work, which is represented in major collections of photography in this country and abroad, has been the subject of numerous international exhibitions throughout her career. Several publications on her work are currently in print.

Over the years, Bernhard has given many interviews, and in reading them one gains considerable insight into her beliefs and ambitions. The intensity of her commitment to the creative enterprise of making photographs always comes through, as does her honesty, directness, and intuitive brilliance. She has freely articulated the origins of her inspiration. As a teacher, she has given guidance to her students about that most difficult of endeavors, the expression of self and the disclosure of obsession. She has spoken frequently of her teaching methodology and

in so doing has revealed much about herself; indeed, revelation is an essential component of Bernhard's philosophy.

Speaking about her early work, she has remarked: "My very brief apprenticeship on a magazine did not bring me into intimate contact with creative photography. I was, however, introduced to the craft, and through a series of fortunate happenstances acquired an 8-by-10 view camera. I was completely uninhibited in my first photographic efforts. I had no notion of how a photograph should be made or should look, or that there were certain things that 'couldn't be done' or were absolutely *défendu*. I did as I pleased, and I made pictures only of things that held my personal feelings."

Bernhard's meeting with Weston most strongly changed her view about photography and its potential. "It isn't that I was interested in photographing the way Weston photographed," she has noted. "That didn't interest me at all. I enjoyed his philosophy—his attitude—the purity of his seeing. And I understood that this was really what I was trying to do, without being aware of it. That's why I continued being a photographer. . . . We shared something—photography was considered universal . . . it was not a cold, mechanical process." In another interview she recalled of Weston: "He remained an inspiration to those who met him. I still am learning from my memory of him—not to be acquisitive, for with one's vision one can possess all beauties; not to be distracted by trifles; to have faith in one's own gift and to use it with respect and love."

From the experience with Weston, Bernhard seems to have come away with an understanding that her concern should be with telling us how, rather than what, to think and feel. She has crafted a philosophy that has contributed to the building of a pathway of thought that is coherent but not absolute. For instance, she has stated: "Looking at everything as if for the first time reveals the commonplace to be utterly incredible. Each animate and inanimate part of the whole seems to exist in a tight network, interdependent and timeless. I consider a minute insect, a mountain range, and a human body of equal significance."

Over the course of various interviews and statements, Bernhard has said:

My photographic images reach dimensions words cannot touch. As the Haiku poems of Japanese literature, expressive photographs lead viewers into the amazing realm of visual poetic imagery.

Every image represents a heightened experience. The photograph is a new illusion of space and a new reality—a new event. A piece of paper, descending from a tree, descending from a seed, now covered with silver from the depth of the earth, exposed to the greatest revealer of all—LIGHT. . . . And there we have it—a photograph!

After all these years, it is still the quality, the mood, the radiance of light which motivates me to work passionately, almost like an obsession. What the human eye sees is an illusion of what is real. The black and white image transforms illusions into another reality. Whatever it might reveal is, of course, only another illusion. What actually exists, we may never know. But at least this experience brings me a little bit closer to understanding this ageless mystery.

I work very hard at organizing. When I work with a model, I am a sculptor. I work to simplify. I want to create power and simplicity. That's what's important to me. And I want to perfect the image. I don't want it to be one particular person, I want it to be all beautiful forms. I'm very instinctive about it.

My own creative work comes to me like a gift, pushing itself into my consciousness. A powerful feeling comes over me. It's hard to explain, but in a way the image creates itself—with a little help from me. It is a timeless experience, almost like being in a trance. Often I have struggled for days to get the image of the photograph to overlap the spirit I see. It is an awesome responsibility, and a lonely one.

I make only one negative when photographing a nude or still life. The moment of exposure is the culmination of rejecting all other possibilities. It often takes me many hours to make a photograph. I consider creating an image a tremendous privilege.

Critical opinion has established Bernhard as one of the foremost interpreters of the human figure. Her photographs of the female body range from sculptural renditions of the human form to abstractions that recast the body into elegant landscapes, to multiple images of women and the natural world with which Bernhard feels we are all intimately connected: "It is my aim to transform the complexities of the figure into harmonies of simplified form revealing the innate reality, the life force, the spirit, the inherent symbolism."

These pictures are not political statements, but reverential and awe-inspiring in intent and effect. What she has called "the eternal body" is the body sacred, a communication with the spiritual. For Bernhard, Eros and art are the same. In the nudes, as in all of her works, she believes that she has a relationship with objects—a holy relationship—that enables them to speak through the language of the eye as it is stimulated by her photographs. In this sense, through the *things* in her pictures, she is communicating the unseen, with the goal being to bridge the seeming emptiness between the material and the invisible. She sees the nude as not exceptional in her work or vision, but as part of the greater whole of what for her is a spiritual realm. "[The nude] represents to me the same universal innocence, timelessness and purity as do all seed pods (suggesting the mother as well as the child, the parental as well as the descendants), conceived according to nature's longing. The human body implies its reproductive function, its vitality and its continuity. . . . I have approached my work with the nude much as I create a still life—with patience and reverence. My quest, through the magic of light and shadow, is to isolate, to simplify, and to give emphasis to form with the greatest clarity. To indicate ideal proportion, to reveal sculptural mass, and the innate life force and spirit is my goal."

One can sense the most intimate glimpse of this wonderfully cheerful and exuberant woman in her comments on teaching and challenge to her students: "Fall in love. Every day. With everything. With life. If you can fall in love, you can be a photographer. I think that is absolutely essential.

"I encourage [students] to discover what is important to them. And that is what should be expressed in their photographs. I consider myself not as a teacher, but rather as a gardener—cultivating, nourishing the soil, providing the best climate for growth. I try to make students aware that they have something very precious and individual to cultivate."

Bernhard has remarked that her goal in photography has always been to express her reverence for the universal order. "As I see it, life and death are two words for the same thing; all components of the living order. To be a creative person is a significant privilege as well as a great responsibility."

From *Ruth Bernhard: Photographs*, exhibition brochure, The Art Museum, Princeton University, Princeton, New Jersey, 1996.

BARBARA MORGAN

So highly does Barbara Morgan regard the ineffable, so profound has been her commitment to the dance, an expressive form that she describes as "the life force in action," and so sure is her sense of the intuitive, it is curious that she has found so complete a life in photography. For this medium, which generally is esteemed for its actuality, would seem not appropriate for her at all. But it is through the work of such an artist as Morgan that we may gain the understanding that above all else photography is a medium of interpretative expression and not of depiction, that photographs may be seen to represent imagination limited only by truth, and material facts raised to the power of revelation. To see Morgan's photographs is to experience the work of a versatile artist whose creative life spans five decades. Her photographs display an energy of both physical and psychic dimensions that clearly echoes every aspect of her spirit and insight. The richness and physical scale of her photographs compel us to delve into their every recess and to become participants in their vitality. For Barbara Morgan, it is the gesture of largesse that speaks.

The subjects and techniques used in her work are varied: nature, man-made objects, people, dance, light drawings, and photomontage. The dance photographs, begun in 1935 with Martha Graham and her company, are justifiably celebrated. They were made with a deep understanding of the cross-cultural sources and the dramatic or ritual schema of the dances and of kinetics, and with an assuredness in the technical complexities of the photographic medium. Working along with her subjects, not in performance but in studios, and fundamentally out of her own creative needs, Morgan recorded not so much the literal dance as the essential gestural aspect of life that the dance symbolized. Each dance was reconceived for the camera and its actions were condensed to those movements that are the most eloquent, the most complete. The connective movements of the overall rhythmic structure were omitted and the thematic movements, those that contain the essence of the dance, isolated, generally at the point of their climactic clarity.

It is interesting that these images should be referred to as *still* photographs. They are, of course, not "cinematic" in the usual sense of the

Barbara Morgan, *Martha Graham, "Extasis" (Torso)*, 1935
Princeton University Art Museum; Gift of Douglas and Liliane Morgan

term, and Barbara Morgan has made no attempt to structure her work in a linear space. The photographs, each of which is expressive of an aspect of a particular dance, primarily reflect the beauty of themselves as pictures. But these images are expressions of states of being relative to time, and while she respects the work of the dancers and choreographers, Morgan's aim has been to evoke the content of the dance without calling on the totality of the dance action. T. S. Eliot wrote that "at the still point, there the dance is," and it is clear that he understood more than most the nature of the concept referred to, especially in photography, as the *decisive moment*.

Barbara Morgan understands this concept very well. Writing in 1940, she observed that "previsualization is the first essential of dance photography. The ecstatic gesture happens swiftly and is gone. Unless the photographer previsions, in order to fuse dance action, light and space expression simultaneously, there can be no significant dance picture."[1] Such an approach requires previous knowledge not only of the dance content, or story, but of what is photogenic; that is, what can be imparted through a picture that will result in its having an existence beyond that of being the record of an event. She has written elsewhere:

When I am full of the subject, picture ideas and treatment spring to mind spontaneously and are not concocted. The power of an image to appear full-blown in my mind is proof of its vitality, and those that persist, I work on. Sometimes I will carry a picture idea in my mind for days and months, but when the moment comes, I like to shoot at a high pitch and develop as quickly as possible, to analyze errors or success while it is fresh. Of course, every step in the making cycle is integral, but I feel that the gestation in the beginning is 90% of the picture. . . .

In this *unforced* meditation, I empty my mind and allow the memorable gestures which inspired the idea to replay themselves: then, while holding these forms clear, I envision trials of lighting, spacing, framing, as a rehearsal—until it clicks. This is especially necessary for such shooting as dance action, for there is not time for trials when the dancers must be kept invigorated by confident direction, together with camera and lighting control. Sometimes in actual shooting the imagined approach is found unworkable and given up for a quite different setup. Nevertheless, this imaginary rehearsal attunes one to essentials.[2]

Morgan often refers to the "rhythmic vitality" of her work. By this she means the translation of literal interpretation such as light and dark, love and hate, natural and man-made, all polarities of sorts, into a kind of visual dynamic. The body of her work must be viewed with this sense of parallels and perpendiculars; of children happy and sad, of a tree's delicacy and strength, of man's ruins and nature's fossils. In one sense, no single picture by her can express the complexity of her thought, for the whole of her work, the design of her books and exhibitions, the sense of her total involvement, is one of a reciprocity between the themes and forms of one image and those of another.

The essential readability of Morgan's photographs is very straightforward. I do not mean this in any pejorative sense, but rather as a way to characterize her approach to the expression of content. The Morgan photograph of an ecstatic, leaping man is exactly that, and a rusting automobile engulfed in a bed of weeds has to do with exactly what is shown—power, decay, growth, man, and nature. Likewise, the luminous swirl of a light drawing may be seen to be the freehand equivalent in pure electric energy of Martha Graham's bodily swirl, which by its schema symbolizes the transcendence of the heroine's personal tragedy in the dance *Letter to the World*. Similarly, Morgan's titles for photographs, such as *Pure Energy and Neurotic Man*, *Fossil in Formation*, *Saeta*, and for one of the images described above, *Resurrection in the Junkyard*, indicate both the literalness of her thought and the purposefulness of her intent.

Nowhere in her work can this sense of the literary be seen as clearly as in the book *Summer's Children*, which in every respect was created by the artist. This book, prepared in the late 1940s and "conceived as an affirmation of the art and science of human relationships," is deceptively simple. At first viewing it appears to be about what children do at camp, but with reflection it may be seen that these are photographs of experiences, not of events. It could not be otherwise, because the author was not so much interested in what the children did, but in what effects each of their actions had. In other words, she was attempting to show the evolving, quiet, yet profoundly moving and sometimes difficult process of human growth. Rather than describe these photographs as universal, it seems to me that they should be regarded as fundamental. In this way, the psychological appreciation of life will be grasped through the evocation of parallel memories in everyone and the burden of interpretation will reside properly with the viewer. It is a

mistake to assume that a universally recognizable photograph means the same thing to all.

As opposed to "straight" photography, in which the literal continuum of observation and reaction is maintained, it is the photomontage that Morgan sees as more nearly approximating imagination itself. The multiple-image system of montage allows her to combine discontinuous thoughts, observations, and ideas into a visual metaphor and also to spontaneously create designs and patterns that relate to her continued interest in painting and graphics. Writing about this form, she has said: "As the lifestyle of the Space Age grows more interdisciplinary, it will be harder for the 'one-track' mind to survive, and photomontage will be increasingly necessary. I see simultaneous-intake, multiple-awareness and synthesized-comprehension as inevitable, long before the year 2000 A.D. It is a powerful means of creating relevant pictures. I feel that photomontage with its endless technological and esthetic possibilities can be not only an inspiring medium for the meditative artist, but that it will increasingly serve the general public as a coordinating visual language."[3]

Morgan is not widely known for her work in photomontage, and while she continues to use it today, her work from 1935 represents an exceptionally early articulation of this technique by an American. In general, her pictures reflect an urban lifestyle that lends itself to this fractured, layered structuring—strata of people, places, moods, and meanings. As designs, her earliest compositions are not unlike aerial photographs, or drawings for the Constructivist sculpture or architecture that emerged in the 1920s. The old solid order of things—once felt in the weight of objects—is now fragmented into components, and these are rearranged into shifting patterns in continuous movement through space.

Morgan's work in photomontage and dance is perhaps her most important photographically because it marked a change in the fabric of prewar American photography. It bridged the abstract and synthetic work developed in Germany and elsewhere in the 1920s and the rigorous straightforward disciplines generally admired in this country and practiced by two of Morgan's close friends, Edward Weston and Charles Sheeler. It was also a connective between the natural, pictorial environment, which for her colleagues and predecessors was the landscape, and her interest in the human world and urban architectonics. She has always viewed nature socially, as a macrocosm of details in which an

intimate world of human experience and values may be found. In the end it is the question of human potential to which she has addressed herself throughout her work. Whether it be in the poetic aspiration to symbolize man's spirit or in the challenge to manipulate the physical craft of her medium, Barbara Morgan has exemplified, as only few others have, the true liberality of personal freedom.

NOTES

1. Barbara Morgan, "Photographing the Dance," in *Graphic Graflex Photography* (Hastings-on-Hudson, NY: Morgan and Morgan, 1971), p. 217.

2. Barbara Morgan, "Kinetic Design in Photography," *Aperture* 1, no. 4 (1953): 23.

3. Barbara Morgan, "My Creative Experience with Photomontage," *Image* 14 (December 1971): 20.

From *Barbara Morgan* (Hastings-on-Hudson, NY: Morgan and Morgan, 1972).

AARON SISKIND:
THE BOND AND THE FREE

When he died in 1991, Aaron Siskind was considered one of the most important photographic artists active in the last half of the twentieth century. Living during this period in New York, Chicago, and finally Providence, he produced a singular body of images that assures his place in the history of the medium. His was a pictorial achievement that helped shape a distinctly late-modernist American photographic style; one that is characterized by a rigorous adherence to the essential qualities of the medium and by the making of a poetic image that is the subject re-presented as metaphor, in a specific abstract form, in order to express the inner self—the subconscious common to all men and women.

Siskind first took up photography in 1930, when he was twenty-six years old and an English teacher in the New York City school system. His early recognition was as a documentary photographer; that is, as a photographer who concentrates his or her attention on the observable realities of the world, usually in a social context. He was active in a leftist organization known as the Photo League, and it was there that he had his first significant exhibitions of photographs made on such occasions as May Day and in the tenements or on the streets of Harlem and the Bowery. He also photographed architecture in Bucks County, Pennsylvania, and on Martha's Vineyard, where he regularly summered throughout his life. Cautiously, in 1940, he began to eschew this sort of work in order to concentrate on a kind of symbolic fragmentism characterized by a simplification of subject, and a decontextualization, frequently achieved by photographing the object close-up. All this was coupled with a rejection of the social documentary subject matter in favor of found objects from nature and the detritus of ordinary human life. His new images did not so much render something as reveal an essence that reflected the emotional absorption of the photographer. His work took on a sophistication and character unknown to the photography of the period, and it was not readily accepted by his realist colleagues, most notably those caught up in the political idealism of the Photo League. Not recognizing that his realist apprenticeship was the

Aaron Siskind, *Gloucester 25*, 1944
Princeton University Art Museum; Gift of Robert Menschel

key to his new way of working, these critics, who were sometimes friends, took his work to be a denial of even more than a style of photography; it was a shirking of public responsibility in an era of grave social realities. This would also be the case with the critics who attacked the Abstract Expressionist artists who emerged from 1930s Social Realism and who would soon become Siskind's friends and artistic colleagues.

Siskind himself had recognized what he felt to be a failure in his earlier work, and in 1947 he admitted: "I found that I wasn't saying anything special. The meaning was not in the pictures but in the subject. There was no new reality. I began to feel that reality in something that exists in our own minds and feelings." Siskind was revealing his new-found understanding that with the documentary photographer there was a misplaced or misunderstood sense of what the pictorial image was about. No image can replace the subject, it can only be a fictive re-presentation with the goal of arresting attention; in the case of documentary photography, this was the desire to correct or remedy perceived social ills. For Siskind, the outgrowth of this idea was the creation of a work of photographic art that transcended its literalism and entered the realm of meaning and physical presence as a pictorial object that had a life and an existence of its own. In short, Siskind had moved from reportage to a different sort of evaluative expression. Now it was one based in forms in relationship within a strict, flat rectangular space. The new sense of resolution was no longer to seek a tangible change, as was the goal of political reform; it was, rather, an aesthetic rearrangement of conflicting forces into, or toward, a state of humane order and understanding. The frame stops being a window into the world and becomes the privileged aesthetic and conceptual locus.

Siskind's photography may be divided into three periods, the first representing his sociopolitical phase that dates from the 1930s to 1943 or '44; the second is that of his integration with the Abstract Expressionist school and his adoption of its distinctive aesthetics between 1945 and 1963; the last is a most complicated period characterized by various new directions that continued until the end of his life. His friend Franz Kline died in 1962, and the following year Siskind made his first trip abroad, to Rome, where he sought to taunt history. In one of his many applications to the Guggenheim Foundation he wrote about the succession of cultures that have existed and still exist in Rome. He seemed to be speaking in a way that revealed his need not for nostalgia, but for a change of environment, as well as his own desire to confirm his place

in history, to add to the continuity of pictorial culture. By 1963, many of the driving forces behind image making in the 1940s and '50s had been punctured by new social problems. Siskind at sixty knew that his beliefs had been affirmed by his public, but he was determined to move ahead nonetheless. One suspects that by going to Europe he was seeking picture possibilities that he might not fully understand even after a lengthy career. He said about the time he left the country: "The pictures that I can figure out . . . I lose interest in as pictures. If they are compelling in some way so that you really want to know what they mean—because they deserve knowing—and you can't find out, that really keeps you interested in them." And he might have added, this keeps one interested in him.

This exhibition at Glenn Horowitz Bookseller concentrates on photographs of the second period of his career; those made while he was closely affiliated with the abstract painters in New York who were simultaneously seeking to redefine what their medium could be and how they could represent the deepest feelings that a new age had inflected upon them. These photographs date from 1943, with one of his earliest representations of a shred of seaweed curled on the sand, through to the sometimes fierce configurations of the 1950s and the very early 1960s. In making such curatorial selections, the goal has not been to reveal the epitome of Siskind's achievement or any ultimate identity, but to survey the period of his most audacious achievement.

Siskind has always been spoken of in the context of Abstract Expressionist artists, and in a somewhat negative way by the photographic community. It was never anything that Siskind concealed; indeed, in interview after interview he relished talking about the associations he had with Adolph Gottlieb, Barnett Newman, Mark Rothko, Robert Motherwell, Willem de Kooning, and Franz Kline, his familiarity with their work, and the pleasure they all took in one another's company. What should be seen here is the fortuitous and incredible coming-together of artists with a mutual concern for the meaning of their lives and a passion for their creative endeavors. In true modernist terms, the artists respected and appreciated their media, none more so than Siskind. It is to his great credit that he took on the challenge of rethinking a goal for photography in which its essential quality, its literalism, could be pushed the furthest but never be lost in what would always be a fundamentally recognizable subject. To most observers at this time, abstraction in photography meant breaking this attachment with the photo-optical construct of the image, and in so doing aligning

photography with the abstracting treatments of other media; all of this was reminiscent of early Pictorialist aims at the turn of the century. The accepted techniques for much of this were still operative, having come out of the late 1920s and '30s in work by László Moholy-Nagy, Man Ray, Gyorgy Kepes, Francis Bruguière, Carlotta Corpron, and a host of other Europeans and a few Americans. In the late 1940s, Minor White, just slightly younger than Siskind, would also explore the terrain that Siskind had set out a few years before; the fundamental notion behind each of their works came from a similar source: the insistence on the part of contemporary artists that it was the objecthood of the work that mattered and that the emotive, evocative power of paint on a surface was understood to convey inner meaning and not be the vehicle of simple depiction. The converse, insofar as photography was concerned, was to apply different means to the same end, by insisting on the unique aspects of the camera that allow it to represent the real in pictorial form and re-present it to create a visual mythology of near primitive power.

Siskind was part of this community of artists in New York. He had been living in Greenwich Village since 1940, and by 1946 he was a regular at the gathering places of the vanguard artists. This was the Village community that Anatole Broyard, in his memoir *Kafka Was the Rage*, described as having "a sense of coming back to life, a terrific energy and curiosity, even a feeling of destiny arising out of the war that had just ended. . . . The Village was charming, shabby, intimate, accessible, almost like a street fair. We lived in the bars and on the benches of Washington Square. We shared the adventure of trying to be, starting to be, writers or painters." It is interesting that Broyard leaves out photographers, and indeed Siskind was much the loner among this community. More or less rejected by his older photographic colleagues, and immersed in the ideas behind the painters' medium, he explored a territory that few are privileged to experience. It was more than being at the right place at the right time; Siskind was there because he had to be. Similarly, Minor White, on the faculty of the California School of Fine Art in San Francisco, was there because he, too, was drawn to the center of creativity. Photographers like Siskind and White felt the intense bond that all artists of like aspiration can share, and regardless of medium, they were free to go as far as their soaring talent enabled them.

Siskind's work was recognized immediately by the artists' community that he frequented. His closest personal friend among the painters was probably Kline, whose somewhat sudden appearance in 1950 with a new palette of black and white and a new take on the gestural tech-

nique has been sometimes stylistically linked to Siskind. There was, no doubt, mutual influence between the two men, but if one studies carefully the character of Siskind's work as it unfolded in the last years of the 1940s, it is the presence of an artist like de Kooning that one senses more than Kline. An interesting footnote to this observation: it was well known that de Kooning kept a print Siskind had given him—*New York, 1950*—in his studio while the painter was working on his series of monumental "Women," and he is reported to have told the photographer: "I learned a lot from it, Aaron."

Siskind's work in this new context was first exhibited at the Egan Gallery on New York's East Fifty-seventh Street in 1947. Charles Egan's exhibition space was one of the very few places in these years where one could see the new works by many of these artists. Siskind, the only photographer to be shown, had five shows there between 1947 and 1954. De Kooning showed there as well, and his now famous black paintings were exhibited in the spring of 1948; these were immediately followed by Siskind's second show of photographs. Elaine de Kooning, in her text piece for Siskind's fourth show at Egan in 1951, wrote: "Aaron Siskind might be called a painters' photographer in that a large part of his public is composed of artists, but also because his work is much more directly related to the contemporary styles of painting than to those of photography." She continued: "But although mood, imagery, tonalities and techniques vary from year to year and, in one show, from picture to picture, there is everywhere present a severe clarity of style through which the 'objects' that Siskind's lens creates are always more poignantly recognizable as his." The photography community's acceptance of Siskind's achievement was less forthcoming, with the notable exception of Edward Steichen at the Museum of Modern Art. Steichen showed Siskind's work first in 1946, again in his seminal exhibition *Abstraction in Photography* in 1951, and several times thereafter, including a more complete representation of nineteen pictures in *Diogenes with a Camera II* in 1952. More importantly, Steichen acquired prints for the Museum of Modern Art's collection—something that other museums took much longer to accomplish.

It was in 1959 that Siskind's work was most fully explicated, with the publication of a book of oversize reproductions accompanied by a text by the respected critic Harold Rosenberg. This confluence of photographic artist and well-placed critic, in effect, leaped over the photographic community and gave Siskind an identity that was unique among his peers. Not all photographers, however, were put off by Siskind's

achievement. Minor White hailed the 1959 book in a lengthy review in his publication *Aperture*, but took Rosenberg to task for his misleading interpretive writing, which, White felt, merely perpetrated "the miasma of misconceptions which seem to rise up like steam around art critics whenever they are confronted with photographs." Rosenberg's text is far off the point; the first insightful examination of Siskind's work would not be seen until Thomas Hess's 1963 critique.

The most important aspect of the 1959 book is that it serves as a kind of summation for Siskind's work to that date. He had been prolific, mounting five exhibitions at Egan, in some of them showing, it is believed, between forty and sixty-five works. Unfortunately, basic documentation of the pictures in these shows has been lost (with the exception of that for 1954), and so the book serves as our entry into how Siskind thought of his work in 1959 and the most significant images he had created by that time.

A special feature of this exhibition is a collection of eight Siskind photographs retained by Rosenberg, and later acquired, along with the critic's papers, by Glenn Horowitz Bookseller. Perhaps the most impressive of these images is *Chicago 224, 1953*, and it might serve to illustrate at least one of Rosenberg's observations about Siskind's work. He wrote: "Like the best of his painter contemporaries, [Siskind] has simplified his means in order to concentrate on the art of choice." Fifteen of the fifty reproduced images in the 1959 book—those singled out by Siskind at the closure of this second period of his work—are represented in this exhibition.

Two images have particular visual richness as well as their historical significance. Printed in the *New York Times* to accompany Jacob Deschin's review of Siskind's first Egan Gallery exhibition, the photograph of wrought-iron metal comes from a series of such images made in lower Manhattan about 1947. Deschin described Siskind's pictures in that exhibition as an "excursion into the realm of creative photography," and he continued: "The visitor to the gallery who attempts to find literal meanings in the photographs will be missing the point. The purpose of the photographer was not to represent objects as such but to convey impressions, make records of a responsive photographer's visual musings." Deschin certainly did not express it well, but he caught an essential quality of all expressionist art going on around him: the deep belief in the stream of consciousness as it applied to discovery, rendering, and interpretation. Less recognized at the time was another quality of Siskind's work: the photograph's projection of its objecthood; its

absolute physicality as a thing, not merely a surface illusion. Flush-mounted and trimmed to the exact edge of the pictorial field, the picture sits literally atop the muted white-painted wooden board on which it is mounted. Nothing comes between us and the work. The mounted ensemble is reminiscent of Alfred Stieglitz's mounting of his "Equivalents" beginning in the 1920s. Siskind forces the viewer to recognize the photographic object through his treatment of the surface on which the picture is mounted, and thus on how it is separated from the wall on which it hangs. It is no longer a pictorially illusionistic vision, a rendering of "what is out there." Elaine de Kooning recognized this when she quoted Siskind himself saying: "When I make a photograph I want it to be an altogether new object, complete and self-contained." Well into the 1950s, Siskind usually showed his photographs flush-mounted on trimmed Masonite panels; this included the work shown in his 1952 Museum of Modern Art exhibition. Only later did he turn to the more traditional form of mounting photographs on heavy drawing board or paper matting material.

As for the image of wrought iron itself, it reveals fully Siskind's exploration into the unique figure-ground relationship that can be achieved in photography. The decorative metal compresses with the black, opaque depth and becomes not an object in space, but shapes flattened and cryptographic. Their symbolic significance is enhanced by the rhythm of the spiral and the constricting vertical and horizontal forms. Not unlike the biomorphic abstract works by a painter such as Gottlieb, whose work was well known to Siskind, the picture takes on its meaning not in the simple identification of the subject, but in the relationships of shapes both negative and positive, projecting and recessional, that work as the mechanism in the picture. Siskind made sure the vertical and horizontal pieces of wrought iron would be parallel and perpendicular to the edges of the picture. This sort of placement of the forms to point out the frame edges of the photograph is yet another demonstration of Siskind's insistence that his subjects be rendered in fully formalist terms.

The mistake made by many of Siskind's critics, including the early ones, was the contention that to be creative in photography was to abandon meaning (which, as Siskind had pointed out so often, seemed to most observers to reside only in the subject photographed) in favor of formalist articulation. We have already indicated what some of his techniques were that were so disparagingly labeled "abstract" or "creative." Siskind's work was far more difficult. You had to look deeply

into the picture and at the picture itself—to read it, if you will, not identify it. You do not look at a photograph to see if the photographer achieves an expected emotion; you look to see what he does, and his variety in animation exhilarates; you are interested without knowing how to label the emotion. And so you are not tempted to excuse your pleasure. Perhaps one of the most telling observations that Siskind made about his work was in an interview in 1963: "Conversation," he said, was a "theme which keeps recurring in my work. . . . Sometimes when you feel you have a picture right, after you examine it or after you make it, you find that there is a terrific amount of internal stuff that supports the original feeling you had. Everything supports it." So much of this understanding comes not only from his knowledge of photography, but from the goals expressed by his colleagues; indeed, from the terms of all modernist art. He concluded: "Disintegration interests me very much . . . not only disintegration, but integration as well." In the mid-1960s, in a presentation titled "Problems of Photography as an Art," Siskind showed the work of several young photographers, many of whom were indebted to his example and teaching. He said: "All of these pictures are saying something about the world, breaking down our normal reactions, normal sight, normal relationships. This is very important for someone in society to do."

The photograph *Gloucester 2*, 1949, is a stunning example of Siskind's work at the conclusion of the decade. Robust, with a sensuous, liquid aura, it is a picture by an exceptionally self-confident artist. The photograph is also important in context. In 1949 several artists, desiring to find a meeting place, rented a loft on East Eighth Street. The plan, for what became known as The Club, was both social and professional. Siskind was a frequent visitor, though it seems that he did not significantly participate in discussions or presentations. In the spring of 1951, after two years of keeping a rather low profile, a group of the artists decided to hold an exhibition of their work in a rented space nearby. Each artist submitted one work and Siskind was asked to contribute. *The Ninth Street Show*, as it was called, included Siskind's *Gloucester 2*, a fact generally omitted from the subsequent scholarly literature about the movement as well as on The Club. The picture reveals the strong impact on Siskind of painterly iconography in the years 1948 and 1949. There is no mistaking the material photographed, but the subtle harmonies and seeming innocence of the drips suggest a wish to express the mysterious ponderings on an elegiac life. The depiction has all the qualities of many of his similar wall pictures

around this date: complete decontextualization, a flattening of the picture plane, and the intricate subtleties of tonal rendering that inspire a restless moodiness.

Siskind was a worldly seeker of physical evidence, and in this task there is a necessity to assemble and evaluate. Pictures such as *Gloucester 2* demonstrate the degree to which Siskind wishes us to judge them through his selection and isolation of such evidence. There is no opportunity for us to change his choices. He has articulated and worked the framing, defined the edge-to-edge expanse of black that grabs onto the surface of the print, and in the printing revealed his joy in handling the photographic material. That Siskind was a master printer with impeccable technique is evinced in the nuanced qualities he brought to each image. The degree of darkness or light, of contrast, of bringing the forms forward or setting them more deeply—all of these aspects of subtle manipulation were the stuff of Siskind's choreographer-like repertoire. And for all their formal exuberance, these pictures never blur the mystery of the subtext that Siskind injects into the surface merriment. Interestingly, though Siskind selected this piece to show with his artist colleagues in 1951, it was not included in the 1959 book. Why? What had changed by then?

In the fall of 1951 Siskind accepted an offer from the photographer and teacher Harry Callahan to join him at the Institute of Design in Chicago. Siskind was to try it for a year and then decide about his future there. He knew he could not move the Village to Chicago, but at the same time his relationships with and among the artists in New York were in a state of flux and, as noted, the values that drove those artists in the 1940s were already beginning to change as the 1950s got under way. Then too, of course, there was the prospect of economic security. Siskind explored his new "studio," the streets and alleys of Chicago, and found that the city was demanding, if not outright exciting. He found extraordinary examples of graffiti, what Elaine de Kooning had described in his earlier work as "the hand-writing of creation," and what Minor White would later describe as "the hieroglyphics of accident and chance." Siskind invited his New York friends and colleagues to visit, returning to check on the doings in New York when he could. He ultimately stayed in residence in Chicago until his forced retirement in 1971, when he rejoined Callahan, who had exited to the Rhode Island School of Design in Providence ten years earlier. Through the succeeding decades, with every passing year, Siskind's world expanded—in both the unpredictable dynamic of what photography could do, as well

as in the locales where he worked: Hawaii, Mexico, Peru, Brazil, Greece, and Italy, and always his central retreat, Martha's Vineyard. One could not be less than totally aware of the ease with which, in his late maturity, he projected his inner feelings and extended his own consciousness through his images. His achievement seemed effortless.

In 1978, for Siskind's seventy-fifth birthday, I wrote: "The maximum articulation of pure form became for him the means of rendering to the public an active and participatory vehicle for the consideration of values. In this sense, he was involved in the joint realization among his generation of artists that a greater authenticity should be given to images than to reportage. In this way he could focus attention—his and ours—on the issues of picture making as symbolic of the choices and responsibilities in daily life. His work succeeds, in my view, not through any novelty but through the purity, order and pertinence of the values thus signaled and the degree of human satisfaction he stimulates." The photographs in this exhibition date from the first years of Siskind's endeavor, and many of them—perhaps even more now than at the time they were made—hold one spellbound by the surprise of his absolute freedom.

From *Aaron Siskind: Photographs, 1944–1963*, exhibition catalog, Glenn Horowitz Bookseller, East Hampton, New York, 1997.

MINOR WHITE'S PHOTOGRAPHIC SEQUENCE "RURAL CATHEDRALS": A READING

Minor White was one of the most important photographic artists active during the thirty years after World War II. Born in Minneapolis in 1908, he began his career in Portland, Oregon, in 1937, and he continued it in San Francisco following an interruption for military service. In addition to being an artist of recognized ability, he was also an influential teacher and writer. His photographs, together with work by such other figures as Alfred Stieglitz, Edward Weston, Paul Strand, and Ansel Adams, helped to shape a twentieth-century American photographic style that is characterized by luminous clarity, lyricism, and grace. In 1953, White moved to Rochester, New York, where he taught at the Rochester Institute of Technology. In 1965, he accepted a professorship at the Massachusetts Institute of Technology, where he remained until his death in 1976.[1]

One of the unique features of White's work was his preference for the grouping of photographs in a form called the sequence. This interest was an initial outgrowth of his early experience in writing poetry, but in the realm of photographic art his most important inspiration was the sequences by Alfred Stieglitz begun in the 1920s. Stieglitz taught that not all photographs need function as individual or summational works, but that certain images in a defined context could serve in support of others, and could create a total statement more complex than single works alone.

White's sequences, highly structured groupings of pictures with similar formats, sometimes contain ten, twenty, or thirty photographs. They are to be studied in a state of concentration and involve recognition of both the content and the feeling—the intellectual and emotional aspects—of each image in relation to its adjacent images. However, one must read the images as an ensemble, in their cumulative assertion of an interconnected idea, to sense the import of the artist's statement. Reading White's sequences depends on understanding both the symbolic and the descriptive capabilities of his photography.[2]

In 1950, referring to the sequence as "a cinema of stills," White wrote: "The time between photographs is filled by the beholder, first of

Minor White, from "Sequence 10/Rural Cathedrals,"
Barn & Gate, 1955
Princeton University Art Museum; Minor White Archive

all from himself, then from what he can read in the implications of design, the suggestions springing from treatment, and any symbolism that might grow from within the work itself. . . . The meaning appears in the mood they [the symbols] raise in the beholder; and the flow of the sequence eddies in the river of his associations as he passes from picture to picture."[3]

In all, between 1946 and 1974, White created or planned some one hundred groups of photographs, including series, sequences with multiple versions, and portfolios. This paper is an investigation of one work. It is titled "Sequence 10/Rural Cathedrals," and it was completed in December of 1955.[4] The photographs, unaccompanied by any text, had been made in the vicinity of Naples and Dansville, New York, two communities south of Rochester, earlier the same year.

This sequence is interesting not only for its beauty and its eloquent meaning, but also for what it informs us about Minor White at a critical juncture in his life. The period in which these photographs were made came two years after his reluctant move to Rochester. Upstate

Minor White, from "Sequence 10/Rural Cathedrals,"
Black Sun, 1955
Princeton University Art Museum; Minor White Archive

New York represented a greatly different creative and photographic problem from that of the California coast with which he had been familiar. The landscape presented a serious challenge to White, whose earlier work had evolved out of a tradition that was nurtured in dramatic and formal natural beauty. New York was, by contrast, the kind of territory that had been treated photographically with an entirely different set of values. Epitomized by Paul Strand's photographs in his 1950 book *Time in New England,* the eastern American tradition had not really affected the western photographers such as White or Ansel Adams. But, now near New England himself, White could not help being influenced by Strand's work. Indeed, White wrote in his journal "Memorable Fancies" that the experience of inevitably visualizing Strand's pictures in the New York landscape was "just like seeing [Edward] Westons all over [Point] Lobos."[5]

 The problem for White, then, was how to deal with his new subject matter. He fought against both himself and his new location for some time. He wrote: "This land is comfortable, cultivated, cramped,

Minor White, from "Sequence 10/Rural Cathedrals,"
Large Barn, 1955
Princeton University Art Museum; Minor White Archive

and inhabited . . . rich farmland that goes soft and pretty and spiritually flat."[6] But eventually, he came to the realization that if he was to continue making photographs, he would have to deal with the landscape before him. Not an easy thing for him to accept—"I resent it," he wrote—and he began to incorporate the use of infrared film into his way of seeing.[7] An obvious technical device to increase tonal contrast, and hence the drama of a scene, White's use of infrared can be seen as an attempt to create dynamism within a landscape that is not inherently so. But to accept this altered technique as the photographer's total solution to a difficult problem would be simplistic. White's attitudes were certainly undergoing a change during his assimilation into his new environment. Likening his first New York photographs to his early work in Portland, White concluded that barns held his interest because they were "all the region offered."[8] Over time, White's anti–New York sensibilities softened. As he continued in this entry in his journal for March 20, 1955: "But photographing those that excite me seems to be resulting in an occasional image that moves me and seems to move a few others.

Minor White, from "Sequence 10/Rural Cathedrals,"
Barn & Clouds, 1955
Princeton University Art Museum; Minor White Archive

Looking at them I get a glance at how Strand is working now. The same subject matter over and over again, but with a deeper penetration each time. If this is the way to communicate the peaks of my inner growth, then I know the approach."[9]

The terrain that White settled upon with his move east was one dotted with farmhouses and barns. It was in these latter majestic buildings that White found the vehicle he needed to make his new photographic statements. He found something magical, or mystical, in these structures that excited his sensibilities; the very title of the sequence, "Rural Cathedrals," conjures up images of monumentality and awe generally reserved for places of worship. Perhaps White was impressed by the barns' venerable age, or the optimism inherent in their vast size, or their stature in glorifying a native American architecture that was both functional and elegant. Whatever it was, they seemed to have elicited much the same response in White as did his earlier sites in California. He wrote: "[Point] Lobos was a place where IT took over now and then, [and] the New York barns [were] another example."[10] The indefinable

Minor White, from "Sequence 10/Rural Cathedrals,"
Graveyard & Barn, 1955
Princeton University Art Museum; Minor White Archive

"IT" is the mystical notion that an outside force was guiding White to photograph. Aesthetic mysticism played a central role in White's mature photography.

As with most all his sequences, meaning here is not obvious. White tends to endow his works with several different planes of meaning. They can, however, be generally interpreted to have three main levels: the superficial, the underlying, and the ultimate.

The superficial meaning of "Rural Cathedrals" is the most obvious one: the sequence is a simple, documentary essay on New York farms. Indeed, four images from the sequence were published as just that in an article titled "Barns for a Harvest Past," in the October 1959 issue of *Architectural Forum*.

The second level of meaning, the underlying one, is somewhat more difficult to discern, but the title suggests it. Rural cathedrals are monuments related to religious experience. Like their urban counterparts, these structures display a richness of existence that demands to be noted. They are relics of a time that serve as noble, and perhaps

Minor White, from "Sequence 10/Rural Cathedrals,"
Toolshed in Cemetery, 1955
Princeton University Art Museum; Minor White Archive

melancholy, reminders. It would be fair to say that these barns, so decep-
tively simple—deceptive in that their simplicity overshadows their ele-
gance and functionality—are treated by White in a fashion that tends
to dramatize. But in his mind this is certainly a fair dramatization, for he
is not aggrandizing something that is banal, but rather bringing atten-
tion through his treatment to something perhaps underestimated.

The ultimate meaning of "Rural Cathedrals" is still more difficult
to pinpoint. Functioning as a metaphor, the sequence can in no way
be fully comprehended without knowing something about mysticism
and White's involvement with it. Ever since arriving in Rochester, he
had increasingly directed his energies inward. He became more self-
searching and began, in 1954, reading books on comparative religion,
including Evelyn Underhill's *Mysticism*, Eugen Herrigel's *Zen in the Art
of Archery*, and Aldous Huxley's *Doors of Perception*. He was very
interested in the Mystic Way; that is, in the psychological process by
which it is understood that a person can establish a relationship with
the Absolute, reach a union with the divine or sacred. It is of this process

Minor White, from "Sequence 10/Rural Cathedrals,"
Potato Cellar, 1955
Princeton University Art Museum; Minor White Archive

that "Rural Cathedrals" functions as a kind of metaphor. White wrote in February of 1956: "Mounting mysticism that was growing all fall is still ascending. Sequence 10 was part of it. That sequence . . . was not processed till about the first of December. Then it dawned on me what had happened. There was no consciousness at the time that a new sequence was in the making. Never has a sequence been made with so little awareness. Only one place—the long shadow of the cross—stood revealed to me at the time I made it. The sequence has the symbols of the Mystic Way, including the black sun."[11]

In a letter to a close friend who had been instrumental in White's conversion to Roman Catholicism early in 1943, he expanded on what was happening to him and on his artistic goals:

The past three months recall the months [during the war] when I joined the Church. It all makes much greater sense now. Then it seemed a kind of substitute for creative activity on an art level, now the two kinds of activity are felt to be the same thing.

Minor White, from "Sequence 10/Rural Cathedrals,"
Small Cloud over Barn, 1955
Princeton University Art Museum; Minor White Archive

A mounting mystical activity started last fall. Evelyn
Underhill's book gave me the intellectual bird's eye view that
I appreciate and can benefit by. I wonder what would have
happened if I had read it 12 years ago. Probably could not have
understood it at all. Be that as it may, this resurgent awareness
of God is upon me—blessing enough.

It took two months to read the book, during which time
many reevaluations had to be made on my own life. . . . Some
kind of practical mysticism is being worked out. Chiefly because
of a dedication to photography—I want to push that medium to
speak of spirit such as I have never been able to push it before;
perhaps Stieglitz did.

A new sequence of photographs was made this fall out of the
mounting wave of mysticism. It set the symbols of the "mystic
way" before I knew what they were. . . . These sequences are
"given" as if directed by an outside force.

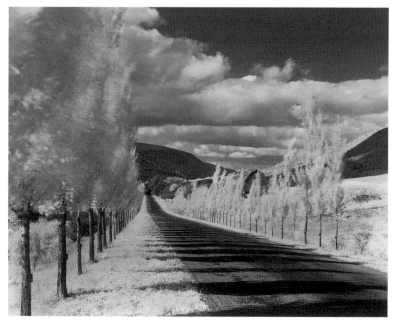

Minor White, from "Sequence 10/Rural Cathedrals,"
Road & Poplar Trees, 1955
Princeton University Art Museum; Minor White Archive

Few persons have had this experience in photography. And for this reason I feel it is necessary, maybe even a kind of duty, to continue for awhile yet in pursuing that way of photographing till it is not a hint of a way, but thoroughly set, that a lifetime devoted to it is necessary. This will give proof that this instrument can carry out the work of God as well as any other. . . .[12]

Underhill divided The Way into five phases:

1. The Awakening of the Self. This is usually an abrupt and well-marked occurrence, accompanied by intense feelings of joy and inner exaltation.

2. Purgation. The Self is aware for the first time of Divine Beauty and realizes in contrast the true nature of its own finiteness and imperfection.

3. Illumination. After a long and hard struggle up a difficult path, the Self now looks upon the sun. This is a state of learning; a contemplative state.

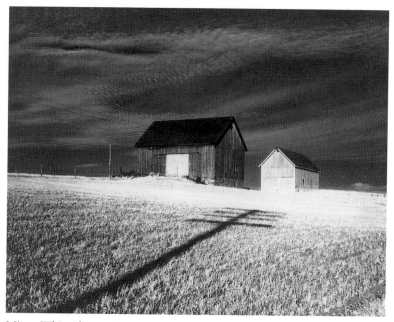

Minor White, from "Sequence 10/Rural Cathedrals,"
Two Barns & Shadow, 1955
Princeton University Art Museum; Minor White Archive

4. Surrender, or Dark Night of the Soul. The most horrible of the experiences of The Way, it is sometimes called "mystic pain," or "mystic death." The Self that formerly sunned under the Divine Presence now suffers under Divine Absence. It is in this stage that the instinct for personal happiness is to be extinguished.

5. Union. The true goal of the Mystic Way. The Self becomes one with Absolute Life and peaceful joy is attained.

It is these five phases, the mystical process of reaching Union, that Minor White has illustrated in "Rural Cathedrals."

The first print, *Barn & Gate*, may be seen to represent Awakening. This is well marked, with the gate serving as a symbol for the process of opening or discovering, but the unopened barn door still blocks the way beyond.

The second print, *Black Sun*, represents White's interpretation of Purgation. In this stage the central theory of the Union of Opposites is revealed. The black sun symbolizes it all. This is not a happy time.

The third print, *Large Barn*, also fits into this category. This barn can be seen as representing all of life. Its vast size is an indication of the universe's enormousness and man's relatively minute part in the scheme of things.

Barn & Clouds is the visualization of the state of Illumination. A beautiful and luminous scene, it represents a cessation of the struggle. A difficult path had been taken in Purgation, and now the seeker is given a respite of beauty and peace.

The following four prints all appear to fall into the category of Surrender, or Dark Night of the Soul. This is indeed the most terrible experience of the Mystic Way, and White has chosen what he considers a frightening prospect to represent this period: death. The fifth print is *Graveyard & Barn*. A vivid contrast to the preceding image, this photograph is subdued and quiet. It is not an optimistic picture, and certainly denotes Surrender. The next, *Toolshed in Cemetery*, is more cheerful. Still within the Dark Night, this image conveys at least a bit of hope. Vegetation and light have returned to the scene (the previous print had just a hint of nature's form; only a dormant tree to the left side). The seventh print is *Potato Cellar*, and it also falls within the state of Surrender. Here, the emphasis has shifted from the two earlier scenes. More of the image is given over to the sky; the power lines lead out from the black entrance of the cellar, outward and upward, toward the sky. Emergence is slowly becoming a factor. The seeker is escaping from the grave that is here depicted as a potato cellar. *Small Cloud over Barn* represents the triumph of the seeker over "mystic death." The grave has been successfully overcome and the sky is now within reach, as signified by the close proximity of the cloud to the barn. The barn, however, still appears ominous. Seemingly unending, it reaches beyond the frame. The barn seems to represent a jail of the soul, with its locked doors and barricaded windows. But the symbolism of the cloud is clear—Union: the final goal is attainable. It is interesting to note that in the sequence, White used four prints out of the ten to depict the stage of Surrender. This may indicate a preoccupation on his part with the pain and suffering he was experiencing at this time in his life.

The ninth print of "Rural Cathedrals" can be understood to represent the passage to Union. Titled *Road & Poplar Trees*, this incredibly vibrant landscape is a relatively simple symbol, with the road itself functioning as a path to be taken toward the ultimate goal. Further, the shadows cast by the poplar trees form faint strips, suggesting the rungs of a ladder, the traditional symbol of heavenly ascent. It is the tenth and final

picture that serves as the summation of the sequence. *Two Barns & Shadow* represents the consummation of the search. The shadow in the form of the cross and the two barns in the background constitute a harmonious unit that works effectively to portray peace. The photograph is about convergence; the shadow representing spiritual life (explicit in the sign of the cross), the barns representing physical life, and nature in the land and sky. The ultimate effect is not excitement or ecstasy but, as the mystics would have it, calm. The Union has been achieved, the Self is one with the Absolute, and the sequence too is complete.

As with all of Minor White's sequences, the ultimate meaning for each work can be apprehended only through a thoughtful contemplation of the photographs, together with a study of the artist's writings and a close analysis of his working method over many years. Though this may be an arduous task, the understanding of his pictorial statements can be deeply gratifying and enriching. Minor White's photographs are among the highest achievements of twentieth-century artistic expression.

NOTES

1. For a complete biography of the artist and reproductions of his work, see Peter C. Bunnell, *Minor White: The Eye That Shapes* (Boston: Bulfinch Press/Little Brown, 1989). On his death, White bequeathed his life's work to The Art Museum, Princeton University. All photographs and unpublished materials noted are from the Minor White Archive there.

2. For a fuller discussion of sequencing photographs see Bunnell, "The Sequence," in *Minor White: The Eye That Shapes*, pp. 231–33.

3. Minor White, untitled introductory statement to the "Fourth Sequence," 1950.

4. Some four versions are known of "Sequence 10." The first appeared in portfolio form in 1955 and the last was published in Minor White's *Mirrors Messages Manifestations* (New York: Aperture, 1969). This latter version is composed of ten images and it is the one discussed here. White was constantly resequencing his works. Much like a playwright altering or changing dialogue, or inserting new scenes, he frequently went back to earlier sequences and rethought them. The earlier version of "Sequence 10," which White produced some thirteen years before the *Mirrors* version, takes a slightly different path to arrive at the same metaphorical conclusion. This version, as revealed in his notes from the period, is composed of fourteen prints, nine of which also

appear in the *Mirrors* sequence. This earlier version of "Sequence 10" follows the same literary route as the later one, but certain of the images take on somewhat different connotations when placed in a variant context.

I am indebted to Philip Maritz for insights about this sequence that he developed in a paper while a student in a 1982 seminar at Princeton University.

5. "Memorable Fancies," July 24, 1954.

6. Ibid.

7. Ibid.

8. "Memorable Fancies," March 20, 1955.

9. Ibid.

10. "Memorable Fancies," January 17, 1957.

11. "Memorable Fancies," February 9, 1956.

12. White, letter to Isabel Kane Bradley, March 7, 1956. White records that Nancy Newhall gave him a copy of the Underhill book about December 15 of 1955. He received a second copy at about the same time from a resident student, John Upton. These copies of the book were the paperback reprint of the twelfth edition (New York: Meridian Books, 1955).

From the *Proceedings of the American Philosophical Society*
135, no. 4 (1991): 557–68 (paper delivered November 9, 1990).

HARRY CALLAHAN

This essay is about the work of an American artist who has devoted himself to photography. Born in Detroit, Michigan, in 1912, Harry Callahan began to photograph in 1938. He is self-taught. In 1946, he joined the faculty of the Institute of Design in Chicago, a school that had begun as László Moholy-Nagy's New Bauhaus, and that later, after 1950, became a part of the Illinois Institute of Technology. In 1961 Callahan left Chicago to direct the program in photographic studies at the Rhode Island School of Design. In 1977, he retired from teaching in order to devote himself fully to his own work. Through all of those earlier years, he maintained an exceptional discipline of personal photography and individual expression, believing that the most substantive gift a teacher can make to his students is the demonstration of his own creativity. Many of those students are now representative of successive generations of important photographic artists in the United States and, in a few instances, abroad. Callahan's personal style has become indelible as an identification of American photographic approach and thought since World War II. Although he has been the recipient of several large exhibitions in the United States, including a retrospective in 1976 at the Museum of Modern Art in New York, this is his first major exhibition in Europe (at the United States pavilion of the thirty-eighth Venice Biennial, in 1978).

Harry Callahan has a reputation for being a quiet man, and indeed he is, preferring, as he might say, "simply to do." His students have benefited from his gentle verbal guidance for years; however, the public has not been generally aware of his thoughts through the written word. He published only a few extended statements, notably in 1946 and 1964, but in recent years he has granted a number of interviews. The quoted remarks in this essay are drawn from some of these diverse published comments. Without the tone of his voice, these comments are only a partial rendering of the man, but the phrasing and the choice of words do reveal Callahan and his manner, adding to what one might call the overall fabric of his being.

Few men have given to photography greater riches than Callahan has, and fewer still, once their achievement has been recognized, have

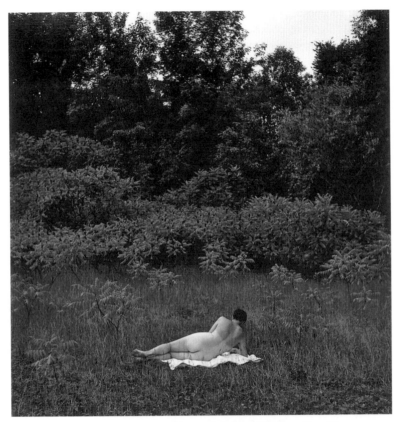

Harry Callahan, *Eleanor, Port Huron,* 1954
Princeton University Art Museum; Gift of Mrs. Saul Reinfeld

maintained such a humbleness of spirit. For nearly forty years, Callahan has demonstrated that the most common of subjects, approached with the most straightforward of techniques, can be made beautifully new.

Callahan's subjects—his family, city streets, façades, and portions of the natural landscape—are photographed so as to appear objective and analogous to truth. But this analogy is deceptive, because Callahan's exact and cultivated vision pervades each work and proves that truth is never quite so true as invention. His vision is particularly subtle when a photograph is isolated, but it becomes unmistakably identifiable when the body of his work is seen as a whole. Callahan directs us toward a more insurgent taste for life, and his pictures enrich us by showing an intimate world where time has stopped to reveal man's unconscious or archetypal values.

The effortless mastery of Callahan's pictures is encyclopedic. While many have discerned in his work the brilliance of formal manipulation, this deliberateness of compositional intent is not fully shared by him. Instead, Callahan professes a strong sense of the uncontrolled in the making of his pictures, something bordering on the religious—seeing himself, in part, as a kind of vehicle in the creation of these images: "I sort of believe that a picture is like a prayer; you're offering a prayer to get something, and in a sense it's like a gift of God because you have practically no control—at least I don't. But I wouldn't make a pronouncement out of it. I just don't know what makes a picture, really—the thing that makes it is something unique, as far as I can understand. Just like one guy can write a sentence and it's beautiful and another one can write it and it's dead. What that difference is, I don't know."[1]

Callahan's photographs are deceptively simple in their straightforwardness. Indeed, the current vogue for considering as art a photograph that is thought to resemble the "snapshot" may be traced to the influence of Callahan's work; in particular, the photographs of his wife Eleanor, and of his wife and Barbara (his daughter), and most of the urban street images. In part, this genre of photography, which is rooted in the nonart of personally familial images, was a source for Callahan's own creative impulse early in his career. Callahan remains part of a close family and he has maintained an interest in their intimate reveries. However, he has also written, perceptively, and as long ago as 1946: "The photographs that excite me are photographs that say something in a new manner; not for the sake of being different, but ones that are different because the individual is different and the individual expresses

himself. I realize that we all do express ourselves, but those who express that which is always being done are those whose thinking is almost in every way in accord with everyone else. Expression on this basis has become dull to those who wish to think for themselves."[2]

In this context, it may be seen that Callahan recognizes that the ordinary snapshot is an illustration, a picture that represents understood and accepted values. He is more interested in public art, something that might be called a defamiliarized image, which, while drawing on conventional or accustomed subjects, transforms their representation into something new and life-giving. He transmutes and compresses his material in an effort to dramatize the subject incisively, to render rather than report it. He continued from the above:

> Photography is an adventure just as life is an adventure. If man wishes to express himself photographically, he must understand, surely to a certain extent, his relationship to life. I am interested in relating the problems that affect me to some set of values that I am trying to discover and establish as being my life. I want to discover and establish them through photography. This is strictly my affair and does not explain these pictures by any means. Anyone else not having the desire to take them would realize that I must have felt this was purely personal. This reason, whether it be good or bad, is the only reason I can give for these photographs.[3]

His urban street images are representative of this transformation of a familiar subject. In recalling his approach to this commonplace environment, one in which we all participate and therefore have an image of, he has said: "How do you make anything out of it?" He thus reveals his concern not simply to show a place or action, but to draft a correspondence between its forms and his artistic feeling. In discussing these images of people walking on the street, Callahan has made this statement:

> It was so strange to me—just people walking on the street—how do you make anything out of it. So I started photographing people with their hands in certain positions or their arms around each other, talking to each other and all this kind of stuff and I found that anything I thought of that way, literally, I never really care much about the picture. I found that when they were walk-

ing by themselves they were lost in thought and they weren't "with it" any more, and so this is really, I guess, what I wanted.

I photographed those by setting the camera at 4 feet with a telephoto lens on a 35mm and just when they filled up the frame, I snapped it. I'm walking and they're walking. Well, that was an exciting bunch for me. I photographed for a long time doing that. To describe what I got. . . . I have no idea. I just know it was moving to me.[4]

This process of what I call defamiliarization has as a fundamental strategy the alteration of the viewer's expectation of what a picture looks like. The photographer recognizes the generally preconceived notion of what a still image is, and he attempts to extend that concept and stylize it. It is an approach based on the fact that normally objects or situations are so familiar that one's perception of them is habitual, and therefore automatic. Thus, in order to renew perception, pictures must be unfamiliar. This is highly complex in photography because the medium has as its inherent basis the mimetic vision of the lens; however, once the objecthood of the photograph is recognized, then this approach to stylization can be readily grasped with all its potentialities. In the context of contemporary experience, Callahan's photographs are a strong antidote to the simplistic description of modern urban life. The social sciences have provided us with all the necessary clichés—alienation, disassociation, depersonalization—and we have been educated to think in these descriptions, which have the effect of generalizing problems that already seem unrelated to our personal lives because they seem so abstract and general. This then becomes the challenge for the photographer: to break down the generalized nature of experience by making images that, in their specificity and uniqueness, serve to engage us in the realities of our lives. The process is but another form of expressive abstraction.

Today, when the conceptual framework of photography is being defined more fundamentally, it is essential to identify the relationship between subject and technique. Callahan's interest in the techniques of photography is integral to his interest in the subject, and these two interests are intimately suited one to the other. His respect for the medium and his freedom of techniques—such as multiple exposure and controlled tonal scale—stem from the spirit of the European avant-gardists of the 1920s, whose views represented a liberal purism of what was

truly photographic. Callahan has said of the subject and its representation in photography:

> It's the subject matter that counts. I'm interested in revealing the subject in a new way to intensify it. A photo is able to capture a moment that people can't always see. Wanting to see more makes you grow as a person and growing makes you want to show more of life around you. In each exploration or concern for the subject, I continue in the area for a great length of time, sometimes a couple of years. Working this way has been the result of my doing the photo series or groups. Many things I can't return to and many things I return to come out better.[5]

With regard to influences on his work, particularly that of Moholy-Nagy, Callahan has recalled:

> He did [influence me], in an underground way. As far as whatever so-called inventiveness I have, I don't think that had to do with him particularly, but he liked it, and that was nourishing.
>
> He hired me on the basis of my photography, and when he first hired me he asked me why I took a picture, and I couldn't tell him. He said, "well, I don't care if it's just for a wish." Which is something he represented—a playfulness, a childlike look at things, which attracted me. You can't be that way forever, but he did it for a long time.
>
> I'm sure that there's lots of influences, but I can't be too conscious of them. Walker Evans must have influenced me somehow; I liked the directness of his photographs, and tried to shoot as directly as possible. But that doesn't work so well anymore, unless it's his—but I like that part of photography . . . his photographs probably struck me the strongest—but that's getting to be like too much Beethoven; I don't know how much more I can look at that, really.[6]

This seeming polarity of influences and interests—Moholy-Nagy and Walker Evans—is not contradictory. Each artist projected an individualized stylization, and their views about the medium are becoming more widely comprehended today as we come to recognize that photography is such that the direct, so-called straight approach is no less manipulative than the more synthetic approach, which is erroneously associated with experimentation and exploitation. This attitude, however, has not always been widely held, and in the past these have been

mutually distrustful traditions. It is because of their fusion in Callahan's work that a more sensible contemporary attitude has been forged. The fact that Callahan vests his most dramatic manipulative work in the camera, and not in the darkroom, places the locus where it belongs—with the vision of the photographer. We must understand that for most other photographers it is necessary to experience vision, but for Callahan, to see is vision. The essential aspect of Callahan's work is manifest in the stylistic device of precise images with the utmost degree of photographic clarity. Not all of his synthetic work rests on multiple exposure, in which there is a significant reliance on chance; but also, through tonal stylization, a no-less fanciful or purposeful synthetic side of his work is evident in his pure photography—for example, his wires against the sky or blades of grass against a neutral background. For while appearing graphic rather than photographic, they are literal representations of the subject.

In identifying for himself an understanding of how he derives his pictures and the extent to which his imagery is realized in the camera, he has remarked candidly about the practice that is commonly called previsualization. This is a concept derived from the working method of Ansel Adams, the first photographer whose work fundamentally impressed Callahan, and others, in which the goal is to visualize the finished photograph before exposure:

> The only previsualization I ever do is—like with the weeds in the snow, I know the background's going to be white and there are going to be lines. No, I think previsualization is in pictures, but I don't think of it in the terms that Adams and the others do. I understand what it means to them, but it doesn't mean anything to me. In fact, I like those little accidents. . . . I sort of believe it's untrue. I mean, are they previsualizing a masterpiece, or a perfect print, or what? If I knew every picture I made was going to be a real picture, maybe I could go along with that, but I can't. . . . I imagine it's a good teaching tool, though, so students can learn the technique of seeing. I suppose that's just their bundle of rules. And Jerry Uelsmann, he doesn't believe in that, he does it all afterwards, and that's his bag of rules.[7]

Elsewhere he has said: "I have ideas. I always go out with an idea, but it isn't a very big deal, you know. It isn't as if I'm going to save the world. Maybe I want to get down low and tilt the front lens, maybe it's that much."[8]

Unlike numerous other photographers of his generation, Callahan has not been haunted by tragedy or negative speculation; rather, his art is about a more lyrical positivist emotionalism. His art is devoid of the socioeconomic values reflected in the major currents in much of today's photography. His view of the antique in Rome, or of the walls and buildings of Peru or Bolivia, or of the earlier Chicago façades, are alike in evincing his respect for tradition and craftsmanship. His is an art that pays homage to human endeavor in its gesture of will, revealing the intensity of interaction between man and nature, man and time.

This romantic impulse in Callahan's work is one that coincided with strong developments in photography after World War II. Minor White's work is a conspicuous example; and like White and others, Callahan should be seen as a romantic artist who used the selective literalness of the camera as a stylizing vehicle for his emotional expression. Callahan's view of woman is the obvious case in point, and these pictures are the most poetic of his work. The feminine is a theme to which his artistic precursors similarly aspired and also thought to be the most poetic. The essential emphasis in romanticism is on the symbol, the intensive enigma, while formal structure is a secondary consideration. The difficulty of projecting a romantic ideal in photography is undeniably difficult; Stieglitz first proposed a solution with his photographs of clouds, and photographers such as Minor White and Aaron Siskind opted for similarly nonobjective imagery through the decontextualization of the subject. But Callahan, intent on preserving the essential ingredient of the photograph—the subject—places a premium on the continuum between recognition and the evocative qualities of the imagination as revealed in the illusionism of his photographic presentation. For Callahan, the interpretation of a photograph should be an act not only of the eye but also of the mind.

Callahan's world is one dominated by the image of nature. This includes those pictures in which the very things of nature are missing, but echoed and metamorphosed through the process of absence and comparison; patterns of grass remind him of building surfaces, and layers of buildings, seen at angles or through alleyways, are the forests of man's creation. Certain of his great textural landscape pictures are like tapestries. Woman stands among the trees as a human presence as much as woman walks the streets of the city. All of Callahan's pictures are environments, landscapes into which he projects his romantic spirit. His pictures are all meant as a confession of deep interest and respect. He is truly in love with woman, and he lives and breathes this admiration and

reverence. In his romantic temperament, woman plays the crucial role. As Goethe said: "The eternal feminine impels us onwards," and no expression of this idea has achieved greater universality in photography than in the work of Callahan. Apart from Stieglitz's obsession with Georgia O'Keeffe, it is doubtful if the woman's world has ever before been so fully revealed in photographs by a man. In Callahan's work-room he once had two images tacked up above his desk that disclose his aesthetic kinship and something of his historical perspective; each is a postcard reproduction. One was of a nude by Thomas Eakins from the photography collection of the Metropolitan Museum of Art; the other, Goya's *Naked Maja*. These two widely differing artists represent woman as a gentle and lyric goddess, an interpretation Callahan shares. His images of the female form may be dematerialized and superimposed on the earth itself, but in none of his images is either a figure or even a leaf mutilated or assaulted.

Callahan's most recent work is in color. It is an aspect of the pho-tographic medium not new to him, but one that he has not utilized for a decade or more with anything like the present intensity. These new pictures are a further exposition of his romantic temperament, through their warm earth colors and their vigorous perspective. They are rich in the intensity of their color, a palette he owes to the recent colorist vision of a younger generation of photographers, yet the pictures are devoid of anecdote and the transitory: a vision that, in black and white, he him-self established early in the 1950s. There are many details in these pic-tures that echo his earlier work: the colorist exploitation of black, not only as shape but as color, precise shadows and deep planes, window reflections as a kind of interior/exterior duality, and the juxtaposition of bits of cultivated nature with the constructed world. There is less pre-cise regularity here, however, and a greater sense of humor, which he refers to as "freedom" and the pleasure of being "less fussy." The fact that all of the recent images are taken in Providence, a city where he has photographed for more than a decade, does not concern him, nor does the observation that the subjects are analogous to his earlier architec-tural work. Callahan, like other mature artists, is fully aware of the compulsion to repeat, to go deeper into what he has seen. Like those before him, he holds the poetic conviction that the emotional forces gen-erated by a place or an object can be made more visible through con-stant and deeper probing. In addition, Callahan has a considerable interest in serialism, and he views much of his work in this ensemble format, preferring to show groups of images all reflective of a similar

involvement with the essence of a subject. As he put it: "It may be with more experience you can photograph more freely, even though you may go back and do the same thing in a sense. You can put some life into it a little easier. But I guess there's certain subject matter that you look for everywhere, and you go back to the same places."[9]

Callahan thinks of little other than his work. His life as a teacher of photography has been dedicated to the young, but likewise through them and their work he has been led back into his own. His work has not radically changed in the forty years he has been making photographs, but they have steadily risen to increased levels of grandeur. Perhaps a comparison with Cézanne is not presumptuous, for like the last works by the painter, Callahan's latest photographs are also the ingenious creations of a master drawing upon a deep repertoire of experience and skill. He has commented on his near-obsessive approach to work: "I photograph continuously, often without a good idea or strong feelings. During this time the photos are nearly all poor but I believe they develop my seeing and help later on in other photos. I do believe strongly in photography and hope by following it intuitively that when the photographs are looked at they will touch the spirit in people."[10]

Callahan speaks little about other artists or photographers, but one knows he is always looking and that he is fully aware. The names Steichen, Stieglitz, Moholy-Nagy, Adams, Evans, Siskind, and those of his students appear in his conversations, usually in the context of his personal familiarity with these figures as mentors or colleagues. He comprehends his place in photography and he recognizes his own uniqueness: "I think in the end that's what it's all about. You are an individual and you are unique and when you make something that really comes out of you it's going to be unique."[11]

He is, nonetheless, a remarkably unpretentious, witty, and kind man, a refreshing personality in this time of expanding and sometimes superficial interest in photography. He senses the temporality in some of this, and he cautions himself even in his delight with his own success and with that of the medium. When asked, "Do you believe you're consciously trying to make the world more interesting?" he replied:

> I've had all kinds of attitudes. About the most I can guess I feel is that some of the great sculptors, the great painters, the great architects, and composers have left something real wonderful for me, and so I'd like to leave something for someone else. That's

about the closest I can come. I thought at one time I should benefit humanity, but I don't even know what that means anymore, and then you think, well, you're doing it to satisfy yourself, but there's more to yourself than just satisfying yourself too, and so I really think it's just that I want to leave something for somebody. I feel whatever I've got is a gift so I have to take care of it, like it was a plant or a child growing or anything else. That's about as close as I can figure it.[12]

NOTES

1. Harry Callahan, in Allan D. Coleman, "Harry Callahan: An Interview," in *Creative Camera International Year Book 1977* (London: Coo Press, 1976), p. 76.

2. Harry Callahan, "An Adventure in Photography," in *Photographers on Photography* (Englewood Cliffs, NJ: Prentice Hall, 1966), p. 41.

3. Ibid., pp. 40–41.

4. Harry Callahan, in Melissa Shook, "Callahan," *Photograph* 1, (Summer 1977): 4.

5. Harry Callahan, untitled statement, in *Photographs: Harry Callahan* (Santa Barbara, CA: Van Riper and Thompson, 1964), n.p.

6. Callahan, in Coleman, "Callahan: An Interview," p. 76.

7. Ibid., p. 75.

8. Callahan, in Shook, "Callahan," p. 4.

9. Harry Callahan, in Jacqueline Brody, "Harry Callahan: Questions," *Print Collector's Newsletter* 7 (January–February 1977): 172–73.

10. Callahan, untitled statement, n.p.

11. Harry Callahan, in Jim Alinder, "An Interview with Harry Callahan," *Exposure* 14 (May 1976): 13.

12. Callahan, in Brody, "Harry Callahan: Questions," pp. 175–76.

From *Harry Callahan: 38th Venice Biennial, 1978, United States Pavilion,* exhibition catalog (New York: International Exhibitions Committee of the American Federation of Arts, 1978).

WALTER CHAPPELL:
TIME LIVED

> To me, the great expedient is *camera vision*: the sensitive use
> of my own eyes under the higher vision of an understanding
> and intuition based on my own knowledge of a relationship
> to *reality*.[1]

In the 1950s, for those who took up the art of photography in pursuit
of revelation, the environment, or we might say the condition, was noth-
ing like today's. A solemn pursuit, the making of photographs that
sought to delve into the self and to expose layers of meaning far
removed from the subject photographed, was also a solitary one. It
required not just physical and psychological stamina, but a resolve
grounded in philosophies of self-analysis, religious mysticism, and pic-
torial expression that were years old, but new to photography. These
ideas had to do with a belief that the photographic medium could
extend its realm beyond mere recording and be part of a creative force:
a depiction of feeling signifying art in spite of medium. Those who fol-
lowed this approach were not the usual persons in photography who
busied themselves with the minutiae of technique, but were deeply com-
mitted aesthetes who believed in an ideal of purposeful creation and
deliberate statement that was fixed in the practice of metaphysics. What
is more, they were equally concerned with the notion of accepting
responsibility for their actions as well as their images. With a very lim-
ited public committed to their works, they frequently had only them-
selves to address and mutually enlighten.

One publication was at the center of their orbit. *Aperture*, founded
in 1952 by Minor White and others, and edited by him, was one of
those classic "little magazines" of the period, but instead of being cen-
tered on poetry or the short story, it was the literal guide to the new
photography. White, who began his mature career just after World War
II in San Francisco, was influenced in different ways by three important
predecessors: Alfred Stieglitz, Edward Weston, and Ansel Adams. But
as was his goal, White went beyond these three, and created a coherent
aesthetic of photography that incorporated something from each: the

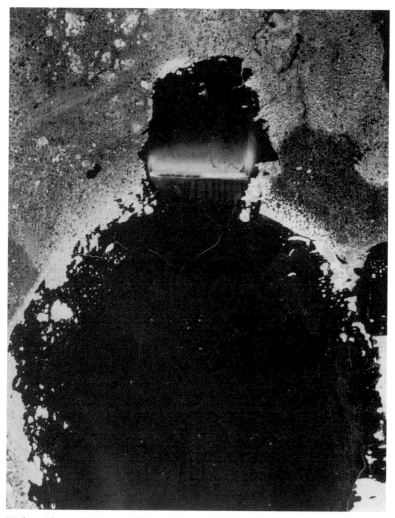

Walter Chappell, *Burned Mirror, Denver, Colorado*, 1956
Princeton University Art Museum; Anonymous gift

metaphor of Stieglitz's "Equivalents," the formalist realism of Weston, and the lyric tonal harmonies of Adams's manipulation of the photographic material.

The photographs by White and his colleagues, who included Walter Chappell, had a very special look. Usually an 8-by-10-inch enlargement from a 4-by-5 negative, the black-and-white image was intense and rich in subtle tonality, and the subject, while realistically rendered, was usually abstracted through a form of cropping or camera decontextualizing. Finally, in presentation, the elegant print was flush-mounted on a pristine white card of about fourteen-by-seventeen inches. Signed on the front face, each picture displayed reverence for the medium, and it also put the viewer on notice that a particular and unique art was at hand.

Today, almost all of this seems somewhat piquantly unfamiliar. Color prints and large scale predominate, and the found object—rendered through the realized vision of heightened awareness—is almost nowhere to be seen. Cynicism and discord are the norm. In retrospect, the work of these photographers at mid-century can now be seen as the high point of the sophisticated modernist aesthetic that first made its appearance in the decade after World War I. These pictures of the 1940s through the '60s are now the material of history—but more than nostalgic; there is much here to teach us. There is much here to respect.

It was into this world of art photography that Chappell entered when he began his exploration in 1954. Born in Portland, Oregon, in 1925, he began studies at the Ellison-White Conservatory of Music at the age of six, and between 1939 and 1943 he studied at the Benson Polytechnical School in Portland, majoring in architectural drawing. From a very early age he was painting with watercolors and oils on paper and canvas. He served in World War II and afterward took up residence in San Francisco and New Monterey, where he continued painting and apprenticed in leatherwork and ceramics. He studied architecture at Frank Lloyd Wright's Taliesin West in 1953–54. In 1954, while hospitalized for tuberculosis in Denver, he began his serious work in photography and apprenticed in that city with Nile Root and Winter Prather.

Having met Minor White while a teenager in Portland, Chappell again made contact with him in San Francisco after the war and became an active participant in White's circle of friends, colleagues, and students centered on the California School of Fine Arts, where he taught. In this context Chappell encountered Edward Weston and his sons, Imogen

Cunningham, Ansel Adams, and others of the San Francisco School. White left California in 1953 to take up a position at the George Eastman House in Rochester, New York, and later he began teaching at the Rochester Institute of Technology. In 1957, Chappell left Denver to join White in Rochester. Through him, Chappell was hired by Eastman House and served as a curator there between 1957 and 1961. During these years, his photographic technique was honed under White's tutelage, and as they worked together, ideas were formulated that moved the concept of *camera vision* far ahead and provided considerable new material for publication in *Aperture*.

Chappell left Rochester in 1961 for a place he built downstate in Wingdale, New York. This house was later destroyed by a fire, which also consumed most of his prints and negatives. In 1963, Chappell was a moving force in the creation of the Association of Heliographers, a cooperative photographic organization and gallery based on Lexington Avenue in New York City, which sponsored a series of exhibitions showcasing a new generation of generally like-minded photographers, including Paul Caponigro, Carl Chiarenza, William Clift, Marie Cosindas, and Nicholas Dean, among others. After 1965, Chappell resided in a variety of places, including Big Sur, Taos, San Francisco, and Santa Fe, all the while pursuing his multiple interests in the visual arts, philosophy, poetry, and American Indian ceremonial life.

Crucial not only to Chappell's work in photography and his other activities on behalf of serious expressive photography, but also to the later work of Minor White, were the philosophy and teachings of the Greek Armenian philosopher and spiritual teacher G. I. Gurdjieff (1872–1949). In the late 1940s when P. D. Ouspensky published his commentary on Gurdjieff's ideas, Chappell began to explore these concepts of self-awareness, knowledge of which he further encountered among the group around Frank Lloyd Wright. He read closely Gurdjieff's *All and Everything*, and he passed information and insights on to White, starting from the time they were together in San Francisco. The study of this philosophy continued in depth over many years. In the late 1950s Chappell, with White, published in *Aperture* elements derived from what was referred to by Gurdjieff as "The Work." Notably, these tenets of self-awareness may be found in an issue of the magazine titled "Some Methods for Experiencing Photographs" (volume 5, number 4, 1957). To understand the unique intensity and direction of Chappell's work, one must delve deeply into the study of Gurdjieff.

Chappell has aided us by translating certain of Gurdjieff's ideas into his own words. The following comes from a text by Chappell that accompanied his photographs in a book titled *Under the Sun*.

Camera vision operates as an intelligent function between the human eyes and the totality of understanding in a moment of active awareness. No camera is needed for this experience, only the deep sensibility of the human mind. To arrest and refine this flow of impressions, creating an independent image in space, I use my camera with the same care and immediacy as I have become accustomed to practice with my eyes. The camera allows me to arrest my vision as a realization in outer space, precisely at that moment when my understanding and consciousness intuitively experience a reality most important for my awareness of Life's essential presence. This image of my *camera vision*, when fully expressed in the perfected print, stands independently as a fusion, or a blending of two otherwise opposing worlds within a unified whole.[2]

This exhibition of Chappell's photographs provides a rare opportunity to see the work of a uniquely inspired photographic artist. It is all the more so because vintage prints of his work are exceedingly rare and, as noted, in the fire that consumed his house and darkroom in the mid-1960s not only were most of his prints destroyed, but his negatives as well. Thus even new prints are not possible. This exhibition represents a cross-section of his work mostly from the 1950s and '60s, with a few later works from the '70s. The range of subjects is a kind of summary of Chappell's attention: ordinary found objects that by isolation and camera treatment are given significance, forms of the natural landscape and phenomena of nature, the human figure.

Two photographs from the 1950s illuminate Chappell's early working method. *Barn Key Hole* and *Lady with White Tear* are images taken in a close-up, decontextualized fashion. Strongly evoking human or anthropomorphized forms, the works are similar to some late Surrealist or early biomorphic work of the Abstract Expressionists in painting, or like photographs by Frederick Sommer that were just becoming known, or by Aaron Siskind, whose work from the preceding decade was widely respected in this wing of the photographic community. The fundamental principle in this approach to photography is that the tenuous connection to photographic reality is not severed. Each subject is re-presented in such a way that our perceptual limitation is expanded.

Each image suggests an inner reality, a kind of scar of the past, a reflection of an act or event once lived.

By the 1960s, Chappell had found subjects that derived more from pure nature: serpentine grasses weaving in flowing water, figurative rock formations, or the sparkling ice that coats, then melts from the limbs of trees, which he describes as the "silver thaw." Light on water, or human hair used as a direct-printing medium, continually fascinated him; the bright highlights become effervescent, dematerialized, and are rendered like a white-on-black calligraphy.

Chappell has always believed firmly in the duality of the corporeal and the spirit, part of the Gurdjieffian principle of heart, mind, and body. Chappell lived with and/or married four women during the period from which these photographs date, and he fathered seven children. As one would expect, images of the nude figure are a significant aspect of his work, especially in the 1960s and '70s. In part as a reflection of his personal biography, one can almost make a correspondence between the subject of a new photograph with the arrival of yet another companion or another birth. In many ways, it is Picassoesque in spirit, from Drid Williams dancing, an incredible self-portrait of father and son—near primitive, almost crude, yet touching—to the image *Piki's Childbirth* and finally *Pregnant Tree Fern, the Day before Riversong Was Born*, of 1978. Whereas in Picasso's work a painterly distortion can suppress overt sexual rendering, in the realism of photography, as Chappell practices it, this is not possible. He takes delight both in his young son and in his own phallus that leaves no ambiguity as to male presence—old and young. In other images, he further reveals the penis in its potent, lustful sensuality and ritualized adornment. It is his desire to present the harmony that is to be found in the sexual/family interior exploration that is at the root of all those cultures that fascinate him.

In the years since he made the photographs exhibited here, Chappell has continued his photographic journey. He became interested in what he termed "Metaflora" photography, a word-form used to describe his work in high-voltage/high-frequency electron processes with organic materials: leaves, blossoms, grasses, etc. In 1980 he released the *Metaflora Portfolio*.

While never at the center of the public eye, Chappell has been nonetheless a continuous presence in the field of art photography for more than forty years. He is one of the very few who has carried on his creative work without regard to fashion, or even to widespread institutional acceptance. At seventy-four and living in northern New Mexico,

Chappell is himself like one of the organic specimens he has used in his "Metaflora" work; he is a living force of manifest presence. These early images that we are now privileged to see are the energy sources that gave rise to this seasoned artist.

NOTES

1. Nathan Lyons, Syl Labrot, and Walter Chappell, *Under the Sun: The Abstract Art of Camera Vision* (New York: George Braziller, 1960), n.p.

2. Ibid.

From *Walter Chappell: Vintage Photographs, 1954–1978*,
exhibition catalog, Roth Horowitz, New York, 2000.

WALKER EVANS:
AN INTRODUCTION TO HIS WORK
AND HIS RECOLLECTIONS

Some time ago, a reviewer attempted to construct a picture of the 1930s by listing the names Walker Evans, Busby Berkeley, and Franklin Roosevelt. While each in a curious way relates to photography, it is fascinating to consider what the name Walker Evans would evoke. In the last few years Evans's photography, through which he probed the physical and psychological environment of the 1930s, has come to represent the era even more vividly than memory, a fitting testament to this highly selective and interpretive artist.

The power of such art to evoke the image of a whole period relates to the photographer's genius in selection. In an analogy rather close to the Darwinian thesis, it may be said that the corpus of Evans's work is reflective of a process of natural selection. From all the visual data, Evans isolated subjects that he then carefully refined, so that, like biological modifications, they were transmitted to us as the most vital and the most suitable. These subjects do not merely show a period, they symbolize it.

Walker Evans was a man of acute visual perception. He had a profound sense of the American myth and a marvelous sensitivity to materials. He has become the progenitor of the contemporary approach to photographing that is most frequently referred to as *documentary*. However, this term is extremely ambiguous and it should be used with caution. In Evans's photographs, his subjects are not stereotyped or sentimentalized, but displayed in terms of their inherent qualities and meanings. In stressing the importance of the subject, especially the presence and factual identity of that subject in relation to its social environment, Evans offers us a picture that in formal terms is organically unified around the subject. His photographs strike us as more powerfully revealing of a specific period in time than those by many of his colleagues, and it is the static, frontal approach that Evans adopted that constitutes the measure of his realism. The self-conscious framing and frontality of an Evans image exploits the fragmenting properties of

133

Walker Evans, *Bethlehem, Pennsylvania,* 1935
Private collection

photography by calling attention not only to the specificity of the angle and to the edge of the photograph, but precisely because of this, to the world outside of the picture's limits. One is forcefully made aware that in every way the subject extends beyond what is pictorially presented; that a world exists beyond the world of the image and it is not the realism of the image that provokes this awareness, but precisely its measure of stylization.

This stylization, which has been identified as unique to Evans, cannot be defined as simply showing things as they are. Evans always insisted, as he did again in this last conversation, that the photographer remain outside of his work. But in saying this, he recognized the precise stylization of his detachment, and he also knew how completely he permeated his pictures such that they could not be separated from him. Even his later photographs taken on New York subways with a concealed camera demonstrate this fact. The mistake so many have made is to assume that there is no style at all. In part this may be because even the moral values that were expressed by Evans were so universal that they appeared not to be of Evans, but of every one of us. In the projection of his style, from his first pictures in 1928, when he was twenty-four, to the last, Evans did not develop; he simply continued. When he began, he had both his themes and his form.

The volume of Evans's pictures from the Farm Security Administration files in the Library of Congress is a document of considerable importance, for it uniquely chronicles the concept of precise selection that has thrust Evans to the forefront of twentieth-century photographers (*Walker Evans Photographs for the Farm Security Administration, 1935–1938*, published in 1975). The book reproduces the entire oeuvre of Evans's three years with the FSA, from 1935 to 1938. It graphically demonstrates the photographer's personal dialogue between selection and rejection, and it beautifully illustrates how some photographs do emerge almost perfect. To my knowledge, no such volume of photographs, reflective of this sort of catalogue raisonné approach, exists for any other photographer, and I understand that Evans was not too pleased with its publication. The artist should have the right to edit his own critical perceptions, but from the standpoint of our need to understand the medium, and of how Evans has come to dominate his field, this work is of major import. It is the sort of thing we need more than the artist does. The artist already knows what he has done. This book should not be confused with a pictorial art book, for while the reproductions are of adequate study quality, their importance lies in

their totality and their relation one to the other, like pieces of an archaeological mosaic. The editors of the book, however, have tried to accommodate both conceptions: sixty-three photographs are reproduced in the classic pictorial format of one to a page, and then the entire collection of 488 images is reproduced within ruled spaces approximately three by six inches, three to a page. Jerald Maddox's text is informative but not integral to the real content of the book. The book may also be used as a catalog for ordering prints from the Library.

Two of Evans's most lasting and complete contributions to the conception of his time are the volumes *American Photographs* (1938) and *Let Us Now Praise Famous Men* (authored with James Agee and published in 1941). In having this complete record of Evans's FSA photographs, we come as near to having preparatory studies by an artist for a finished work in photography as one can. In photography, the act of selection is primary and private, both in the field and in terms of final presentation. Usually only the photographer knows what were his options. We can now see concretely that Evans's eye was so fine for the organization and sequencing of each of his books that nothing in them could profitably be changed. It also points out how fundamental the book format was to the conception of his work. He saw it both in its literate and literary sense, and while he felt the photograph could not be "a story," he used the book for precisely this purpose. Evans's pictures were always published in a contextual format, from his first book, *The Bridge* (1930), with Hart Crane's poetry, to his essays in the pages of *Fortune*. This new publication presents what we rarely have in the medium—evidence of what was left out of certain photographs and included in others, and left out of the selection process in sequencing the books. We come to understand the enormous challenge he faced in making photographs out of the very ordinariness of his subjects; for instance, look inside Floyd Burroughs's home in Hale County, Alabama, or at Frank Tengle's front porch, and one will come to understand the structure of Evans's stylized seeing and the measure of his morality. Like all art, photography is composed of making value judgments and of solving problems.

Evans is one of the few photographers of the first half of the twentieth century to have sufficient public documentation of his life and ideas to provide for their reading. With Eugène Atget, Evans's visual mentor, so little is known that one questions nearly every aspect about him with the exception of the existence of his work. Alfred Stieglitz, one of the other distinctive photographers of the century, is still some-

thing of a mystery, though his correspondence (now in the Yale University Library but as yet unpublished) is infinitely revealing of the man and his work. The publication here of the transcript of Evans's last public talk is significant for both his biography and the study of the medium. Evans's observations are important because they give insight into his work and his recollections of events and goals. In this context, Evans's views on Stieglitz are revealing, and in attempting to clarify Evans's work in terms of documentary or art, it is relevant to discuss the two in some detail.

Evans always regarded Stieglitz with a certain disdain, feeling that the latter's aestheticism was too egocentric. It was difficult for Evans to realize the battles Stieglitz had won for photography because they were all over by the time he came on the scene, and in fact those victories had, in a way, enabled him to begin. I cannot accept Evans's statement when he says that even early on he was not bothered by whether or not his pictures were art. It seems to me that Evans was always closer to Stieglitz than he cared to admit. In their approaches, each believed in the spirituality that is inherent in objects: that to see beneath the appearances of surfaces is to reach a greater truth. The camera, which begins with appearances, can, when respected, reveal these inner meanings. Truth was to be discovered as much as it was to be constructed. In subject selection, each man found the point of departure for his beliefs. Values were set by what one made a picture of. Stieglitz expressed his humanity through subjects that were meaningful to him. Evans did also.

What Evans found most problematic with Stieglitz was reconciling what he felt to be a contradiction between Stieglitz's idealized aesthetics and his concepts of social equality. Evans, like so many of his artistic colleagues of the decade, believed in the nobility of poverty. It was not the economic poverty of their own lot, which was indeed a fact, but the poverty of others. These artists sought out the places where the potential for this expression was most visibly apparent—the poor South and the tenement streets of New York. This historical advocacy led Evans to the style of his work, which, like his subjects, was pure, direct, spare, and sharp. He sought to find the fiber of spiritual substance beneath the surface of things in order to express his rejection of the dichotomy thought to exist between economic poverty and spiritual wealth. To Evans's credit, he never succumbed to a romanticism of poverty or a burlesque of its seriousness. But he also preached no corrective, which was, of course, one reason why he was outside the main thrust of the

documentary movement that surrounded him in that time of political reform. It is also why Evans is now seen as the most substantive documentary photographer of the period.

Nature, which was more to Stieglitz's liking, held little interest for Evans, who said: "I am fascinated by man's work and the civilization he's built. In fact, I think that's *the* interesting thing in the world." He might have referred to the certain rationality of civilization as compared with the irrationality of nature. In this sense, Evans could not accept the capricious photographic accident or make such images as Stieglitz's "Equivalents." I do not think, however, that he fully understood Stieglitz's cloud pictures or recognized that their approaches to the medium were really very similar. Stieglitz's stylization was not that far removed from that of Evans, for whom abstraction and realism—seemingly categorical opposites—were unified in a purely photographic synthesis.

Evans's description and stylization of facts were as personal and as aesthetic as that of Stieglitz, or indeed of Flaubert, the writer Evans most admired. As an FSA photographer, Evans never really fit into the scheme of the group. His pictures were too abstract to be illustration, which, as we all know, shows us only what is already known. They were not considerations of facts as facts, but realistic statements of literary symbolism. Locating and judging a subject is an act of personal responsibility, because the artist identifies with what he sees by photographing it, and in turn he is identifies with it. Evans, when speaking of freedom, is referring also to the responsibility of the photographer who intrudes on privacy and "takes away" the owner's property by photographing. He made these people and artifacts so thoroughly his own that we now locate them most clearly in his photographs, and, if we could encounter them again, we would see them through his eyes. He appropriated whole aspects of our society and gave them back to us as only he could discern them, and in so doing his photographs confer reality upon their subjects.

WALKER EVANS ON HIMSELF
On April 8, 1975, two days before his death, Walker Evans spoke to a class at Harvard about the course of his life and work. Here follow his remarks, edited for the New Republic *by Lincoln Caplan.*

You are at a point where I embarked about forty years ago more or less on my own. I am self-taught, and I still think that is a good way to be.

You learn as you go and do. It is a little slow, but I think that's the way to work. . . .

I have had a good number of years of more or less compulsive photography; I am devoted to it, and I still get a great deal of excitement out of looking at things and getting them the way I want. However, you won't find me overly intellectual about what we are all interested in doing.

I work rather blindly, and I don't think an awful lot about what I am doing. I have a theory that seems to work with me that some of the best things you ever do sort of come through you. You don't know where you get the impetus and the response to what is before your eyes, but you are using your eyes all the time and teaching yourself unconsciously really from morning to night.

There are several tenets that go with this craft of ours. One of them is that the real gift and value in a picture is really not a thought; it is a sensation that is based on feeling. Most people in our tradition are basically rather scared of feeling. You have to unpeel that before you can really get hot and get going and not be afraid of feeling.

We are overly literary, really, although I am very much drawn to literature; but I cannot recommend that as an approach, and I keep trying to tear it down because words are abstract things, and feeling in a sense has been abstracted from them. However, feeling remains in the action of producing pictures. Although photography is more descriptive than music, it is still not a story. Although I have a feeling that much of my work is literary—or is done by a literate man because I read a great deal—it is still a way from abstract thought into . . . feelings abstracted from reality.

These words are all relative. No one knows what reality is ultimately. We are rather drawn toward it. That leads me to observe another thing that came into my mind over the years. That is that the young are drawn into photography because in their minds it is associated with the approach, at least, to reality—bearing in mind, as I said, that you don't reach any of these abstract words like "love" and "honor" and "patriotism" even, and "pride." Those are all approaches to an absolute that is never reached. That goes for the word "art" too. Nobody knows what art is, and it can't be taught. I'm repeating a little bit here, but it's the mind and the talent of the eye of the individual who is operating this machine that produces what comes out of it. He selects, whether consciously or not, what he is doing; and that really leads to the question of style.

One really doesn't associate a machine—a little box with a glass in it—with the personal imprint of the operator, but it is there, and it's a kind of magic, inexplicable quality. After years you begin to tell right away who has some style and who hasn't and who is behind what piece of work you might be looking at. You all know a Weston when you see one; you all know an Adams; and you all know a Cartier[-Bresson]. That is their style; they have been strong enough and persevering enough to imprint it on that paper.

I started with a tiny, little six dollar vest-pocket camera that doesn't exist any more—a fixed-focus arrangement. I used that at first, way back in 1928. Like almost every boy, I was given a box camera, and I got interested enough to develop films under red light in the bathroom. I still have some of those things around. They have a little style to begin with; they are straight at least! But unartistic.

That's where I was alone. Most photographers were very uneasy in my youth, and they were all uncomfortable about whether what they were doing was art or not. I was never bothered about that.

Looking at what I was doing, most people didn't think it was anything at all. It was just a wagon in the street or anybody, but that turned out to be what I presume to say was its virtue.

I just found that this was my métier and walked blindly into it. That was a good thing because I hadn't had much experience or sophistication or study in the field. Again, I just brought my feelings to it. That left me alone, which is a good place to be; it's a little painful at times. I didn't associate with photographers; my friends were writers and painters mostly, and a few musicians. However, I was lucky enough to discover without working for it what I was, namely an artist; and I didn't have to be belligerent about it or fight through all the prejudices about artists and their place in society or civilization. I just fell into that slot—rather creamily, I might say.

Creamily. The word just popped into my head! It doesn't mean it was easy; it means that I belonged. You know that you're home when you're in the slot that's made for you. A lot of people suffer years trying to find that; it just came to me.

I think too much, though, and reading leads to introspective inaction. It's a Hamlet quality. I haven't got a rational structure and the expressible, critical opinion of what the object in front of me means on second thought. I do these things pretty much by instinct, and I have learned to trust that instinct. It took me a long time to feel sure of what

I was doing. Now I know that when something appeals to me, I don't have to think about it; I just go right to it and do it.

If you are at all sensitive, which artists are supposed to be and usually are, it could make conditions psychologically impossible if you're aware of people too much, so I just go about my business unless I find I really am hurting somebody. I *am* intruding mentally, but I know it's not for a harmful purpose, and it doesn't do anybody any harm. If I find myself opposed very strictly, I stop. There is no use getting into an argument about what you are doing. I walk away and think about something else and do something else.

[When I started out I was living] very shabbily and mostly in Brooklyn or Greenwich Village. It was a pretty good time to be there; there were some remarkably serious people, and it wasn't frivolous. We didn't have any narcotics and we couldn't afford to drink, so we were sober most of the time. That's why I'm alive today. A lot of people came along later who overindulged in those two things and damaged their lives and health and brains. You know, don't you, that a brain cell disturbed or killed or ruined specifically by alcohol does not—unlike other parts of the body—replace itself; so many people who started drinking rather early in life are brain-damaged or dead.

I wasn't interested in the commercial or advertising end of photography or the fashions. Since those were the high financial rewards, they were crowded with competitors. I was quite alone. I didn't feel that I was competing with anybody. I would be now because this crowd is rather militantly noncommercial—quite rightly. It's sort of hard on them, but they are. I didn't have any support; among a few artists and friends I did, and that was enough to keep me going. Since there wasn't any money—that's a ridiculous phrase, there's *got* to be something to eat—but there wasn't any check to put your mind on. Even eating wasn't very easy or very well done.

I had a small circle of admirers, but I wouldn't call it a public. I waited a long time before I got anything like that. I don't know precisely when.

[Recognition] makes anybody happy a little bit. You have to take it with some misgivings, however, because it is shot through with falseness and snobbery and wrong values that you know better about than to get aboard.

I think any man who thinks at all clearly is very wary of it. I've seen too many awfully good people ruined by it. However, I didn't have

any financial support for a long time, so I was rather severely disciplined. I had a certain renown before I was able to earn money. I keep saying it, that there wasn't any money around, but you had to do *something* about putting food in your mouth. Of course, most of us were outside the pale and would do almost anything to get a can of beans and didn't care whether it came out of the gutter or where it came from.

I have been making them [photographs] all the time. Well, it's generally sort of straight photography. I get interested in objects a good deal more and more now. It's sort of like collecting, and I get started and am attracted to that naturally. I'm interested in signs a great deal right now, so I find that I do signs whenever I can find them. I usually swipe them too; I've got a wonderful collection!

I *do* have a critical mind, and it creeps in, but I am not a social protest artist, although I have been taken as one very widely. If you photograph what's before your eyes and you're in an impoverished environment, you're not—and shouldn't be, I think—trying to change the world or commenting on this and saying: "Open up your heart, and bleed for these people." I would never dream of saying anything like that; it's too presumptuous and naïve to think you can change society by a photograph or anything else. It's a debatable question, of course, and many people say that some books have influenced government decisions. *Uncle Tom's Cabin* comes to mind as a book that is supposed to have changed a certain atmosphere; I don't know—I never read it. Anyway, I equate that with propaganda; I think that is a lower rank of purpose. I believe in staying out, the way Flaubert does in his writing. Of course, you can't be entirely subjective, but I don't think you ought to intrude. It's rude in a way to say: "This is the way I see things." It infers [*sic*] that you ought to see it that way too.

I am a little more sure[,] at some risk of self-satisfaction[,] of what objects in civilization draw me. I have tested it often enough. I can trust myself to go down paths now that perhaps I wouldn't have had the nerve to penetrate before. That doesn't mean that I think that everything I do makes sense, but I am a little less hesitant about going into some things that I haven't been into before.

Let Us Now Praise Famous Men wasn't published at first because it didn't suit the editors, fortunately. They were at a time, you must remember, when it was rather silly—when there was no money around or business around—to publish a magazine luxuriously called *Fortune*; and they were confused and uneasy, and they didn't think this fitted—

and indeed it did not! It didn't even fit the first publishers who asked for it, to see it.

It was finally published in book form by Houghton Mifflin, and it was completely silently received. I think that nobody bought it. [Its eventual success] was a rather spectacular instance of resuscitation of cast-off material, and of course the world is full of unsung riches around. If you put your mind on it, you could go out today and find very fine work that no public has ever wanted to see or been brought to.

Well, I was overawed by [praise]. I immediately felt that I was reading great prose. I was rather too much overawed by it because I could have been of some critical assistance. In fact, Agee asked me to do some editing, but I wouldn't do it. I still think that is a great book. It has many flaws, of course; but it is a very big and large and daring undertaking and a terrific moral effort, as one reviewer said.

I'd known [Agee] very well. I knew him a long time before we went down there. I was in very close sympathy with that mind; I am very impressed with it. I disapprove of a whole lot too. I had a much more objective approach to artistic raw material. He was very subjective. He used to shock me. I have inhibitions about exposing the personal ego and feelings, and he seems to think that is *the* material and that that is one of the functions of an artist—exposing obscure and hidden parts of the mind and so on.

I think it was Oscar Wilde who said that no poet or even critic who is really an artist is a very good judge of other work. There are notable examples, such as Proust being turned down by André Gide, and Joyce couldn't make any sense out of D. H. Lawrence or vice versa and neither had a word to say to each other. I am a little bit more knowing about photographers, and I have a few friends, but not many. I am very interested in young talent, but that is really the only reason I ever expose myself to them. I like to see their minds and their work, but I don't talk very well [about photography]. Also it descends into a form of invidiousness if you begin to talk about artists or producers who are in a sense competitors too. You don't want to be caught running them down because that is unethical really, I believe.

I am very fond of several I would be glad to name: Robert Frank, Lee Friedlander; [Diane] Arbus was a great friend of mine and great favorite. There are a few others, and then there is a whole crowd of unknown, almost nameless, very gifted students in the universities now. There is a wave of interest in this; I think this is partly for the reason I worked out in my own mind that it looks like an honest medium. Now

that is a very untrustworthy idea; you have to be careful how you kick that around because it infers that many of the young are in there because they don't know any better or have been taken by a fad or fashion. That isn't quite true, and it isn't fair to the young to say that.

Every artist who feels he has a style is a little wary automatically of strong work in view. I suppose we are all a little insecure. I don't like to look at too much of Atget's work because I am too close to that in style myself. I didn't discover him until I had been going for quite a while; and when I did, I was quite electrified and alarmed. . . . It's a little residue of insecurity and fear of such magnificent strength and style there. If it happens to border on yours, it makes you wonder how original you are. Of course the world is full of instances of people intellectually and artistically discovering a style by themselves and being unaware of someone doing the same thing. I've had that happen to me several times.

I have a certain street snapshot affinity to Cartier-Bresson, and I was working that way before I knew anything about him, so that squares me with myself anyway and makes me fear it a little less. Some of that feeling in looking at Atget is despair too that we haven't got the wealth of material that he had except for older towns. You can see what has happened to London and Paris in the last generation; those things that he was doing are hard to find now, and they were just the whole ambience at that time.

When I was young—it was just before the Great Depression—this was a very unpleasant society in the sense that if you weren't interested in commerce and business and commercialism in general, there was no place for you. You had to make one. It was very hard to stay outside of the great sweep of material prosperity, which of course fell on its nose in the '30s. Then there was no use looking for something to do anyway; you *had* to make it yourself. That was a good thing for many artists, I think, because they didn't have any sense of guilt about not being in business or Wall Street or some place like that. They couldn't get in if they wanted to. There was no place for them. You may come to get to know that firsthand yourself! It looks as though there is that sort of thing around the corner. It may produce another good bunch of artists, which is all I'm interested in. Really, I feel rather stony hearted about it, but I have suffered so much from the psychology of it that I don't care very much whether this country prospers or not. I don't want to lead the world or be part of that machinery.

We have a terrible pressure on us all in this country to prosper personally, and you probably feel it already. I think underneath that [. . .] really what my parents wanted was for me to do that because they thought they were being nice to me and saving me the agony of poverty; but they didn't succeed! I succeeded.

Every man's feeling about his civilization is formed by himself out of the surroundings themselves, and they often are not very original for that reason. I got prejudiced in my feelings by the bitterness of the failures of the society which were so evident before any reform took place. You see, anyone my age has lived through a subterranean or almost automatic social revolution of great change. It was a hateful society, and that embittered all people of my age. It was very fascist unconsciously, and all authority was almost insulting to a sensitive citizen. You either got into that parade, or you got a bum treatment. That changed a great deal, of course; its recognized historical landmark seems to be the Wall Street crash, but that's just a convenient peg to hang it on. That was certainly coming, and that awful society damn well deserved it. I used to jump for joy when I read of some of those stockbrokers jumping out of windows! They were really dancing in the streets in the Village the day Michigan went off money and the banks all closed there.

I haven't got a hell of a lot of respect and certainly not much love for the structure of American civilization. I think the government is kind of a joke really. However, when you think about it a little deeper than that, you realize that those flaws and imperfections go with the *idea* of democracy, which upon examination is a pretty wonderful idea.

Like all the young, I went through a time when I was too much of a perfectionist and too much of an idealist. You have to discover, as you probably already have, that those are erroneous forms of thought; they don't work very well or stand any tests or function. Thinking along those lines leads you to see with your critical mind what is behind some of the faults and errors. . . . The idea of democracy is laughed at in very sharply critical circles; but it's a pretty lofty conception, and it's remarkable that it has any functions and forms that are working at all.

I am fascinated by man's work and the civilization he's built. In fact, I think that's *the* interesting thing in the world, what man does. Nature rather bores me as an art form. It doesn't bore me to walk through nature and let it play its forces and influences on me. It's restorative, but I don't use it creatively. In fact, nature photographs downright bore me for some reason or other. I think: "Oh, yes. Look

at that sand dune. What of it?" But if you're in love with civilization, as I am, you stick to that.

I think a great deal about childhood as my life goes on. I get obsessed by it. That's why you see bookshelves so full of so many memoirs. There is a time when you do turn backward—with some reluctance, I must say, because it doesn't seem to me to be the right state of mind. However, that material crowds up, and it is so rich and fascinating that you speculate a great deal on it.

You know, I've gone back far enough to find out that [photographing the scenes of my childhood] can't be done, and it's always a letdown and an ungratifying experience. Things don't look right. You go up to something that you knew in your childhood, and you are full of feeling about it, and that feeling doesn't come through—the object doesn't reflect that feeling. You put something in it that's no longer there, something of yourself. I avoid that strictly now, although I am very interested in the immediate past impersonally. I've got quite a few rare records of streets—particularly slum streets in New York, and Charleston, South Carolina, and Louisiana—that have all been cleaned out and torn down, so that the whole atmosphere has been changed. They take on a tremendous appeal and beauty far beyond the level of nostalgia. However, that's impersonal; it isn't your childhood home and a bedroom and all that. *Now* I love to go into an *im*personal house. I am very interested in how people live and the material mementos they leave of the lives. That all has style too, but it's preferably to me something I haven't seen before. I don't want to be associated with sentimentality of feeling.

Originally published as "An Introduction to Walker Evans' Work and His Recollections," *New Republic* 175 (November 13, 1976): 27–29. Lincoln Caplan, ed., "Walker Evans on Himself," *New Republic* 175 (November 13, 1976): 23–27.

WRIGHT MORRIS

Photographs hold a curious fascination for us that is not unlike the fascination of concise, descriptive prose. Although some photographs reflect their creator's aspiration to poetry, by and large it is the actuality of things as they are that is remarkably reflected in photographs. In a sense, photographs are highly literary, and the photographer, like the writer, has to be both a master of craft and a visionary. Patient accumulation of facts and then speculation about their meaning is the nature of authorship in both media. The speculation is often fictive—it may be untruthful. Perhaps "untruthful" is not quite the exact word; it might rather be said that the specificity of facts can give rise to heightened awareness that can evolve into heightened imagination. When considering the artist Wright Morris, we have in a single figure an exponent of the unity of word and picture. He seemingly found photography ready-made for his vision; and, importantly, he turned to it at a point in photography's evolution that found it ready-made to influence his vision.

Morris's most active photographic period spanned the decade ending in 1948. His work began out of his desire to master one kind of descriptive analysis—he wanted to treat objectifiable data so man's artifacts could be presented as clues to the nature of existence. While it is generally assumed that the photographer is confined to reporting, Morris explores under the surface, to reveal the significance beneath outer appearances. In his pictures, Morris is interested in man's work—he has never been very much interested in nature. Not an anthropologist or a cultural historian, he is an exegete of action and values. Photography provided him with an objective sustained reality, which enabled him to pose and solve problems of literal description. From this, as Morris has put it, the notion evolved "that an accurate rendering of what was 'real' fulfilled the possibilities of fiction." He saw photography, in other words, as a synthesis—a drama combining the apparent duality of fact and fiction.

As a photographer, Morris was more akin to the documentarians of photography's earliest period than to the contemporaneous social propagandists of America in the 1930s. Throughout much of the nineteenth century, photography was viewed as a kind of "self-operation" art, in which the photographed object and the object itself were identical.

Wright Morris, *Straightback Chair, Home Place*, 1947
Private collection

Most photographers still act as though their pictures make factual statements: "This is a wall"; "This is a stove"; "This is a chair." Once one has recognized that photographs have their own meaning, however, they become open to several not mutually exclusive interpretations.

Morris reveals his approach to photography, and indeed to fiction, in his recent novel *Fire Sermon* (1971). In it, he focuses on a young boy, who, after observing the household of a relative, is eloquently described: "He brought so little to what he saw, he saw what was there." This is an identification of what exists with what is seen, and is characteristic of the demanding approach of the documentary. It requires a balance between the contextual environment of the photograph and the photographed image, so that the picture projects its contents directly and can be read simply, even by the inexperienced. Morris aligns himself with a few photographers of his generation: Walker Evans, Russell Lee, and perhaps to a lesser extent Paul Strand. A similar approach can be seen in the earlier work of Eugène Atget and, more recently, in that of Diane Arbus and Robert Adams. These photographers do not abandon or deny artifice, but they aspire to suggest absolutes beyond it.

Early in his work, Morris was not far removed from certain straightforward pictorial documentarians, like Minor White, who with Morris and others were shown in a revealing thematic exhibition at New York's Museum of Modern Art in 1941 titled *The Image of Freedom*. These photographers of the late 1930s rejected both the Social Realism of the Farm Security Administration school and the Stieglitz-Weston aesthetic. They had moved toward a pictorialism devoid of the tricks or charms often associated with the 1920s formalist style and concentrated more explicitly on human values. After about 1941, Morris turned to photographic problems even further removed from pictorialism; that is, he found his true métier in the specificity of things themselves. His photographs of this later period were taken at close range, unemotionally; they were almost gritty in their texture, insistently factual, and they reflected Morris's increasing concern with the vernacular artifact.

A photographer can minimize the pictorial by stressing the subject of his picture, its factual presence, and its identity with a social environment. The finest documentary photography offers us a picture that is organically unified around a subject. This controlled unity is the key to Morris's work. His images are not tempered with sentimentality but restrict themselves to recording the qualities of the subjects. By

examining the work of Walker Evans, who had published *American Photographs* (1938) during the time Morris was working, one can compare varying states of passivity and activism. In their quest for realism, both men take a static, frontal approach to their subjects; but the self-conscious frontality and framing of a Morris image exploits the fragmenting properties of photography. By calling attention not only to the arbitrariness of angle but to the edge of the picture, Morris refers to the world outside the limits of the picture. One is made forcefully aware that the rooms of the Home Place extend beyond what is pictorially presented, that a world exists beyond the world of the image. It is not the naturalism of the image that provokes this awareness but the degree of stylization in the picture. Morris does not glimpse reality, but he stares at it and, when at his best, lets it reveal itself.

Although Morris's photographs are part of his artistic development as well as part of the history of American photography, their intrinsic values remain. His two photograph-text novels, *The Inhabitants* (1946) and *The Home Place* (1948), are landmarks of their genre, brilliantly exploring a most complex form. In these books, pictures and fiction confront one another on opposite pages. They are described by some as "novels-cum-photographs"—most readers have found that the photographs "crush" the prose. But Morris never intended to harmonize the fiction and the pictures as Nancy Newhall and Paul Strand harmonized them in *Time in New England* (1950). Rather, he forged a kind of counterpoint out of the intrinsic characteristics of each medium in order to go for a larger statement. By juxtaposing picture and text, he set out to make each more, not less, than it was alone. He wanted to capitalize on the uniqueness in each. A comparison may be made to the James Agee–Walker Evans volume, *Let Us Now Praise Famous Men* (1941). In combining pictures and text, Agee and Evans used a classic, separatist format. The pictures here are separated into two "books"— all pictures together, then all text. In Morris's books, we do not read the photographs as illustrations nor the text as elaborated captioning. Morris uses words to describe the world that the photographs allude to, a world omitted in the pictures. The prose and the pictures are designed to function as a single unit.

Recently, in *God's Country and My People* (1968), Morris has again used his photographs in conjunction with his prose. While highly autobiographical and refined in form, this book strives to provide examples of what might be salvaged for another generation. Morris exhibits his confidence in the timelessness of his approach to photogra-

phy and to the photographic object. Nostalgia is not an issue. Instead, in this latest volume the photographs provide a checklist of the significant values that comprise the continuing American experience.

PHOTOGRAPHY AND REALITY/A CONVERSATION BETWEEN PETER C. BUNNELL AND WRIGHT MORRIS

WRIGHT MORRIS: Peter, let's work around your idea of the photograph as a mirror and some of the modifications you made in playing with it. The mirror is one of the durable and inexhaustible metaphors we use in the interpretation of what we think constitutes reality.

PETER C. BUNNELL: The nineteenth-century way of looking at the photograph was as a mirror for the memory, and at that time the photographs almost looked like mirrors, with their polished, metallic surfaces. But really the photograph presents a kind of reality that isn't a mirror. It reflects yourself. You see in the photograph what you are. You recognize content only as you have ability to identify and then to interpret.

WM: To what extent do you feel that might have been a reasonably common impression in the nineteenth century? Weren't most people overwhelmed just by the seeing of the self? Didn't they see the standard daguerreotype image as an object reflecting reality?

PCB: Yes, they saw it as presenting the facts. Talbot's book, published in 1844, was the first to be illustrated entirely with photographs and it was called *The Pencil of Nature*. The image seemed to engrave itself without intervention. In effect, I think they didn't interpret at all. I think they saw in the photograph what they would look at in some of yours: the artifact, the thing itself. Only later, after the daguerreotype process was superseded by more manipulative processes and the potentiality of altering the picture was known, did the idea of the photograph as a new object really come into general understanding.

WM: Was there anyone preceding Atget who seemed to be aware of the possibilities of transposing what is commonly accepted as the actual over into a possessed object separate from a mirror reflection? What about the French photographer [Nicéphore] Niepce?

PCB: There were hundreds of photographers who saw, as you did, the possibilities of transposing reality, but most of them are anonymous today. I think we must look for schools or bodies of photographic works rather than individuals. I've always felt, for instance, that in American

daguerreotypes—specifically in the portraits but in photographs of objects as well—the clarity and precision indicate that the photographers sensed a joining of process and object. There is always this sense of moving toward a more pictorial sensibility, where the photographic object supersedes in effect the fundamental integrity of the subject photographed.

WM: The inclination is always to supersede.

PCB: A lot of daguerreotypists didn't know that they were doing this. Their early manuals are fascinating because they told you everything. They are cookbooks. They told you how to get to the point of making one of those pictures but never what to make. In a way, they really had no other option than to respect the integrity of what they took the picture of. It really was only later that they began to see for itself what they had made.

When did you first know of Atget, Wright?

WM: I think I saw my first Atget photographs in 1939 or 1940. An art editor from the *New York Times* gave me a group of them. I had had this little show at the New School for Social Research that he had seen, and he asked if I would be interested. There were hardly any prints of those photographs available at that time, and I had no sophistication whatsoever. But I did know of Atget, and yes, I wanted the photographs. It happened to be a marvelous group, just a marvelous group. It absolutely startled me that anybody should be seeing in such a manner at that time. That sense of being plagiarized before you are born is very tiresome!

PCB: But were you conscious after that time that Atget influenced what you were seeing and doing?

WM: He gave me reassurance and a sense of persistence. Now I think that maybe five of those first pictures may have been portraits of women, his whore series, you know, which were extraordinary because they were so absolutely, beautifully detached and yet so good. The person is there, the situation is there, and they provided an effect of extraordinary bleakness by their sepia tone in contrast to the Paris atmosphere: it's blood-chilling. And then there were a couple taken out in the woods. There was one of a tree. I also had a picture of a tree and roots; and I felt, given the circumstances, Atget's was a picture I would have taken. That simultaneous existence at different times of the same sensibility

has always fascinated me. What I later came to was a kind of metaphysical conviction that we really don't possess anything—we are merely the inheritors of a sensibility that moves among us. This awareness of a common sensibility gives the reassurance that I think we seek in immortality.

PCB: The photograph has a strong sense of that, of immortality. In the introduction to your Venice book, *Love Affair: A Venetian Journal* (1972), you talk about salvaging the experiences of the city. This suggests the transitory nature of the thing itself and that the photograph serves to salvage, to monumentalize, to make permanent.

WM: The word *salvage* is quite misleading and needs to be taken out and honed and broken down and reconsidered. Like any writer, I fall into a period when a word seems fresh and I grab onto it and it's gratifying, and then I wear the word out, and I come back to it, and I say, this word is bearing the burden of half a dozen other words and I don't like it so much anymore. I'm beginning to have that feeling about *salvage*. I am just about prepared to turn it in for a retread. I am about to fall under the persuasion of my own rhetoric, so to speak; but it has an origin in an impulse that is authentic.

As an American of a certain period, I have built into me a certain sensitivity to "the arrears of our culture." I have an instinctive rejection of the fact that we constantly replace. We can speak of this habit as destroying or we can speak of it as progressive replacement, but I don't like it. There is operative in me an effort to put back the sand pile after the water has come in and washed it away. But that tendency does not serve as a real point of motivation. It is merely one of a variety of responses. When I use the word *salvage* in too general a way, I allow myself to oversimplify and turn what is a very complex relationship with an artifact into something that is quite misleading. If somebody says: Really, man, you're just trying to hang onto things that naturally have to be replaced; a kind of nostalgia mania and, basically, although this has a certain attraction and will keep you preoccupied when you're not suffering from migraine, it really leads nowhere; and furthermore it does not constitute what your photographs really seem to be concerned with—I would have to say: Correct. Nostalgia is merely one ingredient.

Only at a certain point am I concerned with a holding action. You remember the Beckett quotation in the front of *God's Country and My People*: "From things about to disappear I turn away in time. To watch them out of sight, no, I can't do it." That speaks deeply to me. Very

deeply. We're dealing here with the zeitgeist. Perhaps everyone in this century is insecure about the persistence of the past. But there is something different too. In all artists, there is something operating deliberately that is ordinarily concealed. I think there is present in any construction an effort to replace what is disappearing. I think it is like the replanting of crops.

PCB: Is the photograph the replacement?

WM: No, I'm thinking simply of any act that is imaginative or creative. That act appears simply to emerge, out of our nature. I am myself convinced that the imaginative activity is organic and that the mind thinks just as a plant gives off buds, and that the depression of the faculty inhibits man and destroys something basic in him. It is an absolute necessity for the mind, like the hands, to replace what is wearing out, to replace the cost of living. We can think and talk about art, talk about all its infinite labyrinthine experimentation, and forget that it comes out of this need to hold on to what is passing. The artist says: "Don't give up! Keep ahold!" Now the photograph cuts through the aesthetic of some of the more inwardly turned and inwardly developed crafts—like, let us say, contemporary painting. Just as writing resists some of the worst forms of erosion, I think photography resists them too. With both photography and writing, beyond a certain point what you do just isn't comprehensible, and you have to come back to the point of departure.

PCB: You mean that the photographs and writings are alike in that both are things in themselves and also refer to a reality aside from themselves?

WM: These two sides of photography are something of a mania with me, and I've repeatedly talked about it. There's even a passage in *Love Affair*, if you remember, about giving up one picture to get another. That was as tactful a way as I could find to say that the camera is the first obstruction between us and experience. I think this is both subtle and almost inevitable. When you begin to be lens-oriented, the object itself is secondary and you wait to see later what it is you've done. On repeated occasions, I have been very vague about what I have done, knowing that I'd see later, or I wouldn't see at all, why I had taken the picture. I waited. I *had* had a shock of recognition, but what it was, I would learn later.

And sometimes I have learned from the photograph—that is, in the photograph I frequently learn the possibilities of the photograph. That is what happened, precisely, with the intrusion of my shadow in the picture of the Model T Ford. In the foreground you can see the shadow of the photographer and his camera between the edge of the picture and the car itself. At first I wanted to eliminate that shadow. It was a distraction toward which I had no ambivalence at all. I just wanted to get it out of there, and unable to get it out satisfactorily, I put the picture aside as one I was not going to try to get into the book I was writing. It became a kind of secondary picture. Then coming back, about three years later, I saw that picture for the first time, and I said: Well! and I looked at it and I attempted to make an adjustment to the variety of impressions I was having from it. Gradually, it began to win me over.

PCB: In the farmhouse picture there is exactly the same kind of intrusion. The photographer's hand and his box get between us and the haystack and house that are the subject of the picture. That was made in 1940.

WM: I'm in sympathy with what I learn from the scene itself, and I do not reject what I found in that picture, saying: My God, there's another intrusion! We'll just cut it off up here.

Under different circumstances something like this could have led me into a very different area of photographic experiment. But obsessed as I was with my material, I thought of it only as an incident. The possibilities and the limitations of photography can be almost summed up in this type of encountered reflection. If you are a photographer, you are obsessed with some concept of actuality. You do not want to diminish the essence of your statement, and then gradually it comes upon you that you are working as a picture maker. And so you have to reconsider and become a little less inflexible about what the medium really should be doing. At first you think you have rather clear ideas about this; it is the so-called straight photography approach. Getting away from that would have taken me considerable time, although it was inevitable—if I hadn't been diverted by the demands of writing. I did not at that point have to make the next step photographically because I was completely preoccupied as a writer.

PCB: Does anything analogous occur in the writing? Do you face that shadow image when you are writing fiction?

WM: Yes, the problems of the craft of fiction are not necessarily concerned with the intrusion of the writer, but they are similar in that the writer must move from one level of dealing with his experience to another level. I've never had to deal with the craft of photography as with writing, however, because by the time I reached the end of that first photographic statement, I was faced with a do-or-die challenge to simplify and make my way as a writer independent of my photography.

PCB: You began your career in the 1930s, and anybody who had to live through that period unfortunately acquired a kind of Social Realist tag. You got it, but I don't think it is applicable, even though you must have been aware of the realistic photographic activity of agencies like the Farm Security Administration. Did you meet Roy Stryker of the FSA and offer to go out on tour, taking pictures of the country as they hired photographers to do in those days?

WM: I was prepared to lay my hands on money if I could. I went to see Stryker, though I had at that time begun to be reasonably suspicious of his eye. He looked through a portfolio I had brought in—flipped through the pages the way a man does who has looked at too many photographs—and commented that the sort of thing I was doing was not at all what they were doing in the department. I said I knew that but I simply wanted to show him my stuff.

PCB: Were you ever in fact primarily concerned with the social implications of your pictures?

WM: I still have this problem. The similarity of my subjects—abandoned farms, discarded objects—to those that were taken during the Depression, and were specifically taken to make a social comment, distracts many observers from the *concealed* life of these objects. This other nature is there, but the cliché of hard times, of social unrest, of depression, ruin, and alienation, is the image the observer first receives. Perhaps it can't be helped. All, or most, photographs have many faces. The face desired is revealed by the caption. I do not have captions, but the facing text reveals the nature of the object that interests me: the life of the inhabitants whose shells they are, as Thoreau said. The social comment may well be intense, but it is indirect, and not my central purpose. These objects, these artifacts, are saturated with emotion, with implications, toward which I am peculiarly responsive. I see many of them as secular icons. They have for me a holy meaning they seek to give out. Only a few, of course, speak out with this assurance, but if the observer

is attentive he will be attuned to my pictures and how it is they differ from most others. Once that is clear, they do not need captions. He is open to the same responses I am.

Although that problem is always present, the photo-text confronted me with many others. Chief among them is that some people are readers, some are lookers. The reader becomes a more and more refined reader, with less and less tolerance for distractions. In my own case, I cannot abide illustrations in a good novel. They interfere with my own impressions. The pictures I need are on my mind's eye. Now the relatively pure *looker* will subtly resent what he is urged to read. He wants all *that* in the picture. Each of these sophisticated specialists resents the parallel, competing attraction. As you have pointed out, Peter, the photograph requires a "reading," as well as a looking—its details scrutinized in a knowledgeable manner. In my case, this was a crisis. If the photograph overpowered the text, or if the reader treated the text lightly, I had defeated my original purpose. It was also crucial for my publisher, who considered me a novelist. *The Home Place* was well received, but pointed up this dilemma. I was losing readers, picking up lookers. Several reviewers asked why this ex-photographer was writing fiction. There was only one way to clear this up. Stop the photobooks. And so I did.

PCB: What was your present publisher's motivation in coming back to the photo-text book?

WM: Me. I was on the verge of changing publishers, along with my editor, and I used the occasion to slip in *God's Country and My People*, a reconsideration and reappraisal of my photographs.

PCB: In *God's Country*, you use the same photographs that are in *The Home Place* plus obviously more. This is a different, explicitly autobiographical kind of text. Could the photographer's shadows in some of the photographs be a kind of self-portrait presence like the autobiographical text of *God's Country*?

WM: You are getting very close to why I felt it necessary to do that book, and why I did it in that manner. It's a reconsideration of material from a later point in time, using essentially the same techniques and the same body of photographs. It was the quality of the repetition that was necessary to this book. Both the writing and the photographs undergo a sea change in the overview taken by the writer. I didn't know what

problems I would have with readers who understandably might take offense and say: What is he doing in repeating himself! But I couldn't go out and make a new world for myself to photograph, and it wasn't advisable. This is a revisitation. In fact, a repossession. But there weren't enough such readers to make any difference. Nobody raised this problem at all.

PCB: Now that you are back in Nebraska, in a real revisitation, you must be challenged to deal again with things that you dealt with before, after, through another point in time. One might ask: Why doesn't he try to find out if the values he tried to exemplify in the barber pole of 1940, say, are really of value now? What is Nebraska now? In other words, what does a writer and an artist who has this time span do? It's something that a person my age can't answer.

WM: I think this is not only a number-one problem for me, I think it's also a number-one problem for people of your generation. There is a diminishment of value in the artifact itself, and there is a limited way in which a photographer can deal with the diminished values of the contemporary artifact. There is a statement to be made about them, but it will be relatively shallow, soon exhausted. Young photographers, of course, orient themselves toward this problem much more positively, but I think aesthetically they face the same problem that I am aware of, the poverty of significance in the artifacts themselves. And when I come back into this old environment, I am startled by the relative richness of the old and the lack of it in the new. We call it progress. We make it new, but we do not love what we make.

PCB: Judging from a photograph of your own house, you are not yourself much of a collector. I mean your house doesn't seem to be filled with artifacts, with objects. You don't seem to need things, however much you describe and photograph them.

WM: What photograph did you see? Our house is bulging, but it's not a museum. Our friends get a contrary impression—or is it the difference between the actual room and a photograph of it?

PCB: Here is a reinforcement of a kind of parallelism and divergence that I was setting up between yourself and Walker Evans. Evans collected like a maniac. When he photographed the soda pop sign in Alabama, he brought it back home with him. The photograph transformed it and he knew that he dominated it. Though he loved the sub-

ject, it wasn't of interest to him in his art. The picture was important, not the subject of the picture. So he brought the sign home. Look at a photograph of his place and of other photographers', and you find more than just lived-in clutter. They're surrounded by collectable artifacts, actual things. You are not.

WM: I'd say it works in reverse with me. If I have the photograph, I can dispense with the artifact. The mobility of my life has made it impractical to hold on to more than books. But not showing in the photograph of our living room is an entrance and a hallway, which have a group of my photographs. They constitute artifacts. In a sense they hang there by accident, not design. They were framed and put up for a Guggenheim exhibition; and when the show was over, they were sent back to me. Now it fascinates me that Evans would have had a need to latch onto actual artifacts. It's idle for me to speculate, but I wonder if there's a difference in our backgrounds. Was he mostly a city man?

PCB: Yes.

WM: I think that would make a big difference.

PCB: I don't mean to say that what he collected was necessarily remnants of Alabama tenant farmers' houses. He was a great Victoriana collector—paperweights, and white marble—bric-a-brac I guess you'd call it. Coming back to Nebraska now, have you gone or have you any inclination to go back to these places that you lived in and photographed?

WM: My God, yes. But our car was banged up soon after our arrival, during the period we had both the time and the weather. We did get over to Central City, my home place, with the local television people; incidentally, they are doing a piece called *Repossession*—we will see if it works. The Home Place, lock, stock, and barrel, was bulldozed out of existence in the late 1950s. Nothing remains but what we have in the book, which does speak up for salvage. For a few days, I did take a few pictures to see if there was a change in my way of looking at similar artifacts. But it was not noticeable. Much that speaks personally to me is still around, but I see little that is new that attracts me. I assume that younger photographers see it differently, but local work that I have seen is past-oriented, reflecting the vogue in nostalgia and "antiques." I sense there is a quandary in what they should "take." And if they take *that* today, what will they do tomorrow? The vast number of photographers,

feeding on anything visible, overgraze the landscape the way cattle over-graze their pasture. As in the novel, there is overproduction and under-consumption. You would know about this, and I wouldn't. In the way of *artifacts*, which is close to my experience, what is it that the young photographer loves?—or that he hates to the point of revelation? Revealing what that is is the one thing that still doesn't come with the camera. Or will that be next?

Originally published as "The Photography of Wright Morris: A Portfolio," and "Photography and Reality/A Conversation between Peter C. Bunnell and Wright Morris," in *Conversations with Wright Morris: Critical Views and Responses* (Lincoln: University of Nebraska Press, 1977).

ROBERT FRANK'S
FOURTH OF JULY—JAY, NEW YORK

Certain of Robert Frank's photographs hold a position in contemporary photography analogous to Jasper Johns's works in contemporary painting. Both artists approach their medium as a forum for problem solving and both are strongly rooted in the form/content structure of pictorial representation. In photography, the issue of the integration of form and content is exceptionally difficult because of the widely held belief that photographs must be a kind of vicarious experience of the subject itself. How something is pictured is frequently ignored in the crush of simple identification, and photographs tend to be treated scientifically as factual statements. To appreciate Frank's work, one must disregard this misguided interpretive practice, because his photographs are overtly symbolic and very skillfully composed to reinforce contextual meanings.

Frank seeks to minimize the obviously pictorial in his photographs by stressing the meanings of his subjects rather than the subjects themselves, and it is the identity of the subject in relation to its broad social environment that he strives to express. In formal terms, his pictures are organically unified around the expressive subject, but Frank rejects the static, frontal approach that was the hallmark of his most sympathetic predecessor, Walker Evans. Instead, Frank exploits the fragmenting properties of photography by calling attention not only to the arbitrariness of the camera angle and to the edge of the photograph but, precisely because of this, to the world outside of the picture's limits.

Fourth of July—Jay, New York is an image that, through all the nuances of its representation, displays and evokes an immensely complex view of American society. The purposefulness with which he incorporates this statement in the tattered and transparent flag is convincingly profound. So are the spatial planes and layers of meaning within the photograph, such that the picture exists simultaneously on multiple levels—the first is the photographic object proper, the second and third are the successively intertwined intellectual and physical layers of the participants in the celebration, of the flag and the ambiguous space in which it exists, and finally the space through it and that which is implied beyond. So subtle is this combination that our immediate experience is

Robert Frank, *Fourth of July—Jay, New York*, 1955
Courtesy Pace/MacGill Gallery, New York

first of the simple and picturesque whole and only later of the total symbolic drama.

This is a photograph about ritual and ritual attitudes. Like all of Frank's work of this period, it is tempered with the sharp nonobjective eye of a foreign observer. In every instance where Frank has used the American flag motif, he is commenting on the literal fabric of American society. He is picturing the fundamental politicization of this society through the image of its social emblem—the flag—suggesting with this symbol everything from individual sentiment to collective conduct. Frank is critical of his American subject, and he knew he was not an innocent abroad, as only one reading of his book *The Americans* (1958) shows. In this picture, we perceive his attitude with regard to American tradition and values as uniquely represented by this particular flag. Consider, for instance, its transparency, its torn and patched composition, and the fact that he has not shown the whole flag—omitting several of the stars or states. In Frank's act of selection, there is an expression of purposeful intent rarely felt in photography. Knowing that experience is indeed a matter of tradition, in collective existence as well as private life, Frank is the heir of certain nineteenth-century photographers who scrupulously depicted everyday life without idealizing it. This particular photograph comes very close to being a masterwork of photography, assuming that one feels, as I do, that this concept is applicable to works in this medium.

Originally published as "*Fourth of July—Jay, New York* by Robert Frank," in *Print Collector's Newsletter* 7 (July–August 1976): 81.

LISETTE MODEL

For the past twenty-five years, the photographs of Lisette Model have been more talked about than seen. Represented in few public collections—most notably that of the Museum of Modern Art in New York—her large, commanding prints have been dear to those lucky enough to have them or even to have seen them. This fact reflects circumstances that are as much a mark of Model's personal idiosyncrasies as they are of her unorthodox and penetrating vision. She was recognized exceptionally early in her career, and some feel perhaps her acceptance was acquired too suddenly and too forcefully, diluting the poignancy of her statement and reducing her desire to more fully enact her historical fate.[1]

Model first began to photograph in Europe in 1933 and she immigrated to this country in 1938. She was not only encouraged but quickly promoted by numerous members of the New York photographic community—among them Ralph Steiner, Edward Steichen, Ansel Adams, Beaumont Newhall, Berenice Abbott, and Paul Strand. It was Alexey Brodovitch who, grasping the emotional precision of her work, hired Model as a freelance contributor to *Harper's Bazaar*. From 1951, Model taught at the New School for Social Research in New York, where she became something of a legend for the passionate character of her teaching.

What links all of Model's activities, and what her students have been drawn to in her work, is not so much a comprehensive theory about photography as an inspired approach to its problems and aims. For many, her most notable student was Diane Arbus, but hundreds have attended her classes, and she is one of the few teachers of photography to be described as exemplary. While not a prolific worker, Model has a very deep understanding of the medium and this apparently has sustained her. "Only the teacher who has himself been fulfilled through his medium," she has said, "is capable of putting another student in contact with himself."[2]

The book *Lisette Model* (1979) is an exceptional achievement in publishing. Its very existence attests to the patience and perseverance of the publisher in dealing with this sometimes recalcitrant artist. By

Lisette Model, *Coney Island Bather, New York (Standing)*, ca. 1939–41
Princeton University Art Museum; Anonymous gift

respecting her work in its large format (generally 20 by 16 inches) and by mirroring this fundamental stylistic quality in a folio-sized book, the publisher has given us a rare opportunity to truly feel the impact of these photographs—their gritty and gutsy quality. The physicality of Model's work has always been one of its most distinctive hallmarks. Had this not been echoed in the publication, much of what this emotional artist stands for would have remained a mystery to newly attracted viewers. The quality of the reproductions suitably reflects the originals and—apart from a niggling feeling that the few pictures that the designer, Marvin Israel, spread across the gutter might better have been printed singly on a page—the whole book is alive. The work literally vibrates with Model's near-clinical vision. The anonymous portraits, especially, remind one of full-scale x-rays unceremoniously exposed and clipped to a light-box awaiting the surgeon's diagnosis.

These photographs will probably be considered by many unfamiliar with them and their origins to be rather contemporary, but this is only because certain characteristics of her style—some notably grasped and expanded by Arbus—have given us a generation or more of photographers whose work reflects back to Model and even her predecessors. The landscape today is littered with knockoffs of their work. Model's selection of subjects and her articulation of the formal aspects of her pictures derive from the work of the decade immediately preceding the date of her first attempts: the German and Russian work of the 1920s, with its belief in naked fact, its belligerence toward class and status, and its defiance of the gentility and obfuscation of art. Her large, coarse prints reflect that spirit of the 1920s, during which "straight" photography was espoused to challenge the prevailing notions of what constituted art, especially those criteria of the aesthetically oriented pictorial photograph.

Most of Model's best photography further reflects an earlier period because it deals with the human condition—whereas the prevailing motif of today's work might be described as one of image structure that deals primarily with itself. The human-condition photograph can be read and to varying degrees appreciated. A syllabus is not required. The other style cannot be read in the same context. The image-structure photograph intends to teach, but through another mode of explication.

Model's photographs hit her prewar American audience hard and elicited strong opinions from the very beginning. She was, for instance, notably linked with but contrasted to Lewis Hine. Commenting on

Model's work exhibited at New York's Photo League in 1941, Elizabeth McCausland wrote: "The scorn and hatred of the photographer are directed not against the human victims but against the social forces which victimize them. . . . Lisette Model has gone . . . beyond the stage of those who can merely scorn; she hates with an active lens. The purpose of this hate is to purify and scourge. Beyond this stage, of course, there is a further philosophical position, where an intelligent love of humanity is possible. One may say that in ages of crisis, hate is love turned inside out."[3] This remarkable observation pinpoints Model's philosophy precisely. McCausland clearly articulates the attitude about aims and goals that Model as teacher later surely gave to Arbus. Arbus's photographs, made during the tumultuous decade of the 1960s, were based on the same perception of love and hate.

The large format of Model's pictures and the fact that most were made from a 2¼-inch-square negative were aspects of their uniqueness perceived when first shown. Today it is hard for us to recall the spirited debate conducted before World War II concerning the technicality and aloofness of candid photography and the controversy between the use of the large-format camera and what was called the "minicam." Model's images were praised for their capacity to reveal more, to express a sense of confrontation, and to embody a space or environment in which the subject existed; in short, these were *pictures*. Pictures with an unfragmented viewpoint and a holistic composition. But belief in this sort of work was limited and declined further in the late 1940s and in the '50s, when the miniature camera and the journalistic approach became dominant. However, interest in a larger-format approach to a kind of photography vérité revived in the early 1960s with photographers such as Arbus. She turned from the 35mm camera to the reflex camera in her courageous attempt to make images of a more self-conscious sort rather than simply to capture on film a vignette of the observed features of those whose lives she had entered and whose humanity had become her own. One recalls the frequently heard comment made after Arbus's work became widely known in the late 1960s that she "had taken the camera away from the sneaks." Implicit in this observation is a quality in her work—as in Model's: the expression of a realized moment of truth between the photographer and the photographed.

NOTES

1. Model, born in Vienna in 1901, moved to the United States in 1938; between 1940 and 1955, her photographs were included in nine exhibitions at the Museum of Modern Art.

2. Model, in Mary Alice McAlpin, "Lisette Model," *Popular Photography* (November 1961): 52–53, 134.

3. Elizabeth McCausland, "Lisette Model's Photographs," *Photo Notes* (June 1941): 3–4.

From *Print Collector's Newsletter* 11 (July–August 1980): 108–9.

DIANE ARBUS

The careers of artists do not always end with their lives. The posthumous fate of Diane Arbus exemplifies the way in which posterity can transform the artist's stature and the significance of his or her work. Prior to her suicide in the summer of 1971, Arbus was not what could be termed a well-known photographer. She had a certain reputation, which, in terms of the profession of photographer, was based in part on her commercial work. In the late 1960s, she had published pictures, sometimes representative of her best and most serious work, in such publications as *Esquire*, *New York Magazine*, *Harper's Bazaar*, *Show*, and the *New York Times Magazine*. However, she was reluctant to contribute to photography journals or to participate in exhibitions; most people, including even her friends and colleagues, knew only a fraction of her total output. She was also loath to become a professional talker (teacher) about photography. Since her death, her work has been included in the 1972 Venice Biennial—she is the first American photographer to be so honored—she has been given a retrospective exhibition at the Museum of Modern Art in New York, and a stunning monograph, *Diane Arbus* (1972), has been devoted to her photographs. It is questionable whether she would have participated in any of these endeavors had she lived.

Diane Arbus was a photographer of great originality and even greater purity, who steadfastly refused to make any concessions whatsoever to her public. Clearly, she must be considered among the two or three major photographers of the last decade, and it may be said that the character of photography has been changed by her photographs. The influence of her work, though most likely not the understanding of it, will increase each year hence. The young photographer of the future will find in Arbus's work the sources of a new modernism as well as the portents of a personality cult. But as with the photographs of Alfred Stieglitz and Edward Weston, her photographs can withstand such markings.

When Arbus's photographs were first exhibited in New York in 1967, she was forty-four. She was not born into the world she photographed. She came from a comfortable New York Jewish family headed by David Nemerov, who owned a once-successful Fifth Avenue

Diane Arbus, *A Jewish giant at home with his parents in the Bronx, N.Y.,* 1970
Princeton University Art Museum; David H. McAlpin, Class of 1920 Fund

store. Her brother is the poet and critic Howard Nemerov. She was educated at the Ethical Culture and Fieldston schools. At eighteen, she married Allan Arbus, and together they became successful fashion photographers. In 1958, Diane abandoned this sort of photography and a year later studied with Lisette Model, that remarkable photographer and teacher whose work remains much less known than it should be. It was Model, whose own photographs show the inspired vision of an artist of fundamental human concern, who imparted to Arbus the understanding that in the isolation of the human figure one could mirror the most essential aspects of society—the understanding that in a photograph the most specific details are the source of the most general conclusions. Out of this experience, Arbus moved from the unreal world of high fashion to a world composed of people who may seem unreal, or tragic, but whose culture is unfortunately interpreted through the mores of another. It is this—the configuration and imposition of a society's values—that is the root subject of Arbus's photographs.

Since her first major exhibition at the Museum of Modern Art in 1967, a show that was directed by John Szarkowski and titled by him *New Documents*, the work of Diane Arbus has been considered in the context of documentary photography. In that exhibition, she showed with two others: Lee Friedlander, whose precisely structured street views were seen to depict a new social landscape, and Garry Winogrand, whose seemingly unstructured photographs were nonetheless based on the strict logic of environmental circumstance. Many observers of this exhibition mistakenly compared the work of these three to that of men and women of the Depression era who, according to the narrow definition of documentary photography, attempted in their photographs to show actuality and subsequently, through their photographs, to alter the course of events. Or to put it another way, to improve and suggest social change. Materialism was perhaps the identifying concern expressed in this photography of the 1930s. In contrast, the 1967 exhibition sought to show that these new documentarians, if indeed that is what they should be called, were interested in the redefinition of the freedom of contemporary life and focused on human concerns more complex than material station alone. They portrayed the nature of anyone's daily life, and the subjects of many of their pictures had not been considered meaningful for photography before. These photographers stated the distinguishing characteristics of that quality we call *modernity*. Their work was often ephemeral, violent, weird, excessive

with that acrid bouquet of urban life that, since the nineteenth century, has been associated with the beauty of circumstance and the sketch of manners.

From the point of view of style, Arbus continued the prewar tradition insofar as Walker Evans may be considered to have been a part of it. For Arbus, like Evans, was a portraitist. Her approach was to devalue a person's outer garments and facts and to concentrate on the individuality of the human being with his combined material *and* mental presence. In so doing, she was no longer a fashion photographer, nor was she a documentary photographer. She had entered into the realm of larger truths—of art. One can understand how clear her approach was, even at the start of her career, from this statement she wrote to accompany a portfolio of her photographs in 1962: "These are six singular people who appear like metaphors somewhere further out than we do, beckoned, not driven, invented by belief, author and hero of a real dream by which our own courage and cunning are tested and tried; so that we may wonder all over again what is veritable and inevitable and possible and what it is to become whoever we may be."

In considering Arbus as a portraitist we are allowed many interpretations, and these were also the opinions she consciously manipulated. The popular conception about portraits is that they are ostensibly intended to show what someone looks like, and that they are truthful. We know they also tell about people and impart a sensibility of what the person's inner being, or character, is like. But we must not fail to realize that this is a multiple interpretation; the subject's own, the portraitist's, and the viewer's. The portrait exists simultaneously for all three but differently in each case. The individual participants are required to interpret each other by actually asking what they know of themselves. One of the things that disturbed Arbus at the time of her death had to do with how misunderstood her work seemed to be, in the sense that it was thought of mainly in terms of the crudest subject identification with no self-reflection. In terms of the imitators of her photographs, these followers simply felt obliged to seek the bizarre in subject and secure its likeness on film. In so doing, they became even less than documentarians, and their work, because it totally lacks the psychological honesty of Arbus's, is not portraiture. Her suicide will have to rest with our consciousness for a very long time, and even then one wonders if its meaning will be understood. It is clear she was not a voyeur. Rather, she was a partner of the individuals whose true test was in living with themselves. Her pictures are about control, discipline in life, and controlled

accidents in living it. In each case, the people she photographed had made the gesture of life their own affirmation of truth, and they were victorious. Her pictures are not of failures, and immorality is not the well from which these people, or Arbus, found nourishment.

Arbus reminds us of Dorothea Lange, because here was another woman who was uncommonly tough. Each of these women could enter a situation that might destroy many people, and photograph, and then withdraw from the edge. We can sense this in their finest work. In this way, one can also understand something of what Arbus found in certain of her visual mentors: August Sander, Brassaï, and Bill Brandt. In the photographer Weegee, Arbus found not only formal aspects of his work to her liking, but a sense of that rude honesty that marked his relation to subject or situation. The violence he showed was often more physical, but the consequences of the situations in which both Arbus and Weegee found themselves were alike.

Her stylistic development seemed to follow a progression from complexity through simplification to highly complex pictures that seemed, however, deceptively simple. From photographs of people taken from a distance and in an environmental context, to a gradual close-up isolation of the figure or head and an accompanying monumentality through the physical scale of her prints, her last pictures revert again to that security of figures in an inhabitable space that exists apart from the photograph itself. It was perhaps as if, in challenging herself to move away from the type of picture that, since about 1967, she had been identified with, she chose the less dramatic, the less capable of imitation.

Arbus's photographs are superb accomplishments reflecting total control of the medium. Her concentrated work spanned a relatively short time, only ten years, but she seems to have sensed the primary hallmark of her work from the beginning. The intense, calculated frontality of her subjects affects us immediately. In this sense, her pictures are almost clinical, like Vesalius's anatomical drawings, and their heroic scale, many almost sixteen by twenty inches in size, causes them to embrace us. It is literally true that when we read a photograph we are in it. We may be drawn in swiftly or slowly, but once we are there we are enclosed. It is the power of the photograph, and its success, to interest us in this way. As any viewing of the original prints will prove, Arbus's pictures are very difficult to stay out of. In fact, it seems to me, what disturbs people more than the subjects of these pictures is the intensity of their power to dominate us, to literally stop us in mid-life and demand that we ask ourselves who we are.

For the collector of original photographic prints, Arbus's work represents a fascinating illustration of aspects of the photographic medium. Save for the pictures she had casually given to friends and colleagues, and the relatively few in museum collections, her estate constitutes the bulk of her life's work. But as is so frequently the case in photography, Arbus rarely printed more images than she felt she required at any one time. For exhibition, for a purchase, or for a reproduction, she made the required prints. So while the photographic medium is, in principle, capable of unlimited duplication, it is, in fact, the medium in which there are sometimes the fewest prints of any one image. It is hardly worthwhile for a photographer to print an edition, because the possibility of a sale of ten, twenty-five, or fifty is simply not yet a reality. Thus, when one places significant value on the personal interpretation of the photographer's own vision as carried through the printing process, the few prints that may remain at a photographer's death become extraordinarily valuable. Such is the case with Arbus. Judging from the information given by the Museum of Modern Art at the time of its exhibition, of the 112 photographs shown, 39 were printed posthumously. Thus, at the time of her death, many of Arbus's most significant pictures were unprinted, or at least not represented with prints in her own files.

In 1971, she issued a boxed portfolio of ten photographs in a limited edition of fifty. It sold for one thousand dollars, and it received wide publicity. It is understood that only two portfolios were sold. The subsequent value of this work is unimaginable, because it now appears that she did not prepare the complete edition of fifty, but printed each set only after the sale had been secured. Such is the complexity of establishing editions in photography. The estate then offered prints from the negatives printed by Neil Selkirk, who prepared the posthumous prints for the museum exhibition. This procedure of posthumous printing is not uncommon in photography, and this practice could be the subject of a more extensive study than space here allows. One can, however, call attention to the practice of Cole Weston, the son of Edward Weston, to make from his father's negatives quality prints, clearly identified as posthumous printings, and sell them at a fraction of the price brought for one by Edward Weston's own hand. From the collector's point of view, the existence of such prints only serves to raise the value of those prints made by the photographer himself. For others, such a practice will provide, albeit too late, the only opportunity to support, in material terms, Arbus's work.

The photographic negative is what might be described as plastic, so that even though the extreme subtlety of the artist's own interpretations cannot be duplicated, a sympathetic and expert printer can render in posthumous prints much of the sensitivity of the artist's own vision. Arbus herself stated that she did not covet the role of printmaker, but this is not to say that she did not exercise exceptional care and judgment in making her prints. Her prints were indeed unique. Their tone, scale, surface, and composition reflected her vision of perfection and her sense of making of the print an object so photographic that the viewer effortlessly penetrated beyond its borders into the very environment of the subject. Her use of supplementary lighting when taking the picture—that is, not relying on simple available light to render a situation satisfactorily—allowed her when printing to have full control over tonal renderings and more convincingly create that picture space in which the subject may exist.

It should not be considered unfortunate that Diane Arbus's work is colored by the circumstance of her death. Not surprisingly, Arbus's work is now surrounded by a great deal of commentary; the personality of its creator will remain as pertinent as her photographs. Arbus expressed her vision with a unique power. She pushed all the way through to the end logically, emotionally, artistically. One does not need to have seen every photograph she made to admire the courage and purity of her effort, to identify with it, and to recognize the cost. Diane Arbus, and the photographers who constitute that community of serious artists to which she belonged, all affirm Thoreau's declaration "Be it life or death, we crave only reality."

From *Print Collector's Newsletter* 3 (January–February 1973): 128–30.

ELLIOTT ERWITT

Elliott Erwitt's photographs are very straightforward. Comedy, one might say. The recognition of his subjects is swift—dogs, women, trees, birds, buildings, cannons, chairs, gourds. The recognition of juxtapositioning is equally swift, and this is critical. The viewer who places himself into one of Erwitt's pictures will not be protected from experience, but he will be safe from outrage. He will recognize that the expression of this artist is nothing less than our humanness.

The things one chooses to photograph are rather the same (with a similar hierarchy of tradition) as the subjects selected by any artist in any medium. Animate and inanimate objects make their appearance in photographs, but it is the way in which the photographer treats these subjects that gives rise to their meaning. Iconography, considered on its most basic level, has to do with recognition rather than treatment, and, unfortunately, in photography the tendency is to focus on iconographic recognition rather than treatment and meaning. In the work of a photographer like Erwitt, this problem may be clearly seen: it is ostensibly hard to take his work seriously because his subjects are so ordinary. This is nonsense. Their ordinariness is only a feature of their recognition. Even the formal aspects of his picture-making seem deficient to those of limited comprehension.

These functions are not important to Erwitt; that is, they are concerns that do not dominate his thinking. He skillfully centers the interest in his subjects and firmly—critically—determines the edges of his pictures. The edges are all-important, because they circumscribe the juxtapositioning of objects so that interpretation naturally follows. In this sense, Erwitt may be seen as a present-day equivalent to those photographers of stereo views whose work was admired a century or more ago for similar compositional techniques, and for the capturing of the sketch of manners, the beauty of circumstance, and the bouquet of modern life.

In the study of a photograph, one of the qualities that is always felt is the degree to which the intellectual operations have been effortlessly and expertly performed. Erwitt's pictures are a comedy so charming that in order to enjoy it we need not think about how it was

Elliott Erwitt, *Las Vegas*, 1957
Courtesy of the artist

accomplished. Indeed, if his photographs had not been easy to make, they would have been impossible. Photographers are not often considered intellectuals, though sometimes they are praised for their curiosity, but in addition to whatever else it took to make these pictures, it took things mental, a sensibility expertly controlled, the exact like of which is not often seen in photography.

Reinhold Niebuhr has said: "Humor is the prelude to faith and laughter is the beginning of prayer." Given that humor has to do with the incongruities of life that at first seem ephemeral, while faith approaches the ultimate reality that life must end, the photographer is particularly adept at expressing humor. Photography verifies everything, from the most meaningfully wrought to the most contingent. But in so doing, it provides us with a changed measure because everything is recorded with the same accuracy, the same particularity, and the same intensity on a sheet of paper where picture size becomes life size. The photograph itself thus becomes experience. It exists in our time even though all of the action recorded is past.

Throughout Erwitt's long career he has consistently viewed the goings and comings of his fellow men with a sharp intelligence as well as a sharp eye. His bearing is such that it allows him to be ever ready to know when a significant gesture might transcend its own circumstances to enter ours. In this way he is not unlike his fellow huntsman Henri Cartier-Bresson; however, Cartier-Bresson is less interested in the situation that will excite our intelligence than in one that will alter our physical equilibrium. Neither man is a reporter or journalist. For in his pictures, each sacrifices locale for the consideration of values. The fact that Erwitt's photographs were taken in Nicaragua, Venice, New York, or Miami only identifies them; that they were made between the years 1946 and 1968 does this as well. The comprehension required to understand the meanings in them will come through having lived the phenomena Erwitt examines.

Finally, Elliott Erwitt's work is not satire. His expression is conducted without prejudice. He is humbled by his own presence in the larger whole of what he photographs. His pictures are a statement of contemporary life; an examination of certain ideas concerning life on a simple human level, but with a very clear eye to our punctilious conduct. Erwitt characterizes the world he lives in and the only world he knows. He loves the world as it is and that is why he understands it so well; that in turn is why, being the artist he is, he can make it over

again into something so rich and clear. His comic touch, like the magic touch of any photographer, is one that helps us through our realities and our illusions.

From *A Portfolio of Ten Photographs by Elliott Erwitt* (Roslyn Heights, NY: Witkin-Berley, 1974).

EIKOH HOSOE

The nature and quality of contemporary Japanese photography is revealed in the work of a few notable artists, and Eikoh Hosoe is pre-eminent among these. A pivotal figure in the spirited development of Japanese photography over the past thirty-five years, Hosoe is an international figure whose work has brought, to himself and to his country-men, the admiration and respect of others in the community of expressive photography.

Postwar Japanese photography is a combination of national traditions and values mixed with external influences. Beginning in the 1950s, Hosoe was a key contributor to the formation of a new expressive style that emerged out of an older Pictorialist school and against that of a realist documentary preoccupation characterized by the work of Ken Domon. Influenced by the American notion that photography could be a medium of personal orientation, one reflective of individual experience and feelings in ways beyond mere depiction or journalism, this new philosophy of picture aesthetics slowly gained a foothold in Japan. Younger photographers like Hosoe, who was born in 1933 and matured after World War II, championed these new concepts.

Through their work, these photographers drew attention to themselves as idiosyncratic artists, but at the same time they were concerned with a unifying legacy, which was their common experience of the war and, in particular, its barbaric conclusion at Hiroshima and Nagasaki. This emotional wrenching of conscience and psyche is felt in the efforts of all the photographers working in the years since 1945; whether their focus is on the external happenings as traced in the physical environment, in the social order, or in the mutilation of the Japanese men and women themselves. It is a curious irony that the photographic artists who would guide the Japanese photographers came from the very nation that had placed so ghastly a burden on them. But Japanese artists like Hosoe recognized the opportunity that a sophisticated use of the photographic image offered. This they saw as a positive feature of the postwar American influence and, as a result, they felt the possibility of a freedom for themselves as artists such that they could become commentators existing outside of the insularity that sometimes marked Japanese society during these years. Their new photography had the

Eikoh Hosoe, from the series "Killed by Roses," untitled, 1961–62
Princeton University Art Museum; Gift of Susan and Eugene Spiritus

power to cause a reconsideration of tradition, to demystify, and also to open the society outward.

Beginning in 1959–60 with his series "Man and Woman," Hosoe has brought us images of startling confrontation and sensuality. This sensuality, and the undercurrent of eroticism, which may be seen as an echo of the primal, is a fundamental part of the Japanese character and culture. One can recognize it also in the contemporaneous Japanese avant-garde theater and dance, especially Butoh. "Man and Woman" is about the very basic excitement between the sexes, and Butoh dancers serve as the models. Breaking new ground and forcefully tearing down expressive barriers, this was Hosoe's debut statement as an artist. It caused a sensation and its import was immediately recognized. "Barakei" (Killed by Roses), Hosoe's next and most famous series (1961–62), is an exactingly allusive and complexly staged drama of pro-found psychological tension. Working with the writer Yukio Mishima, who serves as the primary model, this study of sexuality, presence, and the life cycle is a bizarre blending of the surreal and the baroque. Each pose is choreographed, every photographic technique is deliberately used, and each symbol appropriately selected to carefully foster the work's visual impact and to distance it from the conventional. "Kamaitachi" (1966–69), which followed, is a more direct meditation on Hosoe's own self and experience. It concerns his wartime memories when, as a boy, he was exiled from Tokyo back to the place of his birth, where he felt extreme dislocation. "Embrace" (1969–70) is, in a way, the culmination of Hosoe's serial or narrative works. With nude dancers as models, it is a statement on the human condition, both horrifying and entrancingly beautiful. Using a visual vocabulary of elemental forms, Hosoe speaks of pleasure and pain, difference, aggression, affection, and oneness.

Since 1970, Hosoe has traveled widely, and his photographs made after this date reflect a breadth that is emblematic of a broadened per-spective. Japanese photographers of Hosoe's generation may be divided between those who speak English and those who do not. The latter tend to remain isolated, focused inward on their country and its many repres-sions, while the former use their fluency to give themselves greater free-dom to be more diffuse in their outlook. Hosoe, perhaps the most gregarious and mobile of his generational group, has in recent years redirected his attention to encompass new and differing experiences gained outside of Japan. This may be seen in his extensive study of the architecture of the Spanish master Antoni Gaudí and to a greater extent

in the pictures of the figure in the landscape. Both groups of images relate to aspects of his earlier work. In the Gaudí studies especially, it is clear that Hosoe has responded to the fabulous riot of fantasy in the architecture and to Gaudí's strikingly original expression of the organic. But the feeling for the Japanese idiom is never far below the surface of any Hosoe image. He is an artist with a deep sense of continuity and indigenous tradition and, above all, he has that particular Japanese sensibility toward elemental and physical humanism.

As a Western audience, we may be assured of the pleasure of Hosoe's photographs; their craftsmanship and commanding presence are obvious, as is the sense of their affiliation with works from our own country and our photographic experience during these same years. But these photographs give more. They provide us with a guide to a nation ancient but in transition, and they reveal to us something of the character and feeling of a people with whom we are inexorably bound as with no other.

From *Eikoh Hosoe: Photographs*, exhibition catalog,
Andrew Smith Gallery, Santa Fe, 1990.

TOKIO ITO

The Japanese photographer Tokio Ito's series "Fragment" reveals a quiet, poetic strength. It is a quality unusual for pictures made in New York City, where he has concentrated his attention for the past several years. These photographs focus not on the people of the city, as Garry Winogrand once did, but rather on the most ephemeral aspects of it: light and mood, and the after-reflection of human presence. These are images of unobtrusive moments of intense observation: subtle details of the street, of architecture, of everyday places seen with the eyes of one interested in the blending of the physical and the spiritual.

Tokio Ito's prints are rich in the luxurious tone of the photographic material, with deep shadows that seem to glow in the contrast of the lighter tones, which he mostly renders in shades of gray. Frequently a specular highlight is the only true white in the picture, and as such it draws one to the focus of attention. These prints express a deep sense of curiosity, and of the elation of finding, in an expressive detail, the projection of one's own self in the world.

As a student of the noted Narahara Ikkō, Tokio Ito is well aware of a tradition of the Japanese photographer looking at a city in another country. Ikkō's favored Venice is very different from New York, and so, too, Ito's work is different from that of Ikkō. Nonetheless, it seems to me that the younger artist owes a considerable debt to the brilliant example and approach of his teacher. In the United States, the photographer whose work is suggested to me as similar to Ito's is the Philadelphian Ray K. Metzker. His urban views, focusing on many of the same effects of light, contrasts, and evidences of human presence, are some of the most significant and accomplished photographs made here in the past twenty-five years. However, there is a revealing difference, in that Metzker's sense of the drama of urban life is greater—more American— and his dynamics of the contrast between light and dark tone greater, more intense overall. Ito, on the other hand, impresses one with a kind of mellowness, the satisfaction of an intimacy and simplicity directly felt and not transformed into the graphic exclamation that Metzker achieves. Through this quality, Ito's pictures impress me as so many other things Japanese—a delicate floral arrangement, an elegant calligraphy, an observation of a cloud passing in the sky and casting its

Tokio Ito, *Fragment #73–5*, *New York*, 1990
Princeton University Art Museum; Anonymous gift

momentary veil over the surface of a pebble garden. The conveyance of these qualities of intimacy and privacy of experience in the environment of a great metropolitan city is a testament to an accomplished artist's ability. Such is the ability of Tokio Ito, and this is the nature of his contribution with the series of photographs he calls "Fragment."

From *Rokugatsu no Kaze* (April 1992): 16–19.

MICHIKO KON

Michiko Kon is a photographic artist of compelling originality. Obsessed with the gulf between the mind and the world, she takes up the camera with the relish of one who desires in every way to express the inexplicable. What is real? What is hallucinated? What is alive? What is dead? These are all questions Kon's images force us to consider, but for which they do not provide answers. As in her 1994 self-portrait, Kon hovers behind her still-life pieces like a phantom figure: the arranger, a sorcerer's apprentice, the constructor of a fantasy world that simultaneously repels and attracts with its strangeness and its beauty.

Still-life photography has not always been so vital a category of art. Once, familiar things were arranged in the customary manner of symbolic representation and near-decorative completeness. But in recent years, a number of photographic artists have explored still life in new ways, with different, startling, and oftentimes repulsive subject matter. Kon's array of fish scales, feathers, eyes, heads, flowers, insects, dead fowl, raw fish, and gelatinous materials are all assembled in such a way as to render themselves in transformation as a new and discrete object. Perhaps resurrected as a new object would be a better description, given Kon's often-stated concern for the delicate balance between life and death. What makes Kon's still lifes different is that they are not overall arrangements, but images of almost taxidermic creations that exist within the rigorous spatial confine of the picture space. The photographs thus take on a matter-of-factness that renders the thing replicated in a state of iconic objectivity—a kind of edible ornament. The pictures exist for us as a dream of mingled fascination and disquietude.

The meanings in these works are both real and imagined, and come from deep within the female psyche. The commentary involves a not-so-subtle critique of things sexual in contemporary Japanese culture. This, plus the Japanese obsession for the senses, for the fetishistic presentation of everything from sashimi to a lacquer cosmetic box. Each element in the crafting of her work, from start to finish, promotes the look of precise but not austere observation; this is true also of her most recent color images—mostly in pomegranate red—that speak not of blood, but of rites of fertility and abundance.

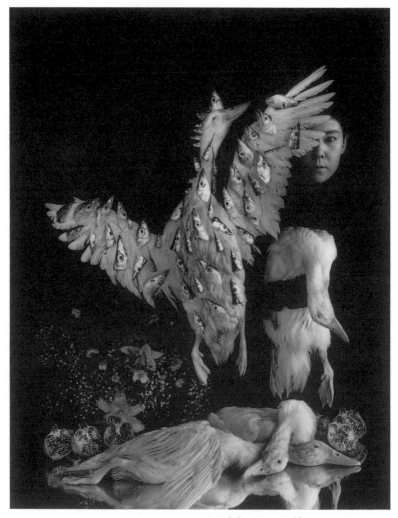

Michiko Kon, *Self-Portrait #4*, 1994
Princeton University Art Museum; Anonymous gift

As a contemporary Japanese photographic artist, Kon creates work that is reminiscent of that from the great period of the late 1950s and early '60s, in which the confrontation with things taboo, with the touch and smell of bodies, with phobias and fears of the subconscious were what gave the images an edge that reflected a state of raw nerves in a Japanese society that was terribly unsettled. Kon has leapt over the intervening years that brought more modest photographic endeavors, and has returned to the sharp principles of earlier avant-garde image-making: surprise, provocation, and spirited joy. She nourishes our imagination as one would the body; hers is an effort to devour aesthetics.

A young artist whose reputation has arisen quickly, Kon is unafraid to push herself toward new directions. Nevertheless, this present body of work marks the identity of a complete artist whose work exudes the emotional aura of what can only be described as poetry. Like all poets, Kon wants to imagine hugely and then find the perfect form that will both capture the thought and suggest what was uncapturable in it. She does not use art; rather, she makes it.

From *Michiko Kon: Kon Box*
(Tokyo: Photo Gallery International;
Tucson, AZ: Nazraeli Press, 1996).

JERRY N. UELSMANN

Although I believe my work is basically optimistic, I would like people to view my photographs with an open mind. I am not looking for a specific reaction, but if my images move people or excite them I am satisfied.[1]

I have always felt I photographed the things I loved.

My images say far more than I could say in words. I believe in photography as a way of exploring the possibilities of man. I am committed to photography and life . . . and the gods have been good to me. What can I say. Treat my images kindly, they are my children.

In his humanity Jerry Uelsmann is impressively real, yet his photographs, born of a fantast's vision, manipulate our deepest and most fundamental emotions, prompting us to suspect his person in art to be romantically independent of the real. He possesses a rare inspiration, which effortlessly moves us. Like all true artists, he is motivated by enthusiasm, and by the enjoyment of creation, which drives him to share his dreams and experiences with us. Unconsciously, we are under his control and this control has been crucial to his success. His art is essentially direct rather than allusive, and his pictures appear analogous to that believable reality so fundamental to photography. But herein is the rub: Uelsmann's interpretative vision pervades each work and causes us to ponder whether reality is really quite so true as invention. Perhaps more consistently than any other photographer of his generation he has sought what Guillaume Apollinaire called art's greatest potential— surprise.

Upon its introduction, photography was understood in terms of a mystery related to its process alone. In recent years, this mysterious or even mystical regard has been transferred to the photographer. Today, he has become the pivotal figure in a creative metamorphosis that links sensory experience and physical process in such a way as to reveal in a picture something much greater than the depiction of any subject or thing. What we have come to realize is that the frame of a photograph marks

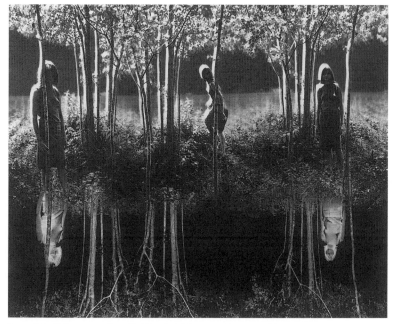

Jerry N. Uelsmann, *Small Woods Where I Met Myself*, 1967
Courtesy of the artist

only a provisional limit, that its content points beyond that frame, referring to a multitude of phenomena that cannot possibly be encompassed in their entirety. Thus creativity in photography is the exposition not only of the photographer's receptivity in observation, or the skill of his craftsmanship, but the delineation of spiritual reality wherein the symbol transcends its model.

In the depths of any art must reside a personality, and like an instinctive animalistic struggle to recover from birth, the artist aspires to express his *self* in his work. How lacking in courage is an art in which the creator examines the collective ideal as opposed to the self-centered individualism of his own being. The key to a work of art lies not only in the work itself, but in the artist's outward labor to be someone. Uelsmann's life, his manners, his physical being, his work, all that forms the aggregate of his personality, imparts a final impression experienced at once as both dark and dazzling.

> Basically I am dealing with the predicament and condition of
> man as it directly involves me as an individual.

> I have gradually confused photography and life and as the result
> of this I believe I am able to work out of my self at an almost
> pre-cognitive level.

> Life relates to attitudes. I have my own attitudes to work with,
> my own ritual, my game of involvement. Images create other
> images. I cannot be asked to be something other than what
> I am, but I enjoy mind-prodding and mind-stretching.

> Learn to use yourself as an instrument.

I first met Jerry Uelsmann at the Rochester Institute of Technology when we were both students there. I don't recall knowing him well—he wasn't making photographs then—but he was the kind of person one always knew was around. He had a kind of flamboyance and vitality that can only be described as humor.

Jerry's humor remains with him today, and while it is no less discerning than wit, it has much of the uninhibited earthiness of vaudevillian comedy. It is reflected in his speech, his mildly eccentric clothes, his mania for collecting bric-a-brac, and in his phantasmagorical letters—some of which include handwriting, photographs, Victorian valentine stickers, Laurel and Hardy vignettes, peace symbols, and Florida gator

heads. It could never be thought that he conducted anything like an old-world salon in Gainesville, but a typical "at home" with the Uelsmanns might begin with libations followed by a superb lasagna prepared by his wife, Marilynn, for a dozen or so people, include a visit to the University of Florida campus for a screening of the complete *Flash Gordon* serials run end to end, followed by dessert at Dipper Dan's, and climaxed by a return to the house for a raucous songfest of maudlin church hymns and nifty tunes from the 1920s conducted, orchestrated, and played with consummate endurance on the grand pianola, pedaled by Jerry himself. He has frequently remarked that he prints his photographs best to Beethoven and bluegrass; and although Earl Scruggs would make a perfect name for his extremely gentle watchdog, he chose instead to name her after a once-famous animal photographer. An addict for musicals of the largest, gaudiest Broadway variety, Jerry entertains a secret desire to be a tap dancer, and he would also admit to a love affair with Shirley Temple—that is, before she became an ambassador to the United Nations.

Social humor and amusing antics are significantly absent in Uelsmann's photography, and it is in his photographs that the darker facets of his being become apparent. For one cannot escape the belief that his comedy conceals an intensity of concern for life and personal doubt that Jerry harbors about life's meaning. Indeed, his interest in photography goes back to the time when, as a teenager, he discovered he could use the camera to divert attention from himself, or to have it function as a kind of buffer in personal encounters. He thought that in so using the camera—or photography—he could exist outside of himself, an idea he would realize in his later life to be naïve. Jerry is passionately in love with life but behind his exuberance is a coldly determined intention to seek the means of expressing the human condition in the most visible way. He understands perfectly well what he is doing. Although he publicly claims innocence in his creations, subtly redirecting inquiries about his approach to the concept of what he calls "in-process discovery," he assuredly possesses what a stranger to him described as "shadow wisdom." Such sagacity befits this double Gemini.

Let us not delude ourselves by the seemingly scientific nature
of the darkroom ritual; it has been and always will be a
form of alchemy. Our overly precious attitude toward that
ritual has tended to conceal from us an innermost world of
mystery, enigma, and insight. Once in the darkroom the

venturesome mind and spirit should be set free—free to
search and hopefully discover.

I can really be excommunicated from the world in the
darkroom.

In the darkroom, a comfortable kind of situation is needed;
for me the darkroom experience seems to relate to the cosmos
outside—in fact, the experience seems to relate to an internal/
external cosmology. There is the opportunity for an internal
dialogue in the darkroom . . . a turning inward relative to
what has been discovered outside . . . the two coming together.
I develop an attitude toward something I am working on and
can spend ten hours or more without becoming uncomfortable.
I am creating something while I am working . . . not just techni-
cal orientation . . . really I am midwifing images and this is
sort of what I am about. I see myself in terms of my self.

Today the artist, more than the priest, reveals the existence of an
intangible extrasensory force, which is constantly affective in our life.
The artist is the surviving exponent of the mysteries, the last believer in
the duality of our world, the last teacher of the method whereby we may
establish contact with the mysterious and convert the mysterious into
the credible. By so completely absorbing the real world, Uelsmann is
able to go beyond it. He is able to annihilate it and to create in its
absence visions and forms that man has hardly ever seen.

The excruciatingly complex techniques of photomontage are
superbly suited to his effort. These techniques are Uelsmann's alchemy.
His volatile photographic images, in which the dominant character is
the dynamism of a psychic order, open to the world of magic. I do not
believe he could ever satisfy himself with what is termed straight photog-
raphy, because for him straight photography is not the resolution of a
vision, but the beginning of a process. He takes pictures simply, rapidly,
and straightforwardly, responding freely to the inspired revelation and
recognition he achieves through the camera. With little or no precon-
ceived notion of a finished photograph, he makes enormous numbers
of negatives, stores them carefully, and in this way prepares his visual
vocabulary for the next step.

In the darkroom he progressively and additively compiles the
visual equivalent of his inner vision. He consciously follows the dic-

tates of his insight in the construction of an image. His work would not be as convincing if it were not totally drawn from himself, and this means working with the negatives of no other photographer. It is the intimacy of the personal, half-forgotten image or event, recorded perhaps years previously, which is drawn from the negative file and brought into the light of a new consciousness. Every discrete step is the commencement of a new moment in his life, a fresh vision of reality, a rape of common sense.

One cannot look at the body of Uelsmann's work without recognizing in it the sustained effort, matched by few photographers of his time, to come to grips with all the problems of photography—to achieve in the end an unmitigated integrity of the whole. Nothing is left out. The failures are important; they matter profoundly. The struggle matters too; in this age of easy images it probably matters most of all.

> The contemporary artist in all other areas is no longer restricted to the traditional use of his materials . . . he is not bound to a fully conceived pre-visioned end. One of the major changes seen in modern art is the transition from what was basically an outer-directed art form in the 19th century to the inner-directed art of today. To date, photography has played a minor role in this liberation.

> By post-visualization I refer to the willingness on the part of the photographer to revisualize the final image at any point in the entire photographic process.

> The truth is that one is more frequently blessed with ideas while working.

> An old Uelsmann negative gathers no moss.

> I'm really very concerned with helping to create an attitude of freedom and daring toward the craft of photography.

Jerry is considered something of the *enfant terrible* of contemporary photography. Consciously drawing on the work of Henry Peach Robinson and Oscar Rejlander, two of the most misunderstood photographers of the last century, he sees himself as their successor. The aim of these men was to create a picture through the combining of photographic bits and pieces. Uelsmann elaborates the discipline to a more

complicated and perfected form. Whereas Robinson and Rejlander used the composite photograph as a technique to fabricate a unified picture of a completed event or idea in conventional linear space and time, Uelsmann presents in his approach to photomontage simultaneously varying systems of idea and event as an analog for the inner and nonlinear processes of thinking and feeling.

It is too soon to tell what Uelsmann's place will be in the history of photography. But we know even now that contemporary photography is not the same as it would have been without him. Many of us, perhaps all of us, feel richer in having experienced his work and this is something that happens infrequently in a lifetime. I feel confident that he will continue to provide for us the imaginative leap to a reality greater than anything we may otherwise observe.

NOTES

1. The quoted statements in this text are from Uelsmann's lectures, his letters, his conversations with the author, and from his published remarks.

From *Jerry N. Uelsmann* (New York: Aperture, 1970).

JERRY N. UELSMANN: SILVER MEDITATIONS

Creators of Jerry Uelsmann's stature may be seen to have altered the language, the substance, and the direction of their art. He personally has been the recipient of considerable critical praise, though the general field of synthetic photography remains only cautiously embraced. Critics have been transfixed by the rational and the realistic in photography, while the irrational and the imaginary have remained foreign to most. Present-day thinking about the medium is dominated by a naturalistic aesthetic, and only a few individuals have encouraged the possibilities of separating and manipulating the syntactical structure of the *language* of photography. Most people still tend to think that when photographers make pictures they must depict objects and scenes that could, in principle, also be described in words. Photographs that appear to lack the assertive handiwork by which the artist has traditionally pointed to his invention are understood to be truly photographic, while artists in photography who employ varied approaches to the synthesis of the medium are shunned. Uelsmann is, of course, of this latter rebellious breed, and in his approach he strives for his senses to reveal, for his mind to re-create, a quintessential structure reflective of how he views the photographic process itself. In one sense his art may be considered conceptual; however, this is not wholly accurate, for the otherness of the outside world is affirmed, not mitigated, by the intrusion of this artist's mind and hand.

The metamorphosis of ideas in photography is one of the most difficult aspects of the medium to understand. How a photographer such as Uelsmann searches for a significant image, first from the selection of the motif, then to the organization of forms, and finally to the combination of each in a picture in which the content is other than pure data, is a kind of process magic—theatrical magic, if the essence is the least bit irrational. This is no different from the process of creation in other media, but it seems that photography has been dominated, in fact handicapped, by the failure of persons to recognize this conception of expression in the medium. So permeating has been the belief that photographs must be a form of vicarious experience of the subject itself that

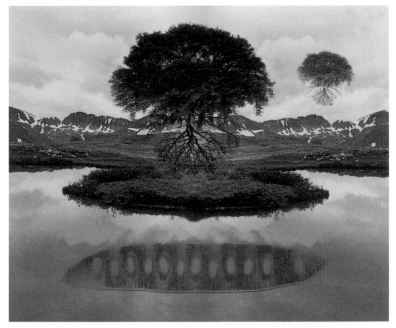

Jerry N. Uelsmann, untitled, 1969
Courtesy of the artist

exceptions to this interpretation are rejected. A picture, properly appreciated, stands away from us as an object on its own—independent and complete. A division of the medium may be seen in which images provide a basis of experience that is on the one hand imaginative, and on the other rational.

Uelsmann's adherence to what he terms "in-process discovery" places him firmly in support of intuition. He affirms that there is no doubt that an important connection exists between his creative activity and dreaming. As the dream is an involuntary act of poetry, so the fortuitous selection and combination of negatives is the reflection of the imagination's independence of the will. In this sense Uelsmann's photographs, like dreams, have either no meaning or several meanings. Photographs freed from the scientific bias can, and indeed usually do, have double meanings, implied meanings, unintended meanings, can hint and insinuate, and may even mean the opposite of what they apparently mean.

Photographs have tended to be treated scientifically as a factual statement: "this is a person," "this is a shell," "this is a building." Contemplation in the face of such concrete things demands a great deal of the mind and the senses. Once one has recognized that photographs have meaning, they become open to interpretation and characteristically several not mutually exclusive interpretations can be made of them. One has to add that most photographs are, usually, incomplete acts of visualization. Something still must be added to them before they can be transferred from the private sector of experience to the public, before they can acquire universality. This something-still-to-be-added must, I think, be more than just the translation of visual, nondiscursive imagery into coherent discursive photographic language; in other words, the transformation of a dream or unconscious fantasy into a work of visual imagination cannot be analogous to the process of interpretation as practiced, for instance, by psychoanalysts. It must, rather, comprise the casting of the central meaning in symbols that are part of the shared iconography of the culture of which the artist is a member, and that therefore carry a heavy charge of shared, public associations and resonances. It is not that the artist actively masters the iconography of his times in order to be able to universalize his private emotions; instead, one aspect of his capability is an exceptional sensitivity and receptivity to the iconographical network that constitutes the culture of his time. This makes it natural for him to express his private emotions in

universal terms, or perhaps not to distinguish at all between the individual and the universal, between the microcosm and the macrocosm.

In this vein, many persons superficially acquainted with Jerry Uelsmann and his work have difficulty recognizing in him the ability to articulate the complex symbolism that a number of writers, especially William E. Parker, have identified in his photographs. I am suggesting that, while Uelsmann does have an inquiring, searching, and aware mind, he is moreover exceptionally sensitive to the iconography of public expression. It is a fact that in photography there is a strong anti-literate sentiment that is most generally brought to bear against any photographer who is the least bit learned in his work. Such is clearly the case with Uelsmann and in his public appearances he often does little to challenge this notion. He is one of the few photographers to talk about his work with commitment and to have articulated a stylistic analysis of his own photographs, but I believe he stops short of verbalizing his awareness of iconology because he fears this very sentiment among his peers. No additional evidence of his ability to use his knowledge need be cited than the considerable body of photographs made over the last fifteen years, which are indicative of his overall expressive achievement.

A necessary precondition of all imaginative activity seems to be what John Keats called "negative capability," the ability to allow oneself to be "in uncertainties, mysteries, doubts, without any irritable reaching after fact and reason": in other words, the ability to abandon the ideal of rational action and stop trying to master reality in favor of letting oneself happen. And, at least for such artists as Uelsmann, the execution as well as the conception of a work of art may also be largely independent of the will. In this it must be seen that all images reveal a psychic state.

In his approach, Uelsmann has affinities to several artists in a variety of media. Like James Joyce, for example, he chooses to let his subjects dictate his methods rather than to impose a method upon his subjects. Uelsmann's description of his working procedures is similar to Jackson Pollock's well-known comment: "When I'm in my painting, I'm not aware of what I am doing." Like action painters, Uelsmann sees the aim of art to be discovery, not the solving of formal problems. At work he proceeds until intuition informs him that a culmination has been reached, which is the way Abstract Expressionist painters recognize that a painting is finished. One discovers what one has done afterwards. Art has to do with finding out something one did not know. This

illustrates the fact that the imagination is autonomous of the will, of the self-conscious ego, and it is presumably the reason why poets and artists before the rise of psychology could believe literally in their inspiring Muse.

Uelsmann's process of self-revealment lies in the imaginative articulation of fragments. These fragments are the components of his existence experienced first, and partially, through the camera, but it is as if he has not lived them until he sees them combined in pictorial form. Indeed, he may also be seen to have now reached the state in his life where he projects these completed visions back onto reality itself. His self-knowledge rests in his ability to synthesize knowledge outside of actual experience and his affirmation of in-process discovery is another way of saying that he values the revealment of autobiography. His pictures reflect a formal order, but their meaning is outside of the logic that confronts the rest of us in our everyday life. He is one of the very few to have depicted the Apocalypse. His work has been determined, in part, out of painful adolescent experience and tempered by the acceptance of the premise that the practice of art is rooted in life and that the felicity of art lies in its sustaining power. Humor, or perhaps more pointedly a kind of wit, has been one of Uelsmann's most characteristic qualities. On the surface it might be seen that this is reflective of his doing what he likes, but it is also reflective of a lingering suspicion that life is set against a background of the potential for tragedy.

Minor White, whose aesthetic derives from Alfred Stieglitz's "Equivalent" form, gave Uelsmann the realization of the poetic reality when Uelsmann was a student at the Rochester Institute of Technology. Significantly, however, White by that time had extended Stieglitz's concept of "equivalency" through his own development of the sequence of nonsimilar images. White draws freely from all fragments of his personal experience and recombines them into controlled autobiographical statements. This sense of control, through the combining of single photographs, and the interest in autobiographical expression, are key elements in White's contribution to the medium and in Uelsmann's subsequent extension of it through his own work. Autobiography is not necessarily in accord with fact, and it may be seen to possess an immense potential for fiction and passion.

While Stieglitz organized his cloud photographs—images so photographic that they were true pictorial abstractions—into sequences or groups, the effect he sought was not so much to re-create experience as to allegorize his emotions. White, on the other hand, takes images that

are more obvious or rational than abstract, and combines them into a kind of cinematic presentation heavily reliant on a varied repertoire of symbols he believes can be "read" in photographs. The goal, as White sees it, is one of freeing the photographic experience from chronological time and making it into the totality of a life experience, which has a cumulative meaning and identification greater than any individual picture. Because of this method his pictures are often fragmentary in themselves and incomplete as allegory.

Uelsmann grasped this concept and has significantly modified it by adopting manipulative techniques that allow him to construct a nonlinear sequence of images within a single picture. White, it must be pointed out, has always adhered to the stylistic purity of the "straight" photograph and his images reflect his strong and continuing solidarity with the group of Stieglitz, Edward Weston, and Ansel Adams. Uelsmann—by 1959 building on the encouragement of Henry Holmes Smith, who placed a liberal emphasis on subjective creativity within the photographic process itself—sought to reinvent the process of picture making in photography by considering each camera negative as only *part* of a single photograph. I use the word *reinvent* very particularly, because this is precisely the contribution made by Oscar Rejlander a hundred years before, but which unfortunately has been lost today because of our inability to see his extraordinary invention beneath the sentiment or subject for which it was placed in service. Photographers such as Uelsmann, Rejlander, White, and Stieglitz extended the concept of photographic time by replacing the finality of exposure time with a construct of conceptualized time as the basis for the experience of photographic reality.

The thought of incongruous juxtaposition was not, at first, an issue with Uelsmann, and his early images are as pictorial in motif and motivation as is the work by the other three photographers mentioned above. Interestingly, Uelsmann's observation on Rejlander's *Two Ways of Life* is that it is "an amazing image in that it is so intricately complex yet so infinitely resolved." Only gradually has Uelsmann developed the ambiguous and more psychologically related experience in which the expression of the irrationality of thinking and feeling is seen in both content and form. In recent years, he has admitted to not knowing what some of his pictures are about. I believe this is due to the fact that he has used single images within these photographs that came about through unpremeditated experience as early as the time of pho-

tographing, when the continuum of recognition and reaction was incomplete and when his subconscious did not absorb and categorize even the observable sensation. It is very much to the point in analyzing Uelsmann's working method that he does not consider using other persons' negatives. He will not borrow from the consciousness of others their visual fragments, which are vividly different from what I have described as his life fragments in visual form. This methodology also relates to, and I believe clarifies, the issue of the symbolic construct of his pictures as discussed earlier. His sensitivity to the iconography of culture is manifested in the gesture of identifying his fragments in the field when photographing, and not only in the selecting of parts for a picture once in the darkroom. It is in this respect that he, like Manet, a counterpart in painting, may be seen to create after nature, and it is why, after all the arguments about synthetic photography are said and done, Uelsmann is a photographer dependent on the real world of primary observation.

Nevertheless, Uelsmann also loves fantasy, and he uses it to carry a distinct moral. Literary art for him does not mean the mere teaching of moral truths, because whatever is honestly worth seeing seems to him also capable of moral implication. His repetition of various images and themes is an emotional rhythm of testing propositions by refutation, as with bringing witnesses forward and cross-examining them. Like artists everywhere, Uelsmann aims not to find wisdom but to put it to work. He believes that reality has room for such models.

In contrast to his earlier pictures, Uelsmann's work in recent years has become less graphically dominating in terms of what may be seen as the relatively simple and harmonious counterpoint of objects and forms. Since about 1972, the picture space in his images has been filled in a more total and stressful fashion, reflecting his own more complex psychic nature. He has reached the point where the work has turned in upon itself, where the mastery of craft has moved outside of illusion and conscious showmanship to a more introspective state of affairs where one can no longer tell so easily what is going on. I do not believe this is a matter of his technique becoming simply virtuosic, but rather that a fundamental change has occurred in the work, where the desire to exert any control over the artistic invention has been relinquished for the sake of creating images that exert control over his own life process in the hope of realizing something he feels is confused or incomprehensible. It is as if he is allowing the dream/image process to stabilize his own

existence. Even today I do not believe we are at a point where this change has been concluded, though I sense a returning to his accustomed security, which in the past has made his pictures more pictorial.

The dominating character and participant in Uelsmann's visual world is man. He is a humanist concerned with man's achievements and interests, with his actions and, as I have stated, with the moral implication of these actions. In many cases, his pictures are singularly expressive of the sexuality of human interaction, and he has mastered the presentation of erotic tension without yielding to pornography or resorting to non-objective symbolism. He uses the clothed or nude figure almost interchangeably. This is true not only with the female, but even more with his depiction of the male figure, which does not appear naked but is almost always used as an expression of the anxiety and the primitive power of male sexuality. Uelsmann's rendering of the human figure is analogous to how one contrasts masks with illusion in the theater, and it is clear that he prefers the mask because it is frank; the figure in the mask is clearly an actor, not someone who is half-persuading you with greasepaint and a wig that he is Othello.

Many persons, including myself, have been photographed by him, and it is difficult to characterize these pictures. Portraiture is an easy label to assign to a large number of them, but it is not wholly satisfactory because Uelsmann's own dominating presence is never far below the surface of our own projection. When we view our likenesses, our composure is shaken by the realization that he has exempted us from the crowd and that we now must contemplate ourselves in a landscape that was not of our own choosing. The interpretation of these pictures will be largely individual when it is most clear that the emotive image is very particular, and when it is not, the tendency is to take comfort and reach out for more universal interpretations.

Uelsmann is one of the few photographers who are not afraid to place themselves before the camera. I believe that this is to intervene in his fantasy life, thus to assure his physical presence there, as well as a gesture to record for posterity the life process of aging-cum-maturing. Technically, Uelsmann's self-portraits are no different from his other compositions, but in conception they are significantly different. His identification with his own being causes him to counter the independence of his will and to more fully conceptualize and control the image. In this way his self-portraits are extraordinarily reminiscent of the self-portraits of the pioneer Frenchman Hippolyte Bayard and not unlike Stieglitz's shadow images of 1916 or Lee Friedlander's recent photo-

graphs. These images are all compelling and rich because they are dom-
inated by a controlled psychological intensity. In portraiture, we are
always concerned with revealment, a quality that is frequently associ-
ated with perceptual truth. Uelsmann has admonished photographers
to get out in front of the camera. Under his terms yes, but when he is
photographed by others he is noticeably reticent and inevitably a comic
pose is assumed in gesture and expression. He is aware of what the cam-
era can do. Not that any of us are not, but in his self-portraits, and like-
wise in his pictures of others, Uelsmann disarms us with the dark
ambiguity between model and persona.

Uelsmann's photographs from the late 1960s and early '70s rein-
force his position in the field, and as I said at the beginning of this essay,
he clearly prefigured the contemporary direction of his medium. In so
doing he has restored a tradition and acquired a position that relatively
few of his generation can match. He has done this through a sustained
endeavor and in measuring his work his failures must be seen to matter
as much as his successes. It has only been in recent years that the pub-
lic dedicated to photography has been able to map the continuous
growth of its artists. Through his many exhibitions and publications,
we have been in a position to follow this artist's work in depth as it has
been created through incessant and thoughtful effort. In some respects
this public awareness of him, which began at a very early point in his
career, has had a profound effect on Uelsmann's own consciousness.
There have been many public events, as his life's chronology shows, but
the slow evolution and tempering of a maturing personality occurs more
through private agonies and obsessions. All of these pictures do not have
the instant appeal of certain of his earlier images, which, both by qual-
ity and familiarity, are considered masterworks. These more recent
images are less simple, more substantive, and in some cases dangerously
close to contrivance or *voulu*. Certainly they are much less apt to amuse
the viewer, but to be a master is to be a master. Uelsmann's innovation
as an artist is in keeping with the multiplicity of his vision. There are
pictures of his as perfect as anything in photography and emotions as
clearly expressed as any in any medium. It is precisely the accommoda-
tion between self-confidence and humanity that makes his pictorial life
so pleasurable for him and, ultimately, so challenging for us.

From *Jerry N. Uelsmann/Silver Meditations*
(Dobbs Ferry, NY: Morgan and Morgan, 1975).

JERRY N. UELSMANN: MUSEUM STUDIES

For forty years, Jerry Uelsmann has been giving us documentation of his ventures of passion; that is, imagery that provokes in us a sense of both mystery and delight, of curiosity and awe. We are amazed by his wizardry in choreographing not only the photographic process, but our susceptibility to enticement. He pleases us warmly when he gives us a new object to be treasured.

Objects are the subjects of these photographs and of this entire body of work. Objects, many of which, while not intended for such placement, have found their way into institutions we call museums. Uelsmann has said that "these places are reservoirs of wonderful and interesting stuff. I never cease to be amazed by the broad range of material we preserve and enshrine, and how that material reflects the human psyche." Can it be that this act is the measure of a society or a culture? I think it is of consequence that Uelsmann has focused on the institutional aspect of the phenomenon of collecting rather than the private. This, in spite of the fact that, as I described in my 1970 essay for his first book of photographs, he is a collector of considerable passion and verve. Many photographers have been collectors (I think here of Ruth Bernhard and Walker Evans). But in most instances, it is clear that for these artists the individual object was a kind of personally significant specimen, an attraction of a different order from the way Uelsmann sees things in combination.

It seems to me that his affection for museums relates very much to his idea of discovery, to the very basics of his procedure in making pictures. Widely known for his phrase "in process discovery," Uelsmann emphasizes the aspect of a search, of finding, of contemplating those elements that go to make up one of his compositions. In so doing he demonstrates, as have other photographic artists before him, that while a certain predilection is necessary for the recognition of subject, one must be positioned correctly and be receptive to the strike of inspiration. In the case at hand, this means that he goes to museums not only

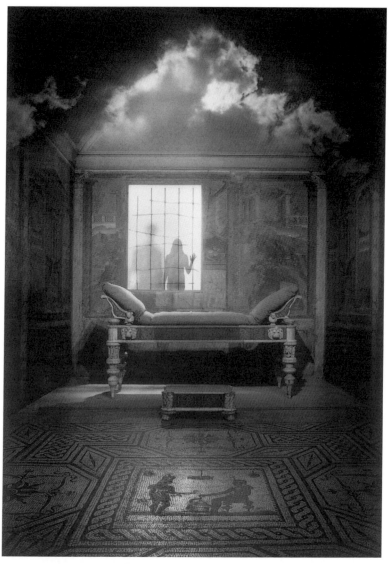

Jerry N. Uelsmann, untitled, 1993
Courtesy of the artist

to observe the display of objects, but to be in a poised atmosphere in which such heightened awareness can be fully active. We should not go to the museums to be sedated, but to be shocked. Shocked in the best sense of the word, meaning that our knowledge is challenged, our familiarity with everything is altered, and our perspective on the human condition is made broader and, hopefully, different. Thus it is that Uelsmann sets himself up, so to speak, for this shock, and in so doing obtains the raw data and the insight to create images that in an entirely different context will cause an even stronger challenge to our awareness of every subject, meaning, and theme.

It is important that Uelsmann does not limit himself to objects of beauty. Indeed, in most of these pictures there is a nervous sense of unease in making selections, and sometimes a flair for the absurd. This has always been characteristic of Uelsmann's photography of whatever sort. It reflects his indebtedness to the surreal, which he sees not as something only of art or outside of life, but as the essence of our rapture for life itself. It is the reason why his oeuvre has such unity, and it is also the rationale for his technique, which makes his approach of combining negatives not just manipulation but a statement of belief and a reflection of his intimate values.

The range of subject matter in these pictures is incredible, and it shows how widely he has traveled. Uelsmann has created his very own eclectic world; in miniature, this box of image cards is what the seventeenth-century Dutch called a *kunstkamer*. He has worked in museums that have brought together the elements of cultures foreign to their own, like the vast compendium that is the Metropolitan Museum of Art, and in small museums within the countries and societies from which the objects originate. This is particularly true with his photographing in European museums. Long before others, and before it took on its postmodern theorizing trendiness, Uelsmann had revealed the capricious juxtaposition between the high and low of culture: Greek and Roman sculptures (real and fake), teacups, and valentines. The presence in several pictures of native Americans, albeit encased in glass-fronted boxes, and their artifacts, juxtaposed with skeletal remains in others, indicates his fascination with temporality and the mortality of living things. There is a huge array of images in which the subject is the world of nature: fossils, shells, stones, stuffed birds, and, pointedly, our Homo sapiens ancestors now dramatized in dioramas: the aftermath of the Darwinian vision. Like photography and its relation to the past, Uelsmann's recon-

figured images represent creatures and man-made objects in the past tense. It is by design that he photographs in museums and not in zoos.

Time is the central element here. Uelsmann is looking back, giving us the luxury of considering things in hindsight. But he wants us to recognize how values change, how importance is established and maintained, but also how it is trashed. How daring it is to rearrange history and even cultural values themselves, sometimes as if to spite those who are given the authority to make these decisions. As he shows in several instances, the clock is ever ticking, signaling that such change is inevitable. What one generation so ambitiously identifies for itself may not, in the end, ever be its final image.

We are at the end of a millennium. I believe that Jerry Uelsmann, a citizen of this century par excellence, wants to warn us not to be too methodical in fashioning our field of vision, but to let our fantasy be free, and never close ourselves to wonder. He asks, How are we to impart the character of our century? Could it be that this box is Uelsmann's museum of the twentieth century?

From *Jerry N. Uelsmann: Museum Studies* (Tuscon, AZ: Nazraeli Press, 1999).

JOHN PFAHL:
ALTERED LANDSCAPES

> A keystone in the arch of human understanding is the recognition that man at certain critical points synthesizes experience. Another way of stating this is that man learns while he sees and what he learns influences what he sees.
>
> EDWARD T. HALL, *The Hidden Dimension*

One of the concepts regarding photography and the making of photographs that has taken the longest to be realized and appreciated is that of intentional creation. Early in this century, the Pictorialists began to articulate the inherent linkages among the act of photographing, the sense of responsibility that falls on photographers because of their pictures, and the sensuality of the pictures themselves. These are the principles that have become the fundamental bases of modern photography. Further, photographs that were once derided as "illustrative" are today not so disrespected because this term is no longer reserved to describe work reinforcing traditional regimes. It now refers to that providing an illustration, or a kind of mechanical, for the activity Edward T. Hall identifies above. The art of successful photography has once again come to be concerned with artifice, and, as is the case with the best writers of literature, the goal of a contemporary photographer like John Pfahl is not to turn viewers into re-readers but into readers.

John Pfahl was born in New York in 1939 and grew up in rural New Jersey. He began his interest in photography at Syracuse University, where he was a student enrolled in a program of advertising and graphic design. Significantly, his earliest work was in color. Following two years in the army, he worked for commercial photographers in New York City and in California. In 1966, he returned to Syracuse and studied color photography, graduating two years later with a master's degree. He has been on the faculty of the Rochester Institute of Technology since 1968. From 1969 through 1974 he made three-dimensional screen-painted photographs on formed plastic. From 1974 through 1978 he worked on an extensive series of related unmanipulated color photographs on the theme of the "altered landscape."

John Pfahl, *Australian Pines, Fort DeSoto, Florida*, 1977 (original in color)
Courtesy of the artist

While working with the musician and composer David Gibson, Pfahl became interested in photographing elements placed in the actual landscape. Deciding to make collaborative photographic music scores, they went out into the forest south of Buffalo, New York, where Pfahl resides, applied tape to trees, and executed two compositions together. The intention, though never realized, was that the visual configuration was to be recorded in notation form and played. The photographic image would serve as a visual backdrop to the musicians. While Pfahl now considers these two pieces to be largely unresolved, they mark the starting point for his later conceptions. *Music I* is one of these two initial efforts.

Pfahl rapidly became interested in the pictorial potential of these alterable acts and has now formed a body of some one hundred fifty images in the series. The idea was not acted upon immediately, however: it was not until the summer of 1975, at the Penland School in North Carolina, that he executed ten works, including *Shed with Blue Dotted Lines*.

The photographer describes the notions of the pictures in his series as follows:

> The added elements suggest numerous mark-making devices associated with photographs, maps, plans and diagrams. On different occasions, they may pointedly repeat a strong formal element in the landscape (i.e. the outline of large rocks echoed in rope in *Outlined Boulders*); they may fill in information suggested by the scene (the red line in *Coconut Palm* or the yellow ropes in the meadow in *Haystack Cone*); they may depend on information external to the photograph itself (the location of Bermuda in *Triangle*); or, finally, they may be only arbitrarily related to the scene (as in *Pink Rock Rectangle*, where the granite boulders simply form the substrate for an imposed figure).[1]

In these pictures, Pfahl creates, usually within twenty or thirty feet of his camera, a construction that is given order and perfection through the manipulation of the optics of the camera. These fabrications may be made with tape, string, rope, or foil positioned on or among the objects in the picture or through the placement of objects, such as balls, in the foreground plane. Pfahl manipulates these illusions carefully and tediously, often making preparatory drawings on a black-and-white Polaroid of the scene or using clear plastic overlays on the ground glass

itself. In all of this, there is the critical notion that the arrangements are not done to mathematical perfection but are purely visual. He has pointed out that his working method demonstrates the fact that since we cannot see the flat picture plane through the ground glass of a view camera we must work with the pictures, in this case the Polaroid, to adjust both the mind and the construction to the picture-making problem. Utmost care is taken not to alter the actual subject in a way Pfahl would consider harmful to his positivist respect for nature. He has described his process as the "possession of the space and then its return to a pure state following my own personal ritual"; he approaches the entire endeavor with a "strategy of affection."[2]

Much has been written about the "Altered Landscapes" series. Pfahl himself has commented most informatively in a number of interviews on his background, techniques, and intentions.[3] The term "picturesque" frequently appears in these interviews. As a concept, the picturesque is very much aligned to the illustrative. Were it not for the unfortunately bad connotations the term picked up during the late nineteenth century, we would realize that the picturesque was originally understood in the context of the striking picture. This interpretation has been overlooked, and therefore much of the reason why Pfahl's photographs are important has been missed. I believe Pfahl's photographs are important; they are very picturesque because they suggest to me his immense pleasure in making them and his ready, indeed, his eager acceptance of responsibility for them.

These pictures are a celebration of both the photographer's art and his deliberateness. Their quality lies in the demonstration of forcing nature to rival art. By addressing his camera to scenes that he feels, as some others do, are on the edge of cliché or novelty, he actually imposes more of himself than might otherwise be the case. Pfahl is not a passing entertainer, but a fervent artist who has worked hard at the detail and the mastery of his craft. He has lifted it from the drudgery that characterizes so much of what is termed "concept art." In a recent lecture, Isaac Bashevis Singer remarked: "In art, like in love, the act and the enjoyment must go together. If there is a redemption in literature, it must be imminent. In contrast to politics, art does not thrive on promises. If it does not impress you now, it never will."[4] Such is the case with the art of John Pfahl.

To be put off by these pictures is somewhat akin to rejecting the idea that we can never subtract from knowledge, but can only add to

it. Pfahl's contribution comes to us through the true pleasure of his wit and his doctrine of spotless technique. In the sense that these pictures reflect the individual ego of their creator, they are expressionistic. While the obviousness of the demonstrated acts—stringing rope, laying tape, wrapping foil—might be seen as only superficial, these gestures, like the gestures of contrivance in any medium, reveal the inner artist. As was suggested earlier, this revelation is particularly difficult for a photographer, considering the traditional inhibitions against methods that have, for too long, only served the basic banality of photographic representation.

Pfahl's imagery is a sure manifestation of the belief that society can produce an art suitable to its nature and, in this case, a specific kind of photographic presence that expresses current societal values. What can be seen in Pfahl's work is a certain and not so subtle anti-popularization that seeks to subdue the rude realities of the 1960s with a beauty more ideal and a morality rather more precious than what was then current. It is removed from contemporaneity and, by reinstituting values and conventions of the past within a mode of thinking about the present, Pfahl creates a revivalist photography. The photographs are scientific in nature in that they build their strength on a mathematical system of perspective and illusion through a precise and unmoving point of view. This anti-emotionalism seeks to reestablish a more rigid self-consciousness of photographic perspective than has been the case with the rash of modernist distortions found, for instance, in aerial photographs, street photographs, and decontextualized details in the 1950s.

Pfahl's reasoning is rooted in an interest in the problems of spatial positioning current among contemporary anthropologists. Instead of finding fault with distortions, orthogonals that converge too quickly, or grossly enlarged objects in the picture plane, Pfahl has made these optical characteristics the topography of his argument. What is new is the immensely sharp awareness of the effects the positioning of the camera might produce in nonpictorial terms, that is, for concerns outside the substrata of interest in the scene itself. This is why his photographs are so very different from the modernist notions revealed, for instance, by Alvin Langdon Coburn in his well-known photograph *Octopus* (1912), or in his words: "Why should not the camera also throw off the shackles of conventional representation? . . . Why not repeated successive exposures of an object in motion on the same plate? Why should not perspective be studied from angles hitherto neglected or unobserved? . . . Think of

the joy of doing something which it would be impossible to classify, or to tell which was the top and which was the bottom!"[5]

It would seem that in Pfahl's photographs, the entire question of the construction of pictorial space has been replaced, as if to prepare us for the last quarter of our century during which we must—as perhaps we have not in years—consider what is retinal and what is perceived. Our momentary, fragmented, and captured vision of disorder and emotion has been replaced by a cool rendering of purposefulness as if to accord another dimension of positivism to the moving force of contemporary human awareness. Pfahl's work is an attack on the problems of space and, ultimately, existence from a rational point of view. Whether Pfahl has read Leonardo's *Trattato* I do not know, but it would not surprise me if he has. Pfahl's work is hidden from us only in the sense that what he does before the exposure is never revealed. We do not go through his work step by step, incident by incident, to discern the way it was constructed, as if we were taking a timepiece apart, because what Pfahl is doing is putting the watch together. If we need to investigate these pictures, it is only to address the issue of three-dimensional realities subjected to two-dimensional photographic surfaces.

Pfahl's work rests at a point in the latter part of the continuum of art's development in which has been reflected man's growing awareness first of himself, second of his environment, then of himself scaled to his environment, and finally of the transaction between himself and his environment. Pfahl's photographs are but one more demonstration of man's inhabitation of many different perceptual worlds; they tell more about man than they provide simple data on human perception. They are not shocking in the sense that some photographs, and most modern paintings, have been shocking, because they do not conform to the popular notion of perception in art. Rather, they ply the delicate balance between understanding and expectation. This point of traverse is the most contemporary aspect about Pfahl's work, which I hesitate to describe with the now-fashionable term "postmodern"; it symbolizes the vastly changed world of today, where ridding the viewer of radical expectation has allowed the artist to reveal himself through intellectual process.

Pfahl's photographs are static in that they do not reflect the traditional view of looking out of a large plate-glass window because of the simple fact that the images allow no movement. Not only is it improper to move one's body or head to see more, there is simply no more to see.

It is just the reverse demand that Pfahl places upon us: to remain still, focused, and unmoving. The glorious color, sometimes pushed to the extreme of decorativeness and verisimilitude, only enhances the tension created by this forced inhibition of movement, a restraint that fully recognizes our need to see a picture and not recreate an experience. The picture is the experience.

Will we ever reach the point where we might believe that we dissect nature along lines laid down by our photographers? Although few accept this proposition, and Susan Sontag cautions us when she writes: "Photography implies that we know about the world if we accept it as the camera records it,"[6] I do not find it a poor proposition at all. Much as we have come to understand nature through our native languages—a fact long held—I do not believe that photographs, let alone paintings, are unacceptable as forms of instruction that might serve this understanding. In such a context, one could move meaningfully to the apprehension not only of nature, but of subtle differences in cultural view by studying the photographs of Peter Henry Emerson, Eugène Atget, László Moholy-Nagy, Alfred Stieglitz, Ansel Adams, and Pfahl, to suggest a list pertinent to this thought. Photographs such as these reflect a patience and a chore in teaching in that they are demanding, and give back to Pfahl the role of one who elucidates discovery through creativity.

John Pfahl has become an influential photographer. In a most straightforward way, the fastidiousness of his color imagery together with its lush descriptiveness has fostered the development of the genre. Quite apart from this obvious impact, however, has been his influence as an educated and articulate artist. He has rejected the cult of naïveté, of working without preconceptions. His own purposefulness has given us a break in the rigidity of convention; his sense of history and his sense of learning have put photography back on track. He is a stylist. He has not been afraid to reveal what he knows, or to reveal his learning states; for him, each picture must have its own reason. "It had to be more that simply a new illusion—the illusion has never been the main point."[7] In this way, John Pfahl is not a magician or an illusionist. He is an artist who favors the elegance of the mind that appreciates reality.

NOTES

1. John Pfahl, "Introduction," Focal Point Productions Slide Set, Rochester, New York, 1977.

2. John Pfahl, interview by Peter C. Bunnell, Princeton, NJ, November 24, 1980.

3. Anthony Bannon, "John Pfahl's Picturesque Paradoxes," *Afterimage* (February 1979): 10–13 (including transcript of interview); Van Deren Coke, *Fabricated to Be Photographed* (San Francisco: San Francisco Museum of Modern Art, 1979), pp. 9–10; Ben Lifson, "You Can Fool Some of the Eyes Some of the Time," *Village Voice*, March 6, 1978, p. 68; Stuart Rome, "Interview with John Pfahl, Sun Valley, Idaho, June, 1980," *Northlight*, no. 14 (1981).

4. "I. B. Singer, at West Point, Meets Cadets of Another World," *New York Times*, September 25, 1980, p. B12.

5. Alvin Langdon Coburn, "The Future of Pictorial Photography" (1916), in Peter C. Bunnell, *A Photographic Vision* (Salt Lake City: Peregrine Smith, 1980), pp. 194–95.

6. Susan Sontag, *On Photography* (New York: Farrar, Straus and Giroux, 1977), p. 23.

7. Pfahl, interview by Bunnell.

From *Altered Landscapes: The Photographs of John Pfahl*
(Carmel, CA: Friends of Photography, 1981).

RAY K. METZKER

Ray K. Metzker has chosen to remain somewhat outside the customary gallery/publication interlace and instead pursues his career in photography with the elegance of quiet dedication. He is, however, a consummate craftsman of the medium, and his photographs should be more widely known and appreciated.

Throughout his work, Metzker has been an exponent of what he has termed "photographic form." Two decades ago, when he was already advanced in his investigations, this was the characterization of much work encouraged at the Institute of Design in Chicago, where he was a student. Metzker's work, together with that of his colleagues there, Ken Josephson and Joseph Jachna, are major reflections of this sort of renaissance in the 1950s. In a crucial publication (*Aperture*, vol. 9, no. 2, 1961), these three photographers first showed the stunning originality of their work and the eloquence of their perception. In a lengthy statement accompanying his pictures, Metzker relates how he came to find the exploration of the medium of greater importance to him than the exploration of a place, which had ostensibly been his first goal as a graduate-student photographer. While one finds intimations of his later pursuits in the work of this period, the modesty of these exercises was soon to be superseded.

After attending graduate school, Metzker began to investigate systematically the possibility that the medium could exist more purely for its own sake than as a conveyance of descriptive content. The goal was to move away from what he perceived as the stultifying domination of the poetic and reportorial views of the medium then current in photography circles, particularly in the educational institutions. Following the example of his mentors in Chicago, Harry Callahan and Aaron Siskind, Metzker did not abandon purest photographic concerns in his investigations nor an essentially urban orientation. The point, however, is to recognize the theoretical and progressive basis of his work.

Until very recently, Metzker chose not to abandon the representational subject, seeing it as a necessary component in his architectonic scheme. In his tightly controlled studies, he has sought to re-explore the kind of photographic illusionism that was characteristic of post-

Ray K. Metzker, *Sky Sweeps*, 1966
Princeton University Art Museum; Gift of Lilyan and Toby Miller

Pictorialist work of the 1920s. His approach was to stress an under-developed aspect of photographs—that is, to read them laterally as a patterning of forms on a flat surface, not only in a kind of recessional depth. In so doing, he sought a dramatic presence for his pictures, with a graphic preponderance of stark black tonal areas and a framing con-figuration that could immediately be grasped as a construction internal-izing forms, and in turn setting an emotional tone. Metzker was not afraid to define for himself what might prove to be a successful picture in his terms: one dealing with problems given in the medium and resolv-able only in the making of convincing pictures. While it is generally understood in art that the work is the solution to problems the artist has posed, this approach to making photographs is somewhat alien to the photographic community, which tends to remain aloof from intellec-tual concerns.

In the winter of 1959–60, the painter Frank Stella, who is five years younger than Metzker, lectured at the Pratt Institute. In the course of a concise and illuminating talk on his own work, he said: "There are two problems in painting. One is to find out what painting is and the other is to find out how to make a painting. The first is learning some-thing and the second is making something."[1] It is revealing that Stella should have spoken these words at the very time when Metzker was try-ing to identify the nature of an alternative photographic option. The approaches of these two artists to their mutual problem are remarkably parallel, though I am not suggesting that they had any personal aware-ness of one another. Rather, the point is that at the precise moment in painting when a younger generation, represented by Stella and of course Jasper Johns, was seeking to free itself from a kind of bondage to an older generation, young photographers were attempting to do the same in their own medium. Both groups of artists were feeling the heavy bur-den of an emotionally charged abstraction that had developed out of the representational art of the 1940s and early '50s. Metzker's problem was to find a way to explore the character of the medium in order to define photography, and then to make a photograph conform to this definition. His fundamental interest was to isolate the unique formal aspects of the medium and to see if they could embody an expressive statement—a statement far removed from the psychological humanism of much of the work surrounding him.

All of Metzker's work since has been a continuous step-by-step articulation of this desire. It has been his challenge to himself to make the picture be *of* something and simultaneously exist independently as a

photograph. This sense of objecthood is the key to understanding the best work in painting since Johns and Stella, and it is the same for the photography of Metzker and others like him. In this sense, Metzker may also be seen to trace his heritage back to Stieglitz, who realized that abstraction in photography was not to be found by distorting the subject, but by establishing the independence of the photograph as an object.

The intensity with which Metzker explored this activity presents a challenge to all who have been familiar with his work during the past two decades. His sense of finish and deliberateness of purpose clearly set him apart from others, and his work must be seen to presage a great many contemporary images and image-making concerns. Concerns such as those he has approached for nearly twenty years are only now coming to be dominant, and not without reason, because the work of certain structuralist artists has vitalized interest in these pictures among young photographers. Some pictures by these artists shock photographers with their minimalism and complex formalism—aspects separate, in part, from the artist's documentary concerns in such images. Behind these photographs is work with a conceptual emphasis placed on the process through which one creates or visualizes. When this idea is transferred to self-conscious photography, descriptive analysis is placed in the service of exploring not the subject but the medium itself. The unsettled state of contemporary photography would suggest that the example of Metzker's work is not understood and that it has not been as influential as it should be.

The most resolved demonstration of Metzker's exploration into the photograph-as-object was his work with the very large format of constructed photographs. He became one of the first, long in advance even of large photographic works of art, to make truly big pictures that identify themselves with the wall. Two of these were included in the 1978 exhibition *Mirrors and Windows* at New York's Museum of Modern Art, and several were in the most stunning presentation of Metzker's work in recent years, Aaron Siskind's exhibition *Spaces*, at the Rhode Island School of Design in early 1978. These large pictures are constructions of multiple photographs that deal with the photograph in every variety of interpretation—time, motion, tonal variation, serial repetition, sequence, scale, and, most importantly for all his work, the frame. Metzker has indicated the enormous effort that went into their conception and fabrication, and the very meager return he received on his investment of time and funds—a frustrating reality that apparently caused him to return to the smaller single-print image. This is unfortunate; these

large works were achievements of an extraordinarily high level for all art of the 1960s.

Metzker's most recent pictures are seemingly disfigured in relation to the past work, but they emerge directly from the earlier images that demanded a single-image reading. However, these new pictures represent a more expressionist phase in his work. A seeming release from the rigors of an unalterable commitment to sharp focus and a pictorial order based on pattern in form, a discrete screen of tonal luminosity encompasses the entire surface. The pictures are uncomfortable in their monochromatic brightness and in their immateriality, yet effective in the same way that some of Frederick Sommer's are. However, their scale seems to me to be unpersuasive at present, as if suggesting that Metzker has yet to exploit fully this new, sensuous experience with the control that was such a dazzling part of his earlier pictorial architecture. The lesson learned from Metzker's adventure thus far is that solutions to problems are not easily settled, and for him, solutions evolve only to suggest further problems. A climactic summing-up should not be expected from this artist; rather, Metzker's significance may be found in his involvement with dimensions of change hitherto unarticulated in American photography.

NOTE

1. Frank Stella, in Robert Rosenblum, *Frank Stella* (Baltimore: Penguin, 1971), p. 57.

From *Print Collector's Newsletter* 9 (January–February 1979): 177–79.

PAUL CAPONIGRO

During the quarter of a century that Paul Caponigro has been a serious photographer, he has produced work of superlative quality and he has established himself as one of the contemporary masters of the medium. His earliest photographs were vitally alive with the robust flavor of his youth. Influenced by those whom he admired or with whom he studied, he frequently made photographs containing pictorial elements that were clearly reminiscent of their virtuosity. The sheer possession of nature was his aspiration. In the mid-1960s, Caponigro's work changed significantly as it came to reflect his more personal and mature approach to selection and visual articulation. Elements of his music and his personal philosophical studies came to manifest themselves more gracefully. Now he was clearly on his own, searching out the reasons for life's existence, its starting point, and its source. Decisive was his interest in how man fit in with the landscape, or more properly, the communion of humanity and nature. Whereas before Caponigro was focused on pure nature, he now grasped that what would be particular to him was to see nature in human terms—sacred terms. He sought out some of the places in the world where he believed this could be most richly explored. In 1966, he went to Europe, specifically to Ireland in order to study the great stone architectural creations there. He also went to England and France, to Stonehenge, Avebury, and Carnac. He has photographed these stones and these sites with an unflinching eye many times since, and the subjects of his photographs are not the awesome constructions themselves, but the acts of those men who built them in an effort to measure and symbolize their relationship to nature. His photographs reflect his understanding of the intensity of their effort, and the character of certain of his images clearly echoes the eloquence of the ancients, and even how their creations rival the monumental stature of the universe.

Out of this experience in Europe, it was inevitable that, in 1973, Caponigro would choose to move from the New England of his birth to the Southwest. Seeking out the consecrated places of the American Indian, he began to photograph again on his native soil. He continues his search to this day, having paused only briefly in the spring of 1976 to explore the opportunities for photography and reflection in the gardens

Paul Caponigro, *Rock Wall #2, West Hartford, Connecticut,* 1959
Princeton University Art Museum; Gift of Marshall L. Posey, Class of 1927

and temples of Japan. His work from the mid-1950s to the early '80s is unified by the absolute precision of his beliefs and, insofar as iconography is concerned—the pattern on the skin of an apple, or in the cluster of sunflower ovules, or on a prehistoric stone, or in the tracings of pebbles in a Japanese garden—these are documents of no specific place or thing, but of spiritual devotion.

Caponigro's articulation of photographic technique is expressionistic. Working in his own way, he looks back purposefully to an older *modern* tradition—that of Stieglitzian photographic expressionism as perceived in the purity and sensuousness of black-and-white photographic materials. It is the tradition with which Caponigro began his work in the 1950s, and he has not abandoned it. He sees the photographic process in almost mystical terms: it is for him a large part of his pictorial content and it is one of the foundations on which he establishes the meaning of his pictures. Infrequently, there is a breakdown between his romantic aspirations and his realized conception. For him the sparkle of tonal definition and the tissue of chiaroscuro are like the fiery heavens: constituent parts of a magic universe. These chemical/optical illusions are no less real than the stone and trees and flowers from which he also draws portents.

Caponigro's complete work has to do with the changes in man's attitude toward nature. These changes take place very slowly; contemporaries do not notice them because the time frame spans several generations, and thus exceeds the capacity of the collective memory. It is this concern for man's history that is at the root of Caponigro's photography. His concern for ancient meaning and the purity of original belief may be a kind of learned archaism, but such deeply felt passion can enrich us with its challenge to mere progressiveness. While photography may be seen today as the height of fashion, a deeper perspective reveals its suitability for historical analysis in the very fact that it must always focus on what is remaining now, and at the instant of its recording it, too, becomes a part of the historical past. Linking the sort of photography Caponigro practices to astronomical time is not whimsical. Light from a distant star—having its origin very long ago and only now detected in our time, just as it descends into our history—is analogous to our guardianship of domains such as the Connecticut rock wall, or a great butte in New Mexico, or Stonehenge: they have been left to us today in their grandeur, not as relics but as examples of God's work, which can be revitalized by the photographer. Caponigro links his pictures to this trajectory and this spirit, and sometimes in his best work, he reveals

a more powerful transcendence than that which we sense in nature itself. The attention and affection that he gives to his pictures is the counterpart of our most exalted mental process: in the beauty of his pictures, Caponigro seems deliberately intending to mirror a concept of absolute beauty.

One might ask if Caponigro's life is less moving to him than is history itself. Not necessarily, for his fifteen-year obsession with the great stone works of the ancients is testimony to his linking the heroics of these people to the potentiality of action by contemporary man. It is as if to say that the dead are always present among the living, in certain places and at certain times, but their presence is perceptible only to a few—for instance, those who are the artists and the poets. There is no question that Caponigro believes that these persons transport us into a world that is vaster than our own, and his complete concern for the quality of his tangible work further suggests that he believes this other world—the world that he identifies with the phrase "beauty of image"— may be more beautiful than our own.

From *Paul Caponigro: Photography 25 Years*, exhibition catalog,
The Photography Gallery, Philadelphia, 1981.

EMMET GOWIN

Can a photograph have the significance of art? Alfred Stieglitz asked this question just over sixty years ago and, like a Zen koan, the statement may be considered in many ways. One way to extract its wisdom might be to reflect upon the photographs of Emmet Gowin, whose approach to photography is to relate significance to tradition. Rejecting the belief of the avant-garde that the past is to serve only as the dishonored foil for the new, Gowin seeks to infuse a wide variety of established artistic values and age-old techniques into his work. This proven set of practices is the starting point for his efforts and the locus of his identity as an artist. And while he appreciates the many other fields of endeavor, Gowin believes that making art is perhaps the highest calling. For him, along with the love of his family, art is the center of his life. He reflects on this when he says: "I feel that whatever picture an artist makes it is in part a picture of himself—a matter of identity." Just how Gowin expresses his cultivated intellect and his philosophy, together with how he seeks to establish his individuality, may be seen in the way he has utilized the photographic medium and identified its critical issues.

Several years ago, Gowin was fond of quoting D. H. Lawrence's observation that "even an artist knows that his work was never in his mind." While one can be sure that Gowin would not disavow this attitude now, he would surely add the qualification that one cannot deny knowledge nor stop growth. He is unusually aware of how we learn, and how we form ourselves as individuals. He understands that this process is both a willful act and an unconscious evolution from the simple to the complex. He has in his mind the kind of work he likes, and he knows the kind of work he wishes to produce. On a basic level, all of his work is characterized by what is called "straight" photography. He identifies his primary and personal photographic mentors, Harry Callahan, Walker Evans, and Frederick Sommer, as all working in this approach and demonstrating to him the validity of accepting the reality of camera vision. In pursuing the unique qualities of the photographic image, all of these men place their trust in the belief that reality is the fountainhead from which their inspiration will flow. The work of each of them is a celebration of both clarity and fact, and each artist has done

Emmet Gowin, *Edith, Danville, Virginia*, 1978
Courtesy of the artist

much to demonstrate the range of possibilities within this technical bias. We can see that when one respects the standards set by such skilled figures and seeks to find his place in the contemporary world, not by any savage gesture, but rather by the exquisiteness of finish and the clarity of rendering, then the purism of the photographic medium presents no handicap. In following through with this attitude, which is by now fundamental to him, Gowin has sought to find the subjects that will fire his personal imagination.

A man of religious and spiritual upbringing, with a sensitivity and respect for the quality of human life and for personal feelings, Gowin found his first important subject matter in the circle of his wife Edith's family. Years and layers of reality were represented both in the multiple generations of people and in their living environment in Danville, Virginia. Their breadth of life and openness to the world was in contrast to what his own family provided, and this homestead was to be the arena in which Gowin matured as an artist. "I admired their simplicity and generosity," he has said, "and I thought of the pictures I made then as agreements. I wanted to pay attention to the body and personality that had agreed out of love, it seemed to me, to reveal itself. My paying attention was a natural duty which could honor that love."

His first substantial pictures, which date from 1965–66, were of a quasi-snapshot appearance. They were taken, however, with large-format equipment and they were pointedly posed, such that the sitter and the photographer shared in the picture-making experience. This is a crucial understanding, for it identifies the linkage that places even his first photographic approach, characteristically, outside of much contemporary photography. The accomplishment of these pictures originates not in formal factors, but in the intensity of their intimacy and in the charged atmosphere of symbolism that is to be found in them. All of the people participating in these pictures are linked sexually to one another; they all know it, but speak little about it, and this is the hidden dimension of family life that energizes the commonest of picture-taking situations. As viewers, we sense that we are privileged in that what we are seeing is the human naturalness of expression even in the presence of the camera, a quality Gowin describes as "loosing the shadow that the process holds over one," and this quality places these pictures in a realm beyond the candid or the usual captured moments that we associate with so many other photographs—both amateur and artistic. Indeed the candid, or "decisive moment," aesthetic, as it has been called, had been Gowin's earlier camera approach during college

and at the start of graduate school, as he worked his way through the examples of his early models, Henri Cartier-Bresson and Robert Frank. Gowin still considers the snapshot to be one of the richest sources of strong images; it was during the years 1966 to 1970 that his admiration for what he called the "homemade picture" was the highest. "I was becoming alive to certain essential qualities in family photographs," he has explained. "Above all, I admired what the camera made. The whole person was presented to the camera. There was no interference, or so it seemed. And sometimes the frame cut through the world with a surprise. There could be no doubt that the picture belonged more to the world of things and facts than to the photographer."

However, Gowin was learning to be an artist, and as much as he appreciated the qualities of innocent photographs, he had to extrapolate from them a critical aesthetic and a conscious methodology for his own world. This is what he knew Callahan had done out of similar inspiration. It was also the pictures by Walker Evans, together with the vividly descriptive and unabashedly personal prose of James Agee, that demonstrated for Gowin a way. These influences, with others that had been accumulating, suggested to him that his route toward an approach to photographing would be philosophical and not merely formal. He gradually turned away from the inspiration of Cartier-Bresson and Frank, recognizing that he did not have the particular view of the world that is reflected in their work. "I realized," he has said, "that that was not my character at all, that I didn't have any kind of cosmopolitan understanding. I had a very local kind of understanding. I was a local person living in a local situation." He continues: "I realized that my own family—Edith's family—was as miraculous as the most distant people in the world and they were at the same time, the most available to me, and perhaps available only to me. So I turned my interest to them—my interest was already with them—but I had not realized that art could be made by simply telling the story of your own life, of your own experience. I should have understood this, but I didn't. I realized that telling my own story, using as subject matter the people I knew and loved, that this automatically involved an intimacy I could not have had in any other way."

Perhaps in no other body of his work is the sense of intimacy and growth so deeply revealed as in the pictures of Edith, whom he met the year he began to photograph. Edith gave him his invitation into her family and she has been his guide through it, but most importantly she, along with their two sons, Elijah and Isaac, have been Gowin's primary

personal foci. Among Gowin's pictures of his wife are some of the most tender, loving, and quiet images in his oeuvre, and also some of the most explicit and dynamic. The underlying energy in all of these pictures is warmly sexual, but the relationship between the partners is so totally natural and trusting that its depiction is singularly poetic. Viewers have naïvely wondered if these pictures are not embarrassing to her, and Edith is known to have replied that we have not even seen the pictures that are *too* personal. These two people know more than what they render in these images, and they do not reveal everything they know about each other. This is meaningful because, through these pictures of flesh and spirit, Gowin is aspiring to elevate his feelings to the realm of public expression, and as with those images of the entire family, his purpose is to "tell those things he feels have a chance poetically of fitting back into life. That means fitting back into the feelings of other people." It is in this way that his photographs become most symbolic, even religious. The pictures of Edith are crystallizations of enlightened human experience. The expressions range from Edith, seminude and ringed with a garland of berries and vines, as the goddess of fertility, to the Earth Mother herself, reveling in the ecstasy of pregnancy. These depictions originate in the most fundamental and collective pictorial tradition known to our culture, though for Gowin, they are perhaps less antique in source than they are an inheritance of the Renaissance.

The light in the pictures of Edith is especially beautiful. No two pictures of her are alike—in terms not of pose or locale, but of the light that makes itself felt as Gowin's own presence as husband and lover. He knows when the light is right, and he projects through these pictures the entrancing feeling that we would not even see Edith if the light were not as it is, wrapping around her face, embracing her body, and at times radiating from her. The metamorphosis of their union is magnificently displayed in these luminous pictures. Like William Blake's watercolors, some of which have inspired Gowin's pictures of Edith, the photographs come alive only when they are palpably present—when, for instance, one has an unmediated view of the pulsations that his printing imparts to the sensitive paper.

The benevolent and simple social richness among Edith's family continues in Danville to this day, and the Gowins return there often from their home in Pennsylvania, but there have been important changes, too, and these have altered his work. By and large Gowin has abandoned the family subject and even the style he used in making their pictures, and some of his admirers, probably with a degree of criticism

but without malice, express a certain loss. Gowin describes his new direction in this way:

> If things happen to our advantage and we find ourselves in a situation we really love and cherish, and it nourishes us, it would be a mistake to hope that we would find that exact situation again. Everything belongs to its season, to its place. I think of the family, for instance, and that family had a different sense at that time. Then the grandmother died, then two uncles died, and the children who were the babies in the pictures were having their own babies; there is that sense of change and our job is simply to take things the way they are. We have to accept what nature presents us. . . . As photographers our feelings also change. And we grow in complexity. These people, my wife's family, were in a sense farmers, weavers, cotton mill people, workers, simple people in touch with nature. And that was affected by where they lived and how they lived, and the way they carried on their affairs. That is exactly what is at the heart of my newer pictures, but the family, in a sense, has grown to be a larger one. I have begun to visit people in Italy, to see different parts of the world, and what fascinates me the most is what man does in his friendship with nature. In a word, to cooperate, to make it more productive, and to advance his relationship with nature.

Beginning in 1973, and over the next two years, Gowin began to turn his attention to making pictures that he characterized as "working landscapes." These pictures are again about the process of change, but now also about a theme he increasingly sensed, both aesthetically and politically: that of man's relation to nature and with a place. At the same time, he was sensing the disruptions in the family structure; he had come to understand that the family also belonged to a particular space, that the family was a part of a collaboration between man and the landscape. As the family itself receded from his subject interest, he realized that the setting for the family, the setting for personal feelings, could be a meaningful subject. He then began to look at nature and consider the questions: "Does the landscape just sit out there? Or have we built ourselves a roadway into nature—when we look on nature, don't we imagine how it may be improved?"

He first worked around the Danville homestead: the circular pictures of buildings and landscape details are part of this investigation,

and on his first trip to Italy, in 1973, he was drawn to the cultivated fields and gardens near Siena. Over the years, this quest to understand man and nature has grown to encompass a variety of depictions and sites. In some of Gowin's images, such as those made in the American Southwest at such places as the Canyon de Chelly, he is interested in nature working alone—the process of erosion, for instance—and in other images, particularly the European pictures in Ireland and Italy, about man using the land—cultivating it, living on it, and making it comfortable. In all of this work there is the deeply spiritual allusion to God's presence. For Gowin, pictures are gateways to the imagination, but such travels of the spirit are not ones of pleasurable fantasy into the picturesque; rather, there is always a certain hesitancy together with the excitement. Like all of us, he is confronted with the acts of man and nature that are in every sense violent. To deal with this violence, Gowin has come to understand that we must live imaginatively. This may be the greatest lesson he has learned from Frederick Sommer. Gowin believes so deeply in the potential of pictures that he transfers all the emotion he feels for a place or a belief into his pictures. Some of his landscape photographs have a kind of thriving energy, not physical energy but an energy that derives from the feeling that there is no emotional escape from the pictures. His manipulation of our emotions in these images is forceful and subtle, and in the few natural landscapes— the canyons and those of Mount St. Helens, for instance—we can meditate on his identification of the difference between these places and those like Danville or Italy where one finds a civilized harmony between man and nature. In the pictures taken in the latter places, there is a sense of the humane, of a certain imperfection or incompleteness, but always with nature's controlling presence—a blowing tree that becomes a blur, a sheep grazing, a coat hanging on a wall in Matera—all understood to relieve an otherwise rigorously constructed pictorial environment. In the pure landscapes, Gowin edges precipitously close to a feeling and a rendering in which stasis exists, in which there seems to be a perfection in the abstract, formal order. These pictures, it would appear, are close to those of Sommer's vision, in the same way that Gowin's other pictures share a conception with those by Walker Evans, or even by Eugène Atget, whose photographs he also admires.

Gowin's most recent photographs, those that have been the focus of his attention for the last three years, are of the Mount St. Helens volcano in Washington State. They continue his fascination with pure landscape and importantly with the constant manipulations nature has

wrought on the land. In them, it is as if the stakes have become ever higher and his continued attraction to this difficult site suggests this. In speaking about his recent pictures, Gowin has said:

> Man cannot afford to conceive of nature and exclude himself. It is an interesting dilemma because people at one time were very much in the habit of saying that nature is full of disorder and chaos, and they wanted to say that art in man's activity is an attempt at ordering. That is all in a sense very very true; this is a correct perception. But nature doesn't consist purely of disorder. What do we say of Mount St. Helens? We say that it is a natural disaster, meaning that disaster is natural. I would not like to see that kind of play on words get transferred into man's convictions about what is characteristic of human behavior, because if you would do this, you would say that disaster is natural and man will always forever bring himself to the brink of disaster. He will always, in fact, stumble into his own disaster. So I am for survival. And I am for the survival of beautiful images.

Out of this fantastic and inhospitable environment, Gowin has produced a series of beautiful and expressive images. He has not ordered the landscape, or conquered it, as we might be tempted to say, but he has given it over to us in a willful form that can be contemplated with the respect it deserves. In so doing he filters nature's violence, this violence of incomprehensible magnitude, through his imagination. He is most enthusiastic about the aerial photographs, in part because they demonstrate his mastery of a challenging camera technique and also because, while they accurately image the terrain below, they are stunningly allusive as well. These are not topographic photographs, but new manifestations so laden with information that they transcend the rational mind, as does the very scale of the eruption that caused such a vast geography to be formed in this way. Pleasurably, however, certain of the pictures remind us of drawings by Leonardo; those remarkably accurate bird's-eye views of river flows seen from high above. The St. Helens pictures are transformations; they take away something from the actual site on their way to being something else. The pictures provide experience, but one that is very different from actual experience. Gowin sees no need for the photograph to render expediently legible all essential information for an understanding of its content. To approach such refined and nonanalytical photographs, one must be prepared for and attuned to those guidelines, those entry points that he

does provide. Sometimes our only pathway into one image will be a repeated element or land formation already seen in another photograph. The act of photographing may allow the photographer to acquire something he had not understood or comprehended, but the goal for the finished picture is to be revelatory, and it can only do this by resisting its power to obscure, by asserting its transformation and positioning itself in our understanding. These are marvelous works, at once deeply moving and entertaining.

With regard to his prints, Gowin believes in and relies on the knowledge that the graphic arts have a rich and still meaningful lesson for us. The example of the work of Northern European artists such as Albrecht Dürer, Martin Schongauer, and especially for the conception of the landscape, Hercules Seghers, provides Gowin with the guidelines for finished products. From these artists and others (notably some of the Surrealists of our own century), he has also learned that pictures may have a narrative content—containing moral messages—and these are the kind of objects he seeks to create. In the small images by Dürer, for example, Gowin admires the compression of information and substance that he believes is extraordinary. Likewise, he feels that the engraved line describes something that is like photographic description, and it is this realization of the integral relationship between the rendering of the photographic print and its content that has given rise to Gowin's obsession with the craft of photographic printmaking.

To some, Gowin's efforts in the making of a print are directed mostly toward casting himself as a kind of self-mythologist. But to him, the insistence on taking care of every minute particular is simply the recognition that making a fine print is not a casual affair. The basic distribution of subject matter is taken care of in the making of the negative, and in terms of composition, the print is generally visualized at the time of exposure. However, the effective positioning, the effective weaving together of elements, the feeling of equilibrium across the picture field, all this must be conceived and executed when the print is made. It is in this endeavor that Gowin spends his most concentrated time, and this is why, on occasion, he believes he creates just one finished print. Further, it is not true that Gowin is insensitive to chance or that he does not make mistakes. Indeed, he gives the impression that he relishes errors, since he views such mistakes as the basis of the few "semi-original" things he does. He has shrewdly observed: "It's just taking care of the photographic process that makes me feel like I'm making progress. I learn most when I make the dumbest mistake. A mistake means you

have to go to the darkroom with patience, with some time on hand, to work out a solution. It means things are not done the way you used to do them." In a like manner, Gowin recognizes that he, too, learned through apprenticeship and therefore, especially in the matter of technique, he accepts the responsibility to be enthusiastic about teaching and spend time with students.

The beginning of Gowin's understanding of the interrelationship between the print and its content dates from his first meeting with Frederick Sommer in 1967. Prior to that time, Gowin had a student's conception of quality photographic prints: mostly that they were a function of negative size. It was Sommer who, during a private conversation in Providence, articulated the idea that prints must be individually tailored to the content and meaning of the picture. This came as a considerable surprise to Gowin, as did Sommer's belief that there is a fundamental relationship between the picture one means to take and that which one actually takes. Gowin has refined this truism when he says: "We are not actively able to predict our work; it is seen in the work afterward. We have a certain intent but all must come out from the experience and the work." Nonetheless, he expresses considerable respect for Edward Weston's notion of previsualization, noting that what most appeals to him is Weston's "force of preparedness," in the sense that when Weston articulated the idea of seeing the photograph finished, before exposure, he knew what he was talking about and he knew how to achieve it. But Gowin goes further than Weston in his visualization of the picture in that he is freer of the subject. Weston's reverence for the actuality of place or thing, that which he called the "quintessence of the object," Gowin shifts to a focus on the truth of the pictorial idea and the uniqueness of the finished print. It is through this device that Gowin, like Sommer, articulates the conception of images about images; meaning that pictures are about other pictures and that they derive from the world of pictorial art. Following this scheme, reality becomes a complex relationship involving fact and imaginative vision. Images thus become more memorable than experience. The dynamic of actual experience is complex and at a distance, while an image is remarkable as an imaginative instrument of this realism; it shines in miniature and it may be studied, close at hand, only inches away from us, where the photograph is.

Responding to Sommer's initial instruction, Gowin went on to learn from this master craftsman and others the importance of quality lenses and the complex printing methods he uses to advance his pic-

tures: such processes as selective and overall bleaching, combination developing, toning, and a form of print masking called "contour mappings." Some images are the result of as many as twelve operations. Gowin makes no secret of these workings; he teaches them in his classes and workshops and he has published his methods in a volume on darkroom procedure. He likes to point out that none of these practices are new, that earlier manuals were the most descriptive and detailed on the subject of toning, and that bleaching out the sky in the view of Matera, for instance, would have been common practice in the nineteenth century. Gowin's recent prints are like few others, including those by his teacher and now colleague, Sommer. He considers some of them monoprints, in that chance actions of certain chemicals can never be repeated, or at least not repeated by design exactly the same way; and in accepting these visual formulations he settles on a final, unique conception for a picture.

In the end, we recognize that Gowin's intent in making photographs is symbolic. For him, the photograph is not a surrogate thing; the thing photographed may not be important at all. In photographing, we do not replicate the object before the camera—we produce a photograph and this is a symbolic operation. To view his work in this way, even early in his career, is something that sets him apart from many of his contemporaries, and it is especially so today. Gowin has no interest in obscuring those qualities that make pure photography essentially what it is. He has been much impressed by the notion of defamiliarization, as articulated by the Russian author Viktor Shklovsky, such that the "challenge of photography," as Gowin sees it, "is to show the thing photographed so that our feelings are awakened and hidden aspects are revealed." But what most fascinates him are the unique qualities of the photograph, the tone that is infinitely nuanced and, particularly, the mystery in an extremely sharp and detailed image. He feels that when you see the finished print, you know more than when you are actually at the site; as he phrases it: "You have an understanding of the place without ever having been a resident." It is this desire to provide more for his audience that drives Gowin to have such a respect for his medium, and ultimately for his audience. Through this endeavor, he wishes to extend photography into the domain of serious and traditional artistic expression. Not out of some desire for the respectability of the medium itself—that is irrelevant—but in a personal sense he wishes to "mirror in the work the feeling that stimulated [him] to think that working was worthwhile." For this creative enterprise, Gowin relies on the density

of implication and the intensity of feeling that he recognizes are his legacy from the tradition set out by those before him and that he accepts as his responsibility to continue.

This sophisticated understanding of creating can be illustrated through a reading of a typical photograph, *Book, The Medical History of the War of Rebellion*, of 1979. The old book that Gowin photographed is not a still life in the usual sense, that is, a depiction of something dead. Rather, it is alive within transition. In the peeling away of surfaces, so that the old is revealed from within the new, we recognize a process we often observe in nature. In building culture, we place the newest interpretations of meaning at the top of our order. These, too, age and in time form the complexity of our collective wisdom. Emmet Gowin discloses this process in all his work. He seeks no end to this cycle, because he knows there is none, and instead he shares the possibilities offered by the contemporary modifications of ancient fables. This analysis concerning the logic of imagery, expressed in Gowin's own idiom, is one answer we might offer in response to Stieglitz's question about the photograph's significance as art. A work of art cannot reveal its wisdom until we ourselves, imaginatively, poetically, find some of its order in the idea of life. Ideas survive, and whatever the art, whatever the material of art, over the longer view, only ideas can resurface with the vividness of art.

From *Emmet Gowin: Photographs, 1966–1983*, exhibition catalog, Corcoran Gallery of Art, Washington, D.C., 1983.

EDWARD RANNEY:
THE CHARACTER OF THE PLACE

In the 1960s, a group of photographic artists emerged that took its approach from an older generation who had matured in the years around World War II. Edward Ranney belongs to the later generation of photographers, whose precursors include such figures as Wynn Bullock, Aaron Siskind, Frederick Sommer, and Minor White. The two generations shared a fundamental aesthetic belief that a photographic image has the potential to express abstract meaning and spirituality. The goal was to make photographs that encouraged viewers to project themselves into the image and to sense the "spirit" beneath the surface. Ranney's luminous photographs clearly invite such contemplation, creating a partnership with him that engages us in recognizing how wonder and beauty came into being.

Ranney was born in 1942 and grew up in Illinois. He began making photographs in 1964 during his senior year at Yale University, where he studied English literature, Spanish, and art history. After his graduation, Ranney traveled to Peru on a Fulbright Fellowship to study the Quechua Indians near Cusco. It was in Peru that his interest in photography deepened, and he soon acquired a four-by-five-inch view camera. The ten years between 1965 and 1975 were formative ones, during which he entered into the community of serious photographers, where he learned from them in person as well as by observing their work. Over the years these included Robert Adams, Paul Caponigro, William Clift, Robert Frank, David Plowden, Paul Strand, Edward Weston, and Minor White. In 1970, after a four-year period teaching Spanish and photography at the East Hill School in Vermont, Ranney moved with his family to New Mexico. At that time, he began to travel extensively to the locations of his early work. His first important exhibition was organized by the Art Institute of Chicago in 1974; his work has been exhibited internationally ever since. He has published three monograph books and has played a crucial role in the discovery and promotion of the photographic heritage of Peru, especially that of the Peruvian photographer Martín Chambi (1891–1973), whose archive in Cusco he

Edward Ranney, *Machu Picchu (Intihuatana)*, 1971
Princeton University Art Museum; Gift of John B. Elliott, Class of 1951

was instrumental in preserving. Ranney has contributed essays to numerous scholarly publications, the most recent of which, "Images of a Sacred Geography," is a history of the photography of Andean sites since 1864.[1]

The title of that essay reveals a great deal about Ranney's approach to photography. Over the years he has consistently acknowledged the sustaining power he found in the work of many nineteenth-century photographers, including the Americans Timothy H. O'Sullivan and Carleton Watkins, among others. What he recognized in their images was an essential connection to the real world, but a world in which the legacy of past cultures and their places of sacred significance is evident. Each of his photographs, whether made in the American Southwest or the Peruvian desert, embodies a part of the past that rises up and stimulates Ranney's intellectual curiosity and visual sensibility. This need to understand in pictorial terms is what sustains him in his effort to depict seemingly arid plains with an interpretive emotion that reveals the hidden spirit. Ranney's landscapes resonate with the work of two contemporary photographers: Paul Caponigro and Thomas Joshua Cooper. Indeed, it was Ranney's encounter with Caponigro and his work in 1970, and in particular seeing his photographs of ancient European sites and stone monuments, that encouraged Ranney to pursue his interest in such subjects at a time when this was unusual.

Although Ranney began his photography of ancient and sacred places in Peru, it was his images of pre-Columbian sites in Mesoamerica, begun in 1970, that were first published in the book *Stonework of the Maya*, in which Ranney provided the text as well as the photographs. In that book, he proves he is much more than an informed observer; he is a learned interpreter of the architecture and sculpture he photographed. In his elegant preface, which follows a quotation by George Kubler from *The Shape of Time* (1962), Ranney wrote:

Along with amplifying our factual knowledge of the ancient Maya, we should also be continuously aware of the value and need for purely visual interpretations of the monuments, interpretations which though not always scientifically informative do inform us in other ways, particularly in giving us a feeling for the spirit of the culture. In this sense, a photograph, like an archaeological artifact itself, has the unique potential for providing an intensely evocative expression of an ancient culture. Both a photograph and an artifact are by nature a peculiar mixture of

poetry and fact. . . . In photographing the Maya landscape I have been guided by forces other than reason and knowledge. The archaeological facts presented in this study are more the result of a very personal need to know certain specific things than they are an expression of a systematic, professional knowledge of an ancient culture. More simply, the photographs themselves came first, and have been the motivating force and focus. In this sense, they, like the monuments which they present, both constitute a world within themselves and exist as metaphors of a universe far more vast and complex than any one literal image or any single archaeological artifact.[2]

By the time he published *Monuments of the Incas*, in 1982, Ranney had been photographing in Peru for a decade and a half and had become a recognized scholar of Peru's photographic heritage, as well as its archaeological sites, architecture, and landscape. Ranney has made a unique contribution to both our historical and our contemporary understanding of Peruvian culture and society through his lectures, articles, and interviews, as well as the exhibitions he has organized. These exhibitions sometimes included his own photographs alongside those of Martín Chambi, as for example at New York's Museum of Modern Art in 1979. Ranney provided the preface to *Monuments of the Incas* and turned to John Hemming, a leading scholar in the field, for the text. In his preface, Ranney revealed what he believes is at the core of his photographic endeavor: something he describes as "visual space." He wrote: "Archaeological documentation of Inca culture has consistently failed over the years to convey the intimate relation between the monuments and their surroundings—the shapes and spaces of the mountain landscape, which the Incas venerated. The unique setting of each major site, with the buildings erected upon it and the sculpture carved from the living rock, together embody the Incas' spiritual intent as well as their practical planning, and can enable us to understand why, as well as how, they built as they did."[3] This piercing interchange between intellectual knowledge and an expression of feelings marks Ranney's imagery, gives it drama and structure, and sets it apart.

It has been said that very few of Ranney's contemporaries can be compared to him. In terms of the concept of "visual space," perhaps pertinent comparisons would be with Norman Carver Jr. in his book *Form and Space of Japanese Architecture* (1955), or Yasuhiro Ishimoto in *Katsura* (1960); their photographs being very much in harmony with

Ranney's of the Inca monuments. The reverence for architecture and the precise, ravishing black-and-white photography of views and details are very similar. Two of Ranney's photographs made three years apart at Machu Picchu, *Machu Picchu (Lower Machu Picchu and the Urubamba Valley)* and *Machu Picchu (Intihuatana)*, demonstrate how strongly Ranney understood the Incas' need to come to terms with the union of heaven and earth, with the binding power of the physical and the spiritual. In the composition of the landscape, the carefully oriented pathway is viewed in conjunction with the surrounding peaks and the river below. The Intihuatana altar stone, placed atop one of the greatest heights, is as if it is in the sky itself, bathed in misty light and braced against the movements of diaphanous clouds.

It might seem a great distance from the transcendent and romantic Inca site at Machu Picchu to Charles Ross's enormous earth sculpture, *Star Axis*, in eastern New Mexico, but for Ranney physical distance is unimportant, because his essential concept of what photography can do is the same regardless of place. Ross, a sculptor with a background in physics and mathematics, built his international reputation on works inspired by the properties of light and celestial movement. Ranney began photographing *Star Axis* in 1979 and has returned to this project each year. He sees his work there as a participation in the creation of a complex cultural and perceptual space, which he refers to as "archaeology in reverse."[4] The astronomy-based sculptural work, still unfinished, is conceived as a naked-eye observatory focusing on Polaris, the North Star, and on the relationship of man to cosmic time and space. Like Ross, Ranney is entirely taken up with concern for how physicality and spirit can re-engage us in an era when such values are threatened, if not entirely discarded. As he suggests in the quotation above, his photographs of this site are a reversal of his other work, in that he is not focusing on ruins of the past, but progressively and serially recording the construction of a work that the maker has devised with a knowledge of, and a kinship to, ancient practices. This collaboration is made more meaningful because the two artists are engaged in a dialogue of art-making, and they will be a part of a jointly lived history when the work is completed.

In 1992, Ranney accepted a commission to photograph the Illinois and Michigan Canal Corridor that moves southwest from Lake Michigan and Chicago. The hundred-mile waterway dates back to 1848, when it was an essential link between Lake Michigan and the Mississippi River. Ranney has indicated that he took on the commission

because for some time he had hoped to bring his experience of recording archaeological sites of ancient America "to bear in photographing both the Midwestern landscape in which I grew up and the city in which I was born."[5] His photographs, together with selected historical pictures and documents, marked the 150th anniversary of the construction. His experience with the place proved to be profound in the way his images revealed the interconnections of the rural-urban exchange in the past and the elegiac present. He further explained his work by quoting Lucy R. Lippard's observation in *The Lure of the Local* (1997) that photographs are inherently "about memory" and that if "space defines landscape, . . . space combined with memory defines place."[6] In 1998, Ranney published his photographs in *Prairie Passage*, of which reviewer Eugenia Parry wrote: "For him topography is never enough. Every image implies a layered story. Whether it remains mute, as in many ancient artifacts, whether he is able to coax it from mere stones, he changes historical places into poignant metaphors of longing."[7] In one of the most moving sections of *Prairie Passage*—the final one titled "Ottawa to La Salle/Peru"—Ranney has, indeed, made visual the poignancy that Parry described. The section details the termination of the canal in the interior of Illinois, and Ranney has perhaps attempted not only a summary of the views already shown, but also a virtual inventory of his personal, twenty-five-year pictorial vocabulary: river views, ancient stones, aged monuments, pure landscape and town views, modern structures, and abandoned houses. One picture very near the end of the sequence, *Illinois River at Peru, Illinois*, belongs to those of his images that are carefully conceived but deceptively simple in appearance. A dog sniffs around in a yard, a barge floats on the river, and the complex web of tree branches and bridge trestlework converges in a skyward mesh. Two very plain houses, set peacefully in the snow, confront the viewer and suggest humble habitation. Here we study a photograph that ennobles the spirit of a society that is, in all its ordinariness, as connected to the past as it is to the future.

Throughout his years of photographing, Ranney has had an interest in what might be termed the chaste landscape, both in this country and in South America. Since the mid-1980s he has directed much of his attention to photographing pre-Columbian coastal areas that extend from the deserts and river valleys between Piura, in northern Peru, to Moquegua near Chile. Ranney cites these pictures as an extension of the landscape work he made in the American Southwest over many years, as well as a variant form of recording many Peruvian archaeo-

logical sites devoid of prominent architectural ruins. Of special interest is his use of the five-by-seven-inch view camera that enables him to explore subtle spatial renderings not possible with other formats. He views the work as pertinent both to professional archaeologists and to the lay audience. What he has said interests him in these Peruvian places are not only the specifics of the site but the enigmatic spaces, vast and planar, pressed between the Andes and the sea.[8]

As with all Ranney's work, his research regarding the sites gives structure to his endeavor, which is not merely documentary in nature. In a Fulbright application he described his aim to produce "many consistent photographs that will stand, much as the work of Carleton Watkins on the Columbia River in 1867, or Edward Weston's photographs of California and the West of 1937; a distinct body of landscape work of enduring significance."[9] And he added: "You can get a cosmology of the culture through all the different photographs you put together."[10] The latter thought is an interesting idea and one that may further connect him to his nineteenth-century predecessors, whose photographs were published in albums and survey reports.

In considering these desert areas, Ranney has used some descriptive phrases first articulated by the sculptor Robert Morris, who also visited Peru: the "palpable emptiness" of the plain, the lines that he felt effectively mediated between the "flat and the spatial." Importantly for Ranney's work, Morris noted that although the lines (networks of built linear structures, believed to be related to observations in astronomy) can be seen more clearly from an aerial perspective, it is only when viewed from the ground that they most effectively transform, and define in human terms, this irrational, overwhelming space that seems to rise vertically before one. This complexity of seemingly simple spaces, and the fascination vastness holds for the human eye, has been central to Ranney's work. It implicitly reminds him how the legacy of expeditionary photography continues to be an important reference for some contemporary photographers such as himself.[11]

Ranney reveals his multiple interests in the past and the lived present in another body of photographs, made over several years. These works, of the New Mexico landscape that he has inhabited for thirty years, embrace the presence of Native Americans and their enduring mystical patrimony. The images have been made at a time of rampant cultural and physical change in this part of the country, and are both a salutation to and an attempt to keep alive the specific and individual character of the environment as it was first noted by photographers a

century before. This approach is emblematic of Ranney's method and confirms how necessary it is for him to work in a metaphorical manner, despite the fact that he believes his way of working is more and more outdated.[12]

One of the strongest of Ranney's works made in this corner of the country is the diptych *Pueblo Blanco, Looking Southeast to Comanche Gap, Galisteo Basin, New Mexico* and *Pueblo Blanco, Looking Southwest, Galisteo Basin, New Mexico*. Made in 1999, it is a pair of images in which motifs and pictorial devices found in earlier Ranney images are panoramically repeated in the two frames. In its treatment of the place, and some of the land features and vegetation, the diptych also recalls works by Paul Strand made in New Mexico in the early 1930s, with which Ranney must have been familiar. The site was inhabited by the Tano (Southern Tewa) culture who thrived there for around four hundred years, from the thirteenth through the sixteenth century. In the foreground of both frames, a prominent rock outcrop overlooks the buried stone and adobe walls of the pueblo, where cholla cactus now covers the surface of mounds in the dry earth. The image on the left looks out to the Galisteo Basin's important landmark, Comanche Gap, an area covered with ancient petroglyphs. The basin is renowned for some of the most vivid rock art in New Mexico. The petroglyphs on the outcrop itself have been interpreted as a representation of the place and seen, even in their fragmentary notation, to emphasize not just the importance of water but the connection between the springs in the ground and the clouds above. The hollow in the rock that catches rainwater was probably formed naturally, and is a striking visual focus that serves to anchor the picture, but also suggests the equivalency of religious and practical experiences. The dreamlike combination of vista and close-up reveals us as spectators of a natural setting in which harsh light models the varied land masses and the brittle beauty of the intimate landscape. Ranney's diptych speaks of the history that has preceded us and thus, by implication, reaffirms the tenuousness of our place in the contemporary world.

Edward Ranney's photographs reveal the faith that he has in his medium. They also reflect his realization that surfaces can disclose inner states, that through the careful presentation of facts, spirit may be discovered, and that with dedication and respect, the character of a place may be shown in its essence. Throughout the years of his photographing, Ranney has pursued a single goal: to position his imagery in a cultural unity as part of a collective meaning he calls "a photographic view

of the world."[13] In so doing, he has earned a reputation for insight and discernment. To be in his company, or to study one of his books, is to confront the serious interchange between intellectual knowledge and the poetics of feeling.

NOTES

1. Edward Ranney, "Images of a Sacred Geography," in *The New World's Old World* (Albuquerque: University of New Mexico Press, 2003).

2. Edward Ranney, "Preface," *Stonework of the Maya* (Albuquerque: University of New Mexico Press, 1974), p. viii.

3. Edward Ranney, "Preface," *Monuments of the Incas* (Boston: Little, Brown, 1982), p. 9.

4. Edward Ranney, untitled statement, in *The Essential Landscape* (Albuquerque: University of New Mexico Press, 1985), p. 128.

5. Edward Ranney, "Notes on Mapping the Corridor," in *Prairie Passage* (Urbana: University of Illinois Press, 1998), p. 204.

6. Ibid., pp. 206–7. Ranney's citation was taken from Lucy R. Lippard, *The Lure of the Local* (New York: New Press, 1997), p. 9.

7. Eugenia Parry, "Books in Depth," *Art on Paper* 3, no. 3 (1999): 69.

8. Edward Ranney, unpublished Fulbright Scholarship proposal, "A Photographic Study of the Landscape and Pre-Columbian Archaeological Sites of Peru's Desert Coast," 1991, p. 5.

9. Ibid., p. 7.

10. Ranney, in Emily Van Cleve, "Ed Ranney Captures the Simplicity of Landscapes," *Santa Fe New Mexican*, July 11, 1997, n.p.

11. Edward Ranney, untitled statement, *Aperture* 129 (1992): 69.

12. John Paul Caponigro, "A Conversation with Edward Ranney," *View Camera* (January–February, 1999): 28.

13. Edward Ranney, untitled statement, in *Minor White: A Living Remembrance* (Millerton, NY: Aperture, 1984), p. 53.

From *Edward Ranney Photographs: The John B. Elliott Collection*, exhibition catalog, Princeton University Art Museum, Princeton, New Jersey, 2003.

THOMAS JOSHUA COOPER:
THE TEMPERAMENTS

On seeing Thomas Joshua Cooper's photographs, we are touched by an intense feeling of psychic energy. They convey this feeling partly in the way they project a distinctive impression of unbending power, and a rootedness in a deep hidden center within them, and they also do it partly through an incredible tension between the imaginative and the phenomenal. We look in a state of incredulousness, transfixed by their force and under the spell of their immense integrity. The intellectual horizon of these pictures is limitless, their precision of craftsmanship breathtaking and daring. In them there is no padding, no hesitancy, nothing that is timid; the entire body of work has a continuity that is unbroken, the pacing is sharp, the rhythms are bold, the technical tact is remarkable. The effect as we look at a large group of Cooper's photographs can only be described as supernatural, a strangely beneficent magic. He is a medium for those mysterious hints of gentleness and grandeur that occasionally absorb the human mind. His is a spiritual emotion.

The range of Cooper's work of the past twenty-five years reflects a life lived with passion, with devotion, and for a vision. The titles of the pictures, and the titles of the series, reveal a great deal. Location is basic; these are the specific places Cooper has gone to find the emblem of his idea, the manifestations of his beliefs. The subtitle, or picture title, identifies the sort of activity that is perceived at a site—ritual, dancing, ceremony, gazing, premonition, dreaming, indicating, remembering. These rites of human endeavor derive first from the impulses of his own experience at the place, but they are also all about exploring one's interior and coming to have a holistic vision of life.

It would seem that photography, the most literal of media, should hardly be the vehicle for this transport of our sensibility. But in its very factuality, and in its capacity for manipulation, the medium's own duality represents the dualism of the human circumstance: thinking and feeling. Behind Cooper's work there is an enormous intellectual apparatus. He is alarmingly articulate about his feelings and his imagery, and he is widely read, frequently punctuating his conversation with quotes from

Thomas Joshua Cooper, from "The Swelling of the Sea,"
Furthest West—The North Atlantic Ocean
Point Ardnamurchan
Scotland
The West-most point of mainland Great Britain, 1990
Courtesy of the artist

Basho, Samuel Johnson, Don Juan, Theodore Roethke, or William Blake. His home and studio are filled with the accoutrements of his thoughts and preparation: more copies of the Oxford and other dictionaries than one would normally require, a vast collection of ordinance survey maps, esoteric and spiritual literature. He remarks when interviewed: "I have no blockages, everything is draining in."

In terms of photography, his inspiration resides in such pictorial work as that by Raymond Moore, Alfred Stieglitz, Edward Weston, and Minor White. Or, more importantly, in the work by photographers of the nineteenth century such as Timothy O'Sullivan, whose pictures reflect a close connection to the land not as a place, but as spirit. Having been born in the western United States and being part American Indian have given Cooper a perspective about the land and about nature that few others have. Cooper thinks of the land as having a subject matter, which is different from having an identification. In many respects this is a more mysterious and difficult notion, and it signifies the search for that ineffable core within the landscape where beauty is found.

Cooper is explicit about this idea: "To find beauty is my job." That is to say, the beauty found in the landscape becomes the metaphor for a way of life itself; an art focused on the land enables him to cope with the actuality of his life, and with those things that he does not understand totally—indeed, that few of us do. He has constantly driven himself to see how deeply he can go into essence, whether it be of sorrow or joy, fear or ecstasy, and to achieve a state of enlightenment in which his emotion can be manifest in a photograph and have it be illuminating not only to himself but to others. This puts him in a select community of artists, artists such as those he admires from photography or, in terms of certain painters, in the company of the likes of Mark Rothko, Barnett Newman, Ad Reinhardt, Agnes Martin, and Cy Twombly. His community of the spirit becomes that which is promulgated by their works of art—objects of intense pathos and single-minded purity that transcend any person.

The physical quality of Cooper's pictures is singular. From their small size early on to their immense scale today, the work is a testament to superior craftsmanship and an admiration for the physical properties of the photographic medium. It is clear that there is little that he cannot do in his manipulation of the print material and of light itself. Light, and the sensation of darkness, is central to the meaning or portent of these pictures. One senses a gravity in them, as he seeks both the point of maximum obscurity and the point of greatest luminosity. For Cooper

it is the darkness and the light that create the whole: that is, the world we inhabit. For him, times of day are of enormous importance. They echo in microcosm the greater passage of historical time. Night is part of the whole, emphatically so, and moonlight is a light he loves deeply. The tonal scale of his pictures is the vocabulary of his expression, and in viewing them we encounter everything he believes can be revealed in the medium. In addition, because he cannot tolerate crudeness, they are crafted absolutely. In his admiration for other artists' work, this demand for perfection in rendering is also found. Through this purity of expression, Cooper believes he and others can bring us into the realm of a higher life, one that is abundant and healing.

With Cooper, there is no rift between feelings and the intellectual, and he is strongly driven by his emotions. In art, he gravitated toward what he could feel long before he knew about such works. This was a sort of visceral learning, in that Cooper encountered both what he understood and what he did not; what he did not, he grasped for as even more of a challenge. That is, to understand the unfamiliar, to quell his fear of it. Fear, fear of the unknown, is a driving force in Cooper's outlook and in his work. His art is the working-out of these fears, the overcoming of them in both a physical and an emotional sense. He recognizes this trait, this anxiety, as expressed in the work of others he admires, and most particularly in the historical identification of the places he has most recently chosen to photograph: the coasts of Scotland, Ireland, and Wales, and of Portugal. The very latest pictures, inspired by the acts of the early explorers, are about voyaging into the unknown, of navigating the spaces among Europe, America, and Asia; between old concepts and the new. They are about yesterday and today, about home and away. Pointedly, the photographs are made at the extreme edge of the European continent, looking toward the West from which Cooper himself comes. In creating such pictures, he often subjects himself to extremes of physical strain; sometimes hanging far out from the drop of the land—over the abyss—held by hand or rope, to achieve the view of maximum magnetism, maximum significance. Testing himself as if to say, This is not a dare, this is the ultimate in emotion and understanding. I will not surrender to bewilderment, my force is absolute.

In making these pictures, Cooper often visits a site several times, seeking just the right conditions. He has to be ripe for each occurrence. Significantly so, because he allows himself only a single exposure to be made at the point of highest intensity when experience and knowledge

become one, and his temperaments blend in the steady execution of the photographer's act.

These sensibilities and working methods all suggest an incredible attachment to valued traditions; traditions not simply in the photography he cherishes, but in creative pursuits generally. When Cooper was a boy, his mother introduced him to the literature of the Chinese and Japanese landscape poets, and what was important for him about this was the centrality of lived experience in relation to learning. In college, his studies were in literature and philosophy; these fields he pursued even before he took up photography. At a critical point in his early life he was befriended by the painter Morris Graves. Cooper learned much from Graves over some five years. The painter was, as Cooper describes him, "a stern and weird man," but Graves gave the younger artist keen advice that he has never forgotten. It was that to be an artist, "one must know the craft, love working, and find a way to make a project with it. The ability to do these things comes from inside you." The concept of project is perhaps the most lasting component of Graves's advice.

This idea has obsessed Cooper, and it characterizes all of his mature work. The arrangement of this exhibition and publication reflect his predilection for ensembles and environments, for two-, three-, and four-part works, and it is in the way these pieces are assembled that the project's concept is revealed. While Cooper operates in the sphere of the emotional, he is most strategic in his location of sites and in his procedure. He has said: "I don't know why people go into the landscape for pleasure—it is work, not easy." With regard to the great feeling that wells up within him, he doesn't like being there. However, it is where he has to go in his search for the revelatory experience. Hence the background reading, the survey maps, the tracking of sites and sacred places of the past (sometimes very modest ones), the search for places where, still today, native peoples find the origin of their being. He needs the assurance that he is in a territory of the magical that, critically, is part of everyone's mythic history. He knows he belongs to a lineage; one, however, that is not predetermined, because people constantly invent new paths that are extensions of the past.

The tradition of which Cooper most often speaks is that of "humanity" itself—of cultural epochs of the primitive, of the ancient, of the fifteenth to the nineteenth centuries, of a few key decades in the twentieth century. He goes back in history to connect with those times that are especially meaningful to him, that intersect with his own emotional situation, notably to those earlier ventures into physical and intel-

lectual areas that were without knowledge. The convergence of seekers from various fields in a singular time fascinates him: Gutenberg, William Caxton, and Magellan, for instance. As things come together, things one does not expect, a picture emerges; quite literally, it is his photograph that comes forth. Cooper structures his works on such ideas and they become the language of his images—the composition, tonal plane, scale, and show of color (in his recent works, a striking palette of indigo and burgundy). In these pictures he displays across the surface of the sheet a belief. As the pictures have become larger, more energized, so too the belief has grown. Cooper senses this, saying: "I want to be a part of something that is generous." That something is the long passage of myth and tradition that embraces the knowledge that you can wrest control of yourself, you can learn what is happening to you. You can participate in a changing world that, possibly, may be changed too by your own creative act of thinking and feeling. His is an expression of the moral power of will.

Cooper's photographs are enthralling in ways that go beyond such limited matters as truth. His is an art that in no way conceals art. His images are so rich and powerful, his pairings and groupings so loaded, and his signals so potent that one can never overlook the presence of the artist. We see in these works straight through into the gut and soul of the man, into the place where he resides. In this process, he wants to guide us in our own walk through the world. It is only through learning that we find identity; Thomas Joshua Cooper has surely found his own.

From *Thomas Joshua Cooper: Simply Counting Waves*, exhibition catalog, Centro de Arte Moderna José de Azeredo Perdigão, Lisbon, Portugal, 1994.

MICHAEL KENNA:
A TWENTY-YEAR RETROSPECTIVE

In the fall of 1975, an exhibition titled *The Land* opened at the Victoria and Albert Museum in London. The works were selected by the British photographer Bill Brandt. In several interviews, Michael Kenna has remarked that his initial encounter with Brandt was not through a personal meeting, or studying his pictures, but through this exhibition, which Kenna saw when he was still a student at the London College of Printing. While it is to the point to comment on the importance that Brandt's own work would later have for Kenna, it is perhaps more relevant to review this exhibition that so impressed the young photographer at a critical time in his early development.

The images Brandt selected are notable for their overall reserve and quietness; they might be described as unheroic landscapes. There are a few pictures that remain outside this characterization, especially one by Ansel Adams, whose work is the antithesis of Kenna's, but on the whole the pictures in Brandt's show are fragmented glimpses that reveal the photographers' concern for the land more as feeling than as place. In the reproductions in the catalog, a long, mellow, and monochromatic tonal scale predominates. In the selection no national school is emphasized. The American exhibitors—among them Paul Strand, Edward Weston, Minor White, Harry Callahan, and Aaron Siskind—give reason to acknowledge that a great deal of attention is paid to landscape by American photographers. These artists, and the others in the exhibition—French, Japanese, Dutch, Italian, and British—are all seen through Brandt's own vision of what a landscape should be. It is his taste for the pastoral that dominates the ensemble. Michael Kenna recognized this viewpoint then, and subsequently he has taken it as his own.

The essays in the catalog would seem to have encouraged a particular development in Kenna's approach, too. Perhaps the most important is Aaron Scharf's erudite piece, which begins: "I thought of the word 'elegant' when I first set eyes on the photographs gathered together in this book." He then explores the theme of moral philosophy with regard to the landscape. John Ruskin's writings play a large role in

Michael Kenna, *Homage to Atget, Parc de Sceaux, Paris, France,* 1988
Courtesy of the artist

Scharf's commentary, as indeed they should, but for our purposes, the pertinent idea is one about the land that is historical, civilized, sometimes mysterious, and, in its transformation into pictorial form, filled with meaning. The belief in pictures, conceived and held by the photographers in this exhibition, forces us to look, to encounter wonder, and to gain knowledge. Surely, the experience of this exhibition was enlightening, and as we consider Kenna's work decades later, we realize that his pictures could have been part of it if he had only made them by that point. However, it was then, in 1975, that Kenna began his search to fashion his place both on the land and in photography. Brandt, the photographs he selected, and the writers who illuminated them helped awaken Kenna to a way.

Looking at Kenna's photographs, one is struck by how he manages to imbue the familiar, natural world with a deepened harmony that invites meditation. His photography is a balanced art, not in the sense that it is stabilized or moderate in its effects, but that opposed qualities are joined in a scrupulously controlled performance.

A particular class of late-twentieth-century landscape is his primary subject, a kind of phenomenology of the land. It is the land seen through an individual temperament, with an eye that relates not so much to the great tradition of topographical British landscape, but to that special intersection between uninhabited land and the modern, cultivated realm where nature is a cohabitant of a place with people and things. Kenna's eye stems organically from his personality, and it provides a pictorial expression of this personality.

For a photographer whose personal history might be seen as more disruptive than harmonious, the characterization of Kenna's work as pastoral is all the more interesting. He was born in the industrial North of England, in what was then part of Lancashire; he grew up in the place where the Industrial Revolution was started and where the vivid remnants of it were still evident in its disused monuments. Since 1980, he has lived in San Francisco. He has photographed throughout the world, and it is difficult to point to any absolutely national character in his pictures; rather, they are the stylized expression of an individual with a consciousness that resides in a complex understanding of contemporary time; his photographs owe their character to no locale, but to a special kind of place anywhere. Likewise, it is clear that as his imaginative life has become richer over the years, his personal roots have become less significant.

The relative position of Kenna's work with regard to the notion of newness or contemporaneity is an important one. So much of today's photographic work suggests an aggressive drive to be new, a substitute for creation rather than the real thing itself. One must consider in this regard Kenna's steadfast use of the monochrome medium, his small prints, and his articulation of a chromatic tonal scale that hints at the Pictorialist work of the past. In these ways and in others, Kenna reveals his sensibility of relating deeply to tradition and his recognition that for him, the past is what nourishes. To deny that source of nourishment is to destroy his sense of life. Kenna's art will appeal only to some, and it will be rejected by those for whom the qualities of the past are not fulfilling. Kenna knows he is good at what he does; he takes pride in that, and he is sure there is no use concerning himself with what others think he ought to be doing; he does what is right for him and for his vision.

Kenna's style matches his ambition; indeed, it is a reflection of it. His style was forged out of his admiration for various pictorial models; models for the way one combined a devotion to a very personal subject matter with a very rigorous command of pictorial form. Kenna's pictures do not look difficult or demanding to the casual observer, and this is a liability in this era of grandiose exposition. For instance, people tend to want to look at representation and abstract representation as opposing, irreconcilable impulses in art. Kenna understands that the difference between realism and abstraction is not as simple as it seems. Moreover, for him the physical qualities of the monochrome medium come first, and it is the tension between realism and tonal abstraction that reveals the essential character of his art. Full-color images lack the poignancy of monochrome. The black-and-white film inherently peels off interesting images from the world; it sees things we do not see, and thus insists on the existence of a phantom presence within reality, a world we cannot perceive. Kenna determines how to construct the relations and connections between these things, and for him it is these relations as abstractly conceived that are the vital elements in his pictures. He is a representational photographer of traditional subjects—landscape and architecture—though he belongs to a generation and to the artistic milieu of the postmodernist photographic art scene. Thus he has remained elusive to many; a photographer who is too "advanced" for the traditionalists, yet too "conservative" for the avant-garde.

Kenna's photographs are among the most attractive of those made today; pleasing in their small size, handsome in their square format,

appetizing in the rich, luminous browns of their tone, they present a particularly cultured and studied refinement. In some respects, the pictures do not seem public, but intimate, things that would be passed around a study room or between people in a library. Some impress only slowly, others meet one suddenly like a quick observation. Despite their low-pitched voice and air of luxury, Kenna's photographs are important contemporary statements. In part, this is because they are not nationalistic but, rather, ideological. The style or feeling may be seen in the work of others; something of it is in Brandt's photographs, and those by Alvin Langdon Coburn. Brandt's influence is significant in ways beyond the style of his high-contrast printing, or his concern in the 1930s for photographing the industrial areas of Britain; it is Brandt's complete sense of history and of psychological character that connects him to Kenna. Surrealist in sensibility, insofar as they share an interest in juxtaposition and symbol, Brandt and Kenna also have a mutual commitment to humanism and freedom.

The range of Kenna's sensuous imagery over the past twenty years is marvelous, and because of this consistent, honest sensuousness, the abstract romanticism is at no point dehumanized or out of character with the pictorial situation. Kenna's work can tell us how beautiful pictures can be when they are made correctly: how the power of poetry resides in our nature, or, as his insight grows more deeply, how it grows more expressive, more ardent, more responsive, more beautiful. He has conveyed large ideas as decently as possible; by means of light and shade, tone and position, all dancing together.

Kenna analyzes his subjects carefully, as carefully as he positions himself with the camera. He thinks about light and atmosphere, what these do to shapes, outlines, perspectives. It is as if he is dealing with still life, with the contemplation of not just how things are, but how they have been. He is drawn to places where some action has taken place. He is drawn to history; that is, to a subject that reveals a past act of man's intervention into the natural order of things, not his contemporary presence. This is perhaps the most important legacy of his upbringing in the once-gloried industrial North of Britain. This sense of history is another reason that Kenna has never been quite so interested in photographing the American scene; the American West is too pure a landscape for him. In spite of living here for many years, he is still a seeker of the Old World; a literate photographic artist in the spirit of his much-admired Josef Sudek or Eugène Atget. Both of these men photographed that part of their world that was disappearing, and similarly Kenna

shows us what may, like any generational evolution, be eradicated in his time.

It is instructive to try to search out Kenna's style and pictorial strategy. Two photographs constitute an enlightening illustration: a picture made in homage to Atget in Paris's Parc de Sceaux in 1988, and one made in the sand garden of the Kamigamojinja in Kyoto in 1987. Each is about a landscape created by man, each has conical shapes as the central motif. Each place reflects a rigorous intellectuality that has given form to the layout, design, and space. Each motif exists against a backdrop of trees and sky. But both of these photographs are essentially anti-intellectual; each is romantic to the point of destroying the essential integrity of the object photographed. Each image is restless, like a troubled vision, in which the clarity associated with the trimmed razor edge of the clipped hedges, or the perfectly clean, brilliant white cones of sand, are covered over with a veil of tone that shifts the rendering from the sharpness and clarity of the high sun to the mystical, mysterious mood of failing light. The objects are not deprived of their rootedness in the world, but that rootedness is suppressed. One thinks, therefore, of Kenna's attitude about these places as both contemporary and historical; for him, they do not exist only in the present; they are seen through the eyes of someone who is interested in transmuting them and reflecting on their past, on their capacity to evoke romantic splendor.

There is perhaps no better evidence of Kenna's acute sensibility with respect to the past than that in his extraordinary series of photographs of the Désert de Retz, an eighteenth-century landscape garden just west of Paris. The centerpiece of this constructed mélange of fantasy structures is a huge artificial ruin erected to serve as a house by the Chevalier Racine de Monville in 1771. This immense, fluted stump of a column is shown in Kenna's photographs as if it were an actual ruin, broken and decayed. There is no hint that the structure is shown as it has always been and in the way it was built—a constructed testament to the romantic obsession with time and transience, erected for its emotional value as a link with ever-changing nature and with the past. It is intended to awake romantic feeling and stimulate the emotions. Kenna's photographs of other objects like it do no less.

In comments about his work, Kenna frequently speaks of romanticism in terms of suggestion, rather than in the visceral qualities of sensation. One of the most successful ways of evoking suggestion pictorially is through the manipulation of light. In his pictures, there is no real sense of time; the uniform treatment of sky, form, other details, is ambiguous

so as to render specificity irrelevant. Completely absent is the use of revealing light, so often exploited by other photographers, and instead there is a tonal sweep that comes right up to the surface and identifies the photographs as works of fiction, as images of his dreams; the sort of world in which he would hope us to live.

Kenna is fascinated with the times of the day when light is at its most elastic and pliant—dawn and dusk—and with the total mysteriousness of night. He knows the photographic material is so sensitive that it will exhibit things the human eye cannot perceive, and that it can, through the length of exposure, extend time even further into the realm of imagined time. His ability to control his material is such that he can more or less create certain lighting effects through his own manipulation. As he has remarked: "Time equalizes itself." In some prints, it is not possible to know whether it is day or night. Night photography was popular with the Pictorialists at the turn of the century. Its use related to their desire to show the new urban metropolis in a disguised manner, concealing certain realities in the flicker of selective darkness. Working in London, one of the major figures was Paul Martin. Even Alfred Stieglitz in New York partook of the current fashion, but he cautioned that many such photographs were merely "novel." Kenna is well aware of the dangers of using such effects, and he has attempted in their use to build a sustained pictorial identity on them, rather than simply picking and choosing subjects for their capacity to be treated. In his mind there is a pattern of appropriateness.

Kenna's most recent work is that made in the giant Rouge plant in Dearborn, Michigan. These pictures seem particularly linked to an earlier body of work of an industrial subject: his Ratcliffe Nuclear Power Station pictures made in the 1980s. The massive architectural forms of each site are abstracted, modeled by the effects of light and shade in such a way that the spectacle is not so much of industrialization, but of sculpture on a monumental scale. Looking at his images of the Ratcliffe cooling towers, one gets a vision of a medieval fortification, a field of turrets, although they are pointedly removed from the surrounding landscape. These shapes are often silhouetted against an animated sky, and their actual brown color is echoed in the tones of the photographic paper. Kenna treats the Rouge plant the same way. Its massiveness is reduced, even concealed, through a concentration on details; elements are obscured in mists of vapor and atmosphere. The shining light of day is rarely seen.

Kenna has alluded to the notion of a stage set when describing his people-less industry-scapes. This characterization is pertinent to the two examples above. These scenes have the appearance of a reductive, generalized environment like that constructed in a theater. And while he apparently wishes to script their interpretation, as he does in all of his works, a question still remains with these particular subjects as to the portent of their meaning. A comparison between Kenna's Rouge pictures and those made by Charles Sheeler in the late 1920s suggests that, whereas Sheeler was unequivocal in his delight in the architecture of modern industrialization and its implied energy, Kenna may not be. Sheeler's pictures are open, sharp, angular, architectonic. Kenna's, by comparison, clothe the architecture in a mood that suggests an environment that has collapsed. It is as if he has transposed yet again his experience of Yorkshire or Nottinghamshire, and relocated it to the postindustrial world of America's Dearborn.

What do the stark shapes, ominous skies, and patina of tone symbolize throughout this twenty-year body of work? What is the attitude of this photographer to his time, his place, his chronology? Is there something in these pictures about self-deception, darkness versus light, or lie versus truth? While personal emotions are freely expressed, what are they about? Nostalgia, failed values? Does Kenna apprehend something gone astray in today's world—a misplaced key to progress, a society and its places that have lost the sense of their being? His pictures have an atmosphere of the elegiac, of a vague disturbance, as if he were brooding on a sense of remembrance, where day becomes night. In his way, Kenna seems driven to make sure his rootedness is not in the here and now, but in what the past tells us of the present, what a social conscience can be like when given the freedom not to be merely critical, but to make a plea for rightness.

The word "idyllic" comes to mind about these pictures: a pastoral charm. There is no irony or telling contradiction explored through them, but rather they are about the links between romance and reality. The pictures convey the aura of intense melancholy: a character. Inherent in them is the paradox of seeing and photography.

From *Michael Kenna: A Twenty Year Retrospective*
(Tokyo: Treville, 1994; rev. ed., Tucson, AZ: Nazraeli Press, 2002).

HELEN GEE:
REMEMBERING THE LIMELIGHT

Memories exist whole in the mind; to put them down in words demands sequence, a sense of time and space, of then and now. This is not the place to reconstruct the sequence of how photography has become a chic phenomenon, but let me use this opportunity to reminisce a bit about one bright moment in the 1950s, when photography was accorded a simple sense of place and value. The Limelight, which Helen Gee opened in 1954, at 91 Seventh Avenue South, on Sheridan Square in New York's Greenwich Village, was at the time one of the very few places in the city where you could see photographs intelligently selected and exhibited. The other notable place was the Museum of Modern Art. At the Limelight, there was an atmosphere of relaxed intimacy and of seeing pictures beautifully. Looking back on those days, before MoMA's new building was constructed, one recalls that Edward Steichen's exhibitions at the museum were shown in what was called the "auditorium gallery," located on the lower level, next to the film theater. I was no resident of the Village, nor indeed of New York City, only a visitor from out of town—but like many others, I was a devoted frequenter of both places, and that was what counted. I can remember well my visits to the city, which always included an uptown stop at Fifty-third Street and then, after what seemed an interminable subway ride down Seventh Avenue, an evening on Sheridan Square.

Each generation creates its own cultural hybrids, and the Limelight was, in its way, just that for a large segment of the New York photographic community. It seems to me that I was first taken there in 1957 by Minor White; I suspect it was to see the *Lyrical and Accurate* exhibition, which he had originally organized for the George Eastman House. I can recall the place and the people. One was Lisette Model, who, every time I saw her afterwards, caused me to remember that first encounter. She was all intensity and challenge: she had quite a contrasting personality to Minor's. The Limelight was a meeting place and a socializing force for photographers—regardless of orientation—and certainly many visitors were at least as interested in the atmosphere and

Arthur Lavine, *The Limelight, New York*, 1954
Private collection

the coffee as they were in the work in the gallery. However, the Limelight was not the sort of place where a Jack Kerouac would have gone, unless, of course, he had been taken there by one of his photographer friends, Walker Evans or Robert Frank. It was a place of enthusiasm and friendship, not at all part of lonely Beat America.

The Limelight was a most prepossessing place. It was a coffee house/gallery, open 6 P.M. to 1 A.M. More than anything Parisian, the décor had a certain San Francisco literary quality about it. Actually, the order of description should be reversed. Helen Gee, whose inspiration and total dedication were behind the enterprise, primarily wanted a gallery, but realizing it could not sustain itself, she combined it with a coffee house. What could have been more apropos in 1954? The Limelight gallery appears to be the first one to have been devoted exclusively to showing photographs throughout its existence (it closed in January 1961). In fairness, it should be pointed out that Limelight was supported by another enterprise, while today's galleries must survive through sales and investment. But herein lies a story not only about Limelight, but also about the medium itself.

In the two decades after World War II, serious photography was recognized in a certain limited sense, and the medium seemed to encourage and be sustained by generosity and even modesty. There was a sense of everyone working for a cause—what Alfred Stieglitz used to call "the struggle"—and a consuming spirit that had at its core a belief in the rightness of the medium as the expressive vehicle for our time. Endeavors such as the magazines *Aperture*, *Camera*, and *Infinity*, or Eastman House, or even the Museum of Modern Art were really rather modest operations, identified with a handful of people: Minor White, Edward Steichen, Beaumont and Nancy Newhall, R. E. Martinez, Nathan Lyons, and several others, giving freely of themselves. Subscription lists were small but composed of devoted followers, museum attendance was good, but—apart from the *Family of Man* exhibition in 1955—nothing like today. Jacob Deschin's photography column in the *New York Times* was everyone's source of news, and he was the spokesman for most of the then-current attitudes and critical positions. Galleries, museums, and publishing houses present a far different picture now, and for many of us who were part of those early postwar enterprises, it is difficult to accept much of today's high-flown activity. I believe we suspect all this action is somewhat impious. This may not be true, but you can see how I am remembering the Limelight.

When you entered through the plain, curtained glass doors you saw first a cluster of six Japanese paper lanterns hanging from the ceiling in the center of the space. Down a few steps, small circular and square tables with dark bentwood chairs were everywhere. Further inside the space, glowing with an inner light of both spirit and drama, was the gallery enclosure of some twenty by twenty-five feet. Stark white walls, composed of horizontal panels, which on two sides did not extend to the floor, allowed for that all-time characteristic vision of gallery-goers: half-bodies circumnavigating the space before the walls. The lighting was straightforward and intense. The photographs, often bleeds, mounted borderless-style, were hung intelligently and with clarity by Helen herself. There were a few times when the photographer was allowed to hang his own work, or even to alter the space somewhat (as in the case of Bert Stern, who painted the walls gray). But the white walls, the crisp lighting, and the unaffected installations were hallmarks of the Limelight.

The record of the exhibitions during the gallery's seven years is a virtual international report on the "state of the art," beginning a decade after the war. Solo exhibitions and group shows included such names as Paul Strand, Ansel Adams, W. Eugene Smith, Minor White, László Moholy-Nagy, Gordon Parks, David Seymour, Robert Capa, Arnold Newman, Edward Weston, Brett Weston, Josef Breitenbach, Henri Cartier-Bresson, Bill Brandt—and earlier masters such as Eugène Atget, Peter Henry Emerson, and Julia Margaret Cameron. In addition, there were the younger photographers: Ken Heyman, James Karales, Robert Frank, Paul Caponigro, Louis Faurer, Walter Rosenblum, Elliott Erwitt, and Jerome Liebling, among many others. The full list is extraordinary, and it gives one pause when considering the current roster of exhibitions in galleries and museums. The record of astuteness in selecting the exhibitions for Limelight was matched in depth only by the lack of any tangible response in terms of sales. A good sale for an exhibition might consist of two prints, usually at $25 each—another stark comparison to today's extravagant activity in the photography market. If more people had purchased prints in those days, would the current state of affairs be any different? Perhaps this is a question for which there is no answer, but certainly if one had purchased meaningfully back then, the resulting collection would be quite something today. In those times, photographers scarcely worried about their sales. For an artist in photography, or an aspiring one, to have an exhibition in New York, and to have

the work handled sympathetically, was about as near to the perfect life as one could reach.

Today in the city, the world of photography is so completely different that to conceive of Limelight would be foolish, and to open a gallery like it would be an impossibility. So fundamental have been the changes in the last decade that to combine a coffee house with a gallery would be considered demeaning by the very photographers one would be attempting to support. Photographers have other opportunities now, and they do worry about their sales. This is as it should be, and so perhaps these observations about the Limelight will be received not so much for any advice they offer, but simply to recall a few of the best and blithest aspects of a special place not too far back in photography's past.

From *Helen Gee and the Limelight: A Pioneering Photography Gallery of the Fifties*, exhibition catalog, Carlton Gallery, New York, 1977.

THE WITKIN GALLERY

In 1914, after nine years of operating his Little Galleries of the Photo-Secession, at 291 Fifth Avenue in New York City, Alfred Stieglitz decided to ask several people what "291" meant to them—what they saw in it, what it made them feel—and he published their responses in the forty-seventh issue of *Camera Work*. It was important for Stieglitz to raise these questions then, on the eve of World War I, as he recognized it to be a critical time for art and for the continuance of his gallery.

Lee Witkin pondered similar questions about his gallery over the years. At its sixth, tenth, and fifteenth anniversaries, Lee attempted to answer such questions by staging retrospective exhibitions to encourage public discussion about the gallery and its significance. Lee was aware of the status he had achieved in establishing such an uncommon enterprise, especially in 1969 when it was founded: a private gallery devoted to the exhibition and sale of fine photographs. It became even more remarkable with each anniversary, and the gallery's continued success has assured a place in the chronicle of photographic history for Lee, and for his successor, Evelyne Daitz.

Stieglitz's respondents described 291 as a laboratory, a refuge, a salon, a center for dialogue, a point of humanity separate from the "lunatics" on the street, a place where artists could be themselves, an oasis of real freedom. Other colleagues and friends of Stieglitz were convinced that 291 was Stieglitz himself, and that may have been true. While the descriptions of 291 would be accurate for the Witkin Gallery as well, its essence was that of a living thing distinct from the individual. In spite of the passing of ownership on Lee's death in 1984 to Evelyne, who had joined the staff in 1976, the Witkin Gallery has continued on a successful course up to this day and its twenty-fifth anniversary. The character of Lee's gallery has changed only slightly, notably in its physical layout and with its move to West Broadway in SoHo. The values that were established for the gallery at the very beginning have been retained, as has the commitment to exhibit and bring forward work of a certain kind and with a particular affection. This dedication to what Stieglitz would have surely called "spirit" is what characterizes Evelyne Daitz and her colleagues, and it is what makes the Witkin still special today.

Scott Hyde, *Witkin Gallery, New York*, 1976
Courtesy of the artist

Scott Hyde, *Witkin Gallery, New York*, 1976
Courtesy of the artist

To be in any business for twenty-five years is not easy. It is a tes-
tament to Lee, and now to Evelyne, that this has been the case with the
Witkin Gallery. Though the market for photographs has now become
serious and very real, if even fashionable, the demands and responsibil-
ities of ownership have become more complex and demanding. It took
more nerve than knowledge to undertake such a project in 1969. It then
took perseverance and skill to continue in business during the period
when interest in fine photography went from very limited (perhaps even
less than it was at the time of Stieglitz's gallery at the beginning of the
century), to limited, to important. It is obvious that Lee and Evelyne
were steadfast in their dedication; that they played a singular role in
changing the state of affairs is now self-evident, and that they did it with
style and grace is also clear.

Lee Witkin was not only a businessman, but a lover of photogra-
phy, a champion of the photographic artist (of today or of the past), and
a man of vision. It is not that his gallery was any kind of sacred place
(as, one suspects, people considered Stieglitz's); rather, it was a place of
warmth and intimacy, a kind of home. Indeed, many people wondered
if Lee did not think it was exactly that, given the way he furnished it

with quaint pieces, Indian pottery, sofas, carpets, glass cases, and the like. If anything, his artists always had to share an atmosphere that seemed wholly of Lee's person and clearly of his making.

Hilton Kramer, writing in the *New York Times* on the gallery's tenth anniversary in 1979, said:

> The Witkin Gallery has been, of course, one of the nerve centers of this new development [the surge in the market for photography], and it, too—like everything else in the photography world—has greatly expanded in the past 10 years. It was never the only center, nor even the first gallery to enter the field, but it quickly won the distinction of being a special place for anyone seriously interested in the art of photography. If the atmosphere is now a shade more pious, businesslike and institutional than it used to be, the Witkin only conforms in this respect to what has happened to art galleries generally, and it has managed to retain more of the ambience of a club for aficionados than most other galleries.

There was so much stuff there, with pictures hung on the walls, mounted on stanchions, and covered in plastic and placed in bins. Books and magazines were on every flat surface. Orchestrating it all was Lee, who never saw clutter or excess, only the evidence of extraordinary creativity, richness of expression, and diversity of media. Evelyne has kept many of the items but things are more critically arranged, as befits her sophisticated, European sensibility, and one feels the same sense of commitment and affection in the gallery today, the same honesty of presentation, and the same pleasure in revealment. The atmosphere of the Witkin Gallery has always been one reflecting its pride in presenting works by artists who are perhaps just to the right of the avant-garde, and who, while alert and aware of their times, believe too deeply in the authenticity of self-expression to trust novelty or fad. This was Lee's taste in selecting artists, and it is Evelyne's, too.

Lee was greatly assisted in founding the gallery by his friend the photographer George Tice. Together, they planned a gallery to promote the work of contemporary photographers. I can remember Lee asking me to have dinner with him one evening in 1968. Because I was then curator of photography at the Museum of Modern Art, he chose a convenient site across the street from the museum, the restaurant atop the 666 building. He wanted to talk about his proposed undertaking. I recall being incredulous at the idea of a commercial gallery devoted to

contemporary photography. And make no mistake, Lee viewed this venture as a business! I thought of the 1950s and Helen Gee's Limelight on Sheridan Square, and I pointed out to Lee that this was a coffee house first, and a gallery second. Helen's mix of contemporary and historical photography was challenging but also an economic necessity. I am sure I told Lee about her experience with meager sales, and that there had been nothing like it since she closed in 1961. I believe I pointed out that the auction market had only just begun with the Weissberg Collection sale in 1967, and that this was an auction of items we would consider to be mere photographica. Put simply, there was little commercial interest in photographs; even the Museum of Modern Art was still offering most photographers $25 for a print. But Lee was determined. I suspect that he took in everything I said and understood it, but went ahead anyway, and without fear, knowing that if it did not work he could at least say that Lee Witkin had made the effort to change it all.

In March of 1969, Lee opened with a group show of five contemporary photographers, all men (Scott Hyde, George Krause, Duane Michals, George Tice, Burk Uzzle), which was followed by a show of three women (Barbara Morgan, Naomi Savage, Nancy Sirkis). Then began a shift toward historical figures: Eugène Atget, artists represented by *Camera Work* gravures, Imogen Cunningham, Edward Weston (the Witkin Gallery is one of the few anywhere that has shown Edward, Brett, and Cole), then Frederick H. Evans. But in what would be characteristic of the next several seasons, the second year brought a near even split between shows of established figures and of younger, lesser-known artists. Today, Evelyne has tipped the balance strongly in favor of new photographers, several of whom have had their inaugural New York shows at the Witkin: Christopher James, Bruce Barnbaum, Keith Carter, Leonard Sussman, Robert Flynt, and Mario Cravo Neto, to name a few.

The first rooms on East Sixtieth Street—at 237 and then at 243—were wonderful. The opening receptions, which were usually held on Tuesday evenings, were occasions of much conviviality, and I assume Lee must have sold some prints during the evenings as well. With show after show—including Wynn Bullock, Dean Brown, Scott Hyde, Doug Prince, and Wright Morris, among others—the years unfolded, and soon the gallery, with its deck at the back, was the Saturday meeting place for all of us who were interested in photography. During the week it was quiet and others frequented the space to receive Lee's counsel in the building of a collection. He prospered, and in 1976 the gallery moved to

41 East Fifty-seventh Street; a very proper address for a now-established gallery of photography.

Lee's success, I believe, had to do with his offering critically important and unusual historical pictures by artists such as those mentioned earlier, and also by the likes of Julia Margaret Cameron, Edward Curtis, Alfred Stieglitz, and Timothy H. O'Sullivan. The history of photography was coming alive again, but now in a forum different from the museums, and Lee gave his clients a sense of personal identification with ownership, and an awareness of the intelligence that is required to form a collection. Evelyne imparts the same understanding today. To study a photograph in a museum is one kind of experience; to commit oneself to an artist's work through acquisition is another.

Lee, of course, was the ideal model for the collector. He coveted many of the works he showed, and he kept back some of the finest pieces for himself, as we saw when his collection was sold after his death. At that time, in 1985, I wrote about him:

> Lee Witkin operated his gallery as a haven for collectors. This is not surprising since he was a compassionate and compulsive collector, not only of pictures but of all sorts of objects out of which he constructed his intimate life. There was a hint of reticence in Lee's personal relationships that suggests he found greater pleasure, if not the possibility to feel real affection, in the things that people created rather than in their more worldly actions. Lee's life was a part of each of ours in a way that was both selfless and selfish—he gave freely but he also possessed. His collection existed to be respected as were his relations with the authors of many of these images—the photographers whose work he championed—and the most obvious commonality among these works is the personal dedication to Lee by each maker. These modern photographers and the magnificent historical examples are all treasures of the human spirit.

It is hard today to explain the difficulty so many had in acquiring photographs some ten or twenty years ago, and now we romanticize the low prices, thinking: How could one not have bought? At an auction in 1970, for example, these lots were purchased by Lee, no doubt for resale, and we can be amused by the values: *Camera Work* issue 2, devoted to Edward Steichen—$20; five Stieglitz gravures from *Camera Notes* and *Camera Work*—$30; William Henry Jackson's *Garden of the Gods*—$50; William Henry Fox Talbot's 1839 publication *Some*

Account of the Art of Photogenic Drawings—$170; and finally, two prints by Edward Weston: *Boats, San Francisco*, 1925—$170, and *Eggs and Slicer*, 1930—$150. But price was only part of the equation; acceptance and desire were the other half, and these feelings took longer to become distinct and ripe. That they did so eventually is a testament to the knowing enthusiasm of the Witkin Gallery.

Another component of collecting is an interest in the artist as a person. In this respect, Lee and Evelyne have once again been models. Their affection for those they have represented has been tangible, and the fact that so many of the gallery artists have remained there for years is evidence of the reciprocal nature of these feelings. It is this trust that one feels in the place—that the gallery is a bright host to works by extraordinary persons.

When one looks over the complete exhibition chronology, one cannot help being amazed by the number of artists and the range of work. Between 1969 and 1993, there have been 285 exhibitions, some running concurrently in two areas of the gallery. The ultimate challenge for an artist is his or her ability to sustain a creative effort, to demonstrate the capacity to produce quality work over time. The shows by artists such as George Tice, Jerry N. Uelsmann, Evelyn Hofer, or Roy DeCarava, to name only a few who have shown again and again at Witkin, attest to this notion, and they reveal the dedication of the gallery to participate in the evolution of ideas. Similarly, a test of a mature artist at the close of a career is to have produced imagery that continues to enrich, fascinate, and cause us to grow. Thus the repeated presentations of the work of Brassaï, Robert Doisneau, Ruth Bernhard, Manuel Alvarez Bravo, Bill Brandt, André Kertész, Ruth Orkin, and Doris Ulmann certify the ability of Lee Witkin and Evelyne Daitz to recognize solid accomplishment, and to foster constant reappraisal. For each visitor, year after year, this gallery has been there to remind one of the benchmarks in photography's history, as well as to call attention to new work. The gallery's own good name has been a guarantee of sorts that has rarely, if ever, been questioned, and this, one senses, is a key reason why the Witkin Gallery has remained a force, holding up a mirror to the photographic medium, for twenty-five years.

From *The Witkin Gallery 25: A Celebration of Twenty-five Years of Photography in New York City* (Toronto: Lumiere Press, 1994).

LIGHT GALLERY

In the fall of 1971, there arrived an exhibition announcement for the Light Gallery, a new venue for photography located at the fashionable address of 1018 Madison Avenue—an area of the city not known for photography since 1903, when Alfred Stieglitz used his home at 1111 Madison Avenue as the publication address for *Camera Work*. The exhibition, *13 Photographers*, included, as one critic noted, the work of twelve men and one woman; today, this would be a contentious issue, back then it was less so. But what was most interesting about the exhibition was the unique mix of the photographic artists: four or five older and well-established figures such as Harry Callahan, Aaron Siskind, and Frederick Sommer, showing together with younger and much less known contemporaries such as Thomas Barrow, Michael Bishop, Robert Fichter, Emmet Gowin, and Keith Smith. The lone woman, Bea Nettles, was among this group of younger photographers.

This commitment to younger photographers was recognized immediately as something special, and as the years went on, Light Gallery's concentration on many more such photographers—too numerous to name, including many more women—became the gallery's hallmark. The exposure of these younger people in a gallery of such quality, what another critic termed "high seriousness," gradually enhanced their own reputations, and today, twenty-five years later, many of these artists are leading figures of the mid-career generation.

What one remembers most about Light, both in the beginning and after its move five years later to 724 Fifth Avenue, was the professional manner in which the work was exhibited and handled. Photography had at last met the challenge of presenting itself in a polished and businesslike yet visually stimulating environment that enhanced the individual works. Few will forget the wonderful curved wall, turning away and inward from the space as you entered. Nor its reverse: the interior, intimate circle where there was always something even more special to see—rare, individual works or small exhibitions of photographers whose images were not readily obtained for sale or resale. When one thinks back to the pioneers—Helen Gee's Limelight in the 1950s, and Lee Witkin's gallery, which opened two years before Light—the stark modernism of the Light Gallery was notable, and indeed, Light's

13 PHOTOGRAPHERS

NOVEMBER 5, 1971—DECEMBER 5, 1971

Thomas Barrow
Michael Bishop
Wynn Bullock
Harry Callahan
Robert Fichter
Emmett Gowin
Roger Mertin
Bea Nettles
Doug Prince
Aaron Siskind
Keith Smith
Frederick Sommer
Todd Walker

LIGHT

A GALLERY FOR CONTEMPORARY PHOTOGRAPHY

PREVIEW OPENING: THURSDAY, NOV. 4, 1971, 5-9 PM
HOURS: MONDAY THROUGH SATURDAY 10-6

Light Gallery, New York,
Invitation to the
inaugural exhibition, 1971
Private collection

design was emulated by many galleries that followed. So, too, was the format of multiple exhibitions: showing one or two photographers in separate spaces. Light pioneered in the pairing of young and old (or less known and known): Garry Winogrand opposite Aaron Siskind in 1972, or William Larson and László Moholy-Nagy in 1974. On other occasions there was the risk of exhibiting two new artists: Mark Cohen and Narahara Ikkō in 1975, or Gary Hallman and Joe Deal the same year. This cycle went on into the 1980s. Light's openings were affairs of great verve, sometimes followed by dinners that are now legendary. And in addition to the quality of the photographers represented, we all remember the directors and the staff: founding director Harold Jones was succeeded by others ably talented; some have become directors of other galleries that have carried on what Light initiated. No one ever seemed too busy to talk about pictures at Light.

In the 1970s, the photography world began to evolve quickly: major museum exhibitions, the teaching of the history of photography, the incorporation of photography into art historical texts and general art periodicals, and the success of the international auction houses all enhanced and contributed to the interest in collecting photography. And the gallery responded by publishing a series of portfolios by their artists, sponsoring books, and reaching out to museums and schools with exhibitions that traveled throughout the world.

Reviewing the prices posted for the gallery's tenth anniversary in 1981, one wonders why every work wasn't sold. But the public's caution and reserve about photography being a collectible with economic viability took some years to neutralize. The number of buyers was limited at first, but as we look back today we can sense what might be called a victory, in the sense that those who believed in the expressive genius of photographic artists and who recognized the meaningful value of the medium itself (not necessarily in monetary terms) had prevailed. It was as if the proverbial question "Is it art?" had finally been answered in the way most significant for a capitalist society: people purchased work by the artists represented by Light Gallery, and in so doing, they helped to sustain the gallery in a way that allowed it such longevity. Light is a gallery that has animated the landscape of photography as only a singular, shining peak can.

From *A Celebration of 25 Years of Light Gallery*, exhibition wall text, International Center of Photography Midtown, New York, 1996.

ACKNOWLEDGMENTS

I must first thank the photographers and their families, whose kind generosity and support with interviews and in other ways helped me as I sought to illuminate their photographs, and who allowed me to enter into and become a part of their lives. Very little of my work would have been possible without their friendship and cooperation. I thank these same photographers, their estates, foundations, and dealers, and the Princeton University Art Museum for permission to reproduce the photographs herein. I also wish to acknowledge the editors and publishers who commissioned many of the texts reprinted here. Their confidence in me is greatly appreciated.

For their early encouragement to publish this book, I acknowledge Ellen Harris, Lesley Martin, and Diana Edkins at Aperture. Also at Aperture, I thank Nancy Grubb for her commitment to the project and for her editorial expertise; Diana C. Stoll, with whom I worked most closely, for her perceptive editing of the book; and Wendy Byrne for the design. I am sure there are others at Aperture who have assisted in ways unknown to me; my thanks go to all of them. I am grateful also to Malcolm Daniel for his cogent and nuanced foreword.

I extend thanks to the John Simon Guggenheim Memorial Foundation for the fellowship that enabled my early study of the work of Alfred Stieglitz and the Pictorialists. Finally, I wish to acknowledge the financial support of the E. T. Harmax Foundation, and of the Publications Committee of the Department of Art and Archaeology, Princeton University, both of which aided in the publication of this book; and also the Spears Fund of the Department of Art and Archaeology, which supported my research and the writing of certain texts in this volume.

P.C.B.

INDEX

Page references in *italic* refer to illustrations.

A

Abbott, Berenice, 164
Abstract Expressionists, 130, 200; Siskind and, 92, 93–95
abstraction, 38, 66, 82, 88, 93–94, 97, 119, 128, 138, 221, 257
Abstraction in Photography (New York, 1951), 95
Adams, Ansel, 71, 75, 80, 101, 103, 121, 124, 126–28, 129, 140, 164, 202, 216, 254, 266
Adams, Robert, 10, 149, 239
advertising photography, 42, 78
Agee, James, 230; *Let Us Now Praise Famous Men*, 136, 142–43, 150
Albright Art Gallery, Buffalo, N.Y., 34
Alvarez Bravo, Manuel, 274
American Photography, 62, 63, 64, 67
An American Place, New York, 23, 30
Aperture, 96, 126, 129, 218, 265
Apollinaire, Guillaume, 190
Arbus, Diane, 9, 143, 149, 169–75; documentary photography and, 171–72; *A Jewish giant at home with his parents in the Bronx, N.Y.*, 170; misunderstanding of work of, 172; as Model's student, 164, 166, 167, 171; as portraitist, 172–73; posthumous interest in, 169; posthumous printing of negatives of, 174–75; printing practices of, 174, 175; stylistic development of, 173
Architectural Forum, 106
architectural photography, 90, 257; Ranney's images of Inca and Maya sacred places, 239–43, 240
Armory Show (1913), 57
Art Institute of Chicago, 239
Association of Heliographers, 129
Atget, Eugène, 136, 144, 149, 152–53, 216, 233, 258, 259, 266, 272

B

Bacheller, Irving: *Eben Holden*, 47–48
Bacher, Otto Henry, 47
Barnbaum, Bruce, 272
Barrow, Thomas, 275
Bayard, Hippolyte, 204
beauty, notions of, 36, 46, 51, 250; Weston and, 73, 75, 76
Beckett, Samuel, 153
Benson, Frank W., 47
Bergson, Henri, 13
Bernhard, Ruth, 78–83, 206, 274; *Classic Torso*, 79; excerpts from statements by, 81–82, 83; nudes by, 79, 80, 82–83; as teacher, 80–81, 83; Weston's influence on, 78, 80, 81
Bishop, Michael, 275
Blake, William, 69, 231, 250
Bourke-White, Margaret, 34
Brandt, Bill, 173, 254–56, 258, 266, 274
Brassaï, 173, 274
Breitenbach, Josef, 266
Brigman, Anne, 67
Brodovitch, Alexey, 164
Broom, 67
Brown, Dean, 272
Broyard, Anatole: *Kafka Was the Rage*, 94
Bruehl, Anton, 34, 41
Bruguière, Francis, 94
Buffalo Bill's Wild West troupe, 57
Bullock, Wynn, 80, 239, 272
Byron, Percy, 21

C

Caffin, Charles H., 13, 43, 50, 51, 57
Callahan, Harry, 99, 115–25, 218, 227–29, 230, 254, 275; color photographs by, 123; defamiliarization process and, 117–19; *Eleanor, Port Huron*, 116; female form photographed by, 116, 117, 122–23; influences acknowledged by, 120; on previsualization, 121; romantic

temperament of, 122, 123; serialism and, 123–24; subject-technique relationship and, 119–20; as teacher, 115, 124; urban street images by, 117, 118–19

Camera, 265

Camera Club of New York, 19, 20, 21, 56

Camera Craft, 63; Weston's articles for, 72–74, 77n.7

Camera Notes, 57, 273

Camera Work, 11, 13–14, 34, 43, 51, 56, 57, 63, 66, 268, 272, 273, 275; Green's *Camera Work: A Critical Anthology* and, 11, 13, 14–15; Kraus Reprint publication of, 14

Cameron, Julia Margaret, 13, 266, 273

candid photography, 167, 229

Capa, Robert, 266

Caplan, Lincoln, 138

Caponigro, Paul, 10, 129, 223–26, 239, 241, 266; *Rock Wall #2, West Hartford, Connecticut,* 224

captions, Morris on, 156–57

Carter, Keith, 272

Cartier-Bresson, Henri, 140, 144, 178, 230, 266

Carver, Norman, Jr.: *Form and Space of Japanese Architecture,* 242–43

Cassatt, Mary, 57

Cézanne, Paul, 124

Chambi, Martín, 239–41, 242

Chappell, Walter, 126–32; *Barn Key Hole,* 130–31; *Burned Mirror, Denver, Colorado,* 127; Gurdjieff's philosophy and, 129–30, 131; *Lady with White Tear,* 130–31; *Metaflora Portfolio,* 131, 132; nudes by, 131; *Under the Sun,* 130

Chase, William Merritt, 35, 47

Chiarenza, Carl, 8, 129

Clift, William, 129, 239

close-up techniques, 38, 90

The Club, New York, 98

Clurman, Harold, 23, 25, 31n.1

Coburn, Alvin Langdon, 21, 43, 44, 50, 57, 258; *Men of Mark,* 49–50; *Octopus,* 214

Cohen, Mark, 277

College Women's Club, Los Angeles, 66

color photography, 128, 257; by Callahan, 123; Pfahl's "Altered Landscapes," 210–17, 211; Weston on, 62, 75

Colwell, Larry, 80

commercial photography, 34, 41

concept art, Pfahl's "Altered Landscapes" and, 210–17, 211

constructed photographs, 221–22

Cooper, Thomas Joshua, 241, 248–53; *Furthest West—The North Atlantic Ocean, Point Ardnamurchan, Scotland,* 249

Corbin, James: "The Twentieth Century City," 22

Corpron, Carlotta, 94

Cosindas, Marie, 129

Craftsman, 57

Crane, Hart, 136

cropping, 38, 128

Cunningham, Imogen, 80, 128–29, 272

Curtis, Edward, 273

D

daguerreotypes, 151, 152

Daitz, Evelyne, 268–70, 271, 272, 273, 274

dance, Morgan's photographs of, 84–86, 85, 87, 88

Davidson, Bruce, 8

Day, F. Holland, 45, 46

Deal, Joe, 277

Dean, Nicholas, 129

DeCarava, Roy, 274

DeCasseres, Benjamin, 13

decisive moment, concept of, 72, 86, 229

defamiliarization, 237; in Callahan's photographs, 117–19

de Kooning, Elaine, 95, 97, 99

de Kooning, Willem, 93, 95

Deschin, Jacob, 96, 77n.10, 265

Dewing, Thomas, 47

Dial, 66–67

Diogenes with a Camera II (New York, 1952), 95, 97

documentary photography: Arbus and new documentarians related to, 171–72; earliest period of photography and, 147–49; Evans and, 133, 138; Japanese photography and,

180; Morris and, 147–50; Siskind and, 90–92

Doisneau, Robert, 274

Domon, Ken, 180

Dürer, Albrecht, 235

E

Eakins, Thomas, 123

George Eastman House, Rochester, N.Y., 129, 263, 265

Egan Gallery, New York, 95, 96

Eliot, T. S., 86

Emerson, Peter Henry, 216, 266

Encyclopaedia Britannica, 74–75

Erwitt, Elliott, 176–79, 266; *Las Vegas,* 177

Esalen Institute, Big Sur, Calif., 80

Esto Publishing Co., 74

Eugene, Frank, 13, 43

Evans, Frederick H., 67, 272

Evans, Walker, 72, 75, 120, 124, 133–46, 149, 161, 172, 227–29, 230, 233, 265; *American Photographs,* 136, 150; *Bethlehem, Pennsylvania, 134; The Bridge,* 136; collectable artifacts and, 158–59, 206; on himself, 138–46; *Let Us Now Praise Famous Men,* 136, 142–43, 150; selection process and, 133, 135–36, 139; on Stieglitz, 137–38; stylized seeing of, 133–35, 136; *Walker Evans, Photographs for the Farm Security Administration, 1935–1938,* 135–36

F

Family of Man (New York, 1955), 265

Farm Security Administration (FSA), 135–36, 138, 149, 156

Faurer, Louis, 266

Fichter, Robert, 275

Film und Foto (Stuttgart, Germany, 1929), 70

Flaubert, Gustave, 138, 142

Flynt, Robert, 272

formalism, 128, 149, 221; Siskind's techniques and, 97; C. White's response to rise of, 38–40

Fortune, 136, 142

Frank, Robert, 143, 230, 239, 265, 266; *The Americans,* 163; *Fourth of July—Jay, New York,* 161–63, 162

Fraprie, Frank Roy, 74

Friedlander, Lee, 9, 143, 171, 204

From Subject to Symbol (San Francisco, 1962), 80

G

galleries: An American Place, New York, 23, 30; Light Gallery, New York, 275–77, 276; The Limelight, New York, 263–67, 264, 272, 275; Little Galleries of the Photo-Secession, New York (291), 34, 57, 268, 270; The Witkin Gallery, New York, 268–74, 269, 270, 275

Gaudí, Antoni, 182–83

Gee, Helen, 263–67, 272, 275

genre photography, 58

Gibbs, George: "Seriousness in Art," 36

Gibson, Charles Dana, 58

Gibson, David, 212

Gide, André, 143

Gillies, John Wallace: *Principles of Pictorial Photography,* 67

Gilpin, Laura, 34

Goethe, Johann Wolfgang von, 123

Gottlieb, Adolph, 93, 97

Gowin, Emmet, 10, 227–38, 275; *Book, The Medical History of the War of Rebellion,* 238; *Edith, Danville, Virginia,* 228; landscapes by, 232–35; Mount St. Helens pictures by, 233–35; printmaking of, 235–37; wife and her family photographed by, 228, 229, 230–32

Goya, Francisco de: *Naked Maja,* 123

Graham, Martha: Morgan's photographs of, 84, 85, 87

Graves, Morris, 252

Green, Jonathan: *Camera Work: A Critical Anthology,* 11, 13, 14–15, 16

Guggenheim Foundation, 71–72, 92

Guggenheim Museum, New York, 159

Gurdjieff, G. I.: Chappell and M. White and, 129–30, 131; *All and Everything,* 129

H

Hall, Edward T.: *The Hidden Dimension,* 210

Hallman, Gary, 277

Harper's Bazaar, 164, 169
Hartmann, Sadakichi, 45–46, 47, 50
Hemming, John, 242
Herrigel, Eugen: *Zen in the Art of Archery,* 107
Hess, Thomas, 96
Heyman, Ken, 266
Hill, David Octavius, 74
Hine, Lewis, 166
Hofer, Evelyn, 274
Horne, Bernard, 34
Glenn Horowitz Bookseller, East Hampton, N.Y., 93, 96, 100
Hosoe, Eikoh, 180–83; "Embrace," 182; "Kamaitachi," 182; "Killed by Roses," *181,* 182; "Man and Woman," 182
Houghton Mifflin, 143
Huxley, Aldous: *Doors of Perception,* 107
Hyde, Scott, 272; *Witkin Gallery, New York,* 269, 270

I
Ikkō, Narahara, 184, 277
Illinois Institute of Technology, Chicago, 115
illustrative photography, 34, 41, 47–48, 56, 78, 210
Image of Freedom, The (New York, 1941), 149
Impressionists, 53
inclement-weather photography, 17–19, 21
industry-scapes, 260–61
Infinity, 265
infrared film, 104
Institute of Design, Chicago, 99, 115, 218
Ishimoto, Yasuhiro: *Katsura,* 242–43
Israel, Marvin, 166
Ito, Tokio, 184–86; *Fragment #73–5, New York,* 185

J
Jachna, Joseph, 218
Jackson, William Henry: *Garden of the Gods,* 273
James, Christopher, 272
Japanese photography, 180–89, *181, 185, 188*

Johns, Jasper, 220, 221
Johnson, Philip, 78
Johnston, Frances Benjamin, 58
Jones, Harold, 277
Josephson, Ken, 8, 218
journalistic approach, 167
Joyce, James, 143, 200

K
Karales, James, 266
Käsebier, Gertrude, 43, 53–59, 68; *The Heritage of Motherhood,* 58–59; *Lolly-Pops, 54;* mother-and-child images by, 57, 58–59; portraiture by, 53, 55–57, 58, 59
Keats, John, 200
Keiley, Joseph T., 37, 48
Kenna, Michael, 254–61; Brandt's *The Land* exhibition (1975) and, 254–56; Désert de Retz photographed by, 259; *Homage to Atget, Parc de Sceaux, Paris, France, 255,* 259; industrial subjects of, 260–61
Kepes, Gyorgy, 94
Kertész, André, 274
Kline, Franz, 92, 93, 94–95
Knickerbocker Athletic Club Theater, New York, 19
Kon, Michiko, 187–89; *Self-Portrait #4, 187, 188*
Kramer, Hilton, 271
Krause, George, 272
Kraus Reprint, 14
Kubler, George: *The Shape of Time,* 241

L
Land, The (London, 1975), 254–56
landscape photography: Brandt's *The Land* exhibition of 1975 and, 254–56; by Gowin, 232–35; by Kenna, 254–61, 255; Pfahl's "Altered Landscapes," 210–17, *211;* by Ranney, 239–47, *240;* by C. White, 44–45
Lange, Dorothea, 34, 80, 173
lantern slides, 19
large-format cameras, 167, 229, 245
large-format photographs: by Arbus, 173; Metzker's constructed photographs, 221–22
Larson, William, 277

Lavine, Arthur: *The Limelight, New York*, 264
Lawrence, D. H., 143, 227
Lee, Russell, 149
Leonardo, 234
Liebling, Jerome, 266
Light Gallery, New York, 275–77, 276
The Limelight, New York, 263–67, 264, 272, 275
Linked Ring, 56
Lippard, Lucy R.: *The Lure of the Local*, 244
Little Galleries of the Photo-Secession, New York (291), 34, 57, 268, 270
Lyons, Nathan, 132n.1, 265
Lyrical and Accurate (New York, 1957), 263

M
Machine Art (New York, 1934), 78
Maddox, Jerald, 136
Manet, Edouard, 203
manipulative practices, 42–43, 58, 66, 67–68, 70, 151. *See also* photomontage
Martin, Agnes, 250
Martin, Ira, 34
Martin, Paul, 260
Martinez, R. E., 265
Massachusetts Institute of Technology, Cambridge, Mass., 101
Matisse, Henri, 13, 66
McCausland, Elizabeth, 167
McClure's Magazine, 47–48, 56
McCune, Julia, 51
Metropolitan Museum of Art, New York, 208
Metzker, Ray K., 184, 218–22; constructed photographs by, 221–22; *Sky Sweeps*, 219
Michals, Duane, 272
miniature cameras, 167
Mirrors and Windows (New York, 1978), 221
Mishima, Yukio, 182
Model, Lisette, 164–68, 263; Arbus as student of, 164, 166, 167, 171; *Coney Island Bather, New York (Standing)*, 165; *Lisette Model*, 164–66
modernism, 27, 30, 128, 214

Moholy-Nagy, László, 94, 115, 120, 124, 216, 266, 277
Moore, Raymond, 250
Morgan, Barbara, 10, 84–89, 272; dance photographs by, 84–86, 85, 87, 88; *Martha Graham, "Extasis" (Torso)*, 85; photomontages by, 84, 88; on previsualization, 86; *Summer's Children*, 87–88
Morris, Clara: "Beneath the Wrinkle," 47–48
Morris, Robert, 245
Morris, Wright, 147–60, 272; on Atget, 152–53; on collectable artifacts, 158–59; conversation between Bunnell and, 151–60; *Fire Sermon*, 149; *God's Country and My People*, 150–51, 153, 157–58; *The Home Place*, 150, 157, 159, 160; *The Inhabitants*, 150; on intrusion of photographer or writer into work, 155–56; *Love Affair: A Venetian Journal*, 153, 154; on mirror metaphor, 151; on photographs and captions, 156–57; on revisiting material, 157–58, 159; on salvage notion, 153–54; on social commentary, 156; *Straightback Chair, Home Place*, 148
Motherwell, Robert, 93
mounting techniques, 97, 128
multiple exposure, 119, 121
Mumford, Lewis, 25, 31n.5
Museum of Modern Art, New York, 9–10, 75, 78, 95, 97, 115, 149, 164, 169, 171, 174, 221, 242, 263, 265, 271, 272
mysticism, 126; Chappell and, 129–30, 131; Gurdjieff's philosophy and, 129–30, 131; M. White and, 106, 107–12, 129

N
Nation, 67
National Arts Club, New York, 14
Native Americans: Käsebier's portraits of, 57; Ranney's New Mexico landscapes and, 245, 246
Neto, Mario Cravo, 272
Nettles, Bea, 275

New Documents (New York, 1967), 9, 171

Newhall, Beaumont, 8, 164, 265; *History of Photography,* 74

Newhall, Nancy, 114n.12, 265; *Time in New England,* 150

Newman, Arnold, 266

Newman, Barnett, 93, 250

New Republic, 67; Evans on himself in, 138–46

New School for Social Research, New York, 152, 164

New York Times, 96, 152, 265, 271

Niebuhr, Reinhold, 178

Niepce, Nicéphore, 151

night photography, 17, 260

Ninth Street Show, The (New York, 1951), 98

Norman, Dorothy: *Alfred Stieglitz: An American Seer,* 11, 15–16, 31nn.2, 8

nudes: by Bernhard, 79, 80, 82–83; by Chappell, 131; in Uelsmann's photomontage, 204; by Weston, 72; by C. White, 25, 45

O

O'Keeffe, Georgia, 25–26, 27, 28, 30, 31nn.3, 6, 7; 44, 68, 123

Orkin, Ruth, 274

O'Sullivan, Timothy H., 241, 250, 273

Ouspensky, P. D., 129

Outerbridge, Paul, 34

P

Panama Pacific International Exposition (San Francisco, 1915), 66

Parker, William E., 200

Parks, Gordon, 266

Parry, Eugenia, 244

Pfahl, John: "Altered Landscapes," 210–17, 211; *Australian Pines, Fort DeSoto, Florida,* 211; *Music I,* 212; *Shed with Blue Dotted Lines,* 212

Photo-Era, 57

Photographic Art, 57

Photographic Times, 57

Photography as Printmaking (New York, 1968), 9

Photography into Sculpture (New York, 1970), 9

Photo League, New York, 90, 167

Photo-Miniature, 67

photomontages: by Morgan, 84, 88; organization of images into sequences related to, 201–2; by Uelsmann, *191,* 194–96, *198,* 202–3, 206–9, 207

Photo-Secession, 14, 34, 56, 74

Picasso, Pablo, 13, 66, 131

Pictorialism, 21, 166, 257; basic tenets of, 32–34, 39, 46, 53–55, 94, 210; Japanese photography and, 180; Käsebier and, 56, 57–58, 59; night photography and, 260; Weston and, 62, 66, 67, 68, 70, 71, 72, 74; C. White and, 32–37, 39, 43, 45, 46, 50

Pictorial Photographers of America, 34, 57–58, 67

picturesque, 213

Plowden, David, 239

Pollock, Jackson, 200

portrait photography: Arbus in context of, 172–73; by Käsebier, 53, 55–57, 58, 59; by Stieglitz, 44, 67, 69; by Uelsmann, 204; by Weston, 64–65, 68, 75; by C. White, 42; C. White as subject of, 49–50, 56. *See also* self-portraits

posthumous printing, 174–75

postmodernism, 257

Prather, Winter, 128

Pratt Institute, Brooklyn, N.Y., 220

Pre-Raphaelites, 36

presentation techniques, 97, 128

previsualization: Callahan on, 121; Gowin's views on, 236; Morgan on, 86; Weston's theory of, 65, 67–68, 236

Prince, Doug, 272

printmaking: Gowin's obsession with, 235–37; Siskind's mastery of, 99; Stieglitz's achievements in, 15–16; C. White's mastery of, 35, 42–43

Proust, Marcel, 143

Puvis de Chavannes, Pierre, 35

R

Ranney, Edward, 239–47; Illinois and Michigan Canal Corridor photographed by, 243–44; *Illinois River at Peru, Illinois,* 244; *Machu Picchu (Intihuatana),* 240, 243;

Maya landscape photographed by, 241–42; *Monuments of the Incas,* 242; New Mexico landscape photographed by, 245–46; Peruvian sites photographed by, 239–41, *240, 242–43; Prairie Passage,* 244; Ross's *Star Axis* photographed by, 243; *Stonework of the Maya,* 241–42; "visual space" concept of, 242–43

Ray, Man, 94

Reinhardt, Ad, 250

Rejlander, Oscar, 195–96, 202; *Two Ways of Life,* 202

Rhode Island School of Design, Providence, 99, 115, 221

Robinson, Henry Peach, 195–96

Robinson, Theodore, 47

Rochester Institute of Technology, 8–9, 101, 129, 192, 201, 210

Rockefeller Center, New York, 29

Rodin, Auguste, 57, 66

romanticism, 50; in Callahan's work, 122, 123; in Kenna's imagery, 258, 259

Root, Nile, 128

Rosenberg, Harold, 95, 96

Rosenblum, Walter, 266

Rosenfeld, Paul: "Stieglitz," 66–67, 69, 72

Ross, Charles: *Star Axis,* 243

Rothko, Mark, 93, 250

Ruskin, John, 254–56

S

Sander, August, 173

San Francisco Museum of Art, 80

Sargent, John Singer, 35, 47

Savage, Naomi, 272

Scharf, Aaron, 254–56

Schongauer, Martin, 235

Seghers, Hercules, 235

self-portraits: by Kon, 187, *188;* by Uelsmann, 204–5; by C. White, 49

Seligmann, Herbert: *Alfred Stieglitz Talking,* 16

Selkirk, Neil, 174

sequences: grouping of photographs in, 101–2, 113n.4, 201–2; M. White's "Sequence 10/Rural Cathedrals," 101–14, *102–11*

serialism, 123–24

Seymour, David, 266

Shaw, George Bernard, 13

Sheeler, Charles, 68, 75, 88, 261

Shklovsky, Viktor, 237

Singer, Isaac Bashevis, 213

Sirkis, Nancy, 272

Siskind, Aaron, 90–100, 122, 124, 130, 218, 239, 254, 275, 277; Abstract Expressionists and, 92, 93–95; *Chicago 224,* 96; documentary photography by, 90–92; Egan Gallery exhibitions of, 95, 96; *Gloucester 2,* 98–99; *Gloucester 25, 91;* image of wrought iron (1947), 96–97; mounting technique of, 97; *New York, 1950,* 95; 1959 book of, 95–96; printing mastery of, 99; "Problems of Photography as an Art," 98; *Spaces,* 221; as teacher, 98, 99

Herbert Small Collection, 19–22

Smith, Henry Holmes, 202

Smith, Keith, 275

Smith, W. Eugene, 266

snapshots, 117, 118, 144; Gowin and, 229, 230

snow photographs: by Stieglitz, 17–19, 21, 29; by C. White, 44–45

Social Realism, 90–92, 149, 156

Sommer, Frederick, 130, 222, 227–29, 233, 239, 275; printmaking and, 236, 237

Sontag, Susan, 216

Southern California Camera Club, 66

Steichen, Edward, 13, 41, 53, 59, 75, 95, 124, 164, 263, 265, 273

Stein, Gertrude, 13

Steiner, Ralph, 34, 164

Stella, Frank, 220, 221

stereo views, 176

Stern, Bert, 266

Sterner, Albert E., 47

Stieglitz, Alfred, 9, 11–31, 34, 37, 39, 40, 46, 48, 50, 53, 56, 57, 66, 75, 101, 124, 136–37, 149, 169, 202, 204, 216, 221, 225, 227, 238, 250, 260, 265, 273, 275; *America and Alfred Stieglitz* and, 15, 23; cloud pictures ("Equivalents") by, 26–28, 30, 97, 122, 128, 138, 201; equivalence theory of, 13, 27, 76, 201; Evans's views on, 137–38; *Fifth Avenue from*

30th Street, New York, 18; *Five Points, 19*; Green's *Camera Work: A Critical Anthology* and, 11, 13, 14–15, 16; grouping of photographs into sequence and, 101, 201; Lake George pictures by, 24, 27–28, 29; New York photographs of 1890s by (Herbert Small Collection), 17–22, *18*; New York photographs of 1930s by, 28–30; Norman's *Alfred Stieglitz: An American Seer* and, 11, 15–16; O'Keeffe photographed by, 25–26, 27, 30, 44, 123; *Old and New New York, 12*; overview of principles of, 11–13; poetic reality in photographs by, 23–25; *Poplars—Lake George, 24*; quality of original prints by, 15–16; retrospective exhibition of work of (1934), 23, 25; Rosenfeld's article on, 66–67, 69, 72; Seligmann's *Alfred Stieglitz Talking* and, 16; snow photographs by, 17–19, 21, 29; street life photographed by, 19–20; *The Terminal*, 17, 19; touch notion in photographs by, 23–25, 26; 291 and, 34, 57, 268, 270; Weston and, 67, 68, 69; M. White and, 126–28, 201; C. White's joint photographs with, 44; *Winter, Fifth Avenue*, 17, 19, 20
still-life photography, 187
Stowaways, 49
straight photography, 39, 40, 43, 65, 66, 88, 142, 166, 194, 202, 227–29; manipulative aspect of, 120–21; Weston on, 69–70
Strand, Paul, 13–14, 21, 27, 39, 66, 68, 75, 101, 105, 149, 164, 239, 246, 254, 266; *Time in New England*, 103, 150
Struss, Karl, 34, 39, 67
Stryker, Roy, 156
Sudek, Josef, 258
Surrealism, 130
Sussman, Leonard, 272
Symbolism, 26, 36
Szarkowski, John, 9, 171

T
Talbot, William Henry Fox: *The Pencil of Nature*, 151; *Some Account of the Art of Photogenic Drawings*, 273–74
Tennant, John, 67, 69
13 Photographers (New York, 1971), 275, 276
Thoreau, Henry David, 156, 175
Tice, George, 271, 272, 274
time, 202; Kenna's ambiguous rendering of, 259–60
titling, 58–59, 87
tonal qualities: in Callahan's work, 119, 121; infrared film and, 104; tension between realism and, 257; in C. White's portraits, 42
Tucker, Anne: *The Woman's Eye*, 58–59
291 (Little Galleries of the Photo-Secession, New York), 34, 57, 268, 270
Twombly, Cy, 250

U
Uelsmann, Jerry N., 8, 121, 190–209, *198*, 274; on darkroom experience, 193–94; human figure in images of, 204; "in-process discovery" and, 193–94, 200–201, 206; and metamorphosis of ideas in photography, 197–200; museum studies by, 206–9, *207*; photomontages by, *191*, 194–96, *198*, 202–3, 206–9, *207*; portraiture by, 204; self-portraits by, 204–5; sequence notion and, 201–2; *Small Woods Where I Met Myself, 191*
Ulmann, Doris, 34, 274
Underhill, Evelyn: *Mysticism*, 107, 109, 110–11, 114n.12
Upton, John, 114n.12
Uzzle, Burk, 272

V
Venice Biennial: of 1972, 169; of 1978, 115
Victoria and Albert Museum, London, 254–56
"visual space" concept, 242–43

W
Watkins, Carleton, 241, 245
Watkins, Margaret, 34

Watts, George Frederic, 35
Weber, Max, 50
Weegee, 173
Weir, J. Alden, 47
Weissberg Collection, 272
Weston, Brett, 75, 80, 128, 266, 272
Weston, Cole, 174, 272
Weston, Edward, 60–77, 88, 101, 103, 140, 149, 169, 202, 239, 250, 254, 266, 272, 274; on art as outer expression of inner growth, 65, 76; Bernhard and, 78, 80, 81; body of work edited by, 60, 62, 63; *California and the West,* 72, 245; *Camera Craft* articles by, 72–74; on color photography, 62, 75; "A Contemporary Means of Artistic Expression," 70; on control of photographic technique, 70–71; *Daybooks,* 60, 62, 69, 75–76, 76n.1; distinct periods in career of, 71; *Dunes, Oceano,* 61; *Edward Weston on Photography,* 62; *Fiftieth Anniversary Portfolio,* 76; as Guggenheim fellow, 71–72; New York trip of (1922), 68–69; nudes by, 72; "Photographic Art," 74–75; photographic education of, 62–63; "Photography as a Means of Artistic Expression," 66; "Photography— Not Pictorial," 70; portraiture and figure compositions by, 64–65, 68; posthumous printing of negatives of, 174; previsualization theory of, 65, 67–68, 236; "Random Notes on Photography," 66, 67–68; Rosenfeld's Stieglitz article and, 66–67, 72; "Seeing Photographically," 75; on straight photography, 69–70; on unique qualities of photography, 65–66; "What Is Photographic Beauty?," 62, 72, 76; on C. White, 40–41; M. White and, 126–28; Wilson's relationship with, 72, 73–74, 75
Whistler, James McNeill, 35
White, Clarence H., 10, 13, 32–52, 53, 57, 59, 67, 68; Asian art as influence on, 35, 41, 43, 45; biographical overview of, 34; *The Bubble,* 35; genre subjects by, 35, 42, 47; Hartmann's observations on, 45–46, 47; illustrative photography by, 47–48; landscape pictures by, 44–45; light effects and, 43–44; "locality" notion and, 37, 46–47, 48–49; Maine views by, 38–39, 45; notions of truth and beauty and, 36; nudes by, 25, 45; personality and demeanor of, 50; "Pipes of Pan" series, 44, 45; political views of, 42; portraits by, 42; as portrait subject, 49–50, 56; printmaking mastery of, 35, 42–43; relocated to New York, 37–38, 42, 48, 49, 50; *Ring Toss,* 33, 47; rise of formal concerns and, 38–40; *The Round Table,* 43; Stieglitz's joint photographs with, 44; as teacher, 34, 38, 39, 40, 41–42, 49, 50, 52n.18; *The Watcher,* 36–37; Weston's analysis of, 40–41; women as subjects of, 35–36
White, Minor, 8–9, 80, 94, 96, 99, 101–14, 122, 126–28, 129, 149, 239, 250, 254, 263, 265, 266; *Barn & Clouds,* 105, 112; *Barn & Gate,* 102, 111; *Black Sun,* 103, 111; *Graveyard & Barn,* 106, 111; *Large Barn,* 104, 112; levels of meaning in work of, 106–13; "Memorable Fancies," 60, 103–5; move east and, 102–6; mysticism and, 106, 107–12, 129; photographs grouped in sequences by, 101–2, 113n.4, 201–2; *Potato Cellar,* 108, 112; *Road & Poplar Trees,* 110, 112; "Sequence 10/Rural Cathedrals," 101–14, 102–11; *Small Cloud over Barn,* 109, 112; as teacher, 101, 201; *Toolshed in Cemetery,* 107, 112; *Two Barns & Shadow,* 111, 113
Wilde, Oscar, 143
Wilson, Charis, 72, 73–74, 75
Winogrand, Garry, 9, 171, 184, 277
Witkin, Lee, 268–74, 275
The Witkin Gallery, New York, 268–74, 269, 270, 275
Worth, Don, 80
Wright, Frank Lloyd, 128, 129

Y
Yust, Walter, 74

TEXT AND PHOTOGRAPHY CREDITS

TEXT CREDITS

For original publication information, please see final page of each essay in this volume. P. 11, "Alfred Stieglitz and *Camera Work*," courtesy of Darte Publishing LLC; p. 17, "Observations on the Herbert Small Collection of Stieglitz's Early New York Photographs," courtesy Center for Creative Photography; p. 53, "Gertrude Käsebier," reprinted by permission from *Arts in Virginia* 16, no. 1 (Fall 1975): 2, 4, © 1975 Virginia Museum of Fine Arts, Richmond, 23220-4007; p. 78, "Ruth Bernhard," from *Ruth Bernhard Photographs* (Princeton, N.J.: Princeton University Art Museum, 1996), n.p.; p. 101, "Minor White," originally published in Peter C. Bunnell, "Minor White's Photographic Sequence, *Rural Cathedrals*: A Reading," in *Proceedings of the American Philosophical Society*, 135: 4 (1991), pp. 557–68; p. 115, "Harry Callahan," reprinted by permission of the American Federation of Arts, from Peter C. Bunnell, *Harry Callahan: United States Pavilion, 38th Venice Biennial* (New York: International Exhibitions Committee of the American Federation of Arts, 1978); p. 133, "Walker Evans," reprinted by permission of *The New Republic*, © 2005 The New Republic LLC; p. 147, "Wright Morris," reprinted from *Conversations with Wright Morris: Critical Views and Responses*, edited and with an introduction by Robert Knoll, by permission of the University of Nebraska Press, copyright © 1977 by the University of Nebraska Press; p. 161, "Robert Frank's *Fourth of July—Jay, New York*," courtesy of Darte Publishing LLC; p. 164, "Lisette Model," courtesy of Darte Publishing LLC; p. 169, "Diane Arbus," courtesy of Darte Publishing LLC; p. 190, "Jerry N. Uelsmann," reproduced by permission of Aperture Foundation; p. 227, "Emmet Gowin," courtesy Corcoran Gallery of Art.

PHOTOGRAPHY CREDITS

Unless otherwise indicated, all photographs are copyright the photographer. Cover: Minor White, courtesy the Minor White Archive, Princeton University Art Museum, © Trustees of Princeton University; pp. 18 and 24, Alfred Stieglitz, reproduced with permission of the Georgia O'Keeffe Foundation; p. 61, Edward Weston, © 1981 Center for Creative Photography, Arizona Board of Regents; p. 85, Barbara Morgan, © Barbara Morgan, the Barbara Morgan Archive; p. 91, Aaron Siskind, © Aaron Siskind Foundation, courtesy Robert Mann Gallery; pp. 102–11, Minor White, courtesy the Minor White Archive, Princeton University Art Museum, © Trustees of Princeton University; p. 116, Harry Callahan, © the Estate of Harry Callahan, courtesy Pace/MacGill Gallery, New York; p. 127, Walter Chappell (1925–2000), © 2000 the Estate of Walter Chappell, reproduction under license, all rights reserved; p. 148, Wright Morris, © 2003 Center for Creative Photography, Arizona Board of Regents; p. 162, Robert Frank, © Robert Frank, from *The Americans*, courtesy Pace/MacGill Gallery, New York; p. 165, Lisette Model, reproduced with permission of the Lisette Model Foundation; p. 170, Diane Arbus, © 1970 the Estate of Diane Arbus, LLC; p. 188, Michiko Kon, © Michiko Kon, courtesy of the artist and Photo Gallery International; p. 211, John Pfahl, © John Pfahl, courtesy of the Janet Borden Gallery, New York.

cotta, which I refused; but a man pulled out the embroidered bag they all wear in their girdles, and extracted a tiny silver coin; it had a full face on one side and a helmeted head on the other—and the beauty and the gaiety were there, with everything that matters, triumphant over the endless disappointments of the ages, and the stupidity of men who are no longer able to cut the stone for their aqueducts and graft the wild olives of their hillsides, as they did so successfully when it was harder to do than now.

I walked most of the steep uneven way down; and we were delayed by meeting Yürüks heading for their summer pastures, and by one muleteer buying a ewe and her lamb for twenty-two shillings from the passing flock. An old white-haired man had joined us, riding to pray during his Bairam in the first mosque down the valley; and as we reached the lower forests and heard the voice of the river travelling up to us along the walls of its ravine, a few large raindrops fell: the clouds had gathered thickly, and Bozburun was hidden; and we hoped and hoped that a downpour was falling on the last crop of the year in Selge.

PART III

LYCIA

In Lycia therefore after leaving the promontory of Mount Taurus we have the town of Simena, Mount Chimaera, which sends forth flames at night, and the city-state of Hephaestium, which also has a mountain range that is often on fire. The town of Olympus stood here, and there are now the mountain villages of Gagae, Corydalla and Rhodiapolis, and near the sea Limyra with the river of which the Arycandus is a tributary, and Mount Massicytus, the city-state of Andria, Myra, the towns of Aperlae and Antiphellos formerly called Habesos, and in a corner Phellos.

PLINY V, 28, 100.

So fared he to Lycia by the blameless convoy of the Gods.

ILIAD VI, p. 103.

9

THE CHELIDONIAN CROSSING

He came soon after to Phaselis . . .
ARRIAN I, 24, 6.

THE WINDOWS ON TO THE TERRACE WERE ALWAYS OPEN now in Antalya, and the call to prayer seemed to float in and out all day long. It was given by loud-speakers; and when a Muezzin in a peaked cap like a bookie sometimes stepped on to his little balcony, he did not much improve it; but even so I think of it with peaceful delight, for its atmosphere seemed to rock our most trivial acts in a cradle of safe and pious words whose passion had become mellow, lying like old wine so many years in the world's darkness.

The coming of evening was now actively pleasant, and the red streaks of sunset illuminated supper on the roof of the *lokanta*. The men sat there longer, chatting over their meal, and I would linger a little too, watching the shapes of their heads—their good looks like those of intelligent guardsmen, with every quality except that life-enhancing curiosity, and their clothes so abstract—regardless, that is to say, of fit. The idea of adapting the suit to the figure is, I have read, quite modern; all through the Renaissance and before it, people bought a dress for its own sake; a bulge here or there did not matter, and the fitting is a device to make up in some measure for our decline in magnificence. The Turks, jostled out of the beautiful tradition of their garments, have not yet adjusted themselves; they buy, rather pathetically, with a repressed hankering for colour and pattern and a disregard for shape. and though they feel bound, in this as in other things, to admire foreign fashions, in their hearts they do not do so. Seftab

and Ender, when they found that I liked them, would show me their grandparents' garments, laid away at the top of some cupboard, wrapped in the towels with embroidered fringes that have come down through Turks and Byzantines from who knows what Lydian or pre-Lydian kings.

In the morning, when I sat in the glassed-in, ramshackle, overhanging balcony of my milk shop, I watched the head of the little servant boy who always fell asleep among the cups and had to be shaken awake to wash them. He might have been designed from some Alexandrian coin, with his full lips and dusky eyelashes. He looked anything but Turkish. What far stream had brought him? The Mediterranean proportion, the curls clustering so gracefully, the rounded neck and chin and eyebrows lightly slanting to the temples—all these fine ingredients had become twisted into an expression of corruption. Who had been responsible—Persians, British, Arabs, Mongols, or Romans—that vulgar people with their talk of liberation—or the mere absence of freedom through the generations? Or simply, and most probably, some voluntary or involuntary break in tradition, by which the *focus* of nations is blurred? These wavering outlines are everywhere in the Middle East today; and a long time will be required for new shapes to settle and grow firm. But Ataturk, while modernizing Turkey, was aware of the danger, and kept the country to its own tradition, nor did he—as a number of Middle Eastern nations have done—degrade the peasant in favour of the towns. While this remains so, the picture of the child asleep among the alien cups is not a Turkish picture, the rootless nation's end.

From such sad reflections I would look up and see Mount Climax and Mount Solyma beyond the domes of the mosque, across the love-in-the-mist gentleness of the bay; and make up my mind that it was time to leave Antalya and ride across those hills. The heat was becoming too fierce in the plain. I had been talking nothing but Turkish for a month, and I began to

feel the strain of one thing and another. My taxi-driver, for instance. Rheumatism had made his teeth fall out; and a grease-stain on his coat collected the dust of weeks without a brushing. He never would let me eat by myself: out of kindness he sat and peeled cucumbers for me, and I longed for a meal at the Ritz or somewhere like it, where one's dishes would be handed from behind in a quiet unconversational way. It is humiliating to be impatient with physical unattractiveness, though it seems reasonable to enjoy the sight of presentable men. Their good looks make them un-self-centred and gay; and there is a lot to be said for women plain enough to be generally interested in life and men handsome enough to be distracted from themselves. It was natural therefore that one day, lunching under the plane trees of Kirkgöz, I should wish for once to eat alone at a separate table; but it offended my driver; I reached the hotel feeling that it was time to go if such little things disturbed me; and I happened on the same afternoon to meet Ernes Talay Bey in the town.

He and his young wife own the chrome mine below the Chimaera. I had known them two years before, when they were waiting in the hotel for a smooth sea and we had visited and dined with them when we passed by their mine in the *Elfin*. I remembered Mrs. Talay with her Eton crop of reddish-gold hair, her round gold ear-rings and sleeveless white jersey high round the neck, her belt with brass knobs, and tight black trousers to the middle of the leg; and herself all gay little curves inside them. She was away now, and Ernes was in Antalya only for a day, but he gave me a letter to his Manager, and told me to cross the bay any week I liked in one of his caiques—the *Tekir* or the *Yilmaz*—whose blue sides and new bright bairam flags were reflected in the harbour below.

I therefore went to the bank where the dreams of life are beaten out in metal. A pleader in the outer office was talking to his creditor, who sat immobile, rather like Mr. Dulles in

looks, with pouches under his eyes and his mouth a little open, smiling and relentless with cold eyes. From this sight of stupidity in power, I passed to the Manager's office, where one was welcomed in a cordial way as if paying a call, and letters, they kindly promised, would be forwarded. Having settled this, and looked in on Ismail Bey at the Museum for more introductions; and having shopped with Naji the policeman for coffee and tea, and sweets to leave instead of payments; and having found out that there was one jeep in Elmali on the plateau, and arranged with its owner that he would carry off my luggage and meet me in answer to a telegram on the western side of Chelidonia—I packed my haversack and bedding and a basket of food, and walked down to the *Yilmaz* before five o'clock one morning.

No one was yet about except a watchman. He helped me on to a coil of rope on *Yilmaz*'s deck and the crew began presently to collect. They came, left baskets and parcels, went off again and returned, and at last we were off: a mechanic, with a woollen shawl round his head and an arak bottle full of water; a man with gold teeth; a peasant who knew the coast as we passed it; an old sailor devoted to Omdi, the skipper's little boy, who sat in an un-English way passionately glued to his lessons; and the skipper himself, who might have been an adolescent German with a fair head. Our flag fluttered out after a short unsuccessful tussle with ropes as we tried to make it do the things one does when one leaves harbour; and the beautiful and familiar shapes of Climax were moving by with a dark blue sea between. I saw the silver rocks, the dips and amphitheatres of cliffs, the easy pointed heights. We passed the banded steps of the gorge, outlined with cedars. We sat and ate together and it no longer seemed a hardship, dipping our bread in salt on the deck in the sun. And in six hours we turned a headland filled with chrome, and landed beside the five or six small houses of the mine.

The Chelidonian shore

When the Manager had met me and read my letter, and let me rest in a neat little house for visitors till the heat of the day was over, we drove to where the chrome is refined above the northern corner of the bay. The installation is a simple affair, worked by crude oil, the ores minced and shaken in two shutter machines under a shed; earth and stone are washed down in running water, and the chrome is kept on one side in a glittering powder like steel. The ships come straight from America and anchor, and the little decauville running down from the shed tilts four or five thousand tons a year into their holds. What do their skippers think of, I wondered, when they spend their days here in the roadless bay and the legend-haunted silence, with no house in sight on all its hills? Beyond the pine trees and the jutting rocks the sea winds in and out to the Chelidonian islands; and the Machine and the Chimaera vie in brightness for forest nomads who have learned their ways.

I spent the evening with the Manager and his wife. He was tall and quiet, with most beautiful hands, that moved gently raising or lowering a long cigarette-holder in pointed fingers, while he talked with much feeling about the place and the work he loved. They both came from Erzinjan, and she had one of those sudden strong faces, with black eyebrows and pouting lips and heavy eyelids, that look at us from Pontic or Cappadocian coins, with too much vigour for time to alter. They gave me the kindest hospitality, and supper in their new fenced garden; and early next day sent the *Yilmaz* to land me on the sandy beach of Olympus, where the sailors let me down into shallow water by a rope at the stern.

* * * *

It was about seven o'clock. The curving sands and woods were bright, and there was no sign of the horses that should have been waiting on the shore. No human trace was there, except a heap of branches collected for firewood, which the

The Chelidonian Crossing

Yilmaz crew began to load in a timeless way. Seagulls were fishing, and their white bodies and the black tips of their wings were reflected by every transparent wave as it turned over: flying fish, their aeroplane fins blue as metal, skimmed the surface of the water: an infinite leisure surrounded us and them. The day was slipping through my fingers and I had been feeling ill. I laid my head on my haversack and slept, till in less than an hour two horses and a donkey were greeted with joyful laconic Turkish words. The donkey, being smallest and weakest and oriental, had to carry the luggage, and Ismail the guide and I rode on up the valley.

The feeling of illness vanished—it had been nothing but frustration and fatigue. In the heat of the morning, the sun spread a velvety scent of broom through the resinous air; and we rode among white boulders, or dipped under sycamores to brown and stagnant crossings of the stream. We were making our way towards an inland basin of woods and fields with the headlands of the Solyma range beyond it, and in about half an hour passed the track to Ardachan. It looked an easy but longer way across the peninsula in the south; and soon after, as we began to climb, we passed the opposite, Tekirova (Phaselis), route to the north. We mounted steadily to Yazir, a permanent village with scraps of a late rough ruin on a rock; and left the trees and rode through stony patches where people grow their summer corn. The day rolled itself out, embroidered, like a garment, with trifles: the line of the pass before us, the wayside greetings, the talk of Ismail about woodlands to which he takes his children to grow strong; the poplars hooded in the breeze like Turkish women turning at the wayside; the water in rare wayside troughs which the horse's nostril blows into ripples before he drinks. As if it were for us that they were woven, we wore these glittering hours, riding among pink freesias, and yellow sage taller than the horse's saddle, or finger-nail buds of oleander tipped like red lacquer.

On Alexander's route across Chelidonia

All the simple ingredients were there that the Greeks enjoyed and made immortal—olive and bay and laurel, the sheep's skull scarecrow that sculptors have carved through the ages, wild parsley, the cricket's voice, and shade in the drip of water, and the sea between steep slopes. As I passed, I tore a sprig of myrtle from a bush and crushed it and suddenly the ambrosial, indescribable fragrance spread its rapture from the unobtrusive leaves dedicated to Aphrodite by someone who surely knew the secrets and the freshness of love.

An old man walking down the stony path told us that we would find poplars and shade to rest in on the other slope; and we now reached the top, three hours from Olympus, among stones that mark the graveyards on a pass. The range of Solyma went rising north of us, in higher and higher shoulders; ways cross it to the uppermost pastures, but no one with an army would choose them if he came from the south-west. I had wished to ascertain this point, and Alexander's march across Chelidonia was now more certainly clear in my mind. The great and shallow valley of the Alağir Chay lay before and below us, filled with smaller ranges and open places and sur-rounded beyond its lesser barriers by high round hills still streaked with snow. All variety was there, and the brown and green lines of the map were changed into sands or plough or woodlands, and every separate dip or rise or hollow a dint in the world's surface with a character of its own. In the south-west was the sea, and the flat sweep of the deltas of the Alağir and Arycanda, with a blur for the little town of Finike at their western end. From there Alexander and his army came marching, between the swamps and the hills, by Limyra to Corydalla, close by the modern Kumluja which was our goal. Then they crossed by our pass—five hours between Kumluja and Olympus; a seven hours' march altogether would take them to Phaselis. A road is to be built, and a faint smoothing had already been made near the top where the lands are easy

at the saddle; and as I walked down on this wide track with no obstructions to contend with, I thought of the strangeness of Alexander's story, and remembered the legend of the founding of his house:

'Gavanes and Aeropus and Perdiccas,' Herodotus says,[1] 'came to the city of Lebaea in upper Macedonia and served the king there for a wage; and one tended the horses, and another the oxen, and the youngest of them, Perdiccas, tended the smaller beasts. The wife of the king cooked them their victuals herself, and saw that the lad's loaf waxed double when she baked. When this same thing happened every time, she told her husband, who commanded these servants to go from his land. Now they said that it was their right to receive their wages before they went; and the sun was shining into the house by the hole in the roof. And when the king heard them speak of wages he said, "I will give you the wages you deserve; lo, here they are," and he pointed to the sun. Then Gavanes and Aeropus stood astonished; but the lad, who chanced to have a knife, said "O king, we accept what thou givest." And he cut round the sunlight with his knife, and gathered the sunlight thrice into his bosom, and departed, both he and those that were with him. So they went away.'

The shaft cut out in the mountain cottage grew mighty enough to illuminate the known world in the age of his descendant. Yet Alexander, wrapped in that brightness, died in the solitude of kings. His vision, not his position, made him lonely; neither Asians nor Macedonians could understand his brotherhood of men. Very rarely and slowly, as the centuries passed, small communities or single individuals conceived it. Augustus put the Macedonian head upon his signet ring: and without Alexander Zeno and the stoics—though intrinsically

different—could not have been. And 'when at last Christianity showed the way to that spiritual unity after which men were feeling, there was ready to hand a medium for the new religion to spread in, the common Hellenistic civilization of the "inhabited world"'.²

This had scarcely begun when, ten years later, Alexander lay dying at thirty-three in Babylonia. With the world behind him and his sunlight gathered, he had wandered far from the young pioneer who walked with his companions across the Chelidonian hills.

As we descended the western slope, and paused to eat beside a trough of water, under a cypress with some cottages near-by, one of my curiosities was satisfied: for I offered a share of my food to an old woman who brought a bowl of yaourt, and she looked at the canned beans with suspicion and rejected them because they were cooked in oil: the most beautiful hillside of olives would have been useless to her; and that is no doubt the explanation—the nomad with his flocks came down from inner Asia, and his women cooked with mutton fat, and the untended trees went back to their native wildness.

An hour and a half's riding from the top brought us down to the lowest foothills, and we then trotted in the shadow of pine-woods along almost level paths. The minaret of Kumluja appeared far ahead in the plain and a Roman milestone, or it might have been the half-buried shaft of a pillar, stood by the wayside in the first of its hamlets as we rode by. The place itself is the centre of a district, and new houses are building in streets parallel to the one long street where the shops are, filled with country goods—lamps, glass-ware and teapots, ropes, rubber hoses, tools, and coloured threads, socks, buttons and printed cottons, and a surprising quantity of tailors. At the police post and Müdür's office I waited, in a cold but not unfriendly police atmosphere, till the Müdür came, sprucely dressed, with white hands and a ring. The head of police was

beside him, younger and more jaunty, with gilt arms embroi-
dered on the sleeve of an immaculate tunic. From the Black
Sea coast whence he came he brought the manners of a
man of the world to the old-fashioned South, and thought
it natural that one should look in the hills for Alexander.

What I wanted was a guide and a horse next morning, a
telegram to be sent to the driver in Elmali to tell him where
and when to meet me, and a room in whatever hotel there might
be; and all these things, and a glass of tea at the Kumluja club
in the High Street as well, were provided. The hotel was
opposite, with four beds in a row and boards scrubbed reas-
suringly clean. A young man owned it, gentle and deprecating
and anxious to please, and told me how much he would like to
furnish it better, how little scope Kumluja afforded, how
foreigners never came, and how much he would like to have a
marble floor. He had been born and bred here, and produced
a little son of exquisite beauty whom he called Idris because he
wished him to have an Arab name, though a Turkish one was
kept for every day. A young, lovely and obviously happy
wife kept herself secluded at the back, and took my clothes to
wash them; and before the evening was over, the authorities of
Kumluja came to my door in a little group with a young man
called Durmush as a guide.

10

THE VALLEY OF THE ALAGIR CHAY

Alexander bade both the envoys of Phaselis and the Lycians to hand over their cities to those whom he despatched to take them over; and they were all duly handed over.

ARRIAN I, 24, 6.

THE RUINS OF THE LITTLE TOWN OF GAGAE ARE ON THE eastern edge of the bay of Finike at the sands' end, where the hills break in red cliff to a shelf, so that a lower acropolis was built below the higher. Nothing much is left on the plain but a rubble of baths and churches and a modern hut or two with wattled chimney and thatch of rushes, hidden under fig and olive and the scented willow called *yidi*, beside shapeless patches of medieval wall. The aqueduct is now only a line of denuded piers; and the theatre has vanished altogether, into a little mosque built fifteen years ago with pride by the neighbouring village of Yenijeköy. Stone gate-posts too have gone: Durmush's uncle, who lived in one of the huts, told us how he had watched their destruction. Only the wall of the highest acropolis has endured, and vestiges of a medieval tower on a rock on the sands which may once have been covered by the sea.

Security, and the coming of the English pump, have been eating up the ruins of Gagae, and the importation of these engines has been altering the bay of Finike during the last few years. The swamps through which Commander Forbes and his friends and contemporaries scrambled a century ago have almost disappeared: the lower Alağir Chay lies under a counterpane of harvests interspersed with orange plantations and

wattle-fenced gardens; acqueducts are again building, in unobtrusive lengths of metal piping; and the ancient towns, now turned to villages, have shifted their old places only slightly, on the low slopes where they flourished and shipped their timber across the Syrian sea.

Rhodiapolis, Corydalla, Gagae—their names are polished away till the edges are worn and the meanings forgotten. It will still take centuries for the Yeniköys and the Akköys and the Karaköys of Turkey to reach such a sweet-sounding vagueness blurred by inaccuracy and time.

Durmush and I rode to Gagae, to look at this, the most southerly of the Chelidonian transits at its opening to the plain: and it still remains in my mind a possible, but not a probable, route for Alexander and his army. All whom I asked, across Chelidonia, for news of the passes, told me that the Yazir which we had come by was the one most used and the shortest; and the outline of the range made me feel fairly certain, since anything to the north of Yazir would be more laborious, and anything to the south would mean a detour for an army marching from coast to coast.

In the plain everything grew richly. Poppies and hollyhocks, borage and honeysuckle filled the banks and ditches; the vines spread and covered large trees with their foliage; and groups of the giant black snake-grass-arum (Dracunculus) grew near the roadside, with a snake wriggling beneath. The sight of four snakes in five days made me walk gingerly among the ruins.

Durmush pointed out a tomb, and the column of a temple as we rode. The latter, some wayside shrine, still showed its site under a small heave of the ground, doomed by the ploughing that had almost reached it; but the tomb was safe in the face of a cliff on our left and must have been missed by Commander Forbes who declares that only two rock-tombs, on the other side of the range, existed east of the Alağir Chay.[1]

Durmush and his wife

Durmush told me about himself as we rode along. He was heavily built and fair, and had learnt to drive a lorry a year ago when he was a soldier. Now he made money in the harvest season, and spent the rest of the year at home, at Yenijeköy, a mile or so inland from Gagae, and had been picked up by chance, by the authorities in the high street of Kumluja, to guide me.

In the course of the next few days I grew in his sight into a dream, an incarnation of enchantment—a delightful thing for anyone to be and one which in the course of my life, now and then, I remember; and a few elderly people here and there may remember it too. But it is an average enough experience for men and women in Christian lands, where both the lightest and the deepest intercourse are drawn from the same well, and the Christian symbolism, that gives holiness to the human body, creates romance.

Perhaps the dullness in Turkish intercourse comes from the want of some such background? To Durmush, at all events, romance came in a different way. He had four children, fair-haired and solid, with whom he was on happy terms as every Turkish father seems to be; to his mother, a handsome aquiline woman younger no doubt than I was, he offered friendliness in exchange for her devotion; and with his father there was a tacit comprehension, as when a sailor is taking over the helm from another. But his wife was more like a piece of unanimated furniture than any woman I have seen. In front of the little house where they had entertained us, when I had slept through the early afternoon and it was time to go, she brought saddles and bridle, and gave him a drink of water, all with her eyes fixed away from his face on the ground; nor did he trouble to cast a look on her as he left! It was I, haloed and disembodied by the legends of his country's history, who ravished him with excitement and delight; and as we rode he would turn at frequent intervals with a glowing face to tell

me how happy it made him to be discovering these new, un-dreamed-of things.

The cornfields whispered around us in the sun. Their bearded heads swished together, and young girls stood among them reaping, slim inside enormous trousers, their chins and foreheads bound in white like armour, as they held their sickles in their hands and watched us pass.

I rode on thinking, after a while, to myself about 'Eros, how Zeus took his shape to create the Cosmos from opposites, to bring it into harmony and love, and sowed likeness in all, and unity extending through all things',[2] and how the sacramental feeling for the body, in spite of all we do to it, persists. Free of such a tradition, homosexuality seems to have done less damage in ancient Greece and in the Levant today, than it does in the West. Its background makes it different there and free from fear. In Europe the most appalling of all fears, the fear of life, is too often a cause; and brings its arid poverty, however much delayed.

Professor Tarn's researches[3] have freed Alexander from this imputation, and it is strange to think how the slander can ever have gained credence in face of the evidence. "What evil has he ever seen in me, that should make him offer me such shameful creatures?" the King cried, when Philoxenus wished to send him two beautiful boys. Arrian writes that 'when he saw Roxane he fell in love with her, but captive though she was, and deep in love as he was, he would not offer any violence, but deigned to marry her', and the political advantages of the match do not seem a reason in themselves for doubting so explicit a statement.

'There is not one scrap of evidence for calling Alexander homosexual' is Professor Tarn's verdict. And if he had been so, fear would not have been one among his causes; but he would have had to be a different Alexander, less reverent to-wards the ritual of life, its disciplines, measures and duties, less

religious, less careful for all forms of excellence or integrity when he met them, less constantly anxious to master his own self. These are all facets of what one may call a sacramental attitude of mind; and a repeated break in what he felt to be a moral law could not be reconcilable with such a background. Nor does his passionate acceptance of life tally with anything that is negative or sterile, though his short busy years gave him little time for private hours.

The women of Macedonia were an exacting troop, beginning with his mother Olympias, and his aunt Polyclea, who had herself carried across the Achelous river to obtain the possession of a throne; and Cynane his sister, 'famous for her military knowledge', who charged at the head of armies in the field, and never married again after her husband's death.[4] Eurydice too, her daughter, when Olympias sent the last message, 'laid out the body of her husband, cleansing its wounds as well as circumstances permitted, then ended her life by hanging herself with her girdle, neither weeping for her own fate nor humbled by the weight of her misfortunes'.

The next generations carry on with the same vigour: Cratesipolis, the wife of Polyperchon, 'held his army together ... most highly esteemed by the soldiers for her acts of kindness ... skill too in practical matters, and ... governed the Sicyonians, maintaining many soldiers';[5] and the Laodices and the Berenices and the Stratonices and Cleopatras make a succession that might daunt as well as fascinate the bravest. Nor were the Persian women too domestic either, but rode in chariots or on horseback, with the children enclosed in litters; and Statira the queen of Artaxerxes drove 'with the curtains open, admitting the women of the country to approach and salute her'. At the king's table his mother and wife were admitted, the first seated above him and the last below.[6]

Their bravery was approved by the sententious estimable Xenophon in the book which Alexander studied, of which a

general echo persists in all the conqueror's treatment of the women of Asia; there is a constant thread of equality and pity in his dealings. There is affection when he talks to the mother of Darius about his own sisters' weaving; and there is friendship too and understanding when 'he heard that his sister had had intercourse with a handsome young man', and he 'did not burst into a rage but merely remarked that she also ought to be allowed to get some enjoyment out of her royal station'.[7]

In the afternoon, now pleasantly cool, with the minaret of Kumluja gradually approaching in the north, I rode thinking about these things, while convoys of herds and flocks drifted from their fields. Whenever a mare came near the road, my pony woke up from his boredom and arched his neck and turned into a thin brown flame between my knees. The bond is very strong. From beyond our sight, animal or human, the physical spark lights the world's interest and beauty—a transformation whence all our arts and pride derive; and thinking with horror of the gelding of creatures—as if mere living were everything that mattered—I was pleased to manage my horse's difficult little curvets about the road. A young friend's complaint came into my mind: she told me that dancing is no pleasure, since too many young men are too much interested in men; and I thought of long-ago dances—the magic when the arms that held one were the right arms, the dullness when they were not—and the poverty of a life that misses—not sentiment, not affection, not friendship, for these can be enjoyed in many versions—but that ripple which runs like the wind over a harp from behind the beginning of time.

Next day we rode to Corydalla, now called Hajjivella, a dull place close by, where nothing but a few fragments of column in the graveyard and a tomb or so are left. The theatre and aqueduct have gone, and a whole mass of architraves are being built into the Kumluja houses; but it matters less since the site

is a poor one, probably chosen because it lay on the main way across the valley, as Kumluja does today.

Rhodiapolis, now Eski Hisar, crowned with pines, is less than an hour's steep ride from a few cottages called Sarajasu. We reached it across the cornfields where wind had beaten hollow places, and our ponies, with that firmness in leading their own lives in spite of circumstances which is the charm and complication of the East, browsed to right and left as they walked through.

A man was busy in his field beside the cottages on their ledge, and with one rather regretful look at his morning's work behind him came with us to show the way. No payment can be given for such service, but I have never known it withheld; and our guide, when we were up there, enjoyed the expedition as much as we did. No houses are in the neighbourhood and the ruins are unvisited by his village below for months on end, so that it was a novelty for us all. Nothing much is known about Rhodiapolis, except for Theopompus who says that Amphilocus founded and called it after his daughter Rhoda— a happy little unwalled town with no history, seen far away on the crown of its hill. Its small theatre was carpeted with pine-needles strewn over the seats, brittle and bright as glass under the sunlight that filtered through the branches. The inscription that disclosed the city's name has fallen, and lies on the ground in two pieces; but little else has altered in the hundred years since the English travellers saw it, and its market and long terrace are there littered with fragments and surrounded by cisterns, apses, pedestals, and tombs on the headland, oddments of the civilizations that have climbed the hill.

It seemed possible to me at this time that Alexander might have come down to the Alağir by its only western pass from Arycanda (Aykirchà), not marching here along the coast at all.

Spratt and Forbes bring him from Elmali by the Arycanda valley,[8] all the way to the coast, and up again by the high

Solyma passes: and they made, I eventually came to think, a double mistake—first in having him up on the Elmali plateau at all, and secondly in making him cross from it to the eastern coast by a pass distant only an hour or so from his army's well-known way over Climax to Pamphylia. If the two routes had really been so close together, branching off parallel from the Alağir valley and its highroad, it would be truly astonishing to put the Thracians to the trouble of repairing a new way instead of using the one by which they came.

This argument is equally conclusive against a crossing from the west into the Alağir valley higher up than Rhodiapolis and Corydalla: Alexander must have neared the coast before he approached the Chelidonian range. But he might have taken the Alağir way down to it, instead of the coast road or the more westerly Arycanda, and I decided to ride up the valley to two cities with Pisidian names, Acalissus, and Idebessus,[9] and to look for myself at the Arycanda pass.

Next morning at five we started from Kumluja. We kept for two hours in open country, which the Alağir river abandons in its lower reaches, flowing out of sight behind hills on our left that narrowed gradually. The valley was dotted with pointed hillocks streaked with what the men told me was chrome. Mineralogists had come here, they said, and one had fallen off his horse. The path began to go up and down in forests, where the Alağir waters, like worms eating into wood-work, trickle through dry little tributary glens; and Ak Dagh shows itself for what it is—a limestone bowl surrounding the chrome hills. Its high but shallow summits barred the north with streaks of snow, and cedars climbed to its knees and dwindled, with naked ridges between them.

Durmush had found two horses and rode behind me, while Ismail who owned them kept abreast on solid bow-legs criss-crossed by laced moccasins over his fancy stockings. An old man also joined us. He was going up the valley and looked

like a fancy portrait of an antique philosopher, reduced, as if
he had been boiled to become soft and small. He was only
fifty-three and many of Alexander's Macedonian veterans
probably looked no younger. Out of his rather toothless face,
and black-rimmed glasses, and clothes that seemed to adhere by
a force independent of gravity in a manneristic way, his friendly
soul looked out mildly victorious, without malice or strain.
He trotted ahead with one of our baskets over his arm, losing
the cushion on which he sat as it slipped away at intervals from
beneath him; and in this natural Canterbury way of travel we
sat to rest under the same plane tree, where everyone rests near
a pool, and continued for another two hours of riding, till the
forests opened to a hilly country of corn and woodland, that
led us to the pale Alağir waters curling over a wide bed of
stones.

Here, under light wicker-work frames that must belong
originally to central Asia, the Yürüks camp and cultivate
summer patches from which the shrinking stream retires. We
greeted them in passing, and asked for the ford, and crossed
where water came to the stirrup, and then cantered easily
along the sandy bed. The hill of Karabuk was on our right
across the water, with ruins, they said, upon it; but our day
was too long for deviations, and our travelling companion
turned left up a side valley filled with plane trees and singing
birds. After another hour and a half of climbing, we reached
a ledge well up against the valley wall; and there, by the village
of Asarköy—the ancient Acalissus—the old man had his home.

It was the hottest part of the day. He made us lie on mat-
tresses on the dais of his verandah, where the valley wind came
scented with olives and vines in flower. Apricot, mulberry,
peach, walnut, plum and cherry, were all about, and the corn,
which we had left yellow near the sea, was green. The eaves
of the roof were finished off—as they all are in the mountains—
with a pattern cut in wood to show against the sky as one

The Valley of the Alağir Chay

reclines; the doors were carved and painted; and all the rugs woven of homespun wools. Amid this simple poverty and beauty, a daughter cooked our meal and brought us water, moving like a Koré young and straight in front with hips already curving under the huge *shirwal*. "Be careful of the glass," the old man said; for it was a tumbler with a gilt rim and he had only one.

I slept, and when I woke up another guest had appeared, with a cap back to front and two rosebuds in its peak, and was washing for his afternoon prayer; our host was spreading a rug for him on the floor, and the two old men made a Rembrandt picture in the half-shade together. He told me he had walked across the valley from Gödene, where already the news of our journey had travelled.

It was surprising how large a crowd had gathered, for Asarköy is so small and scattered that it does not appear to be a village at all. The site of the old city is however very clear, walled off on a headland between two valleys. Scarcely anything except roughly carved tombs are left; and a last impulse to destruction had recently been given by the discovery of some gold ornaments in a grave. They were variously reported, at Finike, Antalya, and finally Ankara, but I was nowhere able to see them; and the trouble with all the antiques of the region, when anyone does take an interest in them, is that they are carried here and there with no record of their origin attached. The inscribed sarcophagus we were looking for was finally located in the maquis, split in two for hidden and impossible gold; and we then relaxed over tea at the café until its owner shut it up and rode with us for another half-hour through the sunset to his house for the night.

It was too late to reach Idebessus, visible on a slight ledge in the wall of Ak Dagh an hour's ride away, above a hamlet called Kozaağachi. We would go there early next morning, and then spend the day over the pass to Arycanda, which

everyone thought difficult and long. The Kahveji's house, alone in its dell, was cool and moist, surrounded by fruit trees and corn. Beside it stood a wooden barn in the shape of the Lycian tombs, and one of the round *yurts* covered with wool, in which the household loom was set as Menander describes it:[10] the two fragile little buildings together seemed to symbolize the whole life of Anatolia, where, in so vast a landscape, with origins so different, the Aegean sea and the steppes of Asia meet.

The Kahveji was a keen, thin man who was pleased to entertain us, and fretted under the remoteness of his life. He treated his wife—strong and fair and a little overblown like a Rubens—with a human affection pleasant to see. He had bought her a sewing-machine; and this and some chairs and tables and a mirror gave an international look to the pleasant room in which they put up my bed. A mattress for Durmush in the other corner promised me a poor night's rest without undressing, but there was nothing to be done about it. A remark that I should like the open verandah to sleep in was dismissed as not even worth contradicting, and I had to make the best of Durmush's suggestion, and look upon him for the time being as a son. There is not more than one room in most of the peasant houses, and there, when the evening talk is over, as many mattresses are laid as are needed or the space will hold.

Now that I had escaped from the squalor of inns into these country places, I never lay down to rest without a thought of gratitude and wonder for the goodness of the Turkish peasants as I found them. The Arabs and Greeks have more aristocratic virtues that lead to enterprise and hatreds and adventures based on exclusion. Goodness, since it is based on sharing, can never be aristocratic, and the Turkish villagers in their poverty are ready to share with all. The simplicity of their goodness is touching—its anxiety to help, its honourableness

and active kindness, its love for children and flowers. Unlike most of the world, they do not undervalue their own—but show ready pleasure if any poor possession, air, view, or water, or any attractiveness in the hard and simple life is praised. They turn willingly from all their own distresses, delighted with whatever the humble excellence may be. Nor can I remember, during all my three visits to Turkey, to have been offended by a discourteous word.

At five-thirty in the morning we set out. The old man had walked from his house to guide us, and in an hour we reached the acropolis of Idebessus, so much dissembled among trees that its contours were hard to see. A rock-tomb was above it in the north, carved in one of the boulders sent down by the over-hanging precipices of Ak Dagh; and from here the city descended—walls, theatre, sarcophagi and stone-cut water-channels, all flattened under moss and the shadowy rigid branches of the pines. Large tombs with long inscriptions stood carved in hellenized barbarian smugness, as if the bourgeois spirit, preoccupied with other men's opinions, must carry its burden of responsibility even through the forgetfulness of Time. For it was as if Time itself, like a tide withdrawing, had receded from this high lip of the valley and no whisper of its movement were any longer heard.

From the ledge above the spring of water, to which the people of Kozaağachi walk from their few houses, the sight wanders over the whole country of the Alağir Chay, and to Solyma beyond it, where the way ran high above the left bank, and the passes of Gödene and Climax went over side by side to the east. One could see how unlikely these heights would be for Alexander with the more southerly routes to choose from; and one could follow the easy lines of the watershed to the Chandir valley, about five thousand feet high on the left, down which his troops marched by the Thracians' road. The wall of rock against which we were leaning was the rampart

from which the Pisidians sallied to raid and take the fort of Marmaris, wherever that might be. From one of its clefts they must have descended, and Idebessus too at that time must still have been Pisidian, for—apart from its name—what little town would sit where its enemies could pour the mountain stones upon it from above? There is a way up through the fissures of Ak Dagh to summer pastures on the plateau, and Elmali, according to Spratt, is three days' ride away. In winter the snow lies deep; and the Alaǧir river is not to be crossed. Impetuous and difficult to ford according to the travellers, it swells in early summer with melting snow, and carries the forest timber to the sea. It comes out of the country 'barely inhabited and late and sparsely civilized, of the unhistoried Solymi and the Lycian Thracians'.[11]

The forest of Kardich, clothing all one side of the southern valley with dark green undulations, used to supply Egypt with timber, and one could see a road there that followed a western ledge or terrace above the river's course. It reached Acalissus below us and a jeep, they told me, had made its way along it; the varied country descended from it in delicate gradations, to where the sea lay curled in distant mists and drowsy in the sun.

We left at eight and rode in a westerly direction, and for an hour and a half skirted the head of the valley, on an orange path that shrank to footholds and is washed away every winter when stones roll from the precipice above. The villagers have planted young pine trees that reach the ridges, and the valley below them lay dark, wide and receptive, a Danae reclining to the sun. At the saddle of the pass were level fields of barley and droves of Yürük horses, and mountain children to watch them though no villages are near; and we rested to let our horses graze under banks of cistus and mullein, where some subterranean moisture had made a patch of meadow—the last, Ismail said, that we would find.

From here for the next three hours the way descended, a

river of stones in a sheer passage. Half a mile or so wide, with black Aleppo pines rooted about it, the pass belonged to the Yürüks, who were coming up with their silky goats and their packs on donkeys, stopping in parties to drink at any water-trough on the way. A woman walking alone through the speckled sunlight carried a gourd of water and a partridge, in a cage built like one of their huts, in her hand: and a double captivity seemed to enclose the bird and her in those enormous walls. For Ak Dagh here is sliced on the south as if a knife had cut it, through two thousand feet or so of its pink strata, a sheer nakedness of rock illuminated by the travelling day; while the opposite wall is in metallic shadow, its stone sheets overlapping dark like bronze. Milton might have seen this passage and described it, and perhaps imagined the wings of Satan as these mountain ramparts, one sunlit and one dark. A few sparse trees grew in the slits; and, against the glowing precipice, the straight cedars climb as they can; but no light living colour wanders about here, except down the blinding white ruin of the boulders, where plane trees feel for the invisible waters with their roots.

I walked down, for it was too rough to ride. The horse's shoes were old and slithered, and his bit had come in two in the way of the Levant, so that his mouth had to be controlled with an inadequate little oddment of wool. By the time we had descended for two and a half hours and were resting, I was ready to take my oath that neither Alexander nor any other army had ever come this way. But the day's march had made it clear that his manœuvres, both from Xanthus and at Termessus, were attacks on the great natural fortress, behind which lay the road to all his reinforcements in the north. Not having penetrated it on the west, he was forced to circumvent and approach it at Termessus since the great southern escarpment extends from Xanthus to Pamphylia, unbroken except by the two valleys of Gömbe and Arycanda.

The Aykirchà gorge

The Arycanda, or modern Aykirchà, was now opening before us, with an easing of the slope to subsiding hillsides and a cottage in the landscape here and there. And on the highroad Mehmet was waiting in his jeep, with my luggage and Mahmud his assistant inside it, who rushed to meet me as if already we were as closely bound to each other as we soon became.

11

THE EASTERN WALL OF XANTHUS

Envoys from Phaselis came to offer friendly relations and to crown Alexander with a golden crown.

<div align="right">ARRIAN I, 24, 5.</div>

A NATURAL DOCILITY IS SHOWN BY TURKISH CLIENTS IN provincial hotels, where the light, switched on or off outside your bedroom door, is only remotely in the power of those who use it. In Iskenderun, in a new varnished bedroom with a telephone, I was startled at 2 a.m. by a voice that asked what I was doing and seemed scarcely mollified by the news that I was reading. At Finike, the landlord surprised me, when I had parted from Durmush and the horses and was setting off with Mehmet in the jeep, by inverting the usual order, and telling me that he was pleased with me, in a kindly voice of power.

Usually, however, landlords either were not interested, or had doubts of their own already, and sympathized with my feelings. 'Fleas as big as frogs' Alexander seems to have written to his mother.[1] In Finike the hotel was particularly clean, and a woman came every day to search the quilt when a guest had gone; but bugs ensconced in the woodwork usually belonged to the inevitable.

The inevitable loomed large, and people were fatalistic more by necessity than choice. Having run out of small presents, I went into a shop stocked with teacups and watches, on the chance that it might contain pocket-knives. It was the wrong place, and the shopkeeper had never had them, but he merely said, "There are no more," and sent me along the street to an equally unlikely place where they existed, not to be opened by

any but a young Goliath. I decided on pens instead. Helped by a schoolboy who took the matter in hand, we filled four or five with ink and found them unworkable, while the owner watched with no trace of anything but a sincere acceptance of their badness. We picked on one at last, for four Turkish liras.

"Cheap," said a bystander, anxious to help.

"If it works," said I.

"Yes, *only* if it works," the owner repeated, with heartfelt agreement, and detachment from things could go no further. But this was not usually compensated by any great interest in ideas, either.

A remarkable optimism, on the other hand, exists here and there, and on that, I suppose, the strength to wrestle with life is supported. Two middle-aged women were in the hotel, brought by a Bey from Antalya who left them there like packages and vanished. They took sad little walks looking neither to the right nor left, not free enough in their thoughts even to realize that they thought a holiday much less pleasant than their home. But one thing they were definite about—and that was the danger of sitting in a car through the defiles of Termessus (which are in fact singularly mild and propped up by hills on either hand). They were not going back that way; and as there was no other short of the fortnightly steamer, the Bey was finding them horses and they would ride—a thing they had never in their lives attempted. Perhaps it would be a turning-point, so I said nothing discouraging, but left them and set off with Mehmet and Mahmud in the jeep on an easy seventy-six-kilometre run to Elmali. It is up the Arycanda valley, which is now the Bashgöz Chay; and there was nothing to delay us but some tombs at the Limyra corner, and the ruins of Arycanda itself, perched on the valley side.

The tombs are a good half-hour's walk above the road, on a cliff that lines the opening of the valley; and there are six of

them cut in the shape of houses out of the solid rock. Fellows mentions them, but cannot have entered them, unless with ropes and ladders: for their sides are smooth as new and inaccessible, built out over the drop. I could reach only the smallest by climbing round its ledge, and found three stone couches with their pillows carved upon them inside it. The valley below begins to look as it must once have done in prosperous times, merging into level stretches of shore; below the drier slopes of corn, in place of the 19th-century landscape of ruins and nomads and swamps, houses cluster with dark green gardens, such as might once again send out funeral processions and leave their dead here beyond human habitation, to dissolve in the warm stone-built shadow and scented living silence of the hill.

The Arycanda, as one drives up it, has none of the varied openness of the Alağir valley. Very soon the gates close in, by which all these water-eaten limestone gorges are divided, step beyond step; and as one curves along, above the stream that runs green and gay, the basin broadens to cultivation, and tilts up between two gorges that meet like the arms of a Y from right and left. The first, to the west, crosses the Alaja Dagh to Kassaba; the second, is the pass from the Alağir valley by which we had come; almost immediately above, again to the west, is another valley and neck that lead to Ernes, the ancient Arneae. As one reaches these passes, visible at the far ends of their defiles, the mountains grow taller and stronger; single cypress trees or cedar show on shoulders that glisten as if pressed and rounded under the weight of the Anatolian plateau which they lift above the sea.

Opposite the two western passes, the ancient city of Arycanda is visible. The rock rears sheer behind it, and spouts white waterfalls under a raised café platform by the road.

Mehmet and Mahmud rested there in the shade, while I toiled up to the city in the middle of the day and thought, not

for the first time, how natural it was for Greek women, who often lived in mountain places, to think it a privilege to stay at home. The walls of Arycanda ran down along an overhanging cliff, sharply. Pilasters and acanthus of a small temple were there under a pine tree; an inner gate with angels held up an obliterated medallion, and a late Roman palace was built with a double row of windows below. High above were the theatre, protected by arcades against the hill; and dateless cisterns cut in the rock; and square-built Hellenistic towers. The whole place must have tilted steeply, one roof upon another's wall; and perhaps, with its white water which once was led along in rock-built conduits, it may have contained the shrine of Helios which from its bold pattern was known as 'prow' or 'trireme', and was near here.[2] Arycanda itself was identified, from an inscription, by Fellows with 'great excitement and pleasure'.

More antiquity was in the valley in his day, or perhaps it is still here and there, hidden from those who use the modern highroad. The grandeur remains, as this sensitive traveller saw it, who felt that he had 'come into the world and seen the perfection of its loveliness' and knew no scenery equal to this part of Lycia in sublimity and beauty.

As we drove on, the lines grew naked and nobler, the trees in their black wedges rarer, and the air gained that radiance which kindles the high cornlands of the plateau. The caryatid mountains remained unseen behind us; and other near and far wide-based mountains appeared.

These serene wide hills, pale and striped evenly with snow; these waters in shallow temporary lakes with grassy strips of islands; cattle in droves about purposeless rivers, where all seems to move slowly in uncrowded spaces and oxen drag the solid wooden wheels invented far away for the steppes of Asia; this glitter of the self-sufficing air above the jade-green velvet pale barley and the corn, and brilliance of wild almond

saplings coloured like the shining lichen of the rocks; this vivid late spring of English flowers—drifts of vetch purple and yellow, grey-leaved cerastium, cornflower and anchusa and mullein, white roses and the orange-red bushy poppy of the plateau—all open suddenly above the bent shoulders of the valleys as one breaks upon the Anatolian plain.

The road follows the lake, which has no outlet but sinks into a cavern and produces the Bashgöz river far below; and beyond its southern shore, across the shallow pastures, we could see the western Ak Dagh hiding Xanthus, the range of Massicytus.

It was no good to suggest to Mehmet that the day was still young and we might set off in that direction. His home was in Elmali and drew him like a magnet; and when I told him what I felt about hotels in little towns (and I remembered Elmali rather particularly), he said I should sleep in his house where insects were not, and we should start next morning early with the Jeep in good order. When the Jeep was brought into question there was nothing more to be said, for it was a shrine on wheels, pampered by Mehmet and Mahmud with unceasing and assiduous devotion. The Turkish customs in 1956 were engaged in practically strangling motor traffic with high duties, and this one and only Jeep of Elmali moved about the two good roads of its district in proud and solitary splendour. To get Mehmet off the good road was in itself a feat of diplomacy: his reason admitted that if I travelled across the sea and spent the enormous sum of fifteen pounds a day on transport, it was not to renounce my ruins at the end, and in a short time he had come to the point of crossing a ploughed field or other obstacle with an unhappy but obliging expression; but he was a lover, and could not really believe that anyone might wish to be harsh with that shabby but adored machine: and so when he said, and Mahmud agreed, for he always did so, that she needed some sort of attention which only Elmali could provide —to Elmali we went, in a northerly direction along the edge

of the plain, and spent the night in Mehmet's house, with two children and his wife who came from Brusa.

Mehmet was gay, kind and easy-going, and had been brought as a refugee baby from Salonica; he had a handsome face now fattening slightly, like some of the Ptolemaic portraits among the Diadochi, with dark hair and blue eyes of that cold, smoky quality different from the English—the difference between a misty and a sharp horizon. He liked country things—the colour of the lake, and the white water-bird, an ibis perhaps, that flew against it; and when he saw a view of which he thought I might take a picture, he would stop of his own accord. He was fastidious too, with his own things, and had a little purse much too small for use which he treasured because of a motor-car worked on it in beads; and when his hands were blackened by attending to the jeep, he would wash them out with a scent called Red Rose, of which he first always poured a little into my hands.

He had no idea of treating me except as man to woman, nor did I ever venture to pay for my meals or any glass of wayside tea; and the fact that it was I who decided where we were to go was a shock which it took him a second or two to assimilate whenever it was repeated. He was of a simple mind—fond of the same joke over and over again, like the word 'asphalt' when the road became really bad: or begging me not to fall asleep, 'uyürma', out of the jeep in the drowsy afternoons, as I sat by its open door. As for ruins, and the idea of history before motor-cars were invented, they left him cold.

But Mahmud, who was poor and was the Jeep's bondslave and adored Mehmet with devotion, had somehow swallowed a streak of romance among the obscure ingredients that had built him; and now and then, if I mentioned some distant country—Cairo, or Baghdad, or India—he would turn to Mehmet with watery blue eyes like an interested parrot, only to be quenched and brought back to the day-to-day level of

the Jeep by his friend and employer's aloofness as soon as our conversation wandered off the road—and the main road at that. Never would Mahmud think himself right when anyone else thought him wrong: his poverty was service, given with an eagerness and a happiness that constantly touched me. His bandy legs, set off by an enormous black patch in the middle of the back of his jodhpurs and by a peaked cap, the only new thing about him, gave a comic jockey turn to his appearance,

straight in front and curved behind, with enormous feet. It was only when looking at his face carefully, and now and then seeing it shaved when circumstances and the Jeep gave a respite, that one noticed how friendly and gentle it really was. It was always Mahmud too who could find a path or knew the names of hills, and would come with me while Mehmet waited placid but uninterested, in some wayside patch of shade.

We now honked our way through Elmali, round the fine Ottoman mosque and the triple waterfall that splashes between municipal railings below it, to a little house among fruit trees.

Apple, vine and fig were held in by a fence of poplar and Mrs. Mehmet reigned here in surroundings frilled and festooned with the cross-stitched embroideries of her youth. Polished furniture, chairs and mirrors, ash-trays and pictures of Istanbul, Naples or Mecca, Arabic prayers in frames—she gave them her care, as one to whom the lesser things of life must suffice; for she had money of her own, she soon told me, and was not very beautiful, with gold teeth and strong hands, and Mehmet, she told me when we had the house to ourselves and could relax, had another wife in Antalya, and spent his winters there.

"We think it hard for women, when there is more than one," said I, reflecting, if the truth must be told, that a good many Christian marriages seem to end that way.

"So do we," said Mrs. Mehmet.

It was probably fairly turbulent for her husband as well, at times.

He wandered about, proud of the beautifully kept little house, with obedience all round him, and yet there was an atmosphere of incomplete possession. His smoky blue eyes looked with cold distaste at the little son, growing up exactly like him, who preferred football to the exams in which he had just failed.

"You were probably like that yourself," said I, and Mehmet laughed: his pick-up gave him more peace and satisfaction; it played ten Turkish song-records on end.

But one human being in the house counted more with him than any machine—even the Jeep; and that was his three-year-old daughter. With an elfish face, long upper lip and straight black hair tied at the top of her head like a Lapp, she conducted the most Freudian of father-daughter passions with a frightening technique of experience, and set up a wail that refused to stop when she heard that he was leaving. He seated her in his arms, but she continued it with eyes shut and mouth open, regulating it for longer endurance to a lower tone; and at intervals one

terrible black calculating eye would un-
close, to see what effect the manifestation
was having, and would shut again before
it was observed. The mother knew all
about this and paid no attention, but
Mehmet lavished concern and endear-
ments on the little Jocasta (whose name
was Uvia) and finally, having fondled
her to quietness, left to attend to the
Jeep—whereupon the Oedipus atmos-
phere lifted and Uvia became a natural
and unimportant child.

On a comfortable mattress in the sit-
ting-room floor I lay and thought of
these domestic things next morning,
hoping that Mehmet would not be too
late in starting. A stork's nest on the
roof opposite was visible through the
trees; and there the wife stood in dignity
and repose, waiting motionless on one
leg to be made love to now and then,
while the husband fidgeted with bits of
paper for the nest. Were there uneven moments, I wondered;
and did not the animal traditions that we call instincts have a
feeling in the first place to make them start? On the Anatolian
plateau the women and the animals' behaviour seemed extra-
ordinarily alike: the tortoises turned their heads aside at the
road's edge with the same self-conscious gesture; the sheep ran
with their noses to the ground, hiding their faces, one against
the other; and the women, wrapped in black above their baggy
trousers, came riding behind them, with only one eye showing
and the cloth held in their mouth to leave their hands free,
looking like one of Dürer's ideas of death.

We left finally in a south-westerly direction for the Massicy-

tus range, that separates the whole of the Xanthus valley from the Elmali plain.

Somewhere the envoys from Phaselis must have crossed it, conducting first Alexander's deputies and then himself with his army; and the ascertaining of this route was the second problem I hoped to solve now that the Chelidonian peninsula seemed fairly certainly settled, and had given Finike (or Limyra close by) as a fixed point on the way. There were at least four routes to choose from for this middle portion of the Macedonian journey, and I found myself in disagreement with both Spratt and Schönborn,³ who assumed a march across the Elmali plain.

It seemed to me that I now knew what Alexander was after, and could see the connection between his puzzling westward turn at Termessus and his midwinter operation against the mountain tribes from Xanthus. They were two parts of a single attack with a single objective—the road that led from Laodiceia to Pamphylia. He was as yet unaware of the comparative ease of a straight march north by Sagalassus—he was possibly indeed unaware as yet of the general friend-liness of the coast—and he looked upon the Laodiceia road as essential for his link-up with Parmenion and the base in Phrygia. His little army was in fact completely in the air, for the sea and even Halicarnassus behind him were still in enemy hands and the Persians held Pamphylia in front of him. He never wasted an effort: he would by-pass anything that had no military or political importance; he would certainly not have attempted a tribal war in winter without good cause: but he had an excellent and indeed urgent reason: he was attacking the tribes that stood between him and his base-road, and this road came by Cibyra into the country north of Xanthus;⁴ it was therefore north that he would attack from the Xanthus valley.

I assumed that the envoys from Phaselis met him somewhere in the highlands of Xanthus, and must have led his delegates

to Finike either by the Arycanda valley or along the coast. Their most northerly course would cross the seven-thousand-foot height which a road now opens to Elmali, and this I proposed to look at later on, though even at the time it seemed out of the question. All other possible paths by which the army could have marched from west to east would be cut through by the way we were now taking, until we reached the coast and the track I have come to think the most likely, from Xanthus through Demre or Myra, by the cities on the sea.

There are a number of passes both north and south of the ten-thousand-foot summit of Massicytus, and we had already visited the western side of one of them during the tour in the *Elfin*. We had then reached Tlos whose rich acropolis, discovered by Fellows, looks out across the Xanthus plain. Mentioned by Strabo[5] as the starting-point of a pass to Cibyra, it had a stone-paved road and Turkish barracks in recent times. Now, it lies prosperous but shrunken among sloping cornlands south of the Deli Chay which we had crossed by the simple expedient of stopping up the exhaust and all other vents of the car and driving through the water. The old city, with many tombs honeycombed in the jutting rock, with gymnasium and a hundred yards of market arcade still standing, and theatre behind high-built walls with seats of polished limestone carved with lion claws—all spoke of centuries of ease. A Lycian stele, among the myrtles and oleanders of the valley, represents with undeciphered letters the earlier age to which the Lycian inscriptions and some of the tombs belong.[6]

From here the southern slopes of Massicytus look easy and gradual, and the passes in winter cannot be hard. Nor, in fact, did there appear to be any difficulty when I came to see them from the eastern side; there are bridle-tracks across them through inhabited lands and a road to Elmali is mentioned.[7] Carvings in stone—sarcophagi I imagine—are spoken of on the paths that lead to the northern passes, where houses are only

built for summer pastures; so that all this country in ancient time must have been richer and more populous than now. But Alexander's route in my own mind came to be pushed farther and farther south as we drove down. For the whole of the north is closed in winter by snow, and why should envoys from Phaselis lead an army by impassable ways when all they had to do was to step back into the friendly valley behind them? And having once got back into the valley, would Alexander not go as far as his centre at Xanthus (where no doubt he had left a few odds and ends) and there take the shortest and easiest way, rather than move up across higher slopes even if they were feasible, from Tlos or Arsa, or any other starting-point? The thing to discover was, I decided, *the quickest and easiest way between Xanthus and Finike*, and everything north of that must be discarded, including Spratt's route by Elmali and even the southern edge of the Elmali plain where two places with Lycian tombs and ruins have been found.[8]

We set out to look for these, in the morning on our way: but the first site, Podalia, which is on a hill to the north of the lake, seemed to be completely unknown to all the peasants in the fields about there; and Armutlu, a village full in sight, was divided from us by the Ak Chay, a deep and bridgeless stream. It would have meant a whole day or more to circumvent these obstacles, and as I had just excluded the Elmali plain from Alexander's marching, I decided not to linger but to move on towards the south. The fact that I was paying so much more than I could afford for the Jeep, and Mehmet's distress at having that pampered object involved in ditches, had no small share in making up my mind.

Apart from the Finike-Antalya highway there are only two motorable roads from Elmali, one to the upper Xanthus and one south-west to the sea: and this, which we were on, was already one of those that made Mehmet say "asphalt" at intervals, though only built during the last two years. It soon

left the plain and the tough little trotting horses, four to a cart, tossing their manes; the willow-fringed lakes in whose pale dream the sword Excalibur might burn; the villages, built of mud and petrol tins, whose wooden dishevelled roofs with untrimmed eaves are bleached by frozen winters. Against the mountain wall of Yumru Dagh and Ak Dagh, one behind the other, we drove into a stony world where the little village of Gömbe sits waiting for summer visitors in the semicircle of its waterfalls and hills. No casual tourists come here, but people of the coast, Kassaba and Kekova and Demre, who must surely have left their stifling summers and ridden up through the forests to this coolness for thousands of years; and I believe myself that it is this civilized seasonal migration rather than the spontaneous local art that has produced stray tombs and carvings in the pasturelands around.

The Jeep broke down at Gömbe, and I sat at the café and heard about tombstones at Gedrop, three hours' ride away, and how Mr. Bean who has walked everywhere had examined them a year or two ago. Mehmet meanwhile, pulling his Jeep about, explained that what was the matter was 'dirt'; and I found it exasperating that he should take the natural unreliability of machines for granted with such easy charm, when we had gone to Elmali and set off very late that morning entirely for the Jeep's sake. It did not take long, however, to polish it, and we drove now east of south, through what is accurately known as the Waterless Valley, with the ridge of Ak Dagh like a grey horse with a snow mane on our right. Pines grew here, single on the caked earth against the naked background, until we drew away and saw the mountain become open and leisurely in the south, with plots of cornland and clumps of trees between its washed ravines.

It was here that my thoughts went round the corner to Tlos, and to our day there, two years before, and I remembered the people—how alike they all were—with green eyes and fair

hair, like Greeks even before the Dorians; and how dignified, polite and friendly, and proud of their village which has dwindled to a hundred and fifty houses from the wealth that once spread the city across the hill. The Xanthus shows there, most beautiful of open valleys, fertile and tended like England, from misty forest pedestals and snow-flecked gorges dark with scattered trees, through low hills descending to the sea.

No road fit for a jeep comes across here, and we now followed our road southward through the forest of Oenium, which Antony gave to Cleopatra for her navy. Its cedars, hidden from the rocky coast, glitter tier above tier with dark horizontal branches along black ridges in the sun. No wind, one feels, can ever toss them, and their rigid elegance makes every other tree seem dowdy; even the cypress, and the fierce Aleppo pine that grows among them, look fluffy and disarranged.

It takes two days for a laden horse to cross the forest from Kassaba to Gömbe, and in the Jeep I lost count of the hours. Towards the late afternoon, people and animals began to meet us; houses and fields appeared, where the trees had turned to oak and pine. We were soon in the oblong hollow of Kassaba, surrounded by slopes, where all the streams are gathered in the flat bottom as in an arena, and have to eat their way collectively through the sunless gorges of Demre to the sea.

THE COAST ROAD OF LYCIA

Further, he reflected that . . . by capturing the Persian coast bases he would break up their fleet, since they would have nowhere to make up their crews from, and, in fact, no seaport in Asia.

<div align="right">ARRIAN I, 20, I.</div>

ONE OF THE CHIEF BLESSINGS OF TRAVEL IS THAT SAMENESS is not its attraction: the pleasant and unpleasant days are almost equally agreeable to remember, once they are over. Since my DDT had come to an end, a certain pattern was beginning to show; good days were followed by depressed nights, so that a graph of my feelings would have looked like a temperature chart of ups and downs at regular hours; and though the night in Kassaba was well-to-do, and most kind, I was glad to get out on to a spirited little pony next morning.

'Shut off from all culture,' as Hans Rott, who travelled there

in 1908 unkindly puts it, Kassaba must indeed have been a rather isolated little place before the road was made. It is now prosperous through cotton and tobacco, has been made the centre of a *nahiye* (district) and is building new houses round a scattered square. It was visited by Fellows and Colnaghi, and by Spratt who describes it as having about a hundred houses and being next in importance to Elmali, though gloomy and tumbledown and surrounded by plague at the time of their visit. Benndorf, forty years later, found it decayed. But its position must always have given it a certain importance, making it a gathering-place of roads as well as waters; and there is a choice of ancient sites around it, whether along the northern axis, by the walled city of Candyba (now Gendova) and on the way to the Arycanda pass by the equally ancient city of Arneae (now Ernes); or by the southern centres above the coast; or through the gorge to Myra (Demre). Any one of these ways must have been feasible to Alexander's army, and I decided to look at the opening of the Demre gorge next morning, and then to follow the line of least resistance where alone the Jeep could manœuvre, along the southern ridge above the sea.

It took an hour and three-quarters, to and fro across the river-bed, to reach the gorge which the Turks call Dere Agzi, or the Mouth of the Valley.

The morning was hot over the long southern ridge and on the quietly sunken expanse where we rode. The oblique gashes of the way to Kash and the smaller one to Demre were visible. The river murmured, rippling and shallow, with tamarisk, oleander, agnus castus and myrtle among its boulders; and as the neat myrtle branches brushed me, I crushed them to smell again their Aphrodite fragrance, so feminine, sumptuous, and tart in the morning sun.

The gorge looked rather Rhine-like, with a castled hill steep at its opening between two entering rivers. Medieval walls

and square round and polygonal towers were based on Grecian stones, and Lycian graves of the familiar house-façade pattern appeared in the rocky walls, one on the west and several on the eastern side. There the entrance to the shady defile was cut in steps over grey herded elephants of boulders. Colnaghi found three bears in the gorge, and Spratt rode through by eighty crossings and Fellows by thirty, with three to four feet of water. All the travellers give the time differently, varying from four to seven hours; but I have found the foreigners less reliable than the local averages, and these give three hours for the gorge or four for the road that crosses the ridge above it.

After looking in, we left the narrow walls and made for a mill and a house beyond, a short distance to the east on a hillock of corn. Near-by, surrounded by brambles in a field with no other ruins about it, was the Byzantine basilica of Dere Agzi, with chancel arch complete and aisles and walls half crumbled and two octagonal baptisteries or towers. It belonged to the 8th century and the Arab wars, when the cities drew inland from the coast and its dangers; and looked at first like an untidy chaos meant to be covered with paint and stucco and marble of which shreds remain. The wearing away of their outer coverings spoils these later ruins. But as I sat trying to draw it—for my camera had failed me—it seemed to grow into its forgotten atmosphere of prayer: the curves imagined by some unknown Constantinople builder recaptured their secure repose. Out of their shapelessness and neglect, lifting light weeds against the sky, the broken arcs by their mere pattern spread warm harmonious shadows over the agricultural simple landscape of olives and corn.

The millers in Lycia used till recently to be Greek, and had no very good name, but the one who lived here had a charming serious face and smile, and left his mill to come with us to see the nearest village muhtar. I had no wish or reason for this detour, and think it was my guide's stratagem in order to get a

meal; and we had to wait till tea and bread and the dark honeycomb were provided. Then, having listened to the muhtar's son, who was learning French at the secondary school in Kash, I rode back by a shaded track under oak trees some way from the river, jogging the pony as they taught me, with the poke of a stick at the base of its neck, and lost in that vacuum of summer feelings when the world seems good.

The house, when I returned to Kassaba, was cool and quiet; four low empty rooms made the living floor, looking on to maize-fields and a garden full of vegetables and flowers. Voices of some of my host's twenty-three grandchildren were murmuring here and there. Someone would always be squatting by the kitchen hearth to brew the coffee or tea; and the brides of the sons in their girlhood had woven carpets, and embroidered the covers of long wooden seats that ran along the walls, and yellow sheets for the bed vacated for the guest. They still talked of Kash as Andifilo—the ancient Antiphellus —and were prosperous, and lived there in winter, and spent the summer months at Gömbe; and they paused here only a month or two to gather or sow their harvest in spring and autumn, weaving the shuttle of millennial seasonal migrations into their own short strands of life. The winter here is unpleasant with constant mists, though three-quarters of the population stay.

The owner of the house was going to Mecca—flying from Ankara at the age of seventy—and I was able to give him a small pocket Quran, bought in Cairo a few months before, that he valued. He had a drooping benevolence, and a strangely shaped head with ears like an elephant's, long and flabby.

"I am not rich, but I live the life I like," he told me; and showed me his photograph as a stalwart young father with a spiky moustache and the present married children on his knee.

Mehmet and Mahmud and the Jeep were refreshed and, as I had rested also, we set off when the heat of the day was over;

163

for it is only twenty-three kilometres to Kash. I had anyway no intention of crossing the ridge as far as the harbour. I would stop on the pass, I told Mehmet, at Chukurbagh, and ride up to the ruins of Phellus, on the mountain above, in the morning.

The Jeep was crawling along and nearly stopped.

"You can't do that," said Mehmet. "There are no houses one can sleep in."

"We will put up the tent," said I; a thing I longed, and continued to long to do, in vain.

"Tent!" said Mehmet. "We will go down to Kash and drive back to Chukurbagh early in the morning."

"Do you think," said I, "that I enjoy waiting till the sun is hot to walk over ruins? And what is it that you call early?"

This touched Mehmet at a rather vulnerable point, and amused Mahmud and the two stray passengers who had attached themselves to us and acted as chorus: but it made no difference to the situation, which was resolved only by my final suggestion that I was to be settled in the best available lodging with a horse for the morning arranged for, and the Jeep would come up to fetch me by ten o'clock.

Mehmet was distressed at the thought of leaving me in discomfort. He would have agreed with the Duke of Wellington that a lady should never be allowed to travel by train alone. I too felt rather gloomy when my ramshackle lodging was found: perched on an insecure stair, it kept planks and rusty petrol tins together without any visible cohesion, as the baroque saints do their draperies. The household, said Mehmet, was good; and a stray man with a stray horse, whom we had met on his way carrying a load of grass, had promised to call for me next day at five.

There was a room, "a fine room" said the man who owned it, with that optimism about the things they live with that makes the Turkish peasant so touchingly agreeable. Having

settled me there, and put up my bed among the sacks of corn which was the household's store for the year, the men all left me. The woman too had to leave, for they were of the poorest poor, and she had to go to cottages scattered on the hill and do their washing. Having rolled out a little flat bread for our supper, she excused herself with a sad look and went, and I was left to a mountainous mother-in-law seated on the small verandah of the only other room, and swollen out of all human proportion by some disease.

She was a terrifying old lady—not so old either, I thought when I looked at her, and probably younger than I was. But she could not move except by waddling cross-legged along the floor with jelly-like convulsions, and her disease, which made people kind to her, had made her ruthless in conversation. She screamed in a harsh voice to all who passed along the path of Chukurbagh below.

She was sorting out rags like a witch and, making room on the tiny platform, asked me to sit beside her; and a feeling of vast loathing, of which I was ashamed, overcame me while she fingered my clothes. Such unreasonable, uncharitable repugnance continued with me all night, and nothing but the poverty and the squalor produced it; for the people were as kind as they could be and gave the best of what little they had; and if, when I had just fallen asleep—thankful for my own eiderdown—the woman came rummaging time after time among the sacks and stores, it was merely because three separate parties arrived and required attention, and some sort of accommodation on the remaining spaces of the floor had to be arranged.

At dawn, the man with the horse was there, and a cushion on its wooden saddle for me to sit on.

The mountain was steep above, an hour's climb away, and its name—Fellendagh—makes it pretty certainly the site of ancient Phellus. The road probably ran below as it does now, coasting above a small patchwork prosperity of gardens, and

the desolation described by Fellows is giving place to vineyards and olives that are now returning after the intervening centuries of rapine, as so much along this coast seems to be doing.

The hill holds this cultivation as in a cup, and beyond its rim one could feel the radiance of the sea in empty spaces. It came in sight, with Castellorizo and other islets, as our path led towards the first of the Lycian tombs.

We lingered on the way to drink out of a sarcophagus which is the village fountain; and then helped to load a camel which the owner of my horse had left his little boy to deal with. The poor beast, in such small incapable hands, was turning its head with foaming green grimaces that made one notice how much better-looking camels would be if they had better-kept teeth. When we had seen to this, we climbed up into the morning gold. Step after step, the edge of the world widened with the increase of the light; the pony grew warm beneath his padded collar, and talked with his ears as he snuffed the steep stones before him; in his dim way perhaps he remembered Pedasos, his Cilician forebear, who was put in the side-traces and followed with the immortal horses,[1] for one might remember anything on such a morning; the troubles of the night melted in a happiness suffused with sunlight, luminous and remote.

The people of Phellus must often have felt like this as they looked from their height on to their fields of Chukurbagh and the flat lands of the ridge and the six eastern ranges, pointed or horizontal, that rise to the snows of the Eastern Ak Dagh above Arycanda.

Their town looked down on the two likely routes of Alexander—the one from Xanthus in the west by Kalkan and Sidek Dagh and Seyret, which is still a road now though unusable by cars at the moment because a bridge is broken, and keeps near the summits above the sharp drop to the sea; and the other from the lower shelves of Massicytus by the Hajioglan valley

into the Kassaba depression. It lay spread at our feet, with two passes winding along Susuz Dagh towards Arycanda between the scrubby hills. They looked as uncultivated and stubbly as the chin of an old Sayyid who shaves himself with scissors; and on our other side, holding all the south, was the sea.

There, round Castellorizo and two little empty islands one fat and one thin, the people of Phellus could see ships as they passed from Syria by Cilicia and Lycia through Rhodes to Alexandria—the trade route of that day.[2] The fashions changed. The quinquereme was invented in Phoenician or Cyprian waters to supplant the trireme, and cataphracts with rowers enclosed under decks rowed by. Their sides looked straight, from above. All these craft were built to equalize the leverage of a single row of oars, and the curve was built, with wood not too seasoned to bend, under water out of sight. Five men sat to each oar in a quinquereme, so that only one skilled rower in five was needed, even on these coasts where the hollow southern seas come with wide spaces between them, and lift the ships' ribs unsupported. The ships grew bigger and bigger through the Hellenistic wars, till the Roman peace came and the pirates stopped, and, with smaller shapes returning, the naval speed and skill declined.[3]

From the beautifully cut stone walls of their little city, the people of Phellus looked out through the clean Aegean air; and temples must have shown on their hill-top, for a column half buried was lying at my feet. The hillside was scattered sparsely with tombs, whose doors and windows and rafters were chipped to look like houses, among the giant yellow sage and bright arbutus, and the honeysuckle scent and broom. In the days of the Byzantines, the city's defences had been re-arranged with haste and fear before they left it; until raids and wars grew too frequent and the solitude increased.

While the sun climbed like a wet flame, four thousand feet

as it seemed below me, I sat for a long time and considered the two roads of Alexander; and felt that there was nothing to choose between them. Perhaps there was a slight tilt in favour of the way we had come, winding through the Chukurbagh gardens in our sight. For the *reason* of Alexander's march must be remembered—that he came to Lycia 'to break up the Persian fleet by capturing their coast bases' and that among these bases (and most important because of the timber in the forests behind them) were the harbours between Patara and Pamphylia tucked out of sight below. Alexander had sent deputies ahead to take over these Lycian seaports, and the probability is that he would choose the route that led most closely by them, so that either he could turn aside at intervals of a few hours to be received by the municipalities of the little towns that are now Kalkan, Kash, Kekova and Demre, or else the authorities themselves and his own deputies could ride up to report to him on his way. A greater certainty than this is not to be inferred; for the alternative route—a six hours' ride from Kalkan to Gendova—is not far away to the north, and the winter weather, or any sort of circumstance now forgotten, might have determined in its favour. The coast could still be reached easily through or above the gorge of Demre; and the traces of ancient tombs and walls are found beside all these ways.

I would follow the ridge road to Demre (Myra); and would then ride over Alaja Dagh which is the barrier between the Upper and Lower Lycias, and that (I would decide in my own mind if the track there seemed ever to have been feasible for armies), would be Alexander's most likely road. I wondered idly why I was giving myself so much trouble to discover, in such obscure places, where an army marched so long ago. Not for writing, for I would make these journeys for their own sake alone with equal pleasure. The pure wish to understand, the most disinterested of human desires, was my spur.

The way of the ridge

Nor does the obscurity of places matter with Alexander, who measured himself by his glory rather than his life and 'wherever I shall fight, shall believe that I am in the theatre of the whole world'.[4] I had come very close, it seemed to me, to the veterans, grizzled and unshaven like the peasants who led my horses, who marched day after day behind the young men who led them, and rested in or by these small walled cities where Greek was spoken, while rumour preceded them and memory followed, and the world's history has rung ever since with their high, hobnailed booted footsteps on the ground.

We rode down from the hill-top of Phellus, and the old woman pushed herself across the floor to kiss me when I gave her a garment or two I could spare; and after I had got over this horror, and Mehmet had brought the Jeep up cheerfully from Kash, and we were on our way again along a road whose ribs nature never meant for wheels—this *familiarity* of the ancient landscape seemed to me particularly clear. The cities with their ruins, reduced now to very poor patches of cultivation and very few living houses, were strung all over the ridge at a distance of a few hours' ride or walk from one another. In some places like Avullu or Baglija, a sarcophagus or two alone remained. Their loosely-walled enclosures of corn petered out among the rocks, and our track with its cutting surface wound on through the maquis to jade-green glades of oak trees with black boughs, whose leaves a cold west wind turned inside out. It gave to this day, and to everything in sight except the ragged permanent stone ridges, a tossing sheen of silk in constant movement; and the Jeep went on with stately lurches, no faster than a horse. Mehmet—over whom the night's lodging was already looming—could only be kept cheerful by the remark that the road was good: at this he would laugh in spite of himself and say "asphalt", while Mahmud leapt in and out of the back to make sure that the wheels still held.

In my mind, I could see the landscape as if it were a map, for

N

we had travelled in the *Elfin* along the invisible coast below. We had seen the road wind up from Kalkan and wondered what it led to; and had rested at Kash (Antiphellus) and bathed in ninety fathoms where a hammer-shaped promontory gives shelter near an island, and a ruined city showed its unnamed wall aslant towards the sea. Byzantine and earlier gates were there, and an eight-windowed church or cathedral, and tombs and palaces whose rooms made ready-walled cornfields for the few houses called Sijakyalis close by. The Mediterranean Pilot merely calls it fort or ruin—Asar Veya Hisar—and adds that the coast 'appears to be steep-to, but has only been partially examined'; but we called the city provisionally Polemus, since that name is still marked a mile or so to the east.[5]

From there we had slipped, for the second time in my life (how fortunate twice in a lifetime), into the exquisite waters that lie round Kekova; and had turned the corner to Tristomo —now Üch Agiz—and seen the outcrops of the ridge above, whose pinnacles are worked here and there into Hellenistic defences. Some fifteen hundred feet up, we had ridden here to Cyaneae which is now Yavi, by a hot gully flagged in places with slabs so anciently worn as to glow like alabaster, and I had looked from the overhanging acropolis to this single pink ribbon of a road winding into shallow distances between Kash and Demre, and had made up my mind to return.

We were now passing a little way south of the beautiful theatre and the tomb-guarded entrance to the town; but the villagers at that time had led us through the city thickly tangled with trees, disclosing an inscription to Hadrian, an arched gate with a disc carved upon it, fine tombs and rough walls. The usual traces of panic and danger still lingered among its peaceful earlier records, carved in difficult places or cut into the cliff.

When Alexander and his friends walked here, the citadels were intact on their hills. Their walls and towers were in sight from one to the other, with broader fields about them than now.

Some pillared temple or portico must always have been appear-
ing, with the snows of Ak Dagh western or eastern behind it,
as one rode past the lion-headed sarcophagi to the straight
gateways across the ridge's undulations along a road where the
sea was out of sight but always felt. It ran like a backbone
through the level landscape painted like some medieval missal
with spiky ridges, and small clear points of rock surrounding
flats of corn, where the army rested beside the scanty waters
that still remain.

It was easy in our own slow travel to picture the comradeship
the day's march produces, with stray discomforts and sudden
good moments of shade or water, or scent of honeysuckle
blown across the track; or to think how the king's sayings
were handed from mouth to mouth along the column, while
he walked under his broad shallow hat of the Macedonian
fashion at its head.[6] The boyhood friendships continued
through these marches lasted him all his life, and the injury to
his memory and to his family, when it came, came through
the absent Cassander,[7] who had no share in these enchanted
days.

The stories trickle haphazard into history, mostly from a
later time, for of this march in Anatolia hardly a detail has come
down. But the character is always the same, ardent, courteous,
and impetuous, with a certainty that never hesitated to strike
when it was essential, and a willingness to spare when it could.

"Bear it," he said, as a soldier passed fainting under a load
of gold which he had taken from his exhausted mule and was
trying to carry. "You need only reach your tent, to keep it
for yourself."[8]

In our day, Wavell, in the desert mess of the Eighth Army,
would send for a double Scotch and leave it, so that the stewards
when he went away might have a drink which only an officer
could order.

Of the Alexander stories a few have survived; but hundreds

more must have circulated round the camp-fires, when the king and his suite had disappeared for their reception in one or other of these little towns. The last one on the ridge appears from a solitary inscription to have been Trysa, otherwise unknown. It is near Gölbashi, on a pointed summit two thousand four hundred feet above the sea, discovered by Schönborn and then forgotten, until an Austrian expedition reached it in 1881 and carried to Vienna the bas-reliefs of the frieze of its heraion. They are as fine as the carvings of Xanthus and of about the same 4th-century date. Of the city little except a few pedestalled sarcophagi and some lengths of wall remain; and in the heraion site nothing sculptured is left except two fragments of cornice askew in the naked enclosure. A herd of goats were browsing by its broken altar and round the few sarcophagi outside the plundered walls; the red-stemmed arbutus made the hill bright; and the ridge was spread flat below with all its minute pools of cultivation left in their rocky pockets as by a receding tide. Its level isolation is cut by the gorge of Demre, whose perpetual shadow lies there at one's feet.

This hill commands the steep descent to the sea, and was easy enough to locate; and Mehmet nursed the illusion that he could find me an animal, or persuade me to walk up late in the sunset to the ruins and still reach the comforts of Demre for the night. But I was feeling tired after the morning's expedition to Phellus and an unsuccessful scramble with Mahmud to reach the beautiful austere Hellenistic theatre of Cyaneae, which turned out to be much too far away. We had jolted along with only two hours' rest, and I had been out since dawn; all this, with the longing thought of my tent unused in the back of the Jeep, I pointed out to Mehmet and added that the night would have to be spent on one side or the other of the hill, where some cottages with roofs sagging like hollow-backed old cabhorses were clustered. A neat new school in the foreground was disappointing for it was shut, as they often are in this

remote part of the country. Mehmet, discovering this to be so, started to grind on again full of the hope that no lodging might be discovered, while he reproached me in a myopic masculine way for not allowing myself to be looked after in a land I didn't know.

Women are handicapped in Turkey by their unimportance, which is so absolute that even flattery is disregarded; the familiar expedient of making men feel better and cleverer than they are fails, since female praise is too idle to count. All I could do with Mehmet was to ask him what he did as a soldier. "Why not pretend you are one tonight and I will lend you the tent while you put me in one of those cottages?"

"The tent!" said Mehmet again, with that voice of scorn. But when we reached the patch of tiny fields, with almond trees blowing about it in the sunset, he led me to wait in a room where the wife of a forestry effendi was looking after a baby, while a cottage near-by was prepared for my reception.

This was a charming evening, with a brisk young woman who set me to rest on mattresses and bolsters, took my dusty stockings to wash, brewed me 'island tea' of hillside herbs, and set about the rolling of the thin peasant bread, damping and sprinkling it with water as if she were ironing, and folding it away. The supper when it came was a 'jajik' of beaten yaourt and cucumber slices, and stewed beans, fried eggs and rice; and the husband, as friendly and as pleasant as his wife, came to eat it beside me. He had found me a little donkey by next morning, and before eight o'clock my expedition was over, since the hill-top of Trysa was only three-quarters of an hour away.

13

THE ROAD TO FINIKE FROM MYRA

A line of fortified positions . . . between the eastern and western cities of Lycia.
SPRATT and FORBES, 157.

SIR CHARLES FELLOWS WROTE THAT THE ROUTE FROM DEMRE across the headland of Alaja Dagh was 'totally unfit for horses. . . . For three hours we did not find a level large enough for a horse to stand upon, and at the end of that time we were among numerous sarcophagi upon the ridge of a mountain about five thousand feet above the undisturbed blue mirror of the sea'.

Spratt and Forbes, the only travellers I know who followed after, give it the same poor reputation, though they diminish the height to four thousand feet and increase the distance to eleven hours instead of nine. Neither version made it appear a likely choice for an army marching; but it was that or nothing if the coast road was the road of Alexander, and I thought I would look at it for myself before making my own guess, while Mehmet, after taking me to Demre, would drive the Jeep back by the way we had come.

Our road was fairly smooth along the last stretch of the ridge, and peasants and a lorry were working upon it as we passed. It is the sparseness of the population that makes the upkeep so difficult; and it is indeed an admirable achievement that there should be any road here at all. On our right, through lonely maquis, the old track ran down to the sea, as it had done for thousands of years till the present Turkish government came to power. Wild pig and bears are still plentiful in the valley where it descends, and the older travellers saw many animals, though I noticed nothing but two squirrels and a weazel in all my journey, and two porcupine quills on the ground.

I had looked at this ancient track before, from St. Paul's harbour in the bay of Andraki (Andriace) at its lower end. We had anchored there in the *Elfin* and had bathed in a cold still stream, and rowed our dinghy along the silted quays whose walls—as in all these cities—showed desperate traces of anxiety and danger, stuffed with the beautiful fragments of their earlier days. Lentulus had broken in here with his ships, forcing the harbour chain,[1] where we spent the morning under pines, among clumps of myrtle, and waded back to the *Elfin* across water that has grown shallow since it carried the Greek and Phoenician navies.

When our Jeep made its long curve round the headland of the ridge and was descending, the old track showed again. One could see it in the distance, with one of the Hellenistic forts and a sarcophagus beside it—at a place called Sura, where a fish-oracle once existed beside a temple to Apollo.[2] Mehmet, cheerfully bored by ruins, pushed on with no idea of stopping, and watched in a pained way while I walked back to where the fortress was visible through my glasses, a half-hour or an hour's scramble away. The suggestion that perhaps the Jeep might like to try to go across country was received as an insult, and Mahmud, tormented now by a divided allegiance,

jumped out to say that he would walk with me if I wished to go.

But there was obviously no temple beside the little fort. It showed through my glasses very clearly and exactly like every other fort that I had lately seen. The whole of this coast from Xanthus is thickly spangled with them, and they are all similar and must belong to the same age though placed on sites that often go back to archaic times.[3] Alexander's generals, who were to succeed him, no doubt noticed the defensive situations and the immense riches of timber behind them, and just as Silifke was possibly a consequence of the raid from Soli, so these numerous fortresses probably sprang up along the line of the Lycian march where the value of the positions was observed. They might tentatively be taken, I thought, as indirect evidence to establish the coastal route, together with other accidental glimpses—such as the march of Polyxenides in Livy, who landed at Patara in 189 B.C. to march '*itinere pedestri*' to Syria.[4]

At the time, however, I felt that the morning was already hot and I had climbed one acropolis already; and this weakness was soon consoled, for as we followed the jeep-road, Mehmet offered an olive branch in the shape of a little temple quite near-by on the right, and stopped of his own accord. Whenever I became difficult, he looked around for a ruin, and in fact I was delighted by this charming little building, of the 2nd century A.D. or thereabouts, decorated with Corinthian pilasters, and opening by a tall door to a space amusingly arcaded, with one bigger and one lesser arch to each side.

In harmony therefore we entered Demre, and made for one of its two cafés, and Mehmet put my chair, as he always did, in the most respectably hidden corner, which was usually just opposite the W.C. To his distress, as soon as it was apparent that I could speak a little Turkish, the whole audience would turn in this unattractive direction to face me, and the fact that

one might just as well let the conversation take place in more agreeable surroundings never crossed his mind.

A sort of offer went round as to who should look after me for the night, and a man took me to stay with his sister in a country cottage among gardens.

The new English pumps now make it easy to grow oranges, and motor-boats take them round the cape to Antalya, to be shipped to Istanbul. In the four years since my first visit the little world of Demre had grown. The orange gardens lapped up to the theatre which before had looked out over open expanses of corn; and the church of St. Nicholas was being attended to by the care of Ismail Bey in Antalya. A graceful apse was coming to life, like Pygmalion's statue, from the earth where they were digging: and a hotel for tourists was the vision for the future in the town. They were presumably expected to arrive by sea, for the forests of Oenium and the hinterland of Elmali are still a complication, and the coast road that Demre dreams of round the headland would cost, they afterwards told me in Finike, two million Turkish liras or more. Of its difficulties I became aware next morning, when a horse had been found and Mehmet and Mahmud had left for their long trek back to Gömbe, to meet me again by the waterfalls of Arycanda in two days' time.

I spent the afternoon resting, until the horse came for a gentle ride round the cliff-walls, where the tombs climb one above the other with a busy feeling as if they were a street of shops. Goatherd children with charming manners scrambled with me up steps nearly effaced. They refused my few pence, and asked with mysterious interest for the figures of the population of Britain. What they learnt at school I never discovered (I have never discovered what I have learnt myself)—except that they are taught to think of the red flag of Turkey as a flower that grows like the poppy, out of the heart of their soil; and their beautiful good manners they learn at home.

The Road to Finike from Myra

My guide, though living so near, had never himself been up to the cliffs. A party drinking tea under an almond tree would have come with us, if they had not been celebrating the father's death like the figures reclined and feasting in the tombs above. From those carved porches we looked at the gorge of Demre, whose wheatfields filled the flat that once was sea. The scar of the defile above was dark in shadow, but all else glowed uncontaminated and fine in the late light, as if it were molten gold. The authorities of the townlet, police and müdür, were strolling, by a path where the wall of the old enclosure of St. Nicholas still shows though all except the church has been demolished. They bowed and hoped I was happy. A woman carrying cucumbers from her fields gave a gift from the bundle to the stranger. And even a poor bitch, suckling her four puppies by the roadside, looked up transfigured in that peaceful glow: she lifted her careful gentle eyes towards us, as if their ceaseless awareness of darkness and danger were slipped for a moment into its sheath.

My guide came at four next morning, and we soon started, and trotted along the level for an hour under a widening streak of dawn. We then turned inland, to circumvent a sea-lake which is a *dalyan* or fishery at the eastern corner of the bay. As I rode, I recognized the landmarks of the travellers before me, unchanged in the hundred years by which we were divided—the water on my right, and on my left a Hellenistic fort of two square towers with a curtain between and around them, seen through the Vallonia oaks that clothe the lower spurs. The mass of Alaja Dagh, which divides the two Lycias, comes down here steep-sided, in one solid movement that pours itself to sea. Far away on its shoulder another fortress showed, but the few wayfarers of the plain denied a track across there: the only inland route passes through higher country farther north, by summer pastures and the Alaja

178

Yaila where a church is reported, between us and the way from Kassaba that leads to Arycanda.

Meanwhile, our path narrowed above the last cornfields that clothe the headland base, until it turned and began its uncompromising climb. It zigzagged up a shallow open gully, evidently washed away by every winter, where all traces of an old road would be lost. It was here that Fellows found no level large enough for a horse to stand on, and Commander Spratt and Mr. Forbes had to save their horses from falling by pushing them from behind or putting their shoulders to the baggage. It was indeed extremely steep, but these young men may have been unlucky too in their animals, which they had difficulty in finding, for it is a great advantage in such places to have a pack-horse accustomed to the way. I did not dismount, knowing by experience that when I do so a man much heavier than I am climbs up and makes the animal less happy than before: but I left the reins on its neck, and let it rest every few paces, and stood well forward in the stirrups to take the weight off. As the start had been so early, the hillside was in shadow to the top. The *dalyan*, smaller with every turn of the screw-like path, looked as the world looks from an aeroplane; the hill sloped steep as a waterfall to meet it; and at the end of an hour-and-a-half of climbing, the loosened sliding stones changed to rock with thorny tufts; the sun shot rays of spears from its hidden horizon; and a footpath for goats on the promontory showed familiar ruins of tombs and walls.

In this solitude not even the goatherd was about, though his flock was browsing. But it was a fortunate day, and a soldier overtook us just as we reached the top of the ascent. He came up from Demre, as he had been doing two thousand years ago, to 'keep watch over the sea'; and he told me that I would find more ruins if I walked towards the headland.

There indeed was the little acropolis, finely cut with many early pieces not much later than the days of Alexander, but

with its stones rehandled in the panic of all this coast. Nor was this all: for the town spread out of sight on the slope to the east, where the houses, guarded by their square tower, must have looked out like a wasps' nest to the fleets of Ptolemy or Demetrius, or seen Charimenes pursued by the sloops of Pericles the Lycian, when he landed to travel through the mountains in disguise.[5]

I did not climb down, for I only discovered this residential area from the opposite hillside later on, the steepness of the acropolis slopes on three sides having hidden everything but the sea. Even now, if I think of that view on some winter's day, the freedom and the light return, the glistening solitude possesses me; the Aegean is plumb below, darkened with sunlight, where vagrant islands dance unfrequented and the morning landscape curves by itself alone.

I sat there idly, and far away the coast of Demre spread waves on flat sands in easy patterns. Like speech or writing they pressed with ceaseless variety from their sea, and under the lightness and foam their run was short or longer according to the depth from which they came.

After an hour or so I returned along the promontory, and noticed the buildings upon it—stone rooms whose walls were pierced with doors and windows cut in the rock itself. I had once seen this in the upper church on the island of St. Nicholas, but had no idea of the date of such building; the drafted blocks that lay about, squared to a gateway, and the four pedestals or altars all seemed to belong to the Roman age. The reservoirs for water cut in the stone were there, and a column lay there, and some public building must have held the headland's neck. All except one of the sarcophagi had been tumbled about and broken at the entrance to the city, and perhaps a little depression on the right held the theatre, for blocks of stone near-by looked like the theatre seats.

This is the only site that Mr. Bean has not examined among

those I have visited in Lycia, and he has kindly looked at my photographs and corroborated this description, and will I hope climb soon and perhaps find an inscription with the city's name. Fellows thinks of it tentatively as the ancient Isium, and the other young men noticed only the acropolis on the headland and no more. But I was sufficiently delighted by its mere existence, with or without identification; for the way up, with natural difficulties and no shred of antiquity along it, had made me doubt whether an army could ever have chosen such a road. The presence of all these buildings on the hill-top proved it a thoroughfare after all, and I now felt pretty confident that the Macedonian army passed by here with only one other rather less likely alternative—through Kassaba to Arycanda.

Fond as he was of geography, Alexander, I thought, would like the ardour with which I was toiling in his footsteps, asking questions in a small way in a manner he would understand: for he cared for such things. It interested him that the Persian sea was only a gulf of ocean, and 'when writing to Olympias about the country of India ... he stated that he thought he had discovered the springs of the Nile; drawing a conclusion about matters of so much importance from very slender indications. But when he had more accurately investigated ... he learned ... that the Indus has nothing whatever to do with Egypt. On this he cancelled the part of the letter to his mother which dealt with the Nile', being scrupulous as a good geographer should be. And when Aristander the seer, in whom he believed, could make no prediction, he 'gave orders that the men acquainted with the country should be summoned' and found out what he could.[6]

There were no men of the country I could ask except the soldier, and he knew little of ruins except that a few existed farther on. We sat on one of the Roman stones and ate the bread we each had with us, and shared the cucumbers and peppers given by the cottagers of Demre; and at nine o'clock

rode on again, skirting steep curves till gentler slopes showed pine-clad highlands, that rose to the summits of Alaja on our left.

A solitary sarcophagus appeared on the hillside, and another group lay smashed and strewn about by the nomads on the easier ground. It looked too as if there might be ruins, but unimportant, some way off on the right. We disregarded them and kept on, to a headland that faced the morning, where another sarcophagus and a wall with towers roughly built guarded the aspect of the sea. Here the path grew steep again, and "I must be an Optimist", I thought, watching the outward-sloping ledges we were on; and finally dismounted.

I had been puzzling over the nine hours which Charles Fellows assigns to this traverse, since the pace we were making (exclusive of our rest) was fitting exactly into the normal time reported by the people of Demre as only five hours and a half. His ascent of the steep tract had taken longer than mine, but even so it left a large gap to be accounted for, and I was coming to the conclusion that these travellers had impeded their horses by trying to ride them too correctly up the steep hills.

Horses with their packs are accustomed to walk alone ahead of their drivers, encouraged or admonished now and then by an 'Ah' or a guttural noise from behind; when the road grows difficult, they put their heads down and seek out their way along it, and a tight hold on the reins not only puts them off their stride and tires them, but also I think makes them unsafe. A good rider *feels* more secure if he holds his horse, but this is an illusion, and it is far sounder to sit back like a piece of luggage, with the reins run loose through a scarf and lying on the animal's neck, though this absence of control is apt to be unnerving downhill. The path we were on was a smooth narrow slab of limestone tilted over space in the wrong direction, with nothing but a wrinkle or two to keep a hoof from sliding; but the horse is of course just as interested as one is oneself, and

if left to his own devices will get by. When, however, we began to descend as if by a corkscrew, I got off and walked.

Charles Fellows had given the horses 'rest after the strain and fatigue of yesterday'; and Spratt and Forbes, whose time was *eleven* hours, and who descended 'the greater part of the defile on foot on account of the slippery surfaces of the rock', also continued to Limyra on foot the next day because of the fatigue of their horses. But my guide, who came from Salonica—the mere raw material of a human being, very slow and fair with huge long hands—was, I knew, going to ride back all the way, and do it that very afternoon; and the inference one could draw from this was that Alexander knew what he was about when he left his siege engines behind him. Such horses as he had with him were probably much tougher up and down the hills than an orthodox modern rider might suppose.

The books of these early travellers, telling of circumstances so much the same in places so little altered, are pleasant company on such a journey. I felt I knew them well, gay and disinterested young men whose days and memories of these coasts and hills never can have faded, whatever their later lives became. And how well they were educated, to enjoy every adventure!

'Often, after the work of the day was over and the night had closed in, when we had gathered round the log fire in the comfortable Turkish cottage which formed the headquarters of the party, we were accustomed to sally forth, torch in hand, Charles Fellows as cicerone, to cast a midnight look of admiration on some spirited battle scene or headless Venus, which had been the great prize of the morning's work' (among the ruins of Xanthus); and these 'conversations all who took part in will ever look back upon as among the most delightful in their lives'.[7] They were splendid young men, however erratic their time-table may have been up the hill.

As we reached the eastern steepness, the bay of Finike opened,

and in its triangle the far familiar headlands of Chelidonia appeared bathed in sky. The slopes were rich with arbutus, grown high like feathery trees with only the pines above them; and the track followed a long gully which turned into a valley. Olives began. One of the Hellenistic towers evidently once spaced along the coast road was on our left, bricked up and turned into a peasant's hut with a roof of rushes; the other two, reported here a hundred years ago, must be destroyed.

Spratt and Forbes describe Finike at that time as a dozen tents and three or four stone houses, with a Greek café and bakery established by a Pasha's order to supply the Sultan's ships that touched here, on the voyage from Istanbul to Alexandria. Then as now this was the seaport for Elmali.

But the thatched huts have grown in numbers and moved up the valley, and a flourishing little town with streets of red roofs and balconied uneven houses appears against the edge of the sea below them. The hotel gave me a friendly welcome and a bath, and I found a taxi for Arycanda next morning; and Mehmet and Mahmud were there ready to receive me, seated at a table under the plane tree, on the wooden platform where the white waterfall spouts below. They too were pleased by the reunion, and made short firm work of the demands of the strange taxi-driver, while I lunched and Mahmud told me about their journey, and Mehmet circled round his Jeep in a sort of ritual adoration, with a pink rose crooked in his little finger and a duster in the other hand.

THE HIGHLANDS OF XANTHUS

In the height of winter, as it now was, he attacked the Milyan territory, as it is called; it belongs to Greater Phrygia, but was reckoned then as part of Lycia.

ARRIAN I, 24, 5.

ABOVE ITS DEFILES, AND THE WALL OF BEIDA DAGH WITH upreared summits (Chalbali and Baraket and Ak Dagh of the east), the Anatolian plateau lies basically level round many mountain islands, and stretches northward to the rolling plains of Phrygia.

The precipices that hang over the Lycian coastlands run back in eroded valleys, shallow, empty, waterless, and patched only with snow. On their bald summits, with gates now vacant, the circular forts of the ancient Pisidians lie aslant here and there like drunken garlands, and the raised clump of some nameless tower breaks the rough and crumbled circlet of their walls.

A vast but easy land is behind the naked barrier, a world of corn with pools of village trees. Poplars, the scented willow, and many fruit trees, are visible far-spaced and far away. The deep winter snow feeds the harvests; and half-way between Antalya and Elmali, and one-quarter of the way to Fethiye, is Korkuteli, near the site of Isinda where the ancient highway ran. West of the Termessus defile, it led by easy reaches round the lake now called the Sögüt Göl, on to Tefenni; and over hills to Laodiceia built by the followers of Alexander, and there took off from the Maeander valley.

It was used as early as the 5th century B.C. and probably before it, when Phrygia and Lydia communicated with Telmessus,[1] and its importance became apparent under Rome. 'Leaving the Southern Highway at Laodiceia, it led southward over a pass into the basin of the Horzum Chay, a few miles

north of Cibyra, and then, turning into the south-east, ran over the western Taurus by way of Isinda and Termessus to the Pamphylian plain; thus it afforded the chief means of communication between the province of Asia and the southern coast'.[2]

This road, I reflected, was probably the goal of Alexander's effort, both in the winter campaign from Xanthus and in the attack on Termessus some months later 'with the intention', as Strabo writes, 'of opening the defiles'. But there might be some doubt as to the direction in which he approached it. Xanthus is the last fixed point we know before the envoys from Phaselis came up and altered the whole campaign: and it is evident that, if Alexander's aim was merely to reach Pamphylia, he could take one of the quick routes, which according to Spratt are open through the year, from the lower Xanthus valley by Tlos or any other of the passes. The Elmali plain itself is, however, said to be deeply under snow in winter. He would have had to fight his way across it to the road, to reach the defiles of Termessus from above: and why should he return with the Phaselis envoys to sea-level, to attack the defiles all over again from the east, if he had already reached the Elmali plateau and the way to Pamphylia lay geographically open?

Apart from this, I had become convinced that his main concern was not Pamphylia but the reopening of communications with Parmenion in Phrygia. His natural way would therefore be north and not east from the Xanthus valley. A road in that direction is not specifically mentioned, but there is indirect evidence for it in the mere existence of a harbour as important as Telmessus (Fethiye), with the rich hinterland of the upper Xanthus and Cibyra behind it. In 189 B.C. when Antiochus was defeated and the lands of his Anatolian kingdom fell to Rome, Telmessus was granted to Eumenes of Pergamum as a reward for his services.[3] Its value to him as a seaport would have been nil if there had been no road to approach it

(since the coast road from Caria was not in his hands). It must therefore be presumed that a way for traffic already existed from Telmessus and Xanthus to the Phrygian road, though no explicit record has yet been found and no mention of such a route is made by Ramsay (who in any case touches very little on the geography of Lycia).

At the risk of being pedantic, I have repeated the evidence, which is more fully presented in my appendix. The whole explanation of Alexander's two campaigns hinges on the importance of this road. When it emerges so to speak into history, we find Manlius, the Roman general, marching down it in 189 B.C., blackmailing Cibyritis on his way.

Alexander, I therefore concluded, began by going north; but even so there was a possibility that, when overtaken by the Phaselis envoys, he might have turned directly towards Elmali and the Arycanda valley, without revisiting his base at Xanthus at all; and I was the more anxious to look into this alternative as it appeared to have been the one assumed by Spratt and Forbes and Schönborn, who took it for granted that the Macedonians marched down by Arycanda. The only modern road west from Elmali makes for the upper Xanthus. But it is enclosed in a mountain barrier whose lowest passes, described as 'pitiless' by Spratt, are nearly seven thousand feet high and hold the snow through May. To circumvent such an obstacle, Alexander must either reach the Cibyra road—and where then would be the sense of marching away to attack it again from the other end?—or must do what I soon felt convinced that he did do—march back to Xanthus and set off eastward along one of our two roads near the coast. No army would dream of crossing so high an obstacle in winter with an easy southern alternative at hand. When I reached Elmali, however, I had not yet come to this conclusion and I wished to verify it in the few days that were left me.

My time was running out and the summer was advancing.

The middle of June, fresh in the empty air of the plateau, was sweltering already in the gorges of Xanthus below. And nothing could get Mehmet and his Jeep to move. "You are tired," said he; "so am I"; and the Jeep was *bozulmush* when I was packed and ready—an ominous word whose full implications I was to learn in the next few days. Mehmet, with that endearing blue-eyed air of a classical demigod who has accidentally hit middle age, maddened me with frustration, and the strain of not knowing the language well enough to be effectively annoyed. It would anyway have been of no use. The art of travel, and perhaps of life, is to know when to give way and when not to, and it is only after the level of grievances has risen so as to be obvious to all that a scene does any good. The moment came, however. Scattering grammar to right and left, I made a speech, and Mehmet tore himself from the arms of his family and started. The Jeep, said he, was in order; we left Elmali while the beautiful Ottoman mosque was calling its faithful at dawn.

The pass has the ridiculous name of Gügübeli, impossible in winter and four hours by jeep both up and down at other seasons. I had been over it some years earlier, with David Balfour, but had not noticed it very carefully nor at that time connected Alexander's marches with these inland hills. We had stopped to visit rock-tombs at Eski Hisar which we took to be the ancient Choma, and had watched the nomads coming down in autumn from their high pastures, their fires gleaming everywhere at night. At every turn of the road one would meet them, the cradles askew on their camels, with sometimes a baby in a flounced sunbonnet loaded inside one of their great cooking-pots, or, wrapped in felt, tied to the mother's back for easy transport.

Now, in June, there was no movement over the passes, but the peasants were out in their fields. Even the townswomen at Elmali mostly still cover their faces, or wear the old-fashioned

black Turkish skirt and veil; but the peasant girls tie a white handkerchief over the mouth and across the back of the head to a knot above the forehead, leaving their plaits to show below it down their back. They do not use the gay striped nomad skirt over the full bright trousers, or the turbans tied out of many silk headcloths, or necklaces and dangles of silver; nor have they the delicate gipsy eyebrows and softer contours, but are thick and strong and square without surprises, their trousers tucked into white woollen stockings, their feet laced with black rubber shoes. They push wooden ploughs behind a camel or small square bleached bullock, or they dig all in a row, bending over their hoes. The men too have given an easy look to western clothes by wearing striped woollen sashes twisted many times round their waists, and white cotton undertrousers that show a span or two above the western article, which they wear suspended loosely and, in appearance if not in fact, rather precariously round their hips.

Beyond Eski Hisar we entered the north-west bay of the green plain and began to climb. A crooked valley leads across a lop-sided bridge under the carving of a pig cut in the rock and mentioned by travellers. A mill and then a clump of oak trees open the long grind of the pass. Towards it, the mountain block of Massicytus and Yumru Dagh, which we had seen from Gömbe, splashes like a ten-thousand foot wave rich in choppy falls and ridges, scattered with pockets of corn. There is a track on the far side of the mountain summits to the left, with no villages along it, though tombs are said to be among the summer pastures. A few sarcophagi and two slices of marble column were on our own road also, near the top of the pass as we climbed.

The surface had greatly deteriorated since both Mehmet and I had been along it, and he told me that it is to be abandoned: no traffic can use it in winter and a new route by the Sögüt lake—the track of the ancient highway—is being planned.

If Turkish enterprise in road-building were to stop, the whole of this Lycian country would slip back to the age of pack-horses in a few years. As it was, we pushed up slowly, unwinding the hills in their blue expanses, till we climbed beyond the pines and reached the weather-whitened cypress trunks among discoloured rocks. From the top a wide curve of trees melting to grassland descended, with the pastoral Cibyritis spread below in a watered plain. Out of sight behind an undulating range, the ancient road ran 'smooth as silk', said Mehmet, to the lake and Cibyra and the frontiers of Ionia.

A fair-weather track goes north, crossing from the upper Xanthus to the Dalaman Chay, whose waters the Turkish Government are now regulating at their source. In this basin of rich secluded country the four cities, Cibyra, Bubon, Oenoanda and Balbura formed their tetrapolis, and lived under their kings, and one hears little of them until Livy[4] describes the coming of Manlius Vulso and his methods with the ruler of the day, 'a man', says Livy, 'faithless and hard to deal with'; and goes on to describe how the consul sent five thousand infantry 'to test his attitude', and how they were met by ambassadors bringing fifteen talents in the form of a golden crown.

'The consul said: "We Romans have no indication of the goodwill of the tyrant towards us, and it is well known to all that he is such a person that we must think about punishing him rather than cultivating his friendship."

'Dismayed by this speech, the ambassadors asked nothing else than that he accept the crown and give the tyrant the opportunity to . . . speak and to defend himself. . . . He came next day, clothed and attended in a style inferior to that of a private person of moderate wealth, and his speech was humble and incoherent, the speech of a man who belittled his own station, and lamented the poverty of the cities under his control. . . . From them, by robbing himself

Cibyra

and his subjects, he promised, though hesitatingly, to raise twenty-five talents.

"'Come, come," replied the consul, "this trifling cannot be endured. It is not enough that you did not blush when, remaining away, you mocked us through your ambassadors; even when here you persist in the same shamelessness. . . . Unless you pay five hundred talents in three days, look forward to the devastation of your lands and the siege of your city.'"

This dialogue, which reminds one of that between the wolf and the lamb in the fable, was perfectly successful, and Cibyra paid one hundred talents and ten thousand measures of grain within six days; and having remained in friendship and alliance with Rome through the following century, was annexed in 84 B.C. by Murena. 'What provocation, if any, impelled him thus to disregard an ancient treaty of alliance and reduce an independent state to subjection, we do not know';[5] but the real reason, the historian suggests, was the desire to control 'the road which connected the province of Asia with the southern coast', the same problem that had, as I surmise, occupied the mind of Alexander, though the methods used were different.

Ever since my first descent I had longed to revisit this quiet basin, so high and so secluded. And when the *Elfin* brought me for the second time to Fethiye, with David Balfour and Hilda Cochrane, the consular Land Rover met us and we drove across the Xanthus where it flows through a miniature gorge into open pastures, and followed it to its source. There from a wooded bay the stream ran into meadows, through a country of gentle ranges framed in snow. Columns lay strewn beside the drowsy flocks. We had seen from higher ground—without having time to visit them—the ruins of Balbura, on the bank of the Kelebek Dagh near Katara across a tributary stream; and had looked through our glasses at its

191

bridge, and theatres, temple floor and terraces and tombs. Continuing northward over an easy high watershed and down long glades of pine and juniper, we had passed through Dirmil, whose name recalls Termilae, the Homeric name of the Lycians; had reached the neighbourhood of Horzum where we knew that Cibyra must be located; and had camped in a cold little gully for the night.

Unpleasantly drenched with dew next morning, we cast around and found the ancient capital not far away on the saddle of a hill. It was, Strabo says, a city of one hundred stadia—about eleven miles—in circuit, when the Pisidians took it from the Lydians and rebuilt it; and it flourished 'in consequence of the excellence of its laws'. Governed by 'tyrants' who ruled with moderation, it was able to put thirty thousand foot and two thousand horsemen in the field; and being there on the road at a crossway of traffic, it spoke the language of Greeks, Lydians, Pisidians and Solymi from Chelidonia; and used the oxide ores in which its neighbourhood was rich[6] 'to carve ornamental ironwork with ease'.

A touch of city opulence and pleasure still hangs there like some half-remembered perfume on the empty hillside and the wide-spaced ruins. A great theatre has its seats, and the neat arch of a vomitorium; a small one has a windowed wing and the heavily-built tier of the scaena in place. We trod on a Hadrian inscription, with one to Tiberius beside it, and above us the market-place and temple levels were built on stretches of Greek or Byzantine walls. The line by which water had been brought across the valley lay in sight from a high necropolis; and, at the head of a sort of Via Appia of sarcophagi, a stadium showed the curve of its seats and the remnant of an arch above them. The hillside, warm and silent under filmy cloud like milk that the sun was drinking, seemed alive not with life but with time.

The new towns need the safety of the hills no longer, and

modern Horzum is busily growing on the plain. While the
goatherds alone, and the goats strung out like rosaries behind
them, tread the thorn-encumbered vanished streets above, a
new road unconscious of its ancestors runs easily along the
level of Tefenni. It has not yet brought much change to the
people of Cibyritis, who live in their small villages in old-
fashioned wooden houses pointed like pagodas, where the
summers remain cool and green, and wheat grows to a late
harvest, and the winter shuts them in with snow. Here and
there in the midst of fields they make a detour in their plough-
ing, to avoid the heap of some lost temple or townlet, where
pieces of carved stone show, while one sycamore tree grows and
another decays, shading the wayfarers' springs through the
ages.

By one such, called Zobran, we rested, near the village of
Kinik in the basin of Xanthus, and were joined by two young
men on their way to a wedding, who sat and strummed on a
lute beside us though we could not make them sing. They are
a tough short population with neat features, and when they
received us officially they did so with a dignified and modest
air, as of conscientious people anxious to carry through a
difficult operation correctly—a touching manner unlike the
ease of Arabia or the servility of the West. The humble
laird Moagetes probably tried so to deal with Manlius, when
that ill-mannered Roman came along.

Travelling alone I was treated in a far easier, and—since
the manners were always perfect—a pleasanter way. On this
my third arrival in the uplands of Xanthus, I hoped to visit
Balbura, and the other two towns of the tetrapolis, Bubon and
Oenoanda, which we had missed before. We thought to
have discovered Oenoanda at the top of the little upper gorge
of Xanthus, but it turned out to be a poor destitute ruin
of Termessus-near-Oenoanda, a colony of the Pisidian Term-
essians mentioned by Strabo, while Oenoanda itself is on

a neck between two passes to the south. Bubon and Balbura and Dirmil too, are all near the northern opening of the Xanthus passes. The former is west of Dirmil at the village of Ibejik, and is described by Spratt as uninteresting, though he mentions a pediment-tomb, and an inscription to a matron celebrated for having children, a thing no one would think of noticing particularly today.[7]

Oenoanda is only five kilometres or so from Injealilar which a jeep or lorry could easily reach from our route at Seki, and the afternoon had not yet begun when we reached this village. A small acropolis, with tombs and smooth walling on a rock, showed below the road as we descended; and I noted them, but had no intention of lingering, and only did so when the Jeep gave out beside the village café and hours passed and every sign foretold another night's delay. The Müdür was a tall thin young man from Istanbul with reddish hair which had already left his intellectual forehead, and he had come and given me tea under the plane trees that make the square. Having settled me happily in an orchard below the office window to sleep on a carpet in the shade, he had been made more intimate by the smallest imaginable ant that crawled into my ear and, finding no way out, panicked inside. Nothing more terrifying can be imagined. It felt like a lorry going round and round, and I rushed into his office and asked to have it drowned—which was done with a glass of water. After that the Müdür talked about the boredom of life in his six villages on the upper Xanthus, snow-bound for four months of the year. A jeep rarely gets up from Fethiye, and all other tracks—to Elmali, to the Sögüt lake, or to Dirmil—are closed except for horses; and Elmali is closed for horses too. He had been six months already and might be marooned here for years, as there appears to be no fixed time of transfer; and he had himself chosen Seki, misled by his love of the sea and a map which placed this village on the coast. Old-fashioned Turkish maps can easily do this, though

the new ones—which I was using—are good enough for the lie of the country, and only rather difficult because of their unfettered choice among a variety of names.

As the afternoon wore on we walked over the unnamed unknown acropolis of Seki, which the Müdür had never visited; and talked about Alexander. We agreed—though he did not know much about it—that the pass over from Tlos and Gömbe, which Strabo mentions, would be out of the question in winter, and that, once up here out of the lower valley, there must have been two routes towards the Laodiceia road to choose from, the one leading north to Cibyra and the other east of north to the lake. There is a slight tilt in favour of the latter, because of its easy open valley, without a ridge between.

We then returned to the Jeep, and saw Mehmet and Mahmud squatting one on each side hitting it gently with spanners, prepared to tinker at it through the night. I left them with forebodings; and slept in the doctor's house in comfort, above a slope of cornfields soft as water, where the sound of water ran too, sinuous and long as a snake's backbone that slides from vertebra to vertebra, in a subtle incarnation of repose.

15

OENOANDA AND THE
PASSES OF XANTHUS

But if the deity that sent down Alexander's soul into this world of ours had not recalled him quickly, one law would govern all mankind, and they all would look toward one rule of justice as though toward a common source of light. But as it is, that part of the world which has not looked upon Alexander has remained without sunlight.

PLUTARCH, *Moralia*, 330D.

THE JEEP WAS STILL *BOZULMUSH* NEXT MORNING. MEHMET looked wan for he had worked at it most of the night, and Mahmud emerged like a thin but sporting water-rat from below it, and they broke the news with as much distress for me as for themselves. That fate should hit them they seemed to think natural, but that I should come so far and not arrive was the wrong treatment for visitors. There was nothing for it but to go to a garage in Fethiye if indeed the Jeep would go. If not, she would have to be loaded on the lorry which united Seki with the world.

I was grieved to miss my towns and the way to the lake which we had hoped to follow, but Mehmet and Mahmud's uncomplaining acceptance stabbed me to the heart. For to Mehmet the Jeep—reduced to a skeleton, patient and prehistoric under the trees, and surrounded by screws—was not a mere machine and a rather unattractive one at that. It was El Dorado, his dream. It was La Princesse Lointaine and the New Age all in one, to which the 'pick-up' that played ten tunes by itself belonged. Nor had he stinted or neglected anything about it, for the Turkish cars that can get no spares because of the present restrictions need a great deal of resourcefulness in their service. One is always grateful for the sight of pure, harmless, and

undiluted happiness in this world: and that is what Mehmet enjoyed, sailing up and down with his Jeep well dusted on the road between Antalya and Elmali, and greeted along it all the way: and it was not money-mindedness but simple easy kindness that had brought him over this gruelling pass. The fifteen pounds a day which were so much more than I could afford had only bought two new tyres, and the road to Myra had eaten up the old ones as if they were jam. The sole difficulty I had had with Mehmet when engaging him was that he had felt that what he asked was more than it was reasonable for me to give. He had only been persuaded when I told him how impossible it was for me to reach these remote places in time, and indeed all my troubles over starting came from this disinterestedness, for the riding of his Jeep was all his horizon and no reflection of mere finance went beyond it. What was a day or two more or less while waiting for such a pleasure? Now there it stood dishevelled, the heartless machine-age personified and bankrupt: and Mehmet arranged for the lorry of Seki to take me to the Oenoanda track, where they and the Jeep would meet me, either on their own wheels or on those of the lorry, when I came down.

The Müdür escorted me, and we turned south a half-hour's walk off the road, into the bay where the high summer pass from Gömbe comes down; and at the village of Injealilar found a horse and the Muhtar's son to guide us up the hill. The grey wall of Oenoanda was visible on the neck of the spur, in a strategic position above the Gömbe track on one side and the Fethiye road on the other, with the ways to Elmali, Dirmil, and Sögüt-Göl fanning out between them. The spur pushes out from the range of Ak Dagh that barricades the lower Xanthus, and the overhang of the deep river-gorge ends in a peak, still streaked with snow in the middle of June, opposite us in the north-west.

This city has scarcely been touched in the hundred years

since Commander Spratt was up here, and the only difference in what he and I saw was due to our climbing the hill on opposite sides. He came from the west by the remains of an ancient way that branches from what is now the modern road to Fethiye, and he discovered the theatre which Hoskins had looked for and missed. These young men—Fellows, Spratt, Forbes, Hoskyn, Daniell, around 1840, and Schönborn and Loew a little later—discovered and identified 'no fewer than eighteen ancient cities', determining fifteen of them by inscriptions. Daniell alone, whose grave is lost beneath a Greek column in Antalya, visited Selge, Syllium, Marmara, Perge and Lyrbe, while Captain Beaufort, a generation before him, made known Patara, Myra, Olympus, Phaselis and the Chimaera. Hamilton, Leake, and Clarke who discovered Termessus, were all turned aside by riots, plague or fever. Fellows in 1838–40 found Xanthus, Tlos, Pinara, Cadyanda, Arycanda, Sidyma, Cydna, Calynda, Massicytus, Phellus, Corydalla, Choma and Trabala; while Hoskyn from H.M.S. *Beacon* came upon the lost city of Caunus, and—in 1841, with E. Forbes —discovered Oenoanda and Balbura.

It was pleasant to see the places they wrote of unchanged. Little enough is known of Oenoanda, except that it sided with Brutus against Xanthus, and seems to have been expelled from the Lycian League when Antony restored the cities' freedoms; and a point of some interest is to be found in its coins, together with those of Bubon and Balbura, for the name of Lycia was not added to them, as it was to the coins of Telmessus, when their inclusion in the League took place under Rome. The exact point where the Lycian border ran when Alexander came here is unknown, but it was probably enough formed by the gorges of Xanthus and their passes, and the omission of the name of Lycia north of these might be a clue. The walls too of Oenoanda resemble the Pergamese building of the time when Attalus was given the port of Telmessus, and strengthen the

conviction that an earlier road to the coast was there to be defended. The more I looked, the more I felt how easily this may have been the route by which the Macedonian army, impressed by the high winter passes, debouched from the gorges, and found Milyas—that vague country—hemmed in by the mountains on their right. One can still feel the awe in the words of Arrian. When another objective offered, they would surely leave the mountains alone, whether it were the pass to Gömbe or the seven thousand feet of Gügübel which even in the good summer weather had just demolished our Jeep; and they would be delighted to move back through Xanthus and along the snowless ridges of the coast.

Meanwhile we had reached the walls of Oenoanda, and were walking below them. Their fine blocks, brushed by the pines and plump as cushions, caught light on facets roughened by the Hellenistic chisel with a perfect elegance of military art. Eaves of stone threw a slanting shadow, and loopholes, windows and towers made their black rectangular patterns. The wall is over six feet thick and as solid as the hill that produced it, and a narrow postern was visible only because an arrow of sunlight fell through. Within, over the dip of the ridge, the city lies half-buried, worn down to the huge stone arches on which its buildings stood. A pillared square overgrown with trees was perhaps a market with pedestals all round it, its space still flagged and smooth; and the theatre is scooped out of the hill beside a half-fallen arcade.

Its stone seats too were latticed with sun or fresh under the shadows that moved like hands to and fro. I sat there for a long time, thinking of all these theatres and what they had seen: of Memnon, who commanded the Greeks for Persia and was Alexander's most dangerous opponent, and how he sent his musician to Byzantium to count audiences so as to guess the city's numbers; and how the commander of the garrisons in Aeolis would sometimes trap and ransom crowded audiences.[1]

Oenoanda and the Passes of Xanthus

The city worshipped in its temples and defended its walls, but here in its theatre and agora and gymnasium it lived; and, in the days that followed Alexander, the little barbarian populations would listen to the plays of Menander and build here in imitation of the coast.

* * * *

The Greek civilization, as Alexander's successors established it through Asia, was one of cultivated oases connected by roads[2], as it still is in a lesser way today. It was a self-conscious colonizing of ideas as well as of people, and was already in the air in Alexander's youth. Isocrates preached it;[3] Philip practised it in Thrace; and Aristotle wrote on colonies, observing that the Greeks 'placed as it were between the two boundaries' of the north and south,[4] were capable of commanding the whole world. There was little idea of fusion in his vision, or in that of any Greek before him except Xenophon: born of island stock, Aristotle looked with a conventional mind on barbarians and slaves.

'Could one have one's choice,' he writes, 'the husbandmen should by all means be slaves not of the same nation, or men of any spirit; for thus they would be laborious in their business, and safe from attempting any novelties: next to these, barbarian servants are to be preferred'; and 'among the barbarians', he considers that 'a female and a slave are upon a level in the community, the reason for which is, that amongst them there are none qualified by nature to govern, therefore their society can be nothing but between slaves of different sexes. For which reason the poets say, it is proper for the Greeks to govern the barbarians, as if a barbarian and a slave were by nature one'.

An even more thorough bigotry appears when he contemplates slavery in action.

'That being,' says he, 'who by nature is nothing of himself, but totally another's, and is a man, is a slave by nature; and

that man who is the property of another, is his mere chattel, though he continues a man. . . . Since then some men are slaves by nature, and others are freemen, it is clear that, where slavery is advantageous to anyone, then it is just to make him a slave.'

A doubt is expressed, but it is not a very firm one.

'Many persons,' he adds, 'call in question this pretended right [of conquest] and say that it would be hard that a man should be compelled by violence to be the slave . . . of another . . .; and upon this subject, even of those who are wise, some think one way and some another'; and his conclusion was one very satisfactory to Philip and his son in Macedonia—'for all persons quietly to submit to the government of those who are eminently virtuous, and let them be perpetually kings. . . .'⁵

With this conditioning then, Alexander at the age of twenty-two came to Asia, and the plan of hellenizing the world he brought from his background, his youth, his teachers, and—possibly most of all—his father. He transformed the plan, but the essence of it was there already: he seized and developed the impulse of his time. The training of youth, instituted in Athens about 335 B.C. and derived from Plato's Laws, spread through the Greek world and into barbarian lands ;⁶ Alexander's games and competitions in Asia, literary and athletic, developed into festivals held for generations in his honour; and theatres in cities soon began to be built in stone. When the Romans came, a vast network, not pure in race but deeply Greek in feeling, had spread from the Mediterranean to India,⁷ and the hellenizing that passed into the Roman world has lived to this day. One may remember the dream of Pyrrhus before his march, when he thought Alexander called to him and offered to assist him. But Alexander lay ill and Pyrrhus asked how he could do it. 'I will do it,' said he, 'with my name': and his name has done it to our time.⁸

Oenoanda and the Passes of Xanthus

Even if this were all, it would be a record of conquest no other human being has attained before or after. But it is not all. The first part of his plan was in the fashion of his day and of his people, but the second was shared neither by his teachers nor by his friends. It was his own, and it steeped him in loneliness. More than two thousand years have had to pass, and Alexander's dream of a united world is still a dream: it has waited, like a sound in mountain walls, for the centuries to give an echo back, and has found a common voice at last and echoes in many hearts. What would one not give to know how it first began?

As I sat in the stillness of the theatre of Oenoanda, where the spirit of Greece lived though probably no Greek had built it, I began to think of what can happen to change a lad of twenty-two who comes for the first time to Asia. Romance reaches the romantic—and Alexander was passionately romantic; and human sympathies come to the warm-hearted, and the Alexander saga could never have existed if his heart had not been warm. Time too must be remembered—the fact that a year and a half or more was spent along the coast of Asia Minor before ever the battle of Issus was fought; and five years before he first adopted the Persian dress in Parthia.[9]

Aristander, his friend and intimate adviser from childhood, was a Lycian; and when they came to Aristander's people on this coastland, it was with the friendship and protection of a Carian queen behind them. These nations were all half hellenized already, so that it was no very sudden step from Europe into Asia; the difficulty of language—the main barrier since Babel—was here largely overcome. And even if this had not been so, I thought of all the Englishmen who have written, and looked with the eyes of youth on these lands and been enchanted, and how the division of customs has melted and the human bond asserting itself remains. This surely happened; and one can watch the change, from the confident young victor

who sent, from the Granicus, the spoils of the barbarians, to the man who comforted the mother of Darius whom he had unknowingly offended:

"It was our custom," said he, "that led me astray. Do not, I beseech you, interpret my ignorance as an insult. What I have known to be in accordance with your habits, I have, I hope, scrupulously observed. I know that in your country it is a crime for a son to remain seated in the presence of his mother . . .; as often as I have visited you, I myself have stood until you gave me a sign that I might sit. You have often wished to show me respect by prostrating yourself; I have prevented it. I confer on you the title due to my dearly beloved mother Olympias."[10]

It is no wonder that he was beloved in Asia, nor is it surprising that, out of these years of familiarity and the continual comradeship of strangers fighting on the same side together, the idea of human unity should arise. The conservative peninsularity of the Macedonians would perhaps be more to be wondered at, if one did not know what the natural intolerance of nations can do.

Xenophon's influence in the liberal direction has I think been unduly disregarded. He was the recognized expert. Anyone with a military or exploring mind would obviously study him carefully before setting out on the Persian adventure and as I have already suggested in passing, the correspondences between Arrian and Plutarch and the *Cyropaedia* are far too numerous to be merely accidental. Alexander's admiration for Cyrus is constantly recorded—his anxiety to visit the tomb; his distress when he found it rifled; his rewarding of the Benefactors; his care to follow the precedents set by the ancient king.[11] All this bears out his reading of the *Cyropaedia*, of which many passages might easily be transferred to Arrian or Curtius.

The ones that deal with the soldiers' life are not important, for they would come naturally to any commander:[12] Alexander,

Oenoanda and the Passes of Xanthus

walking, 'so that the rest of the troops should . . . bear their
toils more easily', or pouring away the water brought him in
the deserts of Gedrosia so as not to drink alone, is Xenophon's
commander bearing more heat in summer and more cold in
winter 'and in all great fatigues more exertion'. It is a com-
monplace of generalship, as is the note that 'all those with
Cyrus were furnished with the same equipment as himself',[13]
compared with Alexander's cry: "What is left for myself
from all these toils save the purple and the diadem? I have
taken nothing to myself, nor can anyone show treasures of
mine, save these possessions of yours, or what is being safe-
guarded for you." Or Cyrus' calling of officers by name,
that 'those who thought themselves known to their commander
would be more eager',[14] and Alexander 'calling aloud the
names . . . even of squadron leaders and captains' before Issus;
telling them, as Cyrus had done, to encourage each one the
ranks below him;[15] and collecting physicians and attending
personally to the wounded[16] as Cyrus had done.

Such too is the detail before Issus, when Alexander led his
army on with halts, 'checking his men by a gesture of his
hand' while Cyrus, 'before they came in sight of the enemy,
made the army halt three times . . .'[17] Or Gaugamela where
'he bade them tell Parmenion that he must surely have lost the
use of his reason and had forgotten . . . that soldiers, if vic-
torious, become masters of their enemies' baggage; and if
defeated, instead of taking care of their wealth or their slaves,
have nothing more to do but to fight gallantly and die with
honour,'[18]—'for who does not know,' says Cyrus, 'that conquer-
ors save all that belongs to themselves, and acquire . . . all that
belongs to the defeated enemy, but that they who are conquered
throw both themselves and all that belongs to them away'.

There are many other such natural parallels, that deal with
hunting, with contests and races, with sacrifices to foreign gods
in their own countries, and even with a sporting feeling for

equality in games; for 'in whatever exercises Cyrus and his equals used to emulate each other, he did not challenge his companions to those in which he knew himself superior' and Alexander, 'learning that in gambling with dice some of his friends did not enter into the same as a sport, punished them'.[19]

All these are likenesses common to the good generalship of any age, as was the generosity which in any case might be, and probably was, inherited by Alexander from his father;[20] yet it is difficult to think resemblances accidental when they appear in many details so continuously, and in small and concrete instances such as the habit, for instance, of sending dishes from their table to their friends: ... 'a present of small fishes to Hephaestion',[21] or 'when any rare fish or fruits were sent him, he would distribute them among his friends and often reserve nothing for himself', as Cyrus, 'well aware that there is no kindness ... more acceptable than that of sharing meat and drink ... distributed to those of his friends of whom he wished to testify remembrance or love'.

An even more isolated instance of similarity is the ruse by which Cyrus diverted the river and entered Babylon, almost exactly repeated before Cyropolis by Alexander.[22]

The evidence, however, for the link of the *Cyropaedia* is not in those actions which anyone of that age might have thought of for himself, but in such behaviour as was unusual and individual for its time. Such is the courtesy shown to prisoners: 'As soon as Cyrus saw them, he gave orders to loose those that were bound, and, sending for the surgeons, desired them to take care of the wounded.' This was a singularity in Xenophon's day, and not less so in the days of Alexander who, receiving the ambassadors of a surrendered city, 'when someone brought him a cushion, made the eldest of them ... take it and sit down upon it'.[23]

'For I came into Asia', he said to his soldiers, 'not in order to overthrow nations and make a desert of a half part of the world,

but in order that those whom I had subdued in war might not regret my victory. Therefore those are serving in the army with you and are shedding blood in defence of your empire, who, if they had been treated tyrannically would have rebelled. That possession is not lasting of which we are made owners by the sword.'[24] The authenticity of these sentiments (never very sure in Curtius), is made probable by similar words in Xenophon before him: 'That so many Persians, so many Medes, so many Hyrcanians, as well as all these Armenians, Sacians, and Cadusians have been so earnest in your service. . . . And even to this day we may see the Hyrcanians trusted and holding posts of government, like those of the Persians and Medes that appear worthy of them.'

"Consider," says Tigranes to Cyrus, "whether you can expect the country to be more quiet under the commencement of a new government, than if the accustomed government continue": and Alexander permitted 'the district governors to govern their own districts as had been their way all along'.[25]

The most remarkable parallel is that which deals with the treatment of women, so singularly exceptional in both. 'Panthea told him [her husband] of the integrity and discretion of Cyrus, and of his compassion towards her . . . "because, when I was a captive . . . he neither thought fit to take me as a slave, nor as a free woman under an ignominious name; but he took and kept me for you, as if I had been his brother's wife"':[26] and Alexander 'pitied and spared' the wife of Darius, and 'treated these illustrious prisoners according to their virtue and character, not suffering them to hear, or receive, or so much as apprehend anything that was unbecoming . . . esteeming it more kingly to govern himself than to conquer his enemies'; for, writes Xenophon, still referring to Panthea, 'weak and unhappy men are powerless, I know, over all their passions, and then they lay the blame upon love'; but Alexander wrote that 'he had not so much as seen or desired to see

the wife of Darius, no, nor suffered anybody to speak of her beauty before him'.

There is surely a strong connection between these stories, and the bond appears again in the king's adoption of Persian clothes, customs, and troops which gave so much offence to the Macedonians. The complaint of Artabazus is in Xenophon, but it might have come word for word out of the mouth of one of Alexander's comrades of early days,[27] just as the 30,000 Persian youths trained by Alexander might have belonged to Cyrus. "We have taken Babylon; and have borne down all before us; and yet, by Mithras, yesterday, had I not made my way with my fist through the multitude, I had not been able to come near you." It was Cyrus who 'thought that princes ought to impose upon their subjects and chose to wear the Median dress himself, and persuaded his associates to wear it' and 'having distributed a certain number to each of the commanders, bid them adorn their friends with them, "as I", said he, "adorn you"'—and it was Alexander who 'wore a composite dress adapted from both Persian and Macedonian fashion'. 'As sovereign of both nations and benevolent king, he strove to acquire the goodwill of the conquered by showing respect for their apparel'; and 'seemed to like the Persian habits' of Peucestas who, alone of his Macedonian satraps, adopted the Median dress and learned their language.

"Nor must you think," said Cyrus, "of filling up your companies only from your own countrymen; but as, in selecting horses, you look for those that are the best . . . so you must choose, from among men of all kinds, such as seem most likely to add to your strength and do you honour . . ."[28] and Alexander, 'whereas before the cavalry were enrolled each man in his own race . . . gave up the separation by nations and assigned to them commanders . . . of his own choice.' Of the Bactrian, Sogdian, Persian and other cavalry 'those that were conspicuous for handsomeness or some other excellence' were brigaded

with the Companions, and as commander over a new cavalry regiment, Hystaspes the Bactrian was appointed. "I have made a selection from the men of military age among you," said Alexander to his barbarians. "You have the same equipment, the same arms. . . . Those ought to have the same rights who are to live under the same sovereign." "It is permitted you," Cyrus had said before him, "if you think proper, by accepting these arms which are such as we have ourselves, to engage in the same enterprises with us and . . . to be honoured with the same distinctions as ourselves."

There can, it seems to me, be no reasonable doubt of the influence of Cyrus—as Alexander thought—or of Xenophon—as it really was—upon him; and this is a fact of increasing interest when we come to the more controversial ideas which he adopted, whose origin has been disputed. The deification: "You, Cyrus, who in the first place are sprung from the gods . . .";[29] the proskynesis, or prostration, which the Macedonians rejected with such scorn: 'All the people on seeing him, paid adoration, either from some having before been appointed to begin it' (which is what Alexander also seems to have arranged), 'or from being struck with the pomp, and thinking that Cyrus appeared exceedingly tall and handsome; but no Persian ever paid Cyrus adoration before.'[30] Arrian refers in passing to Cyrus as the originator of this 'humiliation', but I do not know that any modern author has connected its impact on Alexander with the *Cyropaedia*, nor is the connection to be pressed too exactly or too far. It is not likely that every or any one of these similarities were consciously adopted nor that the situations to which they were adapted were exactly the same. But the book, carefully read, would lie at the back of the young conqueror's mind, and when new problems with the new nations arose, the solution would be there, consciously or unconsciously ready to his hand. It is the process of suggestion which modern advertisement adopts.

The Human brotherhood

Most remarkable is the coincidence between the Xenophon-Cyrus notion of the human tie and Alexander's United World. "Next to the gods," said Cyrus, "have respect to the whole race of mankind, rising up in perpetual succession." When Croesus hailed him as master, he answered: "Hail to you also, Croesus, for we are both of us men."[31] It is he who first affirms a good ruler to differ in no respect from a good father; and Alexander echoes these thoughts, declaring Zeus to be the father of all.

The selflessness of the ruler appears in the *Cyropaedia* in a number of places. "If, elevated with your present good fortune," says Cambyses, "you shall attempt to rule the Persians, like other nations, only for your own benefit; or if you, citizens, envying Cyrus his power, shall endeavour to deprive him of his command, be assured that you will hinder each other from enjoying many blessings:"[32] and just as Alexander desired to render all upon earth subject to one law of reason and one form of government and to reveal all men as one people—Cyrus said on his death-bed, "I have borne an affection to men, and feel that I should now gladly be incorporated with that [earth] which is kind to them."

So Xenophon: while Alexander 'prayed for all sorts of blessings, and especially for harmony and fellowship between Macedonians and Persians', and 'brought together into one body all men everywhere, uniting and mixing, in a great loving cup, as it were, men's lives, their characters, their marriages, their very habits ... He bade them all consider as their fatherland the whole inhabited earth, as their stronghold and protection his camp, as akin to them all good men, and as foreigners only the wicked'.

His acts will always live with the passion that possessed them, while few can read the maxims of Cyrus without boredom; yet it is pleasant to find that the integrity comes through, of the prosy elderly general who had lost his sons in war and lived

in his retirement, under the sandy pines of Olympia, and remembered that he had listened to Socrates in his youth.

So from rock-walls that seem to give so little the great mountain saxifrage blossoms in splendour.

* * * *

We have wandered to the unity of the world from the city state which was all that the Lycians could have known when the Macedonians came. These valleys had a culture of their own since the Bronze Age, but the most they had reached was a federation of separate units,[33] which the Lycian League seem to have invented independently in the valley of the Xanthus. It was efficient enough to maintain their freedom, and Pericles, the last of their native princes, ruled nearly to the time of Alexander. These several units became Greek cities as Aristotle describes them,[34] with walls and 'bulwarks and towers in proper places, and public tables in buildings to be made the ornaments of the walls'; and temples and hall for the chief magistrates, contiguous to each other, on a conspicuous situation, in the neighbourhood of that part of the city which is best fortified. And a large square adjoining, 'like that which they call in Thessaly the Square of Freedom, in which nothing is permitted to be bought or sold: into which no mechanic nor husbandman, nor any such person, should be permitted to enter'; and another square for buying and selling, commodious for the reception of goods by land and sea.

Such were the cities whose battlements Alexander was said to have demolished so that 'by losing their ornaments' they might appear to mourn Hephaestion's death;[35] and these models the Pisidians and Mylians and other mountaineers copied as they grew civilized. Oenoanda, with the paved market, and columns, and the theatre behind them, was one of this general pattern: and though it was small, and nothing could make it 'commodious for the reception of goods' since the

sea was thousands of feet below and the roads all very steep to reach it, yet it did what it could and followed Aristotle's precepts, building 'large cisterns to save rain water', and making its walls 'a proper ornament to the city as well as a defence in time of war'. Its people travelled, and there were soldiers from Lycia and Termessus, and one from the little city of Balbura, who left their painted tomb steles in Sidon.[36]

It was easier to love such places than the union of mankind. This fact is, I suppose, the origin of all wars and most of our troubles; and one can only attain the more universal view by travelling in body or in spirit and noticing how deeply most places are the same. This Alexander did; and the transition must have been working in his mind along the Lycian coast, with the possibly unexpected kindness of a half-oriental world about him.

How happy I am, I thought, as I walked down the hill behind the muhtar's son, who was wearing his secondary school cap from Fethiye at a naval angle and leading my horse down the steep places: how happy I am to have discovered Alexander.

'This unsatisfactory love affair of yours', Victor calls it. But would one not give most of what one has for the chance of meeting such a mind in its lifetime? And is the difference so great when the words and the deeds are there, and only their continued production has come to an end?

The reticences of the living are generally greater than those of the dead. The element of fear is in them; and the happy intimacy, the recognition of one spirit with another, is not so frequent as it might be in this world. But to the scholar, who seeks for no response, but only to listen, the barriers of time are open; the fragments that come drifting through them are warm with life.

16

THE WALL OF XANTHUS

We all dwell in one country, O stranger, the world.
 MELEAGER, translated by Mackail.

THE JEEP APPEARED, AT A SLOW BUT ROYAL WALKING PACE, as the Müdür and I were making for the road: Mahmud was waving from the back. All was well, said Mehmet, for a downhill drive.

It was by now the middle of June, too late for the lowlands. The myrtles, as we descended, changed their strings of pearls for buds of open blossom. The tall candlestick thistles had grown up in the ditches, and their sharp ridged leaves branched to purple heads. Wild doves in the middle of the road moved courting round each other, like slender restless hands.

The road followed a gully with Judas trees in slabs of rock and plane trees in the bottom. Then it looped down for miles, not too steeply, leaving the cleft gorges on our right. From ancient Araxa—now Örenköy—below us the old Xanthus track joined it beside a disused reservoir for water; and the valley soon opened, resplendent and stifling in the sun. The waters of Xanthus, pouring out of their carved amphitheatre, flowed gleaming into cultivated stretches; the mass of Ak Dagh broke down towards them in terraces and ranges; the tributary valleys led to high forbidding passes; and Tlos on its precipice stood out upon the middle way. At the bridge of Kemer we crossed, and reached Fethiye and found the Seke Palas, a clean new comfortable hotel.

Mehmet and Mahmud took off the jeep to be ready next morning, and I drove the Müdür, who had become transformed into an elegant young man in a grey suit, twenty-three

kilometres in a taxi up a northern valley to Üzümlü. It is the
summer resort for Fethiye, set in a rich little plain above pine-
woods and the pointed foothills of chrome; and was also, they
told me, not half-an-hour's walk away from the ruins of
Cadyanda. This turned out to be inaccurate; the ancient
city was pointed out on a summit too high for a late afternoon's
excursion, but we saw what interested me, the opening here
of the most westerly Xanthus route, that leads by an eight-
hours' ride to Ibejik (Bubon).

Spratt wrote on March 4 that 'the passes to the Yailas from
the upper part of the valley' were still shut up by snow;[1] but
this must refer, I think, to passes south-east of our road which
are said to lead to summer pastures only, and are all around
seven thousand feet in height. The way from Üzümlü to
Ibejik is open till late in winter, and fairly low, with villages.
The pass east of it, from Örenköy (Araxa) to Dirmil, is usually
closed by the end of the year; it takes twelve hours and there
are only *yailas* on the way. Both these passes are less used
than the nineteen-hours' route from Fethiye to Oenoanda,
which is followed by the modern road and is now easier
underfoot, since it has a hard winter surface of snow instead
of mud. The main way from Araxa to the north probably
led across the Xanthus bridge now washed away to the junction
with the modern road that winds through the Bedala gorge
to a dip below Oenoanda. A sarcophagus and a Corinthian
capital, and a little altar with marble snakes sipping from two
cups, stand about there on green and watered turf, where the
valley opens to the Xanthus highlands.

I decided to look at Araxa next day on our way back to the
mountains, and meanwhile discussed the passes with the
Müdür's friends at Üzümlü as I had already been discussing
them in the highlands above. The little town was comfortable
and friendly round its square. A mosque and trees and a trun-
cated Seljuk minaret stood beside it, and gardens and fruit trees

surrounded it, as its name, *Rich in Vines*, and that of Injirköy on the pass, the *Fig-village*, imply. Even in June it was near enough to cold places for its grape-sherbet to be mixed with frozen snow. Alexander, in India, 'dug thirty pits which he filled with snow and covered with oak boughs';[2] but here they merely sent a donkey up every day and carried it down from the hills. The pass to the north winding to an easy sky-triangle, and Cadyanda on its height to the south, showed how the ancient city must have held the traffic of the road.*

Fethiye, when I returned and strolled about it, seemed not to have grown much in the four years of my absence, but was beginning to look urban, with a tidy restaurant, a bookshop and a club. It was hot enough to make one sympathize with the young Englishmen who called it so unhealthy 'as to be

* Since writing the account of this journey I have revisited Lycia and ridden up the middle one of the three passes from Araxa, and down from Ibejik to Üzümlü. The middle pass is out of the question for an army, so steep, fierce, waterless and devious above the Xanthus gullies far below: but the way from Ibejik is an old track where one can trace ancient cuttings in the stone here and there. It leads down the Akchay tributary to Örenköy or branches easily to Üzümlü, and was, at the time of my visit, crowded here and there with donkeys carrying loads of figs to the upper levels. The old citadel of Bubon (Ibejik) on its conical hill commanded the northern slopes of the pass right up to its watershed, while Cadyanda and Araxa held the valley. Below Ibejik, where a westerly route breaks in at Pirnaz, tombstones and shafts of column lie about and Ibejik itself has a rough rock tomb on the Lycian pattern that shows at any rate an early intercourse along the pass. From here to the north there is no obstacle except a gentle rise with ancient pedestals and stones, called Topak Tash. Beyond it lies the enclosed plain of Dirmil. A low ridge on the right leads by a few poor summer clusters to the watershed of the middle pass. A small ancient site must have been here also, for shards of Hellenistic pottery lie on the southern slope of this rise. The modern track to Dirmil from the coast comes in at a higher and more easterly point, and before reaching it one crosses the ancient route of the most easterly of the three passes, that led below Oenoanda through Balbura. This site is now deserted, except for a few summer huts and fields; its two theatres, and market-place heaped with ruins are close below the modern road, but the acropolis stretches out of sight up a small valley and there, by one of the tall and ugly lion-tombs, the old track to Dirmil can still be seen—used by local peasants for its shortness, in preference to the modern road.

almost uninhabitable during a great part of the year'. Its chrome hills, they say, are serpentine; and so are most of the red cones of rock that rise in all this country, and produce the mean landscape that stretches to Caria, so different from the noble embrace of the limestone, which folds both the chrome and the contours of the bay in its distant outline.

The club terrace is mere beaten earth edged with petrol tins of flowers, where the well-to-do gather round little tables when the sun departs. A caique, laden no doubt with chrome, moved through the sunset water, that opened sluggishly, as if the heat of the day had melted some syrupy metal paler than gold.

I was anxious to leave now, to get back to the coolness of the plateau and, like Alexander, to meet my friends in Phrygia, who were expecting me in two days' time. We could follow the route by the lake and just do it; and Araxa, a mere nothing on the map, could be glanced at in the morning as one passed. This was my mistake, for no temptation should ever persuade one, anywhere in the Levant, to try to do more than one thing in one day.

Yet all began well. Mehmet and the Jeep appeared, one hour late because petrol had been forgotten and the store was shut; but we were off by six o'clock and running happily across the easy country to Kemer. Here it dawned on Mehmet that I meant what I had said about visiting Örenköy-Araxa, and he turned off the road with the gloom that is bound to make one a doormat for the Fates. Örenköy, they told us, was only fifteen kilometres away, full of ruins; and they pointed out a road which almost immediately scattered into small paths leading to pine trees tapped for resin, which they collected in a tin receptacle attached to each trunk.

In a crisis it became apparent that Mehmet and the Jeep, and Mahmud and I, belonged to two separate categories: the Machine Age divided us. Mehmet became maimed and his

life stopped when the road failed him, like a prima donna whose cast has let her down.

"Where does one go, when there *is* no road?" he cried, abandoning the steering-wheel at an absurd angle.

We turned him round and decided to go back to Kemer and ask again.

"Of course that was not the road," the very same people told us. "That belongs to the forestry." And pointed in what looked a more hopeful direction, remarking that it was thirty-five kilometres away.

"Oh well, we must give it up," said I.

Mehmet's natural kindness now prevailed, and "we will ask again", said he; and we did. The kilometres changed back (in accordance with my map) to fifteen. We set off, and they took us for an hour along the stone-cluttered valley floor that ran almost level.

"Why," Mehmet asked in a reasonable voice during this respite, "do you always choose this sort of a road to drive on?"

"Because," said I, equally reasonably, "the good roads don't go to the ruins; and if it were a good road," I added, "would it not be pleasanter to do it easily in a taxi rather than in a jeep?"

This argument worked, for Mehmet was the fairest of men whenever the Jeep had not clouded his mind with emotion. And we were now in sight of the trees of Örenköy, folded in the seven-thousand-foot Xanthus cliffs behind them. The way to them looked like a grassy level stretch, of the sort liked by trainers to exercise their horses; except that at every two or three hundred yards a runnel for irrigation intersected it, imperceptible until one reached it, and unsuitable for cars; that, and one small river of which the bridge was in process of building, were the only remaining obstacles, and—as far as I was concerned—all trouble vanished when the approaches to

Örenköy showed a low outcrop, a twenty- or thirty-foot cliff of limestone, carved into clusters of the familiar house-façades of tombs, with the ruts of the ancient wheels still cut in the stone before them.

The hamlet was settled round a lost acropolis bright with pomegranate trees in flower; scraps of wall, pieces of column, a stone with an inscription, nothing but dispersed fragments were left—less than in the day when Fellows rode across from Üzümlü and Daniell found the name of Araxa inscribed. It had been an autonomous city, and held the pass, the parallel to Oenoanda above. A decree found here by Mr. Bean describes how the people of Bubon attacked it[3]—indirectly a testimony to the existence of the road between them; and with two passes behind and the river beside it, its position must always have been important till the new road and the bridge at Kemer were built.

Fellows rode there before this happened, and met the nomads climbing from Kemer to the pasturelands round Oenoanda, as we meet them today: and the geographical evidence is all in favour of Araxa or Cadyanda—Örenköy or Üzümlü—as the end of the road from Phrygia and Cibyritis, that provided the reason for handing Fethiye to Pergamum, and gave the winter opening by which Alexander could attack towards the north.

Below the acropolis and the village, beyond a mill lavishly spouting water, the blue Xanthus runs between trees from the opening of its gorge. The bridge across it has decayed; a wooden bridge for pack-horses replaces it; and the ruin of an even older bridge showed a few hundred yards upstream. The track led on steeply round the outer shoulder of the hillside to its junction with the modern road, and all ancient traces would hardly there survive the natural erosion.

The village itself was too small to possess even a café, but a charming and enthusiastic muhtar made us welcome, provided coffee, which is a luxury in Turkey at the moment, and offered

horses, if ever we wanted them, to the gorge that opens one and a half hours' away and has a path along it.

"Why not stay," said Mehmet, "and ride up to it, and we can return to Fethiye tonight?"

What I wanted to do would take the better part of a week—to ride through the pass from Örenköy to Dirmil, and back to Üzümlü by Ibejik; and the season was late, and I had hurt my foot so that it would not be fit for some days to clamber about ruins; and the Jeep was too expensive to keep in idleness. It was better to do as we had planned; to reach the plateau in the cool of the evening; and I would come back next year, and the muhtar would find horses, before the threatened '*sentral*' is built and the wildness of the river leaping from its gorge is tamed.

The Jeep cancelled this decision by bumping and damaging its brake on one of the irrigation runnels as we drove back. It was like a woman who gets her own way by falling ill when things go wrong; and even I, who knew nothing mechanical, realized that a brake is necessary in the mountains of Lycia. I spent the rest of the afternoon reading Xenophon in the heat of the Fethiye hotel, while Mehmet and Mahmud devoted themselves to the Machine Age, getting paler and thinner as they did so. They turned up at eight in the evening to say that the Jeep was again in perfect order, and they would take a little rest and we would go round by the long but easy way through Caria, where cars can drive swiftly along roads smooth as velvet, and we would start at two in the morning, and still reach my friends in time.

In a foolish moment I agreed. The Jeep, I suspected, would break down again if we got beyond help in the mountains, and an important main road, marked as a wide red line, showed on my map between Muğla and Denizli, through country alluring and unknown. The two slaves of the Machine tottered off, Mehmet to a bedroom and Mahmud to curl himself up inside

the tyrant where he slept; and at two, in the darkness, drunk with sleep but clean and hopeful, we set out gropingly to find the Carian road.

I had travelled on it, and there is only one road anyway along the coast. But wherever a flat stretch opened, there would be tracks whose unimportance it was difficult to disentangle in the night. We spent some time trying to make enquiries at a sleeping cottage by a river, but who would open to someone shouting in such lonely country from the dark? So we drove on, with the frantic shapes of the Carian pines vanishing like goblins from the headlights, until the depth of the darkness turned metallic, as if the night were gathering blue skirts about her to depart. When the stars sank back and the detail of the hills appeared, I was surprised to see the Dalaman basin, which I thought we had crossed long before.

We had been making about eighteen kilometres per hour, a rate at which the journey might be foreseen to last three days. But now, I thought hopefully, the daylight has come; the road (which is indeed the one road of Lycia) is good. We can now go quickly. And seeing the empty curves of Dalaman before us, I asked Mehmet if we could not make a better pace.

Whether it was fatigue or an increased concern for the Jeep's fragility, Mehmet continued to drive as if through the most dangerous traffic, not only hooting but almost stopping at every corner before venturing on innocuous landscapes at rest in their peaceful solitude of dawn. This maddening process went on for an hour. Even Mahmud looked pained, and I tried at intervals to point out the length of the way and the passing of time; the full day came and lorries began to rattle past in dust; a little market trail of cows, goats and donkeys began to appear near villages. At last, exasperated beyond endurance, "Do you realize, Mehmet," I said cruelly, "that even the motor-bus has passed us?"

Easy-going as he was, it would have been too much to

expect Mehmet to pay any attention to a woman. His solicitude was full of activity and interest while there was anything to *do*, but it dropped away in rather an English manner without a trace of curiosity when that was over; it was no doubt what Queen Victoria found so boring in Mr. Gladstone. This want of curiosity reaches its lowest pitch in Turkey, and I often thought how dull any pleasure would be, even one's food, if treated as carelessly as the old-fashioned Turk treats his women. But to hear what ought to be the Embodiment of Acquiescence beside him compare the Jeep to a motor-bus must have given Mehmet a horrid jolt, for he cried out, "Ah" as if a stiletto had pierced him to the heart. At the same time, seeing a cow far away beyond the middle distance, he slowed down almost to a walk.

This is useless, I thought; and what does it matter? We will arrive a day late and I will have to send telegrams from Muğla; and I shut my eyes not to continue to be goaded by the slowness of the passing landscape, until the full morning shone about us and we were climbing the mountains of Caria.

We were on the route which in one form or another and with slight deviations must always have been used between the lower Maeander and the south; the Macedonian army must have marched along it from Halicarnassus or Stratoniceia, and seen the misty lake above Caunus opening as we saw it from the curves we were so gingerly ascending.

Harmony was restored. Mahmud, unshaven and thin with wear and tear and looking in his jodhpurs as if Osbert Lancaster had drawn him, kept his cheerful philosophy and leaped out at intervals to trot round the tired Monster and tap its tyres; he was delighted to be out in the unknown, but did not say so, for Mehmet was preoccupied by its weakness and the height of the hills. Although I had been along the road, I had forgotten how many mountains there were between us and the asphalt of Muğla; and Mehmet was constantly

surprised when a new slope appeared for which I had not prepared him. But we saw the rich Carian level opening at last, and at nine-thirty reached garages, petrol pumps and the amenities of modern life, with flower-beds set in round-abouts as a concession to the natural world when kept in its proper place of civic subordination.

Here our little outfit came to rest beside the pavement, look-ing like something between the Marx Brothers and *Waiting for Godot*, for one must admit that the Jeep had a battered look among the polished cars of Muğla. It had become *bozulmush* again, but not, said Mehmet, as my face fell, very seriously. While I lunched, they would put it right; and he went off to make enquiries, and came back with three men to explain that the road to Denizli no longer existed.

"It was indeed there," they said, looking at the thick red line on the map: "but it too is *bozulmush*, and—though you could possibly get by—if anything went wrong it might be three or four days before another car appeared along it; and it is very lonely. The views are beautiful," they added, finding no echo in any of us.

"If you think it better," said Mehmet, so unselfishly, "I will get you a good new jeep, and you will still be able to drive round by the Marsyas gorges and reach Chivril (near the source of the Maeander) before night."

My detour seemed to be widening to embrace the whole of western Turkey. I knew the twisting road of the Marsyas gorges, and the thought of Mehmet at every corner was too much. I accepted his offer, and with the eastern promptness so surprising when it comes, a jeep was found. My luggage was transferred; Mehmet appeared with apples and bread and cherries; finances were sorted out, and a present given to Mahmud who took every small kindness as if it were an opening into paradise; and the moment came to say good-bye. Sud-denly and surprisingly we were none of us able to say anything,

but shook hands with eyes full of tears. The new driver settled in his seat, and bowed towards me. "May your journey be happy," said he. "If Allah wills," said I, and we went.

For hours, as the day wore on and we sped with a wonderfully pleasant nimbleness round the corners of the twisted valley, this departure distressed me. Everything I had done had been wrong. I knew from years of experience that one should never have an appointment at the other end when one travels in Asia. And even after this mistake, I could have sent a few telegrams and borne the heat, and waited till the Jeep and my foot recovered in Fethiye. It was not my fault, perhaps, but I could have avoided all the trouble by not hurrying.

I *had* hurried, and the whole tenor of my companions' life was disrupted—so vulnerable to an outer world is their system, which pleased and contented them and allowed them to practise their virtues. The poor Jeep, their pride, had been shown up for what it was, gimcrack and unreliable; and they were left in a strange part of the country, to get back as best they could over all those mountains alone. The vision of the two figures, crouching in the dust and serving their idol with spanners, came to me at intervals and brought tears every time. It must be fatigue, I thought, not having eaten since two in the morning; and I took one of Mehmet's apples; but the tears continued. It *is* my fault, I thought. What happens to people because of their dealings with us *must* be our business. It is brotherhood, the best thing we find in Asia—brotherhood not because people are the same but because they are different. It is a monstrous wish to make people equal before you can think of them as brothers: the other is the real democracy, and we find and spoil it.

One's sympathy, I reflected, is nearly always tinged with exasperation in the 'old world' of Asia: because it is outside our philosophy, doomed to failure in an incompatible world in

which it is inefficient and hopelessly outchanced. But it is always resilient under the troubles it has asked for; free of envy, and with no thought that one human being is better than any other because of money, or of any human possession other than goodness and good manners. And to come upon a code like that and help to destroy it is cause enough for sorrow.

The coarse granite of the Marsyas gorges flashed by with lavender in flower. Those creeping rocks seemed alive, with a sub-animal life of their own. A tomb or two showed above Chiné, obviously cut to imitate the ugliness of nature. And I was soon drowsing through the afternoon heat of the Maeander.

The new jeep did well. At Nazilli, quickly and unexpectedly, the owner transferred me to a friend. The road, which had been made since my last visit, was smooth; leaving at five, we bowled along through Denizli and a hilly land of cornfields ripe for harvest. As the sun sank, we began to scale high and lonely shoulders, the western supports of the plateau whose southern bastions we had climbed to Elmali so short a while ago.

The owner of the new jeep was a gay adventurous little man who told me he was delighted to see country he had never seen before. He and his car were in that first year's honeymoon which is transitory in most things, and he showed me all the gadgets of the admired one as we raced along at fifty miles an hour. It was only when the night had fallen, when we drove slowly, and moonlight lay around us, that I asked whether it would not be a good idea to use the headlights, and was told that the battery had failed. A little power was left, said he, but better kept for emergencies.

This familiar touch made me feel curiously at home. The estrangement with Asia was over and inefficiency, as such, left me placid and unmoved. It was pleasant driving along the

solitude of the high valley, dimly lifted out of time and space by the moon. The road showed just enough for the car to keep upon it—a grey, bankless river through the night. My thoughts went wandering to Alexander, for after our wide detour we were coming again into the line of his march across the level lands from Sagalassus. Celaenae, which is now Dinar, was behind a long hill upon our right. That march took him five days, and he must have halted here and there; and I thought of those plains that I had traversed in early spring in the slowest train in the world, which left Burdur station at four o'clock in the morning and travelled through the bright ploughlands and pastures, where everything, air, land, water and grass, is pale. There was no detail, and one plain was separated from the next one by hills that are never green. The few trees were poplars, shading the solitary stations and shimmering as if draped in sequins, or cherry trees whose blossom is transparent, or pear trees, pushing out solid nosegays like the whiteness of earth breaking through; out of the strength of their year they pressed their short profusion, hard-won, like an archaic age. The flocks grazed there, behind their shepherds, the long nostalgic monotony of Asia; the goats kept together, with a swishing noise like silk and a sheen as of black satin on their new coats in spring; and Celaenae as we passed it had that touching, fragile look of the fertile oasis just below the windswept plateau, where nothing is lush, but a clean austerity, the stern nurse of beauty, prevails.

Alexander left fifteen hundred troops there, and marched on across the flats which are now prosperous wheatlands, where the Second Crusade wandered in misery and lost its horses; until he reached the huge Persian ramparts of Gordium, built on the ruined gateways of the Phrygians, where—by the pastoral river and the tumuli of the kings—the Royal road to Susa has just been rediscovered. There he found Parmenion, and the Macedonian reinforcements, and, with the Lycian interlude

over, marched south-east to Issus and Tyre, and Persia and Bactria and India beyond.

In the moonlit vagueness I saw that journey, horizon beyond mountain horizon—horizons of the East that seem in themselves to be *nothing*, mere passages for the eye to things unseen beyond. Wave after wave they led through the solitudes of Asia; until after ten years the golden carriage so cunningly and richly constructed,[4] with the Persian Immortals and the Macedonian Companions carved upon it together, bore the dead Wonder back, across the Syrian desert to Alexandria, where for many centuries the East and West could meet.

So the young dream died, of the brotherhood of men. And, absurdly enough, from the thought of that jolting carriage, my mind turned to the Jeep and my two companions left at Muğla. That, I thought suddenly, is why I am so unhappy. I have failed this brotherhood. I should have stayed. And tears threatened again (I had been eighteen hours on the way with practically no food).

And yet, thinking it over, I believe that the fantastical connection was a right one. Alexander's vision ended and was lost for over two thousand years; and we, who are dreaming it again, look extremely like failure at the moment; but if two or three are gathered together, wherever they may be, in its own minute compass the dream and the brotherhood are true.

APPENDICES

Appendix I

Reprinted by kind permission from the *Journal of Hellenic Studies*, Vol. 78, Autumn 1958

ALEXANDER'S MARCH FROM MILETUS TO PHRYGIA

'If anything relative to ancient history escapes my notice, it must be pardoned, for this is not the province of the geographer.'

STRABO, xii. 8.5.

FOREWORD[1]

THE march of Alexander from the Granicus to Issus is given by Arrian in less than a dozen pages scattered among various sieges that are more fully described; Plutarch, Diodorus and Quintus Curtius do less, and no more than a page or two apiece has come down to us on the whole of these movements.[2]

Although his first meeting with Asia was probably the most important experience in Alexander's adult life, and though the Anatolian campaigns lasted a year and a half, or even a little more, out of the short total of eleven years that were left him, the poverty of the sources has imposed its brevity on modern historians also. Professor Tarn—who is as much a bedside book to modern devotees as the Iliad was to their hero—describes the marches and countermarches of Asia Minor in little more than three pages;[3] and there is a great gap left us from classical times between Xanthus and Phaselis in Lycia. It would be absurd to think of filling it. But after sailing down the coast, I believed that some evidence might be gathered by comparing the written scraps left us with the nature of the places recorded, provided this were done before the road-building policy of modern Turkey succeeds in changing the pace of living in these mountains. Hitherto their ruins have scarcely been altered except by a natural decay; and the methods of travel being as slow as ever they were before, except along a very few roads, the flavour of their past is preserved.

In this essay the geography is attempted, with the problems and such answers to them as my rather intermittent journeys seemed able to provide. Someone better equipped than I am may find the outline useful and venture more profitably, before too much time goes by; for the

Appendix I

interest is not one of geography merely. By visualizing the routes which were chosen, the motives and processes by which that choice was made become clearer; and behind these motives and processes is the most dynamic being that the world has perhaps ever known.

I overlap a little to the north and south of the actual problem of Lycia and Pamphylia, because the whole year's campaigns in Asia Minor, from the siege of Miletus to Issus and indeed to Tyre, are held together by a single plan. Their interest lies in the unusual strategy of a naval war fought out on land, and they culminated, not in the battle of Issus, but in the destruction of the Persian sea power and the fall of Tyre. Issus was, as it were, an interruption between three main points: the landing in Asia; the establishment of communications and defeat of Persia at sea; and the conquest of the land empire at Gaugamela in Mesopotamia. In this light the whole march, down the Carian coast and after, falls into position. Its naval aspect is of course well known, and there is no essential problem in Caria, either about the motives or the geography, as there is in Lycia farther on; but here again it seems to me that there were a few points worth noting, more particularly the connexion of Alexander's early years with the family of Ada and the human relationship by which policy may have been influenced at this point.

The Plan

In the camp in the outer city of Miletus, while the attack on the inner city was preparing, Arrian records a conversation between Alexander and his father's general Parmenion, in which the naval plan is outlined that led them down the coast (I. 18. 4–5). The young conqueror—twenty-two years old—was about to discard from strength, if one may use a term of bridge for something so important. His navy was successful. His one hundred and sixty ships had beaten the four hundred Persians (if Arrian's figure is correct) by three days in a race for the harbour approaches. Nicanor, Parmenion's son, had brought them up and anchored them at Lade, which is now a hummock in the Maeander reaches, but was then one of the estuary islands, notorious for a Greek defeat a century and a half before, and close in to the town.

The conversation has come down to us with still a faint touch of that irritation with which Ptolemy, or the man who kept the journal which he copied, wrote down Parmenion's sayings. These were young soldiers jotting their histories, and Parmenion—the man whom Philip had thought

of as 'the only general'—was over sixty, surrounded by many exceptionally capable young generals in the making. He had advised caution on the banks of the Granicus when their first battle in Asia was spread out before them. He had pointed out that it would be better to effect a surprise at dawn across the river, 'whose banks are very high, sometimes like cliffs' and where the enemy, prepared as he was in daylight at that moment, could charge the troops emerging in disorder. And Alexander had replied that he would feel ashamed if a petty stream stopped him after the crossing of the Hellespont; and had led his right to the attack—with white wings on his helmet and his Companions behind him—oblique across the stream (ARRIAN, I 13. 3–6; PLUTARCH, 16. 3).

But now, while Alexander held back, Parmenion was for risking a naval battle. Defeat, he said, would not be very serious, since the Persian navy was anyway supreme. And an omen had been seen—an eagle perched on shore at the stern of the Macedonian ships.

Alexander would not chance a repulse at sea. It would be lunacy to face the crews of the Cyprians and Phoenicians with his own who had not yet completed their training, and with the Greeks 'ready to blaze into revolt' at the first whisper of a naval disaster. As for the omen, he interpreted it differently: the eagle was sitting on land, and it was there that he would beat the Persian navy (ARRIAN, I 18. 6–19).

So he took Miletus by assault, and his little fleet sailed into the harbour while the fight was on and 'jammed their triremes, bows seaward, at the narrowest part of the entrance' to keep out the Persian ships. These sailed towards them again and again, hoping to provoke an engagement, but Alexander held himself in, and guarded the harbour; and the enemy, from want of water and stores, was as good as besieged and made off to provision at Samos. He came back, and again drew out his line to entice the Macedonians, and slipped five ships between their camp and island to catch them unawares. But Alexander collected what he could find ready, and sent ten triremes with orders to ram; and the Persians, seeing the unexpected opposition, doubled back while still at a safe distance, and lost only one slow-sailing ship from Iasus. Then they left Miletus, with nothing done. And it was on top of these successes that Alexander determined to disband his navy.

The conversation with Parmenion is completed by Arrian's commentary (20. 1–2), which states definitely that the young king was inspired by want of money and by his unwillingness to risk disaster with even a portion of his armament. The navy cost him more than a hundred

Appendix I

talents a month, and he could not afford it.[4] 'As he now had a secure footing in Asia with his land troops he no longer needed ships, and he thought that by capturing the coast bases he would break up the enemy's fleet, since they would have nowhere to make up their crews from and, in fact, no seaport in Asia. Thus he interpreted the eagle to mean that he should "conquer the navy from dry land".'

The *safety* of Alexander's genius shows itself in the two oppositions to Parmenion. They are disimilar to each other, startling to the orthodox, and both successful. Five years spent with Aristotle's accurate curiosity to guide him, gave him perhaps this scientific ability to look without prejudice and judge things on their merits when they came. He was asked as a boy what he would do under certain circumstances, and replied that he could not know until the circumstances arose; and this empirical quality of mind is what we meet over and over again as we travel down the coast. It is one among the slender threads by which to trace his ways.

CARIA

He now neglected the example of Cyrus, the route of all the armies before him, and the highroad of Asia; and began his march through the small fertile plains of Caria and the forest ridges that hem them in. At Labranda, in the north of this country, the sanctuary of the double-axed Carian Zeus showed by its name its ancient origin, and a subsidiary track crossed its high saddle, from Alabanda in the pastoral Marsyas valley where the extreme western route from Lydia led to the south. The modern road loops and twists in the Marsyas gorges; but the old way avoided that region of ice-polished boulders and kept to the more manageable westerly foothills, through flats that are often flooded, by the temple of Hecate at Lagina—now Leyne. The modern road to Milas (Mylasa) joins it near the village of Eski Hisar. The city of Stratonicea was built here later for Macedonian veterans by Antiochus I, to hold the key of Mylasa and the Halicarnassus peninsula just where the fertile lands rise to shallow wooded hills: but an easy earlier route must have run through these villages at all times, avoiding the climb to the Zeus of Labranda and its winter snow.

There were two other ways by which the Halicarnassus peninsula could be reached from Miletus—the one along the coast, by the ports of Iasus and Bargylia, by-passing Mylasa; and the other by what is now the lake of Bafa, under Heraclea whose stupendous walls were to be built within a generation, along a road where sixteen columns of a late Corinthian temple still stand at Euromus, near the present Selimiye.[5] The road

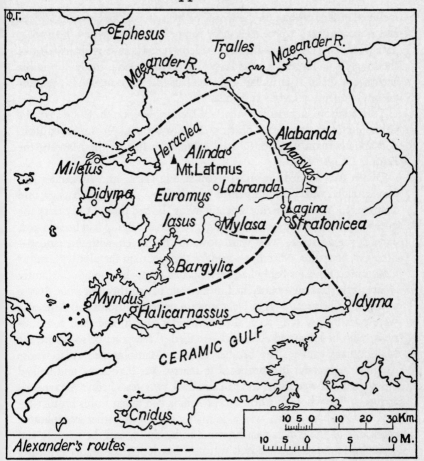

Φ.Γ.

Ephesus

Tralles

Maeander R.

Maeander R.

Heraclea

Alabanda

Alinda

Miletus

Mt.Latmus

Marsyas R.

Didyma

Euromus

Labranda

Lagina

Iasus

Mylasa

Stratonicea

Bargylia

Myndus

Idyma

Halicarnassus

CERAMIC GULF

Cnidus

10 5 0 10 20 30 Km.

10 5 0 5 10 M.

Alexander's routes _ _ _ _ _ _

crosses an old Turkish bridge on eleven arches, to reach the neon-lighted
avenue of Milas, which is a typical small country town in Turkey, and was
numbered in Strabo's day with Stratonicea and Alabanda as one of the
three inland cities of Caria. Its temple has gone, built into a mosque be-
tween 1740 when Pococke saw it and 1765 when Chandler describes the
city; but it still has a gateway with the double axe of Zeus upon it, and a
small, late mausoleum. It was the religious centre, and for a short while,
even in Alexander's lifetime, had been the actual capital of Caria, under
Hecatomnus who founded the native dynasty, and whose son Mausolus
moved back to Halicarnassus whence they originally came.

Arrian does not mention these places, though they are probably

Appendix I

included in the 'capture on the march of such cities as lie between Miletus and Halicarnassus', where Alexander camped and attacked by the Mylasa gate (I. 20. 2, 4). His route from Miletus into Caria is probably that of the Marsyas valley and Alabanda, since the coast road is made impossible and that of Lake Bafa unlikely by the fact that he visited Ada, the dispossessed queen of Caria, in Alinda.

This city now includes the village of Demirjideré, on the east side of the Labranda range that cuts it off from Bafa or the sea. It is reached from Alexander's main road south by a tributary valley of the Marsyas, the Karpuz Chay.

Queen Ada headed the anti-Persian side in Caria, and Alexander had corresponded with her family three years before. This is the background to his visit. While his father was still living, he had thought to marry the queen's niece, and had sent a messenger to Caria. Philip had been vexed, and his son's friends, who were now on the march with Alexander— Ptolemy, Harpalus, Nearchus—paid for their share in the plot with exile.[6] Communications probably had been opened up again, though the family affairs of the Carian dynasty had meanwhile passed through some drastic changes. The great days of Halicarnassus under Mausolus and Artemisia were over by 351 B.C., soon after Alexander's birth, and their son Hidrieus, who had married Ada, had also died, three years or so before the Macedonians came. The brother of both Mausolus and Ada, whose daughter Alexander had proposed to marry, was Pixodarus, and he had ousted his widowed sister, and had also died, two years before Alexander's arrival. The whole of Caria except Alinda had fallen to his brother-in-law, Orontobates, who was a Persian. With this rather complicated panorama of the dynastic background in his mind, and the friendly and flattering foundations already laid from Macedonia, Alexander evidently made for Alinda.

```
                    *Hecatomnus
                         |
       _____
      |              |         |                  |
*Mausolus = *Artemisia  Ada  *Pixodarus = a Persian, sister
   d. 353       |    d. 351        d. 336      to *Orontobates
               |
       *Hidrieus ( = Ada)
           d. 337?
```

* Reigning sovereign.

Appendix I

Arrian does not say that he went there; but he describes the coming of Ada to meet him, and the adopting of Alexander as her son, leaving us to fill in as best we can the background of the planned Carian marriage that had entered into the political dreams of a nineteen-year-old boy (23. 7–8). This background probably had its influence: Alexander, at any rate, came to the walls of Alinda, and there was a warmth in his welcome that made the queen of Caria adopt him as her son. Nor is this human touch unworthy of historical attention: the envisaged marriage in Caria with a half-Persian, half-barbarian, the adoption by a Carian mother, the affection for Persian Sisygambis, the final unity of mankind—all are steps in the same direction and lead Alexander far away from Aristotle and Isocrates, or even from his own first message after his first victory, when he sent from the Granicus 'the spoils of the barbarians in Asia'.

The suggestion that he stayed in Alinda is given by Plutarch in his *Sayings of Kings*, who tells how Ada, 'out of kindness, sent him every day many curious dishes and sweetmeats, and would have furnished him with some cooks and pastry men', but he told her that he wanted 'nothing but a night-march to prepare for breakfast, and a moderate breakfast to create an appetite for supper'.[7] Every visitor to the East has had to find some sort of an excuse on some such occasion, and this vignette of life in Alinda bears a stamp of truth.

Having deviated from the highroad to reach the fortress, Alexander must have retraced his steps for a short way, forded the tributary, the Karpuz Chay, and found the main road again—marooned now in swamps and neglect—that led by Alabanda and Lagina to Halicarnassus.

Lycia

When he left the Halicarnassus peninsula on his way into Lycia, Alexander cannot have diverged very far from the modern road that unites Fethiye, the ancient Telmessus, with Caria. Arrian indeed says little, except that he went towards Lycia and Pamphylia so that, 'when he had gained possession of the coast, he might render useless the enemy's navy' (I. 21. 3)—a confirmation of what had been decided at Miletus; and otherwise no more news is given, except that 'on his route he took in his stride Hyparna, a strong place', as yet unidentified as far as I know.

Other evidence, however, goes to show that he followed more or less the line of the modern road, at any rate from the Ceramic Gulf southward; for the cities of Cnidus and Caunus both remained on his right unmolested, in the hands of the Persian brother-in-law of the late Pixodarus.

Appendix I

Their submission was only made certain nearly a year later by his final defeat. Alexander must therefore have gone straight, as one does now, round the eastern end of Lake Köyjeyiz across the Dalaman river, leaving the two western peninsulas and their cities out of sight.

The leaving of these cities illustrates his policy in a negative way. He goes from place to place with friends to introduce him, and this fundamental management of travel, in a little-known country before maps were frequent, was evidently used wherever possible. In Caria he had found Ada. In Myndus, when the promised opening of the gates failed him, he tried the strength of the walls and passed them by. In Lycia he certainly had friends. The house of Halicarnassus was honoured and in authority there; Pixodarus, before he went over to Persia, while Hidrieus and Ada were still reigning, had an inscription dedicated to him by the Lycian cities of Xanthus, Pinara, Tlos, and perhaps Cadyanda.[8] Alexander's friend, Nearchus the Cretan, seems to have had acquaintance in Telmessus, if there is any foundation for the story in Polyaenus of how he captured the place from a local dynast of the time: this man came out to meet him as an old acquaintance when he sailed into the harbour, and asked if he could be of service; and Nearchus told him he would like to leave some captive music-girls and the slaves who attended them; and with swords hidden in their flutes and small shields in their baskets, they were taken up to the fortress which they captured. Nearchus was, infact, made satrap of Lycia and Pamphylia soon after by Alexander.[9]

Apart from such stray indications, and the help no doubt of others unknown, there was Aristander, the seer from Telmessus. He appears in Plutarch as a friend to Philip and Olympias before Alexander's birth. 'Philip, some time after he was married, dreamt that he sealed up his wife's body with a seal, whose impression, as he fancied, was the figure of a lion. Some of the diviners interpreted this as a warning to Philip to look narrowly to his wife; but Aristander of Telmessus, considering how unusual it was to seal up anything that was empty, assured him the meaning of his dream was that the queen was with child of a boy, who would one day prove as stout and courageous as a lion' (ALEX. 2. 4–5).

Olympias may well have taken a poor view of the other diviners, and have brought up Alexander, who was devoted to her, to trust the Lycian seer. He was with the young conqueror from the beginning, in all his journeys: at Delphi, when the image of Orpheus sweated and 'discouraged many' and Aristander reassured them; at Halicarnassus when a swallow

Appendix I

foretold the treachery of a Companion; at Tyre and Gaza and the founding of Alexandria; at Gaugamela when the fight began. The short words of the narrative in Plutarch and Arrian are touched with gentleness; it appears only here and there, but it comes through. When the soothsayer foretold the fall of Tyre on the very day on which it unexpectedly happened, and the soldiers laughed, the king 'seeing him in perplexity', ordered that the day should not be counted as the thirtieth but as the twenty-third of the month, to give him time. Plutarch explains (25. 2) that Alexander was always anxious to support the credit of the predictions; but one may fairly see more in it than that, and feel how the perplexity of an official trained to conceal it was visible to his friend. And one may also remember the most poignant of all Alexander's moments, when he had killed Cleitus and his generals stood round him in his silence and no one could console him, until Aristander, the friend of his family and his childhood, found the right words, and, 'as if all had come to pass by an unavoidable fatality, he then seemed to moderate his grief'' [10]

Such was Aristander, and it is reasonable to assume that he had friends in Lycia, and had talked to the king about them, and no doubt communicated with them before the army reached them. Their arrival was peaceful. They had come where they could expect a welcome; as they travel on towards Pamphylia this characteristic is more and more worth remembering. If the places that held aloof were not indispensable, Alexander avoided them if he could.

The army rested where the River Xanthus winds half round its city acropolis in the beautiful valley; and Pinara and Patara and thirty smaller strongholds submitted (ARRIAN, 24.1). If we could tell what these strongholds were, we should know a good deal more about the next move, which hinges on where the Lycian frontiers ran.

All the information we get is that, 'in the height of winter, as it now was, Alexander attacked the Milyan territory, as it is called' (ARR: 24.5). The problem of what he actually did attack has been complicated by what Magie describes as the 'uncertainty of what was meant by Milyas'.[11] The territory varied, no doubt, at various times; but it must always have included the basin of Lake Kestel, the double valley of the Istanoz Chay, and the modern Korkuteli near the site of the ancient Isinda. Strabo stretches it between the pass of Termessus to Sagalassus, now Ağlason, and the confines of Apameia, now Dinar, in the north (XIII, 4 *ad fin.*). It bordered on the Pisidians in an earlier age, when they had taken over Cibyra, now Horzum, from Lydia (*ibid.*). Pliny puts it south

of the modern Isparta (which is not far north of Sagalassus) and then describes it as 'beyond Pamphylia—a tribe of Thracian descent, and their town is Arycanda' (*N.H.* v. 95); while Ptolemy the geographer (v. 3.3–4) makes nonsense of this by giving the cities north of Arycanda, Podalia and Choma, to Lycia. Most interesting is Herodotus (i. 173.2) who tells how Sarpedon brought the Lycians from Crete 'to the land of the Milyae in Asia, who were then called Solymi'; and tells how the Lycians 'are called even now Termilae' (vii. 92). The little town of Dirmil north of the Xanthus valley still probably perpetuates this name.[12]

Distracted by such an embarrassment of choice, and after moving north and east a good deal, it dawned upon me that probably the vagueness of the lands of Milyas was just as noticeable in Alexander's day as it is now. 'The Milyan territory, as it is called', was a fairly uncertain jotting in the military journal. I decided to tackle the question from quite a different angle, to forget about the Milyae for a time, and to ask myself *what Alexander was being compelled to do.*

One consideration reduces the scope of this question to a reasonable dimension. It is obvious that a general who renounced the siege of Myndus and omitted to bother about the coastal cities as he passed them by, would not devote his time and strength to anything but an *important* purpose while he knew that every month was strengthening Darius in the east. What motive was sufficiently strong? Not, surely, the mere reduction of bandit villagers in the hills to please his Xanthian friends. The only reason that justified delay and a winter campaign in the wildest hills of Anatolia was a threat to communications, to the link-up in this case between the army and Parmenion in Phrygia.

The gravity of such a threat can be gauged by comparing a similar one later, when the Persians after Issus concentrated on Cappadocia and left Alexander with a bottle-neck behind him; Antigonus, in charge of communications in his rear, had to fight three hard battles, and his reputation and Alexander's trust in him are the measure of the importance attributed to his action at the time.[13] The situation in Lycia was equally critical. With about half his original army (the rest were sent home for the winter or scattered in garrisons) he was exposed on a narrow though friendly coast, with Persia not yet out of action in Halicarnassus behind him and increasing in strength in front, with the sea in command of the enemy, and a hostile block of mountains between him and his own line of reinforcements. Plutarch, 17.3–5, says that at this time 'he was a little unsettled in his opinion how to proceed' until an omen appeared

near the city of Xanthus; and a little uncertainty surely is a fair description of what must have been his state of mind under the circumstances.

He decided to open up a way to the flat lands of the plateau where communication with Phrygia was easy. If this reconstruction is sound, there was only one direction for him to make for, and that was towards the important north road that came down from whatever then represented the later Laodicea, through Temisonium (Kara Hüyük) to what

is now Tefenni, or a little farther south to Cibyra (Horzum), and on by Isinda (Korkuteli) to Pamphylia.

This road was soon to be the chief means of communication between the later provinces of Asia and the southern coast, though there is, so far as I know, no notice of it in the time of Alexander. Ramsay mentions it as important before 200 B.C., and makes the general statement that 'the system of routes, lying east and west, which had been growing during the previous two or three centuries, remained . . . without essential alteration during the Roman rule'.[14]. He brings the road down below Tefenni as far as Horzum where the flat lands offer no obstacle: and there he turns it eastward, by the lake Caralitis, now the Sögüt Göl, to Isinda

Appendix I

and Pamphylia through the Milyan–Pisidian lands. He gives no sign
of a track between Cibyra and the Xanthus valley. But one may make
a negative inference from the history of a slightly later time—the division
after 189 B.C. of these coastlands when Eumenes of Pergamum was given
Telmessus,[15] together with portions of Pisidia and Milyas. If there
had been no means available to him of reaching it, that port alone would
have been useless. Telmessus must already have been the established
outlet for the Cibyratic hinterland with some means of communication
between them, especially since the final outlet for the south, the port of
Attaleia, now Antalya, was not yet built. The existence of a route
down the upper Xanthus is confirmed a little later by an attack from
Cibyra and Bubon, now Ibejik, on Araxa on the lower Xanthus, which
must have come pouring down somewhere along the edge of the Xanthus
gorges.[16] The strong defences of Oenoanda, too, look like Pergamene
work,[17] and point to a road already well enough established to be worth
protecting.

Alexander therefore, I believe, climbed up one of the three passes that
circumvent the gorges of Xanthus. They start either at Üzümlü or
Örenköy, the ancient cities of Cadyanda and Araxa, and lead by a day's
riding through Bubon to Cibyra, and then easily and flatly on to Tefenni;
or from Araxa to Dirmil and Cibyra, below the fortress of Oenoanda
(Injealilar), by Balbura (Katara).

Since writing the account of this journey I have revisited Lycia and
ridden up the middle one of the three passes from Araxa, and down from
Ibejik to Üzümlü. The middle pass is out of the question for an army,
so steep, fierce, waterless and devious above the Xanthus gulleys far
below; but the way to Ibejik is an old track where one can trace the
ancient cuttings in the stone here and there. It leads down the Akchay
tributary to Örenköy or branches easily to Üzümlü, and was, at the time
of my visit, crowded here and there with donkeys carrying loads of
figs to the upper levels. The old citadel of Bubon (Ibejik) on its conical
hill commanded the northern slopes of the pass right up to its water-
shed, while Cadyanda and Araxa held the southern valley. Below Ibejik,
where a westerly route breaks in at Pirnaz, tombstones and shafts of
column lie about, and Ibejik itself has a rough rock tomb on the Lycian
pattern that may show at any rate an early intercourse along the pass.
From here to the north there is no obstacle except a gentle rise with
ancient pedestals and stones, called Topak Tash. Beyond it lies the
enclosed plain of Dirmil. A low ridge on the right leads by a few poor

summer clusters to the watershed of the middle pass. A small ancient site must have been here also, for shards of Hellenistic pottery lie on the south slope of this rise. The modern track to Dirmil from the coast comes in at a higher and more easterly point, and before reaching it one must cross the ancient route that led from the most easterly of the three passes below Oenoanda through Balbura. This site is now deserted, except for a few summer huts and fields; its two theatres, and market-place heaped with ruins, are close below the modern road, but the acro-polis stretches out of sight up a small valley and there, by one of the tall and ugly lion-tombs, the old track to Dirmil can still be seen—used by local peasants for its shortness, in preference to the modern road.

Cibyra and the upper basin of the Xanthus can of course also be reached by tracks that lead out of the lower Xanthus valley over the shoulders of Mount Massicytus (Ak Dagh); but one must remember that it was midwinter, and that an accent of wonder is perceptible in Arrian when he says that the effort was made 'in the height of winter' at all (I. 24.5; see p. 245). The passes that run into the upper Xanthus from the east of Ak Dagh all become snowbound, and not even shepherds living in the highest of the villages use them during the winter months.

The Cadyanda and Araxa passes, on the other hand, are usually possible to the end of December. The villagers told me that the two westerly ones suffer more from rain than snow, and they find the easterly one easier, whose modern road is hard frozen underfoot. It zigzags up from Xanthus bridge at Kemer to the pass of Kara Bel, below the ruins of Oenoanda on a spur; and the old way from Araxa joins it just south of the gorges.

This pass gives a choice of two routes—the one west of north to Cibyra and the other east of north to the Caralitis lake: both equally lead to the ancient Laodicea–Pamphylia road, but the second has the advantage of avoiding the watershed between Xanthus and Indus; being very open and easy, it makes one obstacle the less in winter. This is a detail, and does not affect the general direction of Alexander's campaign. What is impossible to determine, except by excavation and archaeology, is the distance of his penetration into the hill-country.

Somewhere, in the middle of winter, to the north of the three head-valleys of Xanthus, the envoys from Phaselis came up to him, to present their golden crown. The meeting-place cannot have been far north of the boundaries of Lycia at that time, since the Tefenni road which would solve Alexander's problem was only a short distance away.

Appendix I

One may surmise that while the feet of the passes, at Araxa and Cadyanda, were in the hands of Lycian friends, the northern outlets may still have belonged to the hillmen. When Oenoanda, Bubon and Balbura were included in the Lycian League in 84 B.C., the word Lycia was not added to their coins as it was to those of Telmessus, and this difference may suggest a different origin.[18] The excavation of these little cities could settle the question, by the presence or absence, and the character, of any fouth- or fifth-century B.C. objects found there.

Fourth-century or earlier Lycian inscriptions, on the other hand, have been found at Isinda, to the east: and Lycian tombs are noticed by Spratt on the shore of Caralitis;[19] but they appear to be solitary finds, and it seems to me that one might expect such traces along a used highway, where traders would mix with, or influence, the hillmen without actually owning the districts. There are hints of such influence as early as Herodotus, who mentions (vii. 76–77) that the Pisidians (?) each carried two javelins of 'Lycian work',[20] and describes the Milyans as wearing garments fastened about them with brooches, and casques of hide, and short spears, 'and sundry of them had Lycian bows'. Alternatively, these inscriptions might represent a stronger period of Lycian expansion now waning under the Carian or Pisidian impact, as we shall presently find it in Lower Lycia when we get there.

A Pisidian push westward is in fact shown later, in the 3rd century B.C., when a colony from Termessus was settled close to Oenoanda and called Termessus-near-Oenoanda. It is obviously the Pisidian city described by Strabo as 'situated above Cibyra' (xiii. 4.16)—a description which does not fit the older Termessus. It lies, shuffled into heaps of white stones, where the small pastoral Xanthus stream is caught in shallow cliffs along its upper reaches.

The result, then, of my investigations in this region was, in my own mind: (1) That Alexander was making north by one of the passes from Cadyanda or Araxa, towards either Cibyra or Lake Caralitis, to reach the Laodicea–Isinda–Pamphylia road. (2) That he did not reach it, or he would have linked up with Parmenion and his most urgent problem would have been solved. (A few weeks later he had to send a messenger to Parmenion who went disguised in native dress, i.e. through country still unsafe in enemy hands.) (3) That if he had reached it, his first care would have been to secure the *northern* half of the route, that is the link-up with Parmenion, and that it is therefore not to be thought of that he marched *east* from Xanthus, where the passes towards Elmali and Isinda

are over 7,000 feet high and unnecessarily difficult in winter, and where they were leading him away from his goal. (4) That the only reason for imagining his direction to have been east rather than north, towards Isinda rather than Cibyra or Caralitis, is Arrian's mention of the Milyae and their easterly location by Strabo and others. (5) That there is evidence for their more westerly location at an earlier—and therefore more suitable—date in the passages in Herodotus (vii. 76–77 and 92), with its placing of the Milyae–Lycians–Termilae, and in the etymology of Dirmil in the region where they overlapped just south of Cibyra, where, even in Strabo's day, the Milyan (Solymi) language was still spoken (xiii. 4.17). (6) And lastly, even if the Milyan direction in Arrian is incorrect, it would be a very easy slip to make in the military record of the time; the same country was soon to be attempted from its eastern approaches, where it was undoubtedly Milyan. The reference itself is given by Arrian in a very indeterminate way. What his statement does suggest is that Alexander had not yet got very near to his objective, and that it was therefore still shrouded in that absence of concrete nomenclature which every eastern traveller deplores.

LOWER LYCIA

Like love in Shelley's poem, the weaker the evidence the heavier is the load it has to carry. Inferences must be used that the better documented are rich enough to dispense with, until—as a tight-rope walker burdens himself with one object after another, until only his straight, perpendicular balance saves him from falling—so the whole proof rests on the integrity of one thin lifeline of historical imagination. The reasoning has to be honest at the start, or it will not bear the load it has to carry.

The whole of Alexander's journey from Xanthus to Phaselis suffers from this sketchy documentation, and there is a fair case, I think, for allowing some imaginative insight in dealings with the military journal which Ptolemy copied, on which the main part of Arrian's news is based. We see it in a third incarnation, and must remember the stages through which it passed. The first was a straightforward note of events, with no possibility for much selection, at the end of every day. The second, Ptolemy's compilation, was done at leisure later and it is the *choice* of important events made by a very acute mind that was present and therefore knew all about them. It is as good evidence as one can have, and it is fair to assume that in it—unlike the journal from which he copied—every item was meant to tell us something that he himself wished to

remember or that we are intended to know. The third version—Arrian's—is a blurring of this definite picture, made by an honest and intelligent man who was not a Macedonian, and was hampered by the fact that he was transcribing, nearly five hundred years after it had happened, something of which he had no direct knowledge. The background, in fact, is missing: it is this background, the thing that Arrian could not know but that was clear to Ptolemy when he wrote, that, if we could recapture it, would give us all the information we are seeking. To put oneself behind Arrian, into the mind of Ptolemy as he writes, is not, of course, to produce evidence; but it may, here and there, and with the help of the present geography, enable us to find a richer meaning in the text, beyond what Arrian himself, as he copied, was aware of.

One may, for instance, notice the embassies that reached Alexander. There must have been a great many, and they were probably all written down in the Journal as they came. Ptolemy, with his subsequent knowledge, would select only those that mattered; and an embassy in Arrian should therefore be carefully watched, as the prelude to some sort of event. Only three are recorded in Lycia and Pamphylia—from Phaselis, Aspendus, and Selge. The second was an introduction to a military operation, and the first and third led to an actual change of plan. They bring out the quality already proved at Myndus, Alexander's safe and flexible readiness to change his mind. When the envoys from Phaselis reached him in the lands beyond Xanthus (Arrian, i. 24.5), he altered his whole campaign and followed them into Lower Lycia, because the alternative they offered was better.

Four main routes from Xanthus to Phaselis must be considered, with various subsidiary deviations. The most southerly, that can now be followed by jeep when the bridges are not washed away, ran, with a branch to Patara, along the highlands of the coast. Not many miles north of this, a way over the lowest shoulders of Massicytus went by Candyba—now Gendova—either through the present Kassaba and the Demre gorge to meet the coast road at Myra, or by a higher route into the Arycanda (Bashgöz Chay) valley through Arneae—now Ernes. A more northerly—a double route at first—passed high both south of the Massicytus summit and north of it not far from Oenoanda, and made across elevated summer uplands for the south-west corner of the Elmali plain, which it would skirt by Armutlu—whose village still has a Lycian tomb reported—and by Podalia on the edge of the lake, where ruins have been found; from here too the road went down the Arycanda.[21]

Appendix I

A still more northerly pass, from Oenoanda to Elmali, is that of the modern road, which is closed in winter and is the death of a car at any season: it could only have been used for the traffic of the uplands north of the Xanthus gorges, and indeed would not be worth counting at all except that Pliny, v. 95 (see p. 238), mentions Choma—possibly the modern village of Eski Hisar at the eastern outlet of the pass—as part of Lycia. The citizens of Termessus must have passed along some portion of this route within a few decades, to found their colony near Oenoanda, at which time it must have been in the Pisidian rather than in the Lycian sphere of influence.

The two most northerly of these four routes are frozen in winter, and Spratt found snow as late as May on the Elmali pass. Alexander in any case would not be following them in the direction of Elmali at all if, as I suggest, he was making north towards Cibyra rather than east towards Pamphylia. The envoys from Phaselis presumably found him north of the Xanthus passes. They came with most of the maritime cities of Lower Lycia, 'to offer friendly relations and to crown him with a gold crown', and Alexander bade them all hand over their cities to his deputies, which they did. He himself marched to Phaselis soon after. There seems no reason at all to think that he turned east towards the snow-covered routes of the plateau to do this, when he had two clear and friendly ways in the south to choose from. The envoys of Lower Lycia would evidently lead him, and would do so along the most convenient road, above the little harbours with their important shipping trade in timber, for the possession of which he had risked his army in these hills. He marched back, I think, to his base at Xanthus, and, setting out from there in good order, took either the Candyba road or the present main route above the coast. Fellows (349 ff.), and other travellers (see Spratt, i. 139–43) have described it, and given it an air of desolation; but one must remember that all this coastal strip was particularly open to the later raids of Arab pirates; the Byzantine cities moved bodily into safer country inland, as one can see by the ruins of the great domed church of Kassaba, near Demre; the uncultivated earth, with olives and fruit trees destroyed, grew barren and full of stones; and it is only now, with a helpful government in power, that the little plots of tillage are once again expanding, and vines begin to be planted between the limestone ridges. I made my way from Kassaba, where the decay described by Spratt and Forbes is now being replaced by new building; and drove, or rode, from the ruins of Phellus, by the walls and lion-tombs and theatre of Cyaneae,

Appendix I

PHRYGIA

°Apamea

Laodicea

Teferrni

L.Carylitis

Korkuteli

Isinda

Termessus

Chandir

Chandir R.

Antalya

to Pamphylia and Aspendus

Perge

Xanthus Gorge

Oenoanda

Elmali

Araxa

Sarayjik

High ridges

Idebessus

Acalissus

Arycanda

Alagir Chay R.

Climax gorge

Podalia

Armutlu

Gödene

Phaselis

Mt Massicytus

Arneae

Rhodiapolis

Olympus

Xanthus

Kassaba

Limyra

Phoenice

Corydalla

Ardachan

Candyba

Phellus

Gölbashi

Arium?

Gagae

Myra

Patara

Cyaneae

PAMPHYLIAN SEA

Ancient road, Phrygia to Pamphylia
Alexander's route

10 5 0 10 20 30 Km.

10 5 0 10 20 Miles

Φ.Γ.

246

to Gölbashi whose sculptures are in the Vienna museum, and down by the new road to Myra (Demre). The ancient track branches off in sight, towards a Hellenistic fortress and Andriace on the coast.

At Myra the long ridge of Alaja Dagh, that divides upper Lycia from lower, dips steeply to the sea and a zigzagging path climbs it for three and a half hours on end. I saw no ancient trace here except a double Hellenistic tower to guard the valley opening below; and as we struggled up I began to wonder if this could indeed ever have been a much-used route. I found, however, that Fellows, and Spratt and Forbes after him (and not many other travellers have been here), give an exaggerated account of the time and trouble required. Their nine, or eleven, hours are reckoned at five and a half by the people who ride up and down from Myra to Finike, and five and a half was exactly the time I took without counting a rest at the top. A little ruined town[22] clusters on the spur, with a stupendous view of coasts and islands. Its tombs are broken, its columns half buried round rooms and doorways cut solid in the rock. There are walls of a small acropolis and—so it seemed to me —a worked stone that might be the seat of a theatre. They lie huddled among the goats that climb up to browse and rest there.

Alexander had no doubt been told about the hillsides of Lycia before he divided his army to half its strength and set out from Halicarnassus. He had no more than fourteen or fifteen thousand men; and they must either have climbed up by the zigzag path to the little unknown town as we did, or circumvented the whole of the Alaja Dahg massif and come down the Arycanda valley, for there is no other way. In both cases they would end, as Plutarch implies that they did (17.3), at Phoenice— the modern Finike.[23]

From here, across the Chelidonian peninsula, the track to Phaselis is easily traced, the more so since the new Turkish roads have not yet reached these beautiful and lonely hills. One can easily find a pony that deals with the stony paths, and ride to one or other of the small and ruined Hellenised-barbarian centres that lie scattered up and down the open basin of the Alağir Chay, where the highway ran into Pamphylia. The Tahtali range separated this valley route from Phaselis and the eastern coast; and I think there is no doubt that Alexander crossed by what is still the easiest and quickest way—by Limyra at the opening between Alağir and Finike; under Rhodiapolis (Eski Hisar) on the top of its hill on the left; through Corydalla (Hajjivella), and its modern substitute Kumluja; and over the Yazir Pass, where the Tahtali peaks first break

Appendix I

to long and easy ridges. Descending on the eastern side, one reaches a flat bowl where valley-tracks come in from the bay of Ardachan in the south, and Olympus (Jirali) in the east; while the Phaselis track turns northward between Tahtali and the coastal hills, along the ravines of the Ulubunar Chay. It is not more than a long day's ride from Corydalla, and must always have been the main way from Phoenice, although the longer southerly route is just as easy, through Gagae (Yenije-Köy) and Ardachan. There are also higher tracks across Tahtali, branching from the main route to Pamphylia along the Alağir Chay. But none of these would be chosen by anyone marching from Phoenice and the western coast.

One of these ways, crossing from Gödene, was suggested by Spratt; but this is out of the question, since the army, when it moved on from Phaselis, took a short cut to avoid *the difficult and long way round* (Arrian, i. 26.1); and no route can be so described except the Yazir Pass, which would have added two good days to the marching. The pass from Gödene is quite close to the Mount Climax route which the army was soon to follow, and one cannot imagine anyone having a way laboriously made by the Thracians *up* a difficult gorge, when the army could take a practicable parallel route no distance away, by which it had just come *down*. Spratt was writing on the supposition that Alexander came into this country from Elmali and the Arycanda valley: I have been over the only pass he could have taken north of Limyra, and it is not only very difficult in itself, but is also completely overlooked by the cliffs which we know to have been in Pisidian hands.[24]

CLIMAX AND PAMPHYLIA

Alexander therefore came to Phaselis and rested with his army, which then passed up the Climax gorge (Arrian, i. 26.1). This looks, from the sea at Kemer, like three horizontal bands graded into the recesses of the hills: ledges of black pine trees mark its steep stages; and the steps which the Thracians cut are still visible to the eye of faith in the narrow passage, since no alternative route can ever have been used between the Kemer Chay and its rough boulders and the high and narrow walls of stone above. The limestone there is worn smooth by many centuries of passing feet, though few people now go up and down except the nomads to their summer pastures. The Kemer Chay tumbles through solitudes from Tahtali's northern shoulder, but the track soon leaves it and climbs for three hours or so under woods, near Kediyalma, a small hamlet round

Appendix I

a castle, and over the pass to the track from Phoenice to Pamphylia. This lies, planned as it were by nature, along the broad and easy Alagir, over a low watershed, and down the Chandir Chay, and opens out eventually in the Pamphylian plain. It is a natural highway, and must have contained Arrian's 'strong outpost, built to threaten this district by the Pisidians, from which the natives often did much injury to those of Phaselis who were tilling the ground' (i. 24.6).

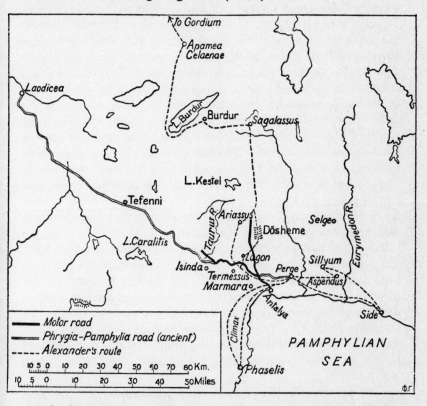

Only three modern travellers, as far as I know, have left notes on this route, and of them Schönborn and Daniell suppose the rock and acropolis of Sarayjik to be the site of this ancient fort, while Forbes[25] places it at Chandir, well down the eastern slope of the watershed, where a medieval stronghold now bars the defile of the valley.

I was prevented by weather from even seeing Sarayjik and its ruins, though I rode over the pass above it and must have been very near;

Appendix I

and I looked down on the castle of Chandir too (Chitdibiköyu in the latest map), without actually examining it, since the modern path keeps high above the Chandir gorge. If forced to choose between these two situations for the stronghold, I should prefer Chandir, although Sarayjik is nearer Phaselis and therefore more likely to have lands tilled by the peasants of that city. But one must consider how the Pisidians— obviously rather precariously lodged in an unfriendly neighbourhood —came and went in relation to their friends on the plateau behind them. To reach Sarayjik they would have to cross the wide broken country and the Alağir river itself; whereas at Chandir they would find themselves on the trade route to Pamphylia with an escape open to the plateau close behind them. It looks as if the normal trade of the two rich provinces of Lycia and Pamphylia had been held up by a robber nest of Pisidian mountaineers descending where the valley narrows at the defile. This would, incidentally, explain the readiness with which the people of Phaselis and the maritime Lycians whose road was cut sent envoys to invite Alexander. 'You want the road to Phrygia', they would tell him. 'It is easier for you to attack it from its eastern end which is free of snow, and from there, once through the Termessus defiles, you will meet with no obstacle.' And then they either added or did not add that a friendly army to eliminate Termessus near their main highroad would be extremely helpful to themselves.

If we agree that what Ptolemy wrote is no haphazard narrative but a selection of events that had their importance in his mind, we may infer that the capture of a small stronghold would scarce be worth putting down unless it had had some bearing, some remembered influence on the decisions of that time. The fuller details, such as we have, are given by Diodorus, xvii. 28.1–5 (which I give in the anonymous translation of 1700, the only one available to me. Dr. Griffith says that there are small mistakes in it, but none that affect my argument):

'In the utmost border of Lycia, the Marmarensians, who inhabited upon a great Rock, and well fortified, set upon the rear of Alexander's army in their march thither [from Lydia to Cilicia], and slew many of the Macedonians; and carried away a great number of Prisoners and Carriage-horses. At which the king was so enraged, that he resolved to besiege the place [he had to have this road clear, F.S.] and used his utmost endeavour to gain it. . . . The ancient Men therefore . . . advised the Younger to . . . make peace . . .; which when they deny'd

Appendix I

. . . the graver Men then advis'd them to kill all the old Men, Women and Children, and that those that were strong and able to defend themselves should break through their Enemies' Camp in the Night, and flee to the next Mountains. The young Men approved of the Councel, and thereupon an Edict was made, That everyone should go to his own House, and Eat and Drink plentifully with his Wife, Children and Relations, and then expect the execution of the Decree. But some of the young Men who were more considerate than the rest (who were about six hundred in the whole), judg'd it more advisable to forbear killing their own Kindred . . . but rather set the Houses on fire, and then to sally out at the Gates, and make to the Mountains for their Security. . . . So every Man's house became his Sepulcre. And the young Men themselves broke through the midst of their Enemies, and fled to the Hills near at hand.'

Some place quite close to the mountains must be chosen, and Chandir seems the more probable in spite of its distance from Phaselis: and as Phaselis was the last city of any importance against the Pamphylian border,[26] her lands may well have extended across the ridges of Climax until they met the boundaries of Olbia on the northern plain. The Chandir gorge is not more than one long day's ride from the city.

Wherever the Pisidian stronghold may have stood, it must have been on the Pamphylian highway. Apart from the geography, Arrian's account makes it evident that this was a recent and harassing infliction on the peaceful peasants—the seizure of a place already fortified, rather than the building of a new one—and such would naturally not be found far off the road. Its capture established the Pisidians right across the traffic between Lycia and Pamphylia. What their presence down here also proves is the fact that the plateau was theirs behind them—the high barrier, sheer as a wall, of Ak Dagh and Beydagh, with its commanded plains of Isinda (Korkuteli) and Elmali.

The Pisidians must also have held the headwaters of the Alağir Chay, and at least the upper part of the gorge that leads to it from Arycanda, with the little cities, Acalissus (Jaouristan) and Idebessus (Kozaağach), that cling to its northern wall. Apart from their Pisidian names, the situation of these places would be impossible with enemies able to raid or throw stones upon them from above. Elmali lies at their back, less than twenty-five miles away as the crow flies, but high on the plateau shelf that stretches behind Lycia and Pamphylia. It might possibly still

Appendix I

have been in Lycian hands; we have seen that there are tombs in this plain, and the Lycian frontiers might have run across it. But against this is the fact that, when Alexander had to send a messenger from Phaselis to Parmenion, he sent him in disguise (possibly by a direct route from Pamphylia, since the guides were from Perge).[27] If Elmali had been Lycian and friendly, he could have sent him openly: Alexander, in fact, would have been on the Cibyra road by Lake Caralitis and entering Pamphylia from the west. The answer is that he never reached Elmali at all, or Isinda either. Surrounded by their deep ravines, their stupendous cliffs and snowbound passes, they hung like the core of a gigantic fortress above him in the north; and the defeating of the mountaineers on the Chandir road was a necessary operation in its circumvention, in which the people of Phaselis, and no doubt the coastal cities also, had every inducement to join. Alexander himself at that time was a man in a hurry, and he would not have lingered to take solitary outposts, unless they had been direct knots of interference on his road.

One other point can be made before we leave the Pisidian stronghold to its obscurity. It is an indirect witness that the Chandir road was indeed the route of the army. It is fairly obviously so, but there might be a particle of doubt from the fact that another road does exist across the eastern foothills of Mount Climax to Pamphylia. I have not been along it, but have made inquiries and have looked carefully at it from the sea; and the ancient blocks are visible where it once dipped down to or climbed up from the beaches. Alexander himself led his immediate followers along the coast, where the south wind, when it blows, makes a passage round two promontories impossible; but the wind veered, and Alexander with his escort got by, though the sea came to their waists.[28] The exploit was not one of his greater ventures, and he himself, in his letters, 'mentions nothing unusual', for he could have kept to this higher road with the mere addition of a morning's ride. It is, in fact, obvious that the people of a city like Phaselis would have some means of getting to Pamphylia and vice versa when the south wind blew. For a time I wondered if this small detour might not have been the route of the army, in spite of the description of the Climax Ladders, so distinctive in the landscape even now. But the presence of a Pisidian fort would have been impossible on the eastern sea-coast, detached by a whole mountain range from its own allies. I was greatly relieved to find that Mount Climax, already so sadly diminished by the existence of this road at all, had still been scaled by the Thracian cutters of steps in its steeper

recesses. As for Alexander's short cut, it is no longer feasible except by two hundred yards or so of swimming at the more southerly cliff. Boulders have rolled from the top of the precipice and blocked the nearer water, and this may easily account for an increase of depth in the last two thousand three hundred years.

PAMPHYLIA TO PISIDIA

Alexander's movements in Pamphylia are quite straightforward. He marched along the coast, with no mention of the temple-state of Olbia which he passed through, where a few rough tombs still show in the low cliff, close to the northerly corner of the bay. Antalya did not yet exist; it was built later by Attalus II—probably as an easier outlet than Telmessus for his connexion with the south coast. Alexander pushed on eastward, leaving Aspendus upstream a few miles on his left after coming to an agreement with its government. He made straight for the important harbour of Side. Having secured this he retraced his steps (he was now much more interested in his communications with Permenion in the north than with the wild coasts of Cilicia) towards Perge, where the guides to the north had come from and where friendly relations with Phaselis evidently existed. But the trouble with all the eastern Mediterranean, and other places as well, is that friendly relations with one set of human beings involve trouble with another. Perge probably disliked Aspendus which 'was accused of having taken and retained some territory of its neighbours' (Arrian, i. 27.4). No sooner had Alexander's army on its return march passed by their city than the Aspendians renounced all their agreements, and were surprised to see the young king back again and ready to besiege them.

His marches and countermarches in this level plain show the same prudent directness and naval preoccupation that we have found hitherto in all his movements. Side was an important, semi-barbarian port, and he left it with a guard inside it; but Sillyon, perched on the cliffs of its oval hill, was inland and on no main route that he needed: he passed it by (Arrian, i. 26.5) and returned to camp in the flat land that surrounds Aspendus. There, in the suburbs of little houses near the Eurymedon river, he came to terms with the citizens of the acropolis, continued his march back to the friendly base at Perge, and thence set out 'to break the defiles', which, as Strabo points out (xiv. 3.9), had been the original object of the attack on Milyas.

'He began', says Arrian (27.5), 'his march to Phrygia, which led past

Termessus.'[29] It did not necessarily lead past Termessus; the ways to the north are easier: but neither the people of Phaselis nor of Perge, both interested in the disarming of Termessus, were likely to tell him so, although the people of Perge at any rate must have been aware of the shorter route towards Burdur. Even if he knew of another way, Alexander still had the route to Cibyra in his mind. He had approached it from Xanthus in the west and was now about to attack the same block of enemy highlands from the east; he could only do this with the intention of making for the Cibyra highway.

The forcing of the pass is described by Arrian in detail (27.5–8):

'The Termessians', he says, 'inhabit a very lofty position, precipitous all round; the road past the city is an awkward one. A height runs from the city as far as the road[30] and there ends; but opposite is a height equally abrupt. These heights make natural gates on the road, and a small guard can cut off all approach by holding them. The Termessians . . . came out in full force and occupied both heights. Alexander . . . bade the Macedonians camp where they were, knowing that the Termessians, seeing them bivouacking, would not wait there in force, but would, for the most part, drift away to the city close by, leaving on the heights only a guard. His guess proved right', and 'he passed the narrow passage and encamped near the city'.

The city is there, more or less as the later Termessians left it, for no one except a nomad or two has lived there since. Its theatre seats look down the steep valley to Antalya and the sea, 3,000 feet below, and the track still leads up to an eastern gate which the forest has swallowed.

A fine wall of the second century B.C. spans the scene of the battle in the narrow valley east of Yenije Boğaz.[31] There is no mention of a wall in Arrian and this fortification was built later, not by the Termessians but by their enemies, since the towers are all directed against the west. There are ten of them, with eastward-opening doors level with the ground. But though it is disappointing to see this *volte-face* of the defences, there is in fact no doubt that this was the natural position where Alexander fought the battle and was joined next morning by the ambassadors from the Pisidians of Selge. This city, hidden in the mountains behind Aspendus, came to offer friendship and 'he found them wholly trustworthy allies. He concluded that a siege of Termessus would be a long one, and so moved on to Sagalassus' (Arrian, 28.1–2), that is to

say that *he swerved away from the long-pursued road to Isinda–Cibyra–Laodicea*, and made in a more direct line for Parmenion and the north.

This is the third of the embassies mentioned on the march from Miletus, and one would like again to look at Ptolemy behind the unconscious pen of Arrian, and guess what was particularly in his mind when he recorded the trustworthiness of the Selgian allies. Did they mention what the people of Phaselis and Perge had been reticent about, and tell him that he was wasting his time over the defiles of Termessus, when an easier road led more directly to his goal? However this may be, Alexander turned north. The route is not specified. He either took the track which the flocks and country people still use—which Manlius probably followed one hundred and forty years later—emerging on to the plateau by the modern Bademağachi, the ancient Ariassus, and thence to Sagalassus (Ağlason) across the level ground, or, just as easily, he turned back for a matter of five or six miles from the site of the wall and took the road which remained in use till the modern motor-road was built. It runs north through the ruins of Lagon (Uzunkuyukahvesi) beside a Seljuk han, crosses the modern road, and climbs the steep but short Dösheme Pass, still paved with ancient stones. The two routes join the modern main road above the defiles, and the first osbtacle they then meet is the Sagalassus range.

Here the last real battle against the Pisidians was fought, and having won it Alexander went leisurely up, capturing villages, by Lake Ascania (Burdur) to Celaenae, which is now Dinar, and on to Gordium over the treeless plain (Arrian, 28.2–29.3). He linked up with Parmenion and the Macedonian reinforcements, and his movements become easy to follow, along the normal highways of armies, through the Cilician gates. Except for a week in the foothills, probably to secure the Karaman route across Taurus, there are no more sideshows; his communications were open behind him and the forces of Darius were collecting in front. In November 333, about a year after the capture of Miletus, the battle of Issus was fought. But the sea-war, to which the year's campaign had really been devoted, was not yet over; and after his victory Alexander still postponed the match with Darius, and concentrated on the coasts of Phoenicia and the hostile fleet of Tyre.

The speech at Tyre, in Arrian's report, gives the gist of the policy as it had already been outlined a year before at Miletus. 'So long as Persia is supreme at sea', said Alexander, 'I cannot see how we can march with safety to Egypt. Nor is it safe to pursue Darius, leaving in our rear the

city of Tyre. There is a fear lest the Persians, again seizing the coast places, when we have gone in full force towards Babylon and Darius, should with a large army transfer the war into Greece, where the Lacedaemonians are at the moment fighting us; and Athens is kept in its place for the present by fear. . . . But with Tyre once destroyed, Phoenicia could all be held, and the best and strongest part of the Persian navy, the Phoenician element, would most probably come over to us. For neither the rowers nor the marines of Phoenicia will have the courage, if their cities are in our hands, to sail the sea and run its dangers for the sake of others. . . . We shall make the expedition to Babylon with security at home . . . with the whole sea cut off from Persia and all the country this side of Euphrates' (ii. 17.1–4).

When this was spoken, Persia was still supreme at sea and the Tyrians had plenty of ships (Arrian, ii. 18.2). It was not till late in November 332 that his admirals came to the king in Egypt with the news that the last Persian resistance on the islands was subdued (Arrian, iii. 2.3–7). The cities which he had left on one side on his march through Caria—Myndus, Cnidus and Caunus—must also have been safely his.

Appendix II

APPROXIMATE MILEAGES

FOR PART I

South Coast (from *The Mediterranean Pilot* Vol. V. 1950): by car or jeep.
Alanya: 67 miles from Antalya, and 116 miles from Silifke (Seleuceia).
Ghazi Pasha (Selinti: 88 miles from Antalya, and 95¼ miles from Silifke (Seleuceia).
Anamur Cape: 117¾ miles from Antalya.
Anamur Castle: 123¾ miles from Antalya, and 59½ miles from Silifke (Seleuceia).
Mersin: 221½ miles from Antalya, 38¼ miles from Silifke (Seleuceia).
Mersin–Soli 5½ miles; Soli–Lamas R. 17 miles; Lamas–Corycus castle 7¾ miles; castle–Silifke 8 miles; Tashuju Iskele 5 miles; Agha Liman 3½ miles; Cape (Sarpedon) Cavaliere (738 feet) 10 miles; Kilinderé 18½ miles; Cape Kizilman 11; Anamur 9½ miles; Cape Anamur 6 miles; (Charadrus) Kaladeré 11; Antiochia ad Cragum 10 miles; (Selinti) Ghazi Pasha 8¾ miles; Alanya 21; Manavgat 27 miles; (Side) Eski Antalya, 5½ miles; Laara 29 miles; Antalya 5½ miles = 219 miles.

FOR PART II

Zerk (Selge): Manavgat along main road W., turn at 25 klm.; Besh Konak 34, i.e. 59 klm. from Manavgat; then 3½ hours ride up.
(Lagon) Uzunkuyu Kahvesi: 17 klm. from Antalya just N. of Korkuteli road.
Termessus: 2 hours walk, from Güllük Yenije Kahvesi on the main Antalya–Korkuteli road.
Sagalassus: 7 klm. from Ağlason, which is 25 klm. by either of two routes off the Burdur–Bujak road. Burdur is 126 klm. by main road from Antalya. Ağlason—Basköy on map: Akpinar Dagh is the mountain of Sagalassus.
Ariassus: an hour's walk from Bademağachi, which is the first village

on the plateau west of the Antalya–Bujak road, after the Kirkgöz pass. It is 57 klm. from Antalya.

Dösheme pass: from Kirkgöz on the Antalya–Bujak road, to Kovanlik, and on to the top of the pass by earth-tracks. Or 41 klm. from Antalya to the foot of the pass.

Susuz = Boğazköy on map.

FOR PART III

Across Chelidonia to (Corydalla) Hajjivella = Kumluja: 5 hours' ride from Olympus; which is 5 hours' motor boat from Antalya.

Eski Hisar (Rhodiapolis): 2 hours' ride from Kumluja.

Asarköy (Acalissus): 5¾ hours' ride from Kumluja.

Kozaağachi (Idebessus): 1 hour from Asarköy: 5 hours' ride on to Aykirchà valley.

Yenije Koy (Gagae): 2¾ hours' slow ride from Kumluja. . .

Kassaba to
{
Gömbe: 2 days' ride (reported).
Ernes–Elmali: 7 hours' ride (reported).
Aykirchà–Finike: 7 hours' ride (reported).
Demre by gorge: 3 hours' ride (reported.)
Demre above gorge: 4 hours' ride (reported).
Kash by road; 23 klm.
}

Kash to Demre: by road 42 klm.

Demre to Gömbe: by road 100 klm.

REFERENCES

FOREWORD

(See Bibliography for full Titles and Authors)

[1] Arrian I, 20, 1.
[2] Arrian VI, 19, 4–5.
[3] *Camb. Anc. History,* VI, XII and XIII.
[4] See Chapter 15 for Xenophon.
[5] *Camb. Anc. History,* VI, 31.
[6] „ „ „ VI, 16 and 18.

CHAPTER 1

[1] M. V. Seton Williams: *Anatolian Studies,* 1954, 161.
[2] Heyd I, 367.
[3] According to the *Mediterranean Pilot,* V, 162.
[4] D. Magie, 671 and note.
[5] W. F. Ainsworth: *Travels and Researches in Asia Minor etc.,* II, 90.
[6] Quintus Curtius III, 7, 5–6.
 Arrian II, 6, 1–2.
[7] G. L'Estrange: *Lands of the Eastern Caliphate,* 131.
[8] Anna Commena: *Alexiad,* XII, quoted by Beaufort, 283.

CHAPTER 2

[1] E. J. Davis, *Life in Asiatic Turkey,* 12.
[2] Xenophon, *Anabasis,* I, 2, 22.
[3] W. Ramsay, *Hist. Geog.* 45; D. Magie, 270 and note; Droysen, 191.
[4] G. Cousin, *Kyros le Jeune en Asie Mineure,* 253.
[5] G. L'Estrange, *Lands of the Eastern Caliphate,* 133.
[6] W. Heyd, *Commerce du Levant,* II, 668.

References

7 A. H. M. Jones, *Cities of the East Roman Provinces*, 291–5; see also for Antony and Cleopatra below.

8 According to an inscription lost in 1922 in Smyrna. M.A.M.A. II, 6.

CHAPTER 3

1 Herodotus, VII, 91; Strabo, XIII, 1, 63; Pauly, XI, 389.

2 H. A. Ormerod, VI; D. Magie, 281–4 and 298–300; Plutarch, *Pompey*; Strabo, XIV, 5, 2; Dio. Cassius: *Roman History*, XXXVI, 20 ff.

3 Appian, II, 465.

4 Vergil, *Georgics*, IV, 125.

5 Sissouan, 388 and Beaufort.

6 Strabo, XI, 12, 2.

7 Euripides, *Helen*.

8 *Wuthering Heights*, Catherine on Heathcliff.

9 Diog. Laertius, IX, 113.

10 F. Beaufort, 201.

11 S. Runciman, *A History of the Crusades*, passim; Sissouan, passim; Heyd, I, 366–72.

12 i.e. in the quarrel with Cleitus.

13 Arrian, VII, 9, 1–9.

14 Sissouan, 383 ff.

15 Sissouan, 380 ff; Beaufort, 10.

CHAPTER 4

1 Quoted in Sissouan, 378.

2 Sissouan 371 quotes Benedicts' *Petroburgensis Abbatis Vita et Gesta Henrici II Angliae Regis*: ed. Th. Hearne, Oxon, 1735.

3 Heyd, I, 303 ff, and II, 350.

4 Sissouan, and Heyd I, 550.

5 (For Antiochus III) Bevan; Polybius XXI, 43; Appian, *Syrian Wars*; Livy XXXVIII, 37, 8 and XXXIII, 20; Diodorus, XXIX, 13.

6 Lucan, *Pharsalia*, VIII, 257.

7 (For Ibn Batuta) Heyd, I, 547; (for Karamanlis) G. L'Estrange; (for slaves) Heyd, II, 555.

8 *Iliad* IX, 155, line 410.

References

9 *Anatolian Studies*, III, 1953, 10.

10 Ansbert in Second Crusade, *Bibl. des Croisades* III, 268 ff.

CHAPTER 5

1 Pliny, *Natural History*, XXXI, 73; Leake, 133; G. L'Estrange, 151; Heyd, I, 303; 548, II, 354 ff, 441, 559, 623; Beaufort, 126–32.

2 Al. Bashmakoff, *La Synthèse des Periples Pontiques*, 75 (Paris, 1948); Strabo, XIV, 3, 8–4, 3; Spratt and Forbes, 215–6; D. Magie, note p. 1132. For Thebe and Lyrnessos see *Iliad*, II, 38, and VI, 110 and passim; Strabo, XIII, 1, 61; XIV, 5, 21; J. L. Myres, *Who Were the Greeks?*, 141; Pausanias, III, 3; Jones, *Cities*, 124.

3 W. Ramsay, *Studies in the History and Art of the Eastern Princess of the Roman Empire*, 295.

4 Cicero, *Verres*, II, 1, 54.

5 Acts, XIV, 24–5.

6 Plutarch, *Cimon*; Thucydides, VIII, 81, 87; Xenophon, *Hellenica*, IV, 8, 30; Livy, XXXVII, 23, 3; Pauly, II, 1725.

7 Cicero, *Verres*, II, 1, 53.

8 Arrian, V, 26, 4; *Iliad*, IX, 155; I, 9; II, 24; XII, 217.

9 Plutarch, *Moralia*, 142, 30, C.

CHAPTER 6

1 Droysen, 131.

2 *Iliad*, IV, 72 (with top-knots and long spears).

3 Spratt and Forbes, I, 201–7 (for Climax); I, 173–9, II, 11–12 (for Sarayjik).

4 Arrian, I, 24, 6; Diodorus XVII, 3 (given under the year 332 B.C., but should be 333).

5 Spratt, II, 11–13. See also for coast route below.

CHAPTER 7

1 Pauly–Wissowa–Kroll, 732; Jones, *The Greek City*, 29.

2 Magie, 522 and 1136.

3 Livy, XXXVIII, 15, 4; Spratt, 234–8 and XI.

4 Diodorus, XVIII, 44, 4.

[5] Arrian, I, 27, 5; Spratt, I, 241 ff.

[6] Rott, 26–31; Leake, 133 ff. (from Koehler's account).

[7] Jones, *Cities*, 133.

[8] J. L. Myres, 125; Ormerod, 86.

[9] Diodorus, XVI, 4.

CHAPTER 8

[1] By Diodatus of Erythrae and Eumenes of Cardia, *Athenaeus* X, 434 B.

[2] Spratt, II, 17–32 (Daniell's journey).

[3] Strabo, XII, 7, 1 and 5.

[4] Bevan, II, 1 ff.

[5] Polybius, V, 72 ff. for the whole of these events.

[6] Jones, *Cities*, 125 ff.; Pauly II A, 1257; Polybius, see above.

[7] Jones, see above and 28; 'The oldest signs of Greek culture are the Persian coins of Aspendus and Side' (Pauly, XVIII, 354).

[8] Plutarch, *Moralia*, 328 D.

[9] See particularly W. W. Tarn, *Alexander the Great and the Unity of Mankind*, 123 ff.

[10] Quintus Curtius, X, 3, 12–14; and VIII, 8, 12.

[11] „ „ IV, 10, 23.

[12] „ „ V, 2, 13–15

[13] „ „ VI, 5, 5.

CHAPTER 9

[1] Herodotus, VIII, 137.

[2] W. W. Tarn, *Alexander*, I, 146.

CHAPTER 10

[1] Spratt, I, 185–189.

[2] Pherecydes of Syros, 7th or 6th century B.C.

[3] W. W. Tarn, *Alexander*, II, 319 ff.

[4] Polyaenus, 44, 347; and 60, 359.

[5] Diodorus, XIX, 11, 7; and XIX, 67, 2.

[6] Quintus Curtius, III, 3, 23; Xenophon, *Cyropaedia*, III, 1, 8; Plutarch: *Life of Artaxerxes*, 445.

References

7 Quintus Curtius, V, 2, 20 ff.; Plutarch, *Moralia*, 818 B.

8 Spratt, I, 198. For Schönborn see Ritter; Erdkunde IX, II 742–3, and 804.

9 Spratt, I, 167–72.

10 Menander, *The Girl from Samos*, 139.

11 Benndorf, *Reisen*, 145.

CHAPTER 11

1 Adolf Ansfeld, *Der Griechische Alexanderroman*, 82.

2 Fraser and Bean, *The Rhodian Peraea*, 131.

3 Spratt, I, 200. Schönborn.

4 Magie, see chapter 14, note 1.

5 Strabo, XIV, 3, 3.

6 Spratt, I, 35 ff.; Benndorf, 139 ff.; Fellows, 177 and 316; Myres, 94.

7 Spratt, I, 52 ff.

8 Spratt, I, 289 ff. Fellows' location was found to be mistaken.

CHAPTER 12

1 *Iliad*, XVI, 286, line 152.

2 Rostovtzeff, I, 228.

3 W. W. Tarn, *Hellenistic Military and Naval Developments*, 122–52; Cecil Torr, *Ancient Ships*, 34.

4 Quintus Curtius, IX, 6, 22.

5 *The Mediterranean Pilot*, V. (1950), 144.

6 *Athenaeus*, XII, 537 E and F.

7 *Camb. Anc. History*, VI, 480 ff.; W. W. Tarn, *Alexander*, II, 42 and 297.

8 Plutarch, *Alexander*, 498.

CHAPTER 13

1 Appian, *Syrian War*, IV, 82.

2 *Athenaeus*, VIII, 333 D; Rott, 342; Spratt, I, 135–37.

3 Dr. Tritsch, *Anatolian Studies*, Vol. II, 18 (1952).

4 Livy, XXXVII, 45, 2.

5 Polyaenus, V, 42, 226; Pauly, XIX, 2.

6 Arrian, VII, 16, 2; VI, 1, 4–6; Quintus Curtius, V, 4, 2.

7 Spratt, I, 15; I, 139–57.

References

CHAPTER 14

1 For the highway: Ramsay, *Historical Geography*, 45–6, 49; Magie, I, 241 and 265 and notes; Cousin, 271; Herodotus, I, 78 and 84 (for Telmessus).

2 Magie, see above 241.

3 Livy, XXXVII, 56, 4; Polybius, XXI, 46, 48, 2.

4 Livy, XXXVIII, 14, 3 ff.

5 Magie, I, 242.

6 Spratt, I, 181.

7 Spratt, I, 264–71; Strabo XIII, 4, 17.

For Alexander's route see Schönborn (Ritter's *Erdkunde* IX, II, p. 838) who describes the track West of Elmali as impassable on 17th Feb., while the plateau north of the Xanthus valley was partially clear of snow.

CHAPTER 15

1 Polyaenus, *Stratagems*, trans. R. Shepherd 1793, V, 44, 226 and VI, 49, 256.

2 E. R. Bevan, *The House of Seleucus*, I, 22.

3 Isocrates, *Philip*, 120.

4 Aristotle, *Politics* (Everyman trans.) Book VII, 7.

5 „ „ „ „ III, 13, 17; on Slavery, I, 2; 5; 6; VII, 10; see also Isocrates, *Nicocles*, 15.

6 A. H. M. Jones, *The Greek City*, 223–4.

7 Bevan, II, 265.

8 Plutarch, *Pyrrhus*.

9 Plutarch, *Alexander*, 503.

10 Quintus Curtius, V. 2, 20–22.

11 Arrian, VI, 29, 4 and 9; Quintus Curtius, VII, 6, 20 and 3, 3; *Camb. Anc. History* VI, 13, 390; Plutarch, *Moralia* (Loeb), 246.

12 Xenophon, I, 6, 25; II, 6, 8; Arrian, VI, 26, 1–3.

13 Xenophon, VII, I, 2; V, 2, 19; Arrian, VII, 9, 8; V, 26, 7.

14 Xenophon, V, 3, 46; Arrian, II, 10, 2.

15 Xenophon, III, 3, 39; Arrian, III, 9, 5–6.

References

[16] Xenophon, V, 4, 18; VIII, 2, 24; I, 6, 12; Arrian, II, 12, 1; Plutarch, *Alexander*, 500 and 468.

[17] Xenophon, VII, m. 4; Quintus Curtius, III, 10, 3; Arrian, II, 10, 1.

[18] Xenophon, III, 3, 45; Plutarch, *Alexander*, 492.

[19] Xenophon, I, 2, 10; VIII, 3, 24 and VI, 2, 6; I, 4, 4; Plutarch, *Alexander*, 500 and 482; Arrian, VIII, 18, 11; Plutarch, *Moralia*, 181, 28.

[20] Xenophon, V, 1, 29; VIII, 2, 13; VII, 5, 35; V, 1, 1; Plutarch, *Moralia*, 178, 18 and 21; Plutarch, *Alexander*, 576; Plutarch, *Moralia*, 179, 7; Plutarch, *Alexander*, 483 and 498.

[21] Xenophon, VIII, 2, 3; Plutarch, *Alexander*, 488 and 483.

[22] Xenophon, VII, 5, 15; Arrian, IV, 3, 2.

[23] Xenophon, III, 2, 12; Plutarch, *Alexander*, 515.

[24] Xenophon, V, 4, 13; IV, 2, 8; Quintus Curtius, 11, 299.

[25] Xenophon, III, 1, 30; Arrian, III, 5, 4; and Quintus Curtius, VI, 3, 10 on same subject.

[26] Xenophon, VIII, 6, 3; W. W. Tarn, *Alexander*, 29 and 128. Compare also Xenophon VIII, 6, 8 and VII, 4, 2 for Cyrus' treatment of those who voluntarily helped him.

[27] Xenophon, VI, 1, 47; VI, 4, 7; V, 1, 14; Arrian, IV, 19, 6; Plutarch, *Alexander*, 481–2.

[28] Xenophon, II, 2, 26; II, 1, 15 and 19; Quintus Curtius, I, 345; Arrian, VII, 6, 3–5; Quintus Curtius, II, 495–7.

[29] Xenophon, VII, 2, 24; Arrian, III, 3, 2.

[30] Xenophon, VIII, 3, 14; Arrian, IV, 11, 9; Quintus Curtius, VIII, 5, 5.

[31] Xenophon, VIII, 7, 25; VII, 2, 9–10; VIII, 7, 25; Plutarch, *Moralia*, 180, 15 and 330, 8.

[32] Xenophon, VIII, 5, 24; Arrian, VII, 11, 9; Plutarch, *Moralia*, 329, 6.

[33] Glover, *Pericles to Philip*, 367; Spratt, I, 306; Jones: *Cities*, 96–100; Rostotzeff, I, 154; Hall, *The Civilization of Greece in the Bronze Age*, 60; Bevan, I, 84.

[34] Aristotle, *Politics*, VII, 11 and 12; Th. Fyfe, *Hellenistic Architecture*, 158 ff.

[35] Plutarch, *Pelopidas*, 147.

[36] Now in Istanbul Museum.

References

CHAPTER 16

[1] Spratt, I, 48.

[2] Athenaeus, III, 124.

[3] Magie, II, 1122; see also Hoskyn, *R.G.S. Journal XII.*

[4] Diodorus, XVIII, 26, 2.

APPENDIX I

[1] The following works have been used and are quoted by the names of their authors: Arrian, *Anabasis* (Loeb); Plutarch, *Life of Alexander* and *Moralia* (Loeb); Strabo, XIII and XIV (Bohn); Q. Curtius, *Alexander* (Loeb); *Diodorus Siculus*, anon. translation (London, 1700); W. W. Tarn, *Alexander* (Cambridge) 1948, and in *CAH*, VI (1927), cc. 12–15; D. Magie, *Roman Rule in Asia Minor* (Princeton, 1950); E. R. Bevan, *House of Seleucus* (1902); W. M. Leake, *Journal of a Tour in Asia Minor* (London, 1824); T. A. B. Spratt and E. Forbes, *Travels in Lycia, Milyas and Cibyritis* (London, 1847); Charles Fellows, *Travels and Researches in Asia Minor* (London, 1852); Carl Ritter, *Die Erdkunde von Asien*, IX, pt. 2 (Berlin, 1859).
I wish to express my especial thanks to Dr. G. T. Griffith for his kindness in reading this paper, checking references and correcting mistakes, and to Prof. Gomme and Mr. G. Bean too for their help.

[2] Arrian, I, 17.3 to II, 7.3; Plutarch, *Alex.* 17–19; Curtius, III, 1 and 4–7; Diodorus, XVII, 21.7–31.

[3] From p. 17 to 24 of his *Alexander*, and in *CAH*.

[4] *CAH* 360. Cf. Plutarch, 17.3.

[5] Fellows, 276; Magie, 85.

[6] Plutarch, 10.1–4.

[7] *Moralia*, 180a (Alexander, No. 9).

[8] Magie, 1375, n. 15; also E. Kalinka, *Zur historischen Topographie Lykiens*, Vienna, 1884, p. 39, for copy of inscription.

[9] Polyaenus, *Strat.* v. 35; *CAH* VI, 364.

[10] Plutarch, 52.2.

[11] P. 761; cf. Bevan, I 83 and 93 (quoting Forbiger, *Handb. der alten Geographie*, II, 323).

[12] Suggested by Spratt, I. 266. (It should be added that in Ptolemy 'Αρύκανδα is an emendation, though almost certain, of 'Αραβένδαι.)

[13] Tarn, *Alexander*, II, 177.

References

[14] *Historical Geography*, 45–6; cf. Magie, 241 and 1138.

[15] Strabo, XIV, 3.4, p. 665. Cf. Magie, note on p. 762.

[16] Magie, p. 1122, quoting G. Bean's inscription.

[17] Magie, 522.

[18] A. H. M. Jones, *The Cities of the Eastern Roman Provinces* (Oxford, 1937), 105.

[19] Spratt, 252; cf. Magie, 1374; Mr. G. Bean is publishing a paper in the B.S.A. which I have not yet been able to see. He points out that the so called 'Lycian' tombs, overlapping into Caria and Pisidia, need not necessarily be of Lycian origin.

[20] 'Pisidian' is Stein's conjecture, to fill an obvious lacuna; and λυκιο-εργέας is an old conjecture found in Athenaeus, V, 486. (Both are accepted by Powell in his translation.)

[21] Magie, 519.

[22] Isium, according to Fellows, 363.

[23] This place name, Φοινίκη, is correctly translated by Langhorne, but the Everyman edition (which is taken from Dryden) gives 'Phoenicia', which is impossible; so does the Loeb translation, with the order 'Cilicia and Phoenicia'. Plutarch's 'as far as Phoenice and Cilicia' is a natural way, I think, of describing a route which went *via* Finike to Side on the Cilician border (see p. 253); the Phoenician coast was far away and the capture of Tyre a year ahead with Issus in between. Prof. Gomme, however, suggests that there is some doubt whether Phoenice, i.e. the town on the site of Finike, or Phoenicia was intended by Plutarch (or his authority). Alexander's march led him from Phoenice—little known in his day—to the borders of Cilicia; but this detail might easily have been overlooked in Plutarch's time and the well-known Phoenicia be taken for granted. [Plutarch's words are ἠπείγετο τὴν παραλίαν ἀνακαθηράσθαι μεχοι τῆς Φοινίκης καὶ Κιλικίας.]

[24] A Schönborn's work, *Der Zug Alexanders durch Lykien*, published in 1849 in Posen, I have not been able to see. But the account of his travels in C. Ritter's *Erdkunde von Asien*, IX, Part II, 560 ff., shows that he also, though with misgivings, brought the Macedonians down from Elmali and Arycanda.

[25] See Spratt, II, 11–12 for Daniell's view; and *ibid.* I, 203–7. For Schönborn see previous note.

References

[26] Strabo, XIV, 4.1 mentions a Thebe and a Lyrnessus between Phaselis and Attaleia, but apparently in Pamphylia. Their sites have not yet been discovered.

[27] Arrian, I, 25.9.

[28] Plutarch, 17.6–8; Arrian, I, 26.1–2; Strabo, XIV, 3.9. (The sentence in the text is a combination of these passages; for the three give different versions, the picturesque detail coming from Plutarch and Strabo. Arrian's account as usual is the most sober. It was obviously a small incident which, because of its colourful setting, lent itself to later embroidery.)

[29] Telmissus in the translation, and the MSS. of Arrian give it too.

[30] The Loeb translation has 'up to the road', which may mislead. I am told that 'as far as' is in fact the meaning.

[31] Heberdey in *RE* v.A (1934), *s.v.* Termessos, 739; Spratt, I, 233–8.

BIBLIOGRAPHY

ALEXANDER

Adolf Ansfeld: *Der Griechische Alexanderroman.* Leipzig, 1907.

Arrian: (Loeb).

Cambridge Ancient History, Vol. VI.

Quintus Curtius: (Loeb).

Diodorus Siculus, Books XVII and XVIII. London, 1700.

J. G. Droysen: *Alexandre Le Grand.* Paris, 1934.

Plutarch: *Lives* (Everyman).

Plutarch: *Moralia:* (Loeb).

Ch. A. Robinson: *The Ephemerides of Alexander.* Providence Brown University, 1932.

W. W. Tarn: *Alexander The Great and the Unity of Mankind.* Proc. Brit. Acad, XIX, 1933.

W. W. Tarn: *Alexander.* Cambridge, 1953.

Ch. de Ujfaloy: *Le Type Physique d'Alexandre Le Grand.* Paris, 1902.

BACKGROUND (CLASSICS)

Appian: (Loeb).

Aristotle: *Oeconomica* (Loeb).

Aristotle: *Politics* (Everyman).

Athenaeus: (Loeb).

Herodotus: (Loeb).

Iliad: (trans. by A. Lang, W. Leaf and E. Myers). London, 1949.

Isocrates: (Loeb).

Pliny: *Natural History* (Loeb).

Polyaenus: *Stratagems.* Trans. by R. Shepherd. London, 1793.

Polybius: (Loeb).

Strabo: (Loeb).

T

Bibliography

BACKGROUND (GENERAL)

Anatolian Studies: Brit. Inst. of Archaeology at Ankara, 1952 ff.

M. Biener: *The Sculpture of the Hellenistic Age*. New York, 1955.

Byzantium: Edited by N. H. Baynes and H. St. L. B. Moss.

W. B. Dinsmoor: *History of Greek Architecture*. London, 1950.

Th. Fyfe: *Hellenistic Architecture*. Cambridge, 1936.

Th. Gomperz: *Greek Thinkers*. London, 1949.

H. R. Hall: *The Civilization of Greece in the Bronze Age*. London, 1928.

J. L. Myres: *Who Were the Greeks?* London, 1949.

H. A. Ormerod: *Piracy in the Ancient World*. London, 1924.

H. W. Parke: *Greek Mercenary Soldiers*. Oxford, 1933.

B. C. Rider: *The Greek House*. Cambridge, 1916.

C. Ritter: *Die Erdkunde von Asien*. Band IX, *K ein-Asien* II. Berlin, 1859.

M. Rostovtzeff: *Social and Economic History of the Hellenistic Age*. Oxford, 1953.

W. W. Tarn and G. T. Griffith: *Hellenistic Civilzation*. London, 1952.

Cecil Torr: *Ancient Ships*. London, 1894.

S. Toy: *A History of Fortification*. London, 1955.

R. E. Wycherley: *How the Greeks built Cities*. London, 1949.

BACKGROUND OF CITIES

E. R. Bevan: *The House of Seleucus*. London, 1902.

J. A. Cramer: *A Geographical and Historical Description of Asia Minor*. Oxford, 1832.

W. Heyd: *Commerce du Levant*. Leipzig, 1923.

A. H. M. Jones: *The Greek City from Alexander to Justinian*. Oxford, 1940.

A. H. M. Jones: *Cities of the East Roman Provinces*. Oxford, 1937.

D. Magie: *Asia Minor under the Romans*. Princetown, 1950.

Murray's Handbook, 1878.

Pauly-Wissowa-Kroll: *Real Encyclopaedie der Class. Altherthunes-wissenschaft*.

W. Ramsay: *Historical Geography of Asia Minor*. London, 1890.

Charles Texier: *Asie Mineure*. Paris, 1862.

The Mediterranean Pilot, Vol. V. 1948.

Bibliography

FOR PART I

A. Janke: *Die Schlacht bei Issus*: in Klio, X, 1910 (Leipzig).

A. Janke: *Auf Alexander's des Grossen Pfaden*. Berlin, 1904.
These two dissertations may be studied for the siting of the battle of Issus (with excellent plans of the coast). They uphold the Deli Chay as against the Payas advocated by Delbrük, etc.

F. W. Ainsworth: *Travels and Researches in Asia Minor*. London, 1842.

Ansbert's *Chronicle in Bibliotheque des Croisades*. Paris, 1829.

F. Beaufort: *Karamania*. London, 1817.

J. T. Bent in *J.H.S.* XII (1891); XI (1890); and *R.G.S. Journal* XII, 1842.

C. R. Cockerell: *Travels in S. Europe and the Levant* 1810–17. London, 1903.

Georges Cousin: *Kyros le Jeune en Asie Mineure*. Nancy, 1904.

E. J. Davis: *Life in Asiatic Turkey*. London, 1879.

M. Gough: *The Plain and the Rough Places*. London, 1954.

G. L'Estrange: *Lands of the Eastern Caliphate*. Cambridge, 1905

Kinnear: *Journey through Asia Minor, Armenia and Koordistan*, 1813–14. London, 1818.

Livy: (Loeb).

Lucan: *Pharsalia*.

S. Runciman: *A History of The Crusades*. Cambridge, 1951–54.

Sissouan ou L'Armeno-Cilicie. Venice, 1899.

Xenophon: *Anabasis*: (Loeb).

FOR PART II

F. Beaufort: see above.

Cicero: *The Verrian Orations*: (Loeb).

Langkoronski: *Städte Pamphyliens*. Vienna, 1892.

W. M. Leake: *Journal of a Tour in Asia Minor*. London, 1824.

G. L'Estrange, see above.

H. Rott: *Kleinasiatische Denkmäler aus Pisidien, Pamphylien, Kappad. u. Lykien*. Leipzig, 1908.

J. L.Schönborn, in Ritter *Erdkunde, Kleain-Asien*, II, 738 ff., or *Programm d. Öffent l. Prüfung d. Schüler des K. Friedr.-Wilhelms Gymnasium zu Posen 11 April 1843*. Posen, 1848.

Bibliography

T. A. B. Spratt and E. Forbes: *Travels in Lycia*. London, 1847.

R. Paribeni: *Annuario R. Sc. Archaeol. in Atene e delle Missioni Italiane in Oriente*, III (1916–20).

FOR PART III

O. Benndorf and G. Niemann: *Reisen in Lykien und Karien*. Vienna, 1884.

C. R. Cockerell: see above.

C. Fellows: *Travels and Researches in Asia Minor Caria and Lycia*. London, 1852.

Hoskyn in *R.G.S. Journal* XII. 1842.

Kalinka: *Zur Histor. Topographie Lykiens*: Kiepert Festschrift.

Livy: (Loeb trans.) see above.

C. T. Newton: *Colnaghi's Journal Travels and Discoveries in the Levant*. London, 1865.

Schönborn, see above.

Tritsch: in *Anatolian Studies*, see above.

Xenophon: *Cyropaedia* (Bohn).

INDEX

Abdastart, 113

Abdurrahmanlar, 65, 68

Acalissus (now Asarköy), 138–9, 143, 251, 258

Achaeus, 111–12

Achaia and Achaians, 27, 64

Achelous, river, 135

Ada (Queen of Caria), xix, 202, 230, 234–6

Adalia (see Antalya).

Adana, 8, 12

Adramyttium, xvii

Adrianople, 49

Aegean Sea, 5, 20, 71, 141, 167

Aeolis, 199

Agesilaus, xxiii

Agha Liman, 28–9, 257

Ağlason (formerly Shakalsha, Sagalassus), 94, 99–102, 104, 237, 255, 257

Agrianes, 102–3

Ak Chay, 157, 214, 240

Ak Dagh (formerly Mt. Massicytus), 138, 142–4, 150, 158, 166, 171, 185, 197, 212, 241, 251

Akpinar Dagh, 257

Alabanda, 232–5

Alaeddin (Karamanli), 36, 49–50

Alağır Chay, ix, 77–8, 80, 82, 127, 129–45, 148, 247–51

Alaja Dagh, 148, 168, 174, 178, 182, 247

Alaja Yaila, 179

Alanya (formerly Coracesium, Candelore), 37, 42–4, 47–52, 54, 58, 257

Alaouites, 45

Alcetas, 91–2

Aleppo, 3, 50, 144, 159

Alexander the Great, xvi–xxiii, 3–7, 10, 12, 16, 18–20, 22, 26, 33–5, 41, 50, 55, 58, 60–1, 63–5, 67, 74, 76, 80–2, 84–5, 87, 89–91, 94, 99–100, 102–4, 113–15, 127–32, 134–9, 142, 144, 146, 155–7, 161, 166, 168–72, 174, 176, 179, 181, 183, 185–8, 191, 195–6, 198–211, 214–15, 217, 224–5, 229–56; character of, vii, 114–15, 134–6, 202, death of xxii, 64, 128–9 ideal of a united world, 114, 128, 201, 209, 225, 235; march from Miletus to Phrygia, 229–56

Alexandretta (Iskenderun, formerly Myriandus), xv, 4, 8, 45, 146

Alexandria, 58, 167, 184, 225, 237

Alinda, xix–xx, 234–5

Amanus river, 4, 7,

Amaury, 43

America and Americans, 5, 30, 68, 79, 84, 87, 125

Ammon, xxii

Amphilocus, 137

Amuk, 3, 8

Anamur (formerly Stamené), ix, 23, 25, 33, 35–7, 39–44, 54, 68, 257

Anatolia, xvii, 58, 60, 141, 148, 150, 154, 171, 185–6, 229, 238

Andrakı (formerly Andriace), 175, 247

Andria, 119

Andriace, 175, 247

Andricus, Mount, 42

Anemurium, 38, 40

Ankara, 60, 140, 163

Antalya or Adalia (formerly Attaleia), ix, 41, 43, 48–9, 52–3, 58, 60–1, 65, 68–74, 78, 83, 87, 89–90, 94, 96, 98–9,

Index

Antalya (*continued*)
105, 121–3, 140, 147, 153, 157, 177, 185, 197–8, 240, 253–4, 257–8
Antigonus, 92, 238
Antiocheia ad Cragum, 43, 257
Antiochus I, 232
Antiochus III, the Great, 27, 43, 111
Antiochus VII, 48
Antiphellus (now Andifilo or Kash), 119, 163, 170
Antony, Mark, 17, 27, 159, 198
Apameia, 237
Aperlae, 119
Arabia and Arabs, 3, 10–11, 17, 19–20, 28, 32, 45–6, 50, 60, 109, 122, 141, 162, 245
Arabis Su, 58
Araxa (now Örenköy), 60, 193, 212–15, 217, 240–2
Ardachan, 126, 248
Ariassus (now Bademağachı), 93, 99–100, 255, 257
Aristander, xvii, 181, 202, 236–7
Aristotle, xvii, xx, xxiii, 200, 210–11, 232, 235
Armenia and Armenians, 5, 29, 33, 36, 42–3, 206; Leo II, 29, 43; Peter I, 43; Rupenian dynasty, 33; Sir Adan, 42
Armutlu, 157, 244
Arneae (now Ernes), 161, 244
Arrian (quoted), vii, xvi–ii, xix–xx, xxiii, xxv, 3, 7, 10, 13, 41, 55, 64, 73, 81, 89–90, 94–5, 102, 104, 121, 131, 134, 146, 160, 185, 199, 203, 208, 229–31, 233, 235, 237, 241, 243–4, 248–9, 253–6
Arsa, 157
Arsinoe, 35, 43
Artabazus, 115, 207
Artaxerxes, 135
Artemisia, 234
Arycanda (now Aykırchà), 127, 137–8, 140, 144–5, 147–9, 156, 161, 166–7,
177, 179, 181, 184, 187, 198, 238, 244, 247–8, 251
Arycandus river, 119
Arymagdus valley, 36, 38
Asar Veya Hisar, 170
Asarköy (formerly Acalissus), 139–40, 258
Ascania (now Burdur) Lake, 103, 255
Asia, xvii–xx, xxii–iii, 15, 19, 47–8, 62, 113–15, 129, 137, 139, 141, 149, 160, 186, 191, 200–3, 205, 222–5, 229–32, 235, 238–9
Asia Minor, xvii, 48, 202, 229–30
Aspendus (now Balkız) and Aspendians xix, 57, 59–67, 111, 113, 244, 253–4
Assyrians, 26
Ataturk, 122
Athenaeus (quoted), 1
Athens and Athenians, xviii, 26, 201, 256
Attaleia (later Satalya, now Antalya), 41, 43, 48, 57, 98, 240
Attalus of Pergamum, 57, 94, 98, 198, 253
Augustus, Emperor, 99, 128
Avullu, 169
Aykırchà (Arycanda), 258

Babylon and Babylonia, 35, 129, 205, 207, 256
Bactria, 35, 91, 115, 207, 225
Bademağachı (formerly Ariassus), 93–4, 99–100, 255
Bafa lake, 232, 234
Bağlıja, 169
Bahche pass, 4, 7, 10
Bakırlı, mountain, 80
Balbura, 190–1, 193–4, 198, 211, 214, 240–2
Balfour, David, 74, 94, 188, 191
Balkız (formerly Aspendus), 57, 59–67, 111

Index

Baraket, 185
Barbarossa, 23
Bargylia, 232
Bashgöz Chay (formerly Arycanda valley) 147, 244; river, 150
Baskey, 257
Bean, George, vi, 110, 158, 180–1, 217
Beaufort, Captain (traveller), 13, 18, 28, 32, 58, 85, 198
Bedala gorge, 213
Beida Dagh, 185
Beldibi, 85, 87
Benndorf (traveller), 161
Bent (traveller), 18
Berenice, 43
Besh Konak, 105–6, 257
Beydagh range, 80, 93, 251
Bijikli, 98
Bitter River (Picrum Hydor), 18
Black Sea, 49, 130
Bodrum (formerly Castabala), ix, 3, 8–12, 27
Bogazköy (Susuz on map), 258
Bonjuluk, 38
Boucicaut, Marshal, 48
Bozburun, 105, 108, 112, 117
Boz Yazı, 35
Brundisium (now Brindisi), 26
Bubon (now Ibejik), 190, 193–4, 198, 213–14, 217, 240, 242
Bujak, 257–8
Burdur (formerly Ascania), 95, 103, 254–5, 257
Büyük Chay (Kara), 36
Byzantium and Byzantine, 11, 17–19, 28, 33, 39, 52–3, 59, 65–6, 96–8, 122, 162, 167, 170, 192, 211, 245

Cadusians, 206
Cadyanda (now Üzümlü), 198, 213–14, 217, 236, 240–2
Calabria, 28

Calandro (now Kaladeré), 41–2
Calycadnus (now Gök Su), 16–17, 20, 23, 25–7, 29, 54
Calymnos, 28
Calynda, 198
Cambyses (quoted), 209
Candelore (now Alanya), 42, 47–52, 54
Candyba (now Gendova), 161, 244–5
Canning, 49
Cappadocia, 238
Caralitis lake (Sögüt Göl), 239, 241–3, 252
Caria, i, xviii–xx, 60, 187, 215, 218–21, 230, 232–6, 242, 256
Cassander, 171
Castabala (now Bodrum), ix, 3, 8–12, 27
Castellorizo, 166–7
Caunus, 198, 220, 235, 256
Cavaliere, Cape, 28, 257
Cecil, Lord David, vi
Celaenae (now Dinar), 103, 224, 255
Celenderis (now Kilinderé), 33
Ceramic Gulf, 235
Cestrus river, 59
Chakraz, 97
Chalbalı, 80, 185
Chaltıjık, 85
Chandır river and villages, 80–2, 142, 249–52
Chandler (traveller), 233
Charadrus (see Kaladeré), 257
Charimenes, 180
Chelidonia, ix, xv–vi, xxi, 52, 73, 84, 121, 124–5, 127, 129, 132, 138, 155, 184, 192, 247, 258
Chilakka (Assyrian), 26
Chimaera, Mount, 119, 123, 125, 198
Chiné, 223
Chinnock, E. J. (quoted), 102
Chitdibiköyu castle, 250
Chivril, 221

Index

Choma, 188, 198, 238, 245

Christianity and Christians, 11, 22, 28, 48–9, 57–8, 68, 91, 98, 129, 133, 153

Chukurbagh, 164–6, 168

Cibyra (Horzum), 155–6, 186–7, 190–2, 195, 237, 239–43, 245, 252, 254–5

Cibyritis, xv, 91, 187, 190, 193, 217; Manlius Vulso, 91

Cicero, 61–2

Cilicia and Cilicians, i, ix, xvi–ii, xxi, xxv, 3–54, 61, 167, 250, 255

Cilix (Phoenician), 26

Cillus, 26

Cimon, 62

Clarke, Dr. (traveller), 91

Cleitus, 237

Cleopatra, 17, 159

Climax, Mount, ix, 73–88, 122, 124, 138, 142, 248, 251–2

Cnidus, 235, 256

Cochrane, Hilda, 191

Cockerell, Mr. (traveller), 28, 49–50

Colnaghi (traveller), 161–2

Coracesium (now Alanya), 37, 42–4, 47–52, 54

Corinth, xix, 19

Corycus, 16–18, 20, 28, 43, 257

Corydalla (now Hajjivella), 119, 127, 132, 136, 138, 198, 247–8, 258

Cratesipolis (wife of Polyperchon), 135

Cremna, 99

Crete and Cretans, xvii, 27, 236, 238

Crimean War, 13

Croesus, 209

Crusades and Crusaders, 11, 17, 28, 33, 36, 39, 42, 49, 54, 57, 97–8, 224

Curtius (quoted), 7, 10–11, 102, 203, 206, 229

Cyaneae (now Yavı), 170, 172, 245

Cydna, 198

Cydnus river, 12

Cyme and Cymaeans, 41

Cynane (sister of Alexander), 135

Cyprus and Cyprians, 25, 30–1, 33, 36–7, 43, 49, 58, 167, 231; Peter I, 43, 58, 73

Cyrene, 34

Cyropaedia, 203, 205, 208

Cyropolis, 205

Cyrus, xxiii, 5, 15–16, 115, 203–9, 232

Daketüzü, 38

Dalaman Chay (formerly Indus river), 190, 219, 236

Damietta, 58

Damlajık Burnu, 86

Daniell, Mr. (traveller), 69, 80–2, 84, 87, 104–5, 198, 217, 249

Darius, xviii, xx, 3–4, 6–7, 10–11, 114–15, 136, 203, 206–7, 238, 255–6; battle against Alexander, 3–8

Davis, E. J. (traveller), 18, 259

Davis, Peter (botanist), 77

Deli Chay (formerly Pinarus river), 4, 6, 156

Delos, 26

Delphi, 236

Demetrius, 180

Demirjideré, 234

Demre (formerly Myra), 28, 156, 158–9 161, 168, 170, 172, 174, 176–82, 244–5, 247, 258

Denizli (formerly Laodiceia), 218, 221, 223

Dere Agzı, 161–2; Byzantine basilica, 162

Derme, 108

Dinar (once Celaenae), 103, 224, 237, 255

Dio Cassius, 27

Diocaesareia (now Uzunja Burj), 16, 21–2

Diodatus Tryphon, 48

Diodorus, 81, 92, 229, 251

Dirmil, 192, 194, 197, 213–14, 218, 238, 240–1, 243

Index

Domitian, 23
Dörtyol (near Issus), 6
Döşheme, 94, 96-8, 100, 255
Düden (formerly Catarrhactes) river, 59-60

Egypt and Egyptians, xviii, 34, 48, 57, 101, 143, 181, 255; Cairo, 49, 58, 151, 163
Elaeussa, castle of, 17
Elias, Khizr, xxi-ii,
Elmalı, 130, 137-8, 143, 147, 150, 152, 155-6, 158, 161, 177, 184-8, 194, 197, 223, 242, 244-5, 248, 251-2, 258
England and English, 3, 20, 40, 54, 76, 114, 122, 131, 137, 151, 177, 202, 214, 219
Epaminondas, xxiii
Epidaurus, 63
Epyaxa, Queen of Cilicia, 10
Ermenek, 36
Ernes (formerly Arneae), 148, 161, 244, 258
Erzinjan, 8, 125
Eski Hisar (formerly Rhodiapolis), 137, 188-9, 232, 245, 247, 258
Eumenes of Pergamum, 186, 240
Euphrates, 256
Euripides, 63, 113
Euromus, 232
Europe, 19, 39, 134, 202
Eurydice, 135
Eurymedon river, 59, 105, 108, 253

Fellendagh mountain, 165
Fellows, Sir Charles (traveller), 75, 149, 156, 161-2, 174, 179, 182-3, 198, 217, 245, 247
Fethiye (Telmessus), 185-6, 191, 194, 196, 198, 211-14, 217-18, 222, 235
Fıdık Köy, 35

Finike, x, 28, 127, 131, 140, 146, 155-7, 174, 177, 183-4, 247, 258
Forbes, Cmdr. (traveller), 78, 131-2, 137, 174, 179, 183-4, 187, 198, 245, 247, 249

Gagae (Yenije-Köy), 119, 131-3, 248, 258
Gallipoli, 49
Galonoros or Candelore (now Alanya), 42
Gaugamela, 204, 230, 236
Gaza, 237
Gedelle, 83
Gedrop, 158
Gedrosia and Gedrosians, 113, 204
Gendova (formerly Candyba), 161, 168, 244
Genoese, 49, 80, 83, 87
Georgics, 28
Ghalib Bey, 50-1
Ghazi Pasha (or Selinti) river, 43-4, 46-7, 257
Gödeme, 140, 142, 248
Gök Derè, 83
Gök Su valley (formerly Calycadnus), 16, 20, 23, 25, 29, 54
Gölbashi (formerly Trysa), 172-3, 247
Gömbe, 144, 158-9, 163, 177, 189, 195, 197, 199, 258
Gordium, xvi, xxi, 103, 224, 255
Gough, Michael and Mary, 18
Göynük path, 85
Granicus, xviii, xx, 203, 229, 231, 235
Greece and Greeks, xv, xviii, xx, 8, 11, 17-20, 23, 27, 31, 34, 42-3, 47, 49, 53-4, 58, 60, 62-3, 66, 71, 75, 90, 97-8, 106, 108, 110, 113-15, 127, 134, 141, 149, 159, 162, 175, 192, 199-200, 202, 210, 230-1, 256
Griffith, Dr. Guy, vi, 250-1
Gügübeli pass, 188, 199

Index

Güllük, 90
Güllük Yenije Kahvesi, 257
Gulnar, 25, 30

Hadrian, 58, 69, 99, 170, 192
Haifa, 49
Hajıoglan valley, 166
Hajjivella (formerly Corydalla), 119, 127, 136, 247, 258
Halicarnassus (now Bodrum), xvii–ix, 155, 220, 232–6, 238, 247
Hamadan, xxi
Hamilton (traveller), 198
Harakilise Arana, 41
Harpalus, 234
Havazönü, 78–9, 82
Heberdey (traveller), 18
Hecataeus, 42
Hecatomnus, 233
Hellenic Studies, Journal of, vi
Hellespont, the, xvii, 34, 231
Hephaestion, 119, 205, 210
Heraclea, 232
Heribert-Grubitch, Prof. and Mrs., 92
Herodotus (quoted), 26, 128, 238, 242–3
Hidrieus, 234, 236
Holmi, 30, 43
Homer, 58, 63–4, 79, 113, 192
Homosexuality, 134
Horzum Chay and Horzum, 185, 192–3, 237–8
Hoskyn (traveller), 198
Hyparna, 235
Hyrcanians, 206
Hystaspes, 208

Ibejik (formerly Bubon), 190, 194, 213–14, 218, 240
Ibn Batuta, 48, 57
Idebessus (now Kazaağachi) 138, 140, 142, 251, 258

Imbaros, Mount, 29
India and Indian Ocean, xxii, 20, 35, 54, 151, 181, 201, 214, 225
Indus river (now Dalaman Chay), 181, 241
Injealılar (formerly Oenoanda), 190, 194, 240
Inje-kara, 46
Injirji Kahvesi, 93
Injirköy, 214
Ionia, xv, 190
Isinda (see Korkuteli), 237, 239, 242, 251–3, 255
Islam, 5, 10, 36, 45
Iskenderun (see Alexandretta), xv, 4, 8, 45, 146
Ismail Bey, 105, 124, 177
Isocrates, xx, xxiii, 200, 235
Isparta, 101
Issus, ix, xviii, xxi, 3–11, 103, 202, 204, 225, 229–32
Istanbul, 32, 43, 52, 106, 153, 177, 184, 194
Istanoz Chay, 237
Italy and Italians, 25, 30, 49

Jaouristan (Acalissus), 251
Jihan (*see* Pyramus river), 9–11
Jirali (*see* Olympus), 248
Julian the Apostate, 12
Justinian, 11

Kaladeré (formerly Charadrus or Calandro), 41–3, 257
Kalkan, 166, 168, 170
Kara river (formerly Arymagdus), 36; Kara Dagh, 83, 108
Kara Bel, 241
Karabuk, 139
Karaman (*see also* Labranda), xvii, 16, 22, 31–2, 36, 74, 83, 255

Index

Kardich forest, 143
Karpuz Chay, 234-5
Kash (formerly Antiphellus), 161, 163-4, 168-70, 258
Kassaba, 148, 158-61, 163, 167, 179, 181, 244-5, 258
Katara, 191, 240
Kedialma hamlet, 77, 248
Kekova, 158, 168, 170
Kelebek Dagh, 191
Kemer, 74, 76-8, 83-5, 87, 212, 215-17, 241, 248
Keriz, 108
Kestel lake, 237
Kılıj Arslan, 57
Kilinderé (formerly Celenderis), 31-2, 43, 257
Kınık, 193
Kinnear (traveller), 18, 25
Kırkgöz, 59, 94, 97-8, 123, 258
Kızılman, Cape, 35, 257
Knights of St. John, 10, 29
Knolles, author of *Grimstone's General History of the Turks*, 25
Koehler (traveller), 98
Konia, 16
Korkuteli (nr. Isinda), 93, 181, 237, 239, 251-2, 257
Kovanlık, 258
Köyjeyiz lake, 236
Kozaağachı (formerly Idebessus), 140, 142, 251, 258
Közeli, 111
Kumluja, 127, 129-30, 133, 136-8, 247, 258
Kuru Chay, 6, 95

La'ara, 59, 61, 89, 257
Labranda (Karaman), xvii, 16, 22, 31-2, 36, 74, 232, 234
Lacedaemonians, 256
Lade, 230

Laertes, 47
Lagina (now Leyne), 232, 235
Lagon (Uzunkuyukahvesi), 59-60, 95-7, 257
Lajazzo (now Ayas), 48
Lamas river, 17-18, 257
Langkoronski, author, 104
Laodice, Pontic princess, 111
Laodiceia (now Denizli), 155, 185, 195, 239, 241-2, 255
Leake, Col. (traveller), 18, 31, 51
Leghorn, 30
Lentulus, 175
Limyra, 119, 127, 147, 155, 183, 247-8
Livy (quoted), 55, 176, 190
Loew (traveller), 198
Logbasis, 111-12
Lucan (quoted), xxv
Lucullus, 27
Luke, Sir Harry, vi, 94
Lusignans, 43
Lycia and Lycians, ix-x, xv-iii, 58, 64, 74, 76, 78, 80-2, 84, 119-225, 229-30, 235-48, 250-2; Lower Lycia, 243-8
Lydia and Lydians, 35, 122, 185, 192, 232, 237, 250
Lyrbe, 198
Lyrnessus, 58, 84
Lysander, xxiii

Macedonia and Macedonians, xvi, xix, xxi, xxiii, 4, 10, 18, 33, 59, 65-6, 75, 82-3, 86, 94, 103, 114, 128, 135, 139, 155, 171, 181, 187, 199, 201, 203, 207-10, 220, 224-5, 231-2, 234, 244, 250, 254-5
Maeander valley and river, 185, 220-1, 223, 230
Magie (author), 237
Magnesia, peace of, 27
Mallus, 64
Ma'mun, Caliph, 12

Index

Manavgat (formerly Melas) river, 53, 59, 105, 257
Manlius Vulso, 187, 190
Marmarensians, 250
Marmara, 198
Marmaris, 143
Marsyas gorges, 221, 223, 232, 234
Massicytus, Mount (now Ak Dagh), 119, 150, 155–6, 166, 189, 198, 241, 244
Mausolus, 113, 233–4
Medes, 206
Mehmet Bey, 54
Meleager (quoted), 212
Mellesh, 41
Melliköy, 96–7
Memnon (governor), xvii, 199
Menander, 141, 200
Mersin, ix, 8, 12–15, 37, 52, 257
Mesopotamia, 10, 35, 230
Milas (formerly Mylasa), 232–3
Miletus, xviii, 229–32, 234–5
Milyas and Milyans, 185, 199, 210, 237–8, 240, 242–3, 253
Mirza, the, xxi–iii
Missis (formerly Mopsuestia), 11
Mithridates, 27
Mithridatic Wars, 27
Mitylene, xvii
Mongols, 122
Mopsuestia (now Missis), 11
Müdürü (Nahiye), 104–6, 129, 194–5, 197, 212
Muğla, 218, 220–1, 225
Muhammad Ali, 11
Murena, 191
Murtana, 61
Muslim and Muslims, 36, 58, 68, 80
Mu'tasim, 11
Myceneans, xv
Mylasa (now Milas), 232, 234
Myndus, 236, 238, 244, 256

Myra (now Demre), x, 28, 119, 156, 161, 168, 174, 176–82, 197–8, 244, 247
Myriandus (near present Alexandretta)

Nagidus, 43
Naples, 17, 30, 153
Napoleonic Wars, 58
Nazilli, 223
Nearchus, xvii, 234, 236
Newton (quoted), 28
Nicopolis, 5

Oenium forest, 159, 177
Oenoanda (now Injealılar), x, 190, 193–4, 196–211, 213–14, 217, 240–2, 244–5
Ojaklı bridge, 6
Olba (now Ura), ix, 16–17, 22
Olbia, 58, 251, 253
Olivier (traveller), 18
Olympias (mother of Alexander), 135, 181, 203, 236
Olympus (now Jirali), 119, 127, 198, 248, 258
Opis, xx, 114
Örenköy (formerly Araxa), 60, 212–18, 240
Orontobates, xix, 234
Ossa, 76
Ostia, 26
Ottomans, 33, 35, 49, 152
Ovajık, 77–8, 108

Palestine, 35, 57
Pamphylia, ix, xv–i, xviii, xx, 27, 43, 48, 55–117, 138, 144, 155, 168, 186, 230, 235–242, 244–5, 247–56; defiles, ix, 89–103, 186; plain, ix, 57–72, 82, 186; rivers, 59–60
Panthea, 206
Parmenion, xxi, 10, 155, 186, 204, 224, 230–2, 238, 242, 252, 255; Nicanor, son of, 230

Index

Patara, 168, 176, 198, 237, 244
Parthia, 202
Payas, 5
Pednelissus (now Baulo or Bala), 111
Pelops, charioteer of, 26
Perdiccas, 91-2, 128
Pergamum, 112, 217
Perge, 55, 59-62, 65-6, 69, 89-90, 99, 104, 198, 252-5
Pericles the Lycian, 180, 210
Persia and Persians, xvii-xx, 3-7, 13, 16, 34-5, 61, 65, 113-15, 122, 135, 155, 160, 168, 181, 199, 203, 206-9, 224-5, 230-1, 234-6, 238, 255-6
Peucestas, 207
Phaeton, 31
Phaselis (now Tekirova), xvi-ii, xx, 27, 55, 59, 81, 87, 99, 104, 119, 126-7, 131, 146, 155, 157, 186-7, 198, 229, 241, 243-5, 247-52, 254-5
Phellus, 119, 165-7, 169, 172, 198, 245
Philip (father of Alexander), xviii-ix, xxiii, 34, 200-1, 230-1, 234, 236
Philip Augustus, 36, 42
Philoxenus, 134
Phoenice, 247-9
Phoenicia and Phoenicians, xviii, 167, 175, 231, 255-6
Phoenix, 84
Phrygia and Phrygians, 65, 89-90, 94, 155, 185-7, 215, 217, 224, 229, 238-9, 250, 253
Pinara, 198, 236-7
Pinarus river (now Deli Chay), 4, 6
Pırnaz, 214, 240
Pisa, 30
Pisidia and Pisidians, 58, 76, 81-2, 90, 92, 94, 101, 103-4, 138, 143, 185, 192-3, 210, 237, 240, 242, 245, 248-55
Pixodarus, 234-6
Platanistus, 42
Plato, 91, 201
Pliny, 29, 119, 237, 245

Plutarch (quoted), xix, 71, 196, 203, 229, 231, 235-8, 247
Pococke (traveller), 233
Podalia, 157, 238, 244
Polemus, 170
Polyaenus, 236
Polybius, 111
Polyclea (aunt of Alexander), 135
Polyperchon, 135
Polyxenides, 176
Pompey, 17, 27, 48
Provençal Island, 29
Ptolemy, 180, 230, 234, 238, 243-4, 250, 255
Ptolomeis, 53
Publisher (John Murray), III,
Pyramus (now Jihan) river, 9-11
Pyrrhus, 201

Ramsay (traveller), 187, 239
Rashat islet, 87
Redman, Mr. (British Consul), 4
Reis Dagh, 52
Rhodes and Rhodians, 28, 43, 62, 167; Hannibal defeated by, 62
Rhodiapolis (now Eski Hisar), 119, 132, 137-8, 247, 258
Rome and Romans, 11, 17-20, 22, 25-7, 38, 43, 46, 59-64, 66, 96, 99, 106, 108, 122, 149, 167, 180, 185-7, 190-1, 193, 198, 201, 239
Rott, Hans (traveller), 160
Roxana (wife of Alexander), xx
Rum, 57

Sacians, 206
Sagalassus (now Ağlason), xxi, 94, 99-102, 104, 155, 224, 237-8, 254-5, 257
Sağırı Chay, 105
St. Nicholas island, 180
Salonica, 151, 183
Samos, 28, 31, 231

Index

Saracens, 17, 33

Sarajasu, 137

Sarayjık, 78, 81, 249–50

Sardis, xviii, 111

Sarıchınar, river, 83

Sarpedon, 28, 64, 238, 257

Schönborn (Austrian traveller), 80–1, 104, 155, 187, 198, 249

Sebaste, 17

Sehler ridge, 29

Seki, 194–7

Seleuceia (now Silifke), ix, 16–17, 20, 23, 25–7, 30, 33, 36–7, 42–3, 49, 257

Seleucus, 16–17

Selge and Selgians, ix, 59, 69, 94, 99, 104–17, 198, 244, 254–5, 257

Selimiye, 232

Selinti or Trajanopolis (now Ghazi Pasha), 43–4, 46, 257

Seljuk and Seljuks, 19, 48–52, 54, 57, 59–60, 62, 73, 96–7, 213, 255; Manzikert, 60

Severus, 6, 22

Seyret, 166

Sharapsa, 53

Sicily, xxiii, 26

Side, 27, 41, 53–4, 57, 60–1, 66, 105, 253, 257

Sidek Dagh, 166

Sidon, 113, 211

Sidyma, 198

Silifke (formerly Seleuceia), 16–17, 20, 23, 25–7, 30, 33, 36–7, 43, 48, 176, 257

Sillyon, 60–1, 65–6, 99, 105, 253

Simena, 119

Sini river, 35, 38

Sisygambis, xx, 235

Sivri Dagh, 83

Smyrna, 25

Socrates, 210

Softa Kalesi (Armenian castle), 33, 35–6; surrender to Joseph Barbaro, 35

Sögüt Göl lake (formerly Caralitis), 185, 189, 194, 197, 239, 241

Soli (Pompeiopolis), ix, xvii, 13, 16–17, 21, 26–7, 257

Solyma, 76, 80, 126, 138, 142, 247–8; Mount, 90–1, 122, 127

Sophocles, 113

Sparrow, John, vi

Sparta, 5

Spratt (traveller), 78, 80, 82, 95, 97, 137, 143, 155, 157, 161–2, 174, 179, 183–4, 186–7, 194, 198, 213, 242, 245, 247–8

Staméné or Stalimore (now Anamur), 25, 33, 36–7, 39–42, 54, 68

Statira, wife of Darius, 115, 135

Strabo (quoted), 26, 41–2, 156, 186, 192–3, 195, 229, 233, 237, 242–3, 253

Stratoniceia, 220, 232–3

Sultan Bey, 52

Sunium, 28

Sura, 175

Susa, 35, 224

Susianians, 113

Susuz, 96, 167, 258

Syedra, 48

Syllium, 57, 198

Symi, 28

Syria and Syrians, 3, 10, 19, 25, 27, 35, 43, 48, 132, 167, 176

Tahtalı, see Solyma, 247–8

Talay, Bey and Mrs., 123

Tamerlane, 58

Tancred, 11

Tarn, Professor, xx, 134, 229

Tarsus, 10, 12

Tashajıl, 105

Tashuju Iskele, 257

Taurus, 17, 21, 29, 33, 41, 46, 48, 52–3, 62, 86, 90, 104, 119, 186, 255

Tchandır (Chandır), 82

Tefenni, 185, 193, 239–41

Tekeova Dagh, 80

282

Index

Tekirova (formerly Phasclis), xvi-ii, xx, 27, 55, 87, 126-7
Telmessus (now Fethiye), 185-7, 198, 235-6, 240, 242, 245, 250, 253
Temisonium (Kara Hüyük), 239
Termessus and Termessians, xvi, xx, 59, 76, 82, 89-95, 99, 103-4, 147, 155, 185-6, 193, 211, 237, 242, 254-5, 257
Termilae, 238, 243
Thebe, 58, 84
Theodoret, 18-19
Theopompus, 137
Thessaly, 76, 210
Thrace and Thracians, 34, 73, 76, 102, 138, 142-3, 200, 238, 248, 252
Thrasybulus, 62
Tigranes, 206
Timon, 31
Tissaphernes, 62
Titus, 23
Tlos, 156-8, 186, 195, 198, 212, 236
Topak Tash, 214, 240
Toprak Kale (Arab castle), 10
Trabala, 198
Trajan, 46
Trajanopolis, or Selinti (now Ghazi Pasha), 43-4, 46
Tribigild the Goth, 112
Tristomo (now Üch Agız), 170
Troy, 49, 64, 68
Trysa (now Gölbashi), 172-3
Turkey and Turks, xv, 3, 8-10, 14, 23, 25, 30, 32, 37, 39, 44-5, 47-8, 50, 52, 54, 58, 68-9, 72, 75, 77-8, 81, 83, 93, 105, 109-10, 121-2, 126, 132-3, 141-2, 146, 150, 156, 164, 173, 175, 177, 190, 217, 219, 221, 229, 233, 247
Tyche, 21, 71
Tyre and Tyrians, xviii, 225, 230, 237, 255-6

Üch Agız (formerly Tristomo), 170
Ulubunar Chay, 248

Unbelievers' Way, 87
Ura (formerly Olba), 16-17, 22
Üzümlu (formerly Cadyanda), 213-14, 217-18, 240
Uzunja Burj (formerly Diocaesareia), 16, 21
Uzunkuyukahvesi (formerly Lagon), 255, 257

Valerian, 11
Venice and Venetians, 36, 69
Verres, 61-2
Vespasian, 23
Viareggio, 30

Walid, 11
Waterless Valley, 158
Wavell, Field Marshal (later Earl), 171
Wellington, Duke of (quoted), xv, 164
Wilhelm (traveller), 18

Xanthus, ix-x, xvi-ii, xx-i, 99, 144, 150, 155-7, 159, 166, 172, 176, 183, 185-225, 229, 236-45, 254; Eastern Wall of, ix, 146-59; highlands of, x, 185-95, 213; wall of, x, 212-25
Xenophon, xxiii, 4-5, 75, 115, 135, 203-9, 218

Yakut, 57
Yavı (formerly Cyaneae), 170, 245
Yazır pass, 126, 132, 247-8
Yelbis Kalesi, 38, 40
Yeni Dagh, 76
Yenije Boğaz, 254
Yenijeköy, 131, 133, 248, 258
Yumruk Dagh, 158, 189
Yürüks, 83, 106, 117, 139, 143-4

Zeno, 128
Zerk, 108-10, 112-13, 115-16, 257
Zeus-Olbius, temple of, 21
Zobran, 193